The Art
of
Visual Effects

The Art
of
Visual Effects

Pauline B. Rogers

**Focal
Press**

Boston Oxford Aukland Johannesburg
Melbourne New Delhi

Focal Press is an imprint of Butterworth–Heinemann.

Copyright © 1999 by Butterworth–Heinemann

 A member of the Reed Elsevier group

 Recognizing the importance of preserving what has been written, Butterworth–Heinemann prints its books on acid-free paper whenever possible.

 Butterworth–Heinemann supports the efforts of American Forests and the Global ReLeaf program in its campaign for the betterment of trees, forests, and our environment.

Library of Congress Cataloging-in-Publication Data
Rogers, Pauline B. (Pauline Bonnie)
 The art of visual effects : interviews on the tools of the
trade / Pauline B. Rogers.
 p. cm.
 ISBN 0-240-80375-2 (paperback : alk. paper)
 1. Cinematography--Special effects. 2. Cinematographers
Interviews. I. Title.
 TR858.R65 1999
 778.5'345--dc21 99-23410
 CIP

British Library Cataloguing-in-Publication Data
A catalogue record for this book is available from the British Library.

The publisher offers special discounts on bulk orders of this book.
For information, please contact:

Manager of Special Sales
Butterworth–Heinemann
225 Wildwood Avenue
Woburn, MA 01801-2041
Tel: 781-904-2500
Fax: 781-904-2620

For information on all Butterworth-Heinemann publications available, contact our World Wide Web home page at: http://www.focalpress.com

10 9 8 7 6 5 4 3 2 1

Printed in the United States of America

Table of Contents

So much of the movie world is, as John Dykstra says, "smoke and mirrors" and we all love it!

When I write my "On the Set" column for *International Photographer Magazine* about a movie shooting on an exotic location, I will inevitably get a call asking, "how was . . . ?" I try not to laugh.

Few people (except, perhaps, those who know what a magazine budget really is) believe me when I say, "Who knows . . . ask the crew!"

Part of the job of a writer is to make the reader believe that he or she was really there – that what is on the page jumps off the page with that "alive" feeling.

So many times it really is smoke and mirrors. I blow the smoke (with my writing) to mirror the words I pull out (and sometimes it takes a great deal of pulling and begging, and, okay, blackmail) to get the images from my subjects.

True, at times, I would like to throttle a few of them (as they would me, I'm sure). It's hard to get anyone to talk about themselves, even harder to get them to explain what they do and how they do it. It's especially hard to get these wizards of visual effects to stop, think, and then explain just how they make the audience believe their smoke and mirrors.

Thank you – to the many people who took the time to reveal what they do, why they do it, and how. It makes watching the movies all the more exciting for me.

A special **thank you** to a few others :

George Spiro Dibie, president of Local 600 (the cinematographers guild) and executive editor of *International Photographer Magazine*, for permission to reprint the ILM articles.

To Philipp Timme and Conny Fauser, for being my proofreader and helping me get a glossary together, when I knew I was in over my head. And Steve Prawat of Imageworks, for those esoteric definitions.

To Nagisa Yamamoto (ILM), Don Levy (Imageworks), and Bob Hoffman (Digital Domain) publicity for running interference (and sometimes even finishing the interviews) with their people.

To Hollie Meyer, for transcribing those interviews when I couldn't listen to another tape.

To Scott Moffet, for coming to my aid when the computer decided to take a vacation on me!

To Jeff Ptak, for making it possible for me to sit at the computer for hours on end.

And to those faithful assistants, associates, and crews of these wonderful visual effects people, for pitching in and helping out when we all needed them the most.

You all made this project what it is!

In the Very Very Beginning . . .

Up until the turn of the century, hardworking people in need of a diversion would plunk down their hard-earned nickel or dime and take home roughly written "dime novels" that would, for a time, transport them into a world of imagination. The amount of fulfillment they received often depended on how graphic the writing and how vivid their imaginations were.

In 1894, however, Thomas A. Edison revealed a new invention. For a nickel, thrill seekers could look into the Kinetoscope and see moving photographs of a blacksmith at work, a lady contortionist, Annie Oakley's prowess with a gun, Sandow the strong man lifting weights, a train pulling into a station, and more. For the first time, the American public was able to look at 35mm films, most under 50 feet in length, which traveled past the eye at 46 frames per second.

It was a novelty at first. Soon, however, the viewing public wanted more stories to fire their imagination. To keep the nickels flowing meant an expansion of techniques.

Edison and his group began looking for new techniques. The historic dramatization of *The Execution of Mary, Queen of Scots*, photographed at Edison's studio in Orange, New Jersey, took place on August 28, 1895. Created by Alfred Clark, it was more than likely the first known use of "special effects." Instead of pacifying the public, it sent them into shock. Had a human life been sacrificed for the sake of a penny arcade amusement?

To chop off the queen's head, Clark had stopped the camera crank before the ax fell. The other player "froze" while the queen hurried out of camera range. Then, a dummy was put in the actor's place. Finally, the cranking was resumed, and the headsman finished his swing. After the negative was processed, a few frames were cut from the end of the first take and the beginning of the second.

Film Special Effects had been born.

Some seven years later, in France, the use of "arret" – or the stop – controlled by a whistle off camera, gave notice to both actors and camera operators to stop the action, and pin registration, until the camera work was resumed.

This widely used technique was the basis of visual effects, until someone was able to bring technique and talent together.

According to his own account, George Melies was photographing the façade of the Paris Opera House when his camera jammed. After making quick adjustments, he resumed cranking. When he saw the film, he was surprised to see a passing bus change abruptly into a passing hearse. A magician by profession, he added this "trick" to his act. Soon, his Montreiul studio was equipped with trapdoors, mirrors, winches, pulleys, wire riggings, and other magician art.

From 1896 to 1912, Melies made close to 500 films, shot with a camera anchored to permit substitutions and multiple exposures. Everything was staged in the manner of vaudeville "turn." The audience would view the finished project as though sitting front row center.

Unfortunately, because of the reaction to *Mary, Queen of Scots*, the movie- makers were only doing fun and fantasy. Audiences now saw elves, angels, dragons and ghosts as they mysteriously appeared and disappeared – all in innocence and fun.

At the time, the British began their assault on the "effect," by doing their first "double-exposure" shot, which depicted a ghost and the vision of a fatal duel in Alexander Dumas's *The Corsican Brothers*. Suddenly, horror, in the guise of fantasy, was being accepted.

In 1901, London photographer Robert W. Paul invented a printer that would take multiple exposures in the camera in another direction. He was able to combine images from several negatives to create fantasy productions like his film *The Haunted Curiosity Shop*.

In this film, in rapid succession, the top half of a lady enters a room, followed by her lower half. When an elderly owner tries to embrace her, she turns black, then changes into an Egyptian mummy, which finally dissolves into a skeleton. Then, three gnomes appear. They perform a dance, then merge into one. When the old man pushes the gnome into a jar, a cloud of smoke emerges and a giant head appears, frightening the man away.

Some films were pure fantasy, but most had a message – intentional or not. In 1905, Walter Haggar, a traveling showman and producer, made a movie called *D.T.'s or the Effect of Drink*. Here he showed a man returning home drunk. As he begins to undress, his coat assumes the shape of a dog and walks away. Then some vases take on the shapes of owls. Demons appear. Finally, his bed becomes a monster

that romps about the room, with him aboard. It finally explodes. As the man crashes back to earth, he swears he will never get drunk again.

Along with the message movies and the horror fantasy, early producers tried sweet and sentimental stories. They brought to the screen classic tales. In transporting *Alice in Wonderland* to the screen, Cecil Hepworth, a leading British film producer, made some 16 scenic dissolves. He toned and stained colored shots on an 800-foot production. He stayed very true to the Tenniel illustrations, which he set in an unusually elegant surrounding.

Incidentally, the production was staged by Gaston Valle, son of the noted stage magician. He eventually joined forces with Melies, after the magician refused to join Pathe.

Naturally, mini-rivalries began to develop in this new industry. Pathe and Gaumont were the first to declare open war. Gaumont created a special effects stage 70 feet wide and 100 feet high at his Paris studio. He enclosed the entire studio in glass, to permit the use of daylight lighting for indoor photography. He even added trapdoors and large submarine tanks.

Now, moviemakers began to see other uses of the techniques. Realizing the public was news-conscious, as long as they didn't have to read the small print or listen to information again and again, photographers and producers began to re-create newsworthy events via models and miniatures. Many followed Melies's 1897 technique of staging battles with model ships, blowing up cities, marching troops, exploding volcanoes – all in the guise of telling the public what was happening in the "world."

To depict *The Battle of Santiago Bay*, an artist by the name of Blackton mounted canvasses turned upside down and filled them with water. The ships were photographs of the originals, cut out and mounted on wooden bases, pulled with strings. Explosions were black powder set off with a wire taper. Mrs. Blackton and an office boy blew the smoke into the scene. Both fainted because they had never smoked cigarettes before.

Edison also joined the "effects" world. In his Spanish-American War series, he combined miniatures and actors as well as full-scale set pieces in scenes of model ships. These were shot via double exposure and staged as simultaneous action, using false perspectives.

It wasn't all that amazing to the producers that the public accepted these tricks as real. Since the cinema itself was regarded as a miracle, it only followed that the patrons were unaware of the fact that

it was impossible to make movies by moonlight or maintain a steady camera during an earthquake.

Many really believed that the re-creations of the San Francisco earthquake (1906) were actually shot on location. How could they know it took all the strength and energy these moviemakers had just to stay even.

While fire effects and beheadings were being perfected for new stories and fantasy purges, other cinematographers were working on different techniques. Edwin Porter, producer and cinematographer for Edison, was probably the first to combine several new techniques in a 1902 project called *Uncle Josh at the Picture Show*. He used mattes, stop motion, and miniatures.

In *The Great Train Robbery*, he showed one actor batting another's head with a chunk of coal during a fight in the coal tender. The actor then tosses the "corpse" overboard. It was the most important use of mattes to date. One scene showed a train passing outside the window of a set, representing a depot. The other was a moving outdoor background, as seen through the open door of a "speeding" baggage car. The indoor/outdoor shots were doubled on the same film, but the images were free of ghosting because they were exposed through complementary protective masks, i.e. matte.

Even so, matte work was limited. Photographer Otto Brautigam was developing some sophistication in the work. His matte and counter matte system made it possible for new composite effects. He was, probably, the first to perfect dual roles for actors. However, his work was marred by the unsteadiness between the two exposures in Edison's films.

In 1914, however, Bell and Howell introduced a camera with a pilot pin film movement. This solved the problem. Now, audiences saw King Baggot as brothers in the 1915 Universal version of *The Corsican Brothers*. They also saw Mary Pickford as mother and child in the 1921 film *Little Lord Fauntleroy*. The Pickford film used intricate glass mattes, allowing her doubles to touch and even kiss.

American filmmakers were not the only ones experimenting with their realities. In Germany, future Pathe producer Oskar Messter, inventor of the crucial Maltese Cross projector principle, made psychological horror stories, well before their time. His *Das Gewissen*, the story of a servant who murders his master for a cache of gold, was made in 1903. It featured a money bag that changes into a skull and a

portrait of the victim that comes to life and points accusingly at the culprit.

In Italy, *L'Inferno*, made in 1909, brought to life the horror of hell. This was a version of Dante's *Divine Comedy*.

In England, in 1906, Walter Booth made one of the first attempts at serious science fiction with the remarkable *Possibilities of War in the Air*. The bombardment of England was carried out by a fleet of mysterious dirigible-like aircraft, which were eventually destroyed by a young inventor's remote-controlled missile; it was the predecessor of today's very real weaponry. Fantasy, even then, was beginning to predict the future.

Even isolated Australia got into the picture. For Gaumont's *The Great Barrier*, Norman Dawn used matte shots, in which underwater scenes of reef life were filmed from a watertight box, weighted with sandbags. The upper portions of the scene were masked off to create a waterline. Surface views of dripping coral reefs were photographed into the matted area.

In the same picture, he photographed rare Queen Pigeons (there were no more than four to be found) in a flock by setting a small glass painted with rare birds sitting motionless on the mound where the rare birds gathered. He then set up a blind and shot the painted birds, along with their living companions, to create the illusion of a larger group of rare creatures.

Still in all, American and British effects began to dominate. Vitagraph's 1909 version of *The Life of Moses* baffled everyone. The closing of the Red Sea over the Egyptian soldiers was accomplished by Albert Smith and J. Stuart Blackton, by first photographing the soldiers on the beach at Coney Island. As a huge breaker was superimposed, coming in from the right, it broke over them.

Then the film was turned over and a wave was exposed breaking from the left (anti-halation backing was unknown). In the final composition, the waves appeared to engulf the soldiers from both sides.

The Star of Bethlehem was double-exposed by photographing a spotlight through a copper wire screen. This created a shimmering effect.

Soon, animation, miniatures in two-dimension, fully constructed in glass shots to add foregrounds and architectural details, stop-motion sequences, puppet work (1912's *War in Toyland* in color), oriental shadow plays by Lotte Reiniger (1912's *The Flying Coffer*), as well as

"gag" pictures from Mack Sennett and others were the norm. The heyday of special effects had finally begun.

By the late 1920s, combinations of shots were normal. Effects were beyond the novelty stage. Departments were created to experiment and introduce anything that would make the fantasy more real.

Movies like *The Ten Commandments*, made in 1923, and *The Thief of Baghdad,* in 1925, parted the Red Sea and flew Douglas Fairbanks aloft on a flying carpet. And, for the most part, audiences weren't aware of the tricks and the gags.

Effects were here to stay.

Or were they?

The advent of the "talkie" seriously damaged the future of these movie tricks. As long as the film was shot "silent" and augmented by a live orchestra, everything was okay. But once Al Jolson "talked" and "sang" in *The Jazz Singer*, effects camera work was doomed in many productions.

When the camera was frozen in a soundproof booth, cinematographers began to faint from the heat. The mobility of the camera was so restricted that many a production simply forgot effects. Even westerns were doomed to extinction because of the difficulty of recording sound out-of-doors. Talking pictures demanded realism in presentation.

But the effects masters weren't daunted. They just took a break, thought about the challenge, and came up with other ways of accomplishing their magic, even with the camera restrictions. In came other approaches to miniatures, rear projection (in Fox's *Lilliom*), and other techniques. Danger and realism cropped up, once again, in the new "talkies."

By 1932, "talkies" were here to stay, and moviemakers had a handle on them. Soon, the visuals became most important. A growing cycle of fantasy and horror films took over. *Murder in the Rue Morgue*, in 1932, had traveling matte shots. *Tarzan, The Mast of Fu Manchu,* and *Gunga Din* featured new and different techniques from floods to jungles to attacking wild beasts. *King Kong*, the most popular special effects' oriented film of its time, pitted a stop-motion giant ape against prehistoric monsters and man in 1933.

There was, according to the experts of the time, nothing that couldn't be done with the camera. They had conquered the unconquerable.

Then came a new age of entertainment – television. It brought more work to the studios and created the "postproduction" field of work. Effects took on a new dimension.

While some fell by the wayside because they were done within the camera only, others crept up because they could be done out of the camera. Experiments for one phase of the industry often affected the other.

Techniques developed for *Flash Gordon* and *Buck Rogers*, two classic television series, admittedly were the prototypes for the feature film's major steps into effects – *Star Wars* and *Indiana Jones*. Just as today's epics could not have been made without the experiments on these low fantasy films, the effects created by today's masters could not have been made without the experiments of people like Melies.

The following pages are a homage to and a trip through the creative minds of 16 effects masters. It is their past, present, and future "experiments" that will assist writers, directors, and producers in bringing to the screen more and more sophisticated stories to entertain savvy audiences through the new millennium.

Note: An earlier form of the above first appeared as an article in International Photographer *magazine (May 1989), when the author was a freelance writer.*

HOW DO THEY DO THAT?????
The Incredible Work of ILM

Did your stomach get all knotted up when Meryl Streep's neck twisted several times in **Death Becomes Her**? Were you charmed when the sad and lonely girl made friends with a ghost named *Casper*? Did you hold onto your seat when actress Helen Hunt was swept into Mother Nature's shout of autonomy – a *Twister*? Were you shocked when Tom Cruise's face was revealed as Jon Voight pulled his mask off in *Mission Impossible*? You were not alone.

These are some of the startling visuals created by a very low-profile company based in an industrial complex in San Rafael, California. Though the neighbors know what kind of magic goes on behind the doors of a complex that will remain nameless, few will give away the secret. They have too much respect for the work, and the man who created the magical world.

Twenty-some years ago, a young movie maven came up with a twist on the hero legend. His production company, Lucasfilm Ltd., created a story that plucked a young person from his safe world and threw him into an adventure with a mysterious princess and a charming rogue. He sent them into a faraway land and placed all sorts of wondrous obstacles in their paths. Using amazingly advanced yet relatively new technologies, such as motion control photography, his Industrial Light & Magic created worlds that only words once explained.

Star Wars became an overnight success. And George Lucas and his crew showed Hollywood where their imaginations could lead them. The 1977 Academy Award brought a new buzzword to the industry – "visual effects."

It began with a mastery of the traditional arts of blue-screen photography, matte painting, and model construction. The company pioneered the development of motion control cameras, optical compositing, and other advanced effects technology.

Over the years, ILM has garnered 14 Academy Awards for Best Visual Effects and 9 Technical Achievement Awards. They have played a key role in 6 of the top 10 box office hits of all time and contributed

leading-edge effects to over 100 feature films, as well as hundreds of commercial productions and attractions.

Each time the ILM wizards approach a new project, they put a different spin on their techniques. Since the 1980s, they have led the way in the use of computer graphics, developing software techniques such as morphing, enveloping, and film input scanning. They have created wholly computer-generated characters in *The Abyss*, *Casper* and *Terminator 2*; lifelike distortions of the human body in **Death Becomes Her** and *The Mask*; and startling 3-D computer animation in *Jurassic Park* and *Twister*.

Every one of the 700 plus employees will agree that 1996 was a banner year. As the 12 months ended, they were still feverishly working on new innovations for 1997 releases such as *The Absent-Minded Professor, Speed 2,* **Spawn,** *The Lost World: Jurassic Park,* and **Men in Black**. They were also trying to do the "last two" shots for the re-release of the **Star Wars Trilogy Special Edition** (see next month's magazine).

They also had time to put their singular style behind four of the biggest end-of-the-year films to come out of Hollywood. In **101 Dalmatians**, they created some of the most lively and very real-looking creatures ever brought to the screen. For **Mars Attacks**, the crew created totally autonomous "Martian" worlds, as well as popping these lively creatures into Tim Burton's bent reality. In **Daylight,** they made everyone believe Stallone and his female companion were really struggling for their lives in the deadly waters below the Hudson River. And, for the newest **Star Trek** adventure, they made **Alien** look tame compared to what the Borg can do to the stalwart Enterprise crew.

101 Dalmatians

"When you are doing an animal picture, especially when those animals are the stars, the first thing you have to figure out is what you can get the real animals to do, and what you can't," says ILM's Doug Smythe. Unlike *Jurassic Park*, where details about the creatures could be decided as they went along, in **Dalmatians**, these creatures had to be absolutely true to life.

A 10-year veteran of ILM's magical crew, Smythe has received four awards from the Academy of Motion Picture Arts and Sciences. These include two Technical Achievement Awards, one for the

invention of the morph process that transforms images of any one object or character into another and one for digital-image compositing systems. A Scientific and Engineering award was for the co-invention of a Digital Motion Picture Retouching System. And, his Oscar for Best Achievement in Visual Effects was for his work on **Death Becomes Her**.

"We had puppies down here a lot," he says. "It was great! The little buggers were roaming around everywhere." To study their movement style, visual effects supervisor Smythe and crew sat with the puppies watching them as they played, as they attempted to react to commands. "This way, we could determine whether particular shots required some synthetic approach (puppets or CGI), or if real puppies could be used." They also studied such details as the density of fur and how it came off their body.

After a short while, it was clear that the puppies were great actors if they were sitting still or were going from point A to point B. "A little food and they made a beeline toward it full speed," Smythe says. "If we wanted sneaky or stealth action, we realized we would have to do it."

Once the technicians completed their hands-on study of the puppies, they turned to the technical approach. "We would figure out how they moved and how they fit with the camera," Smythe explains. "Then we had to find a way to create them through CGI.

"We began by photographing a puppy on top of a Plexiglas platform," he continues. "We used a really cool rig that carried Nikon-style 3:5:8 cameras. Using synchronized shutters, we photographed them from 10 different angles at the same time."

These photographs were used by Geoff Campbell, Kyle Odermatt, and Wayne Kennedy as a "hero" model in the computer. "We used Alias Power Animator™," Smythe explains. "Once we had a model in the computer, we began to animate walk, trot, and run cycles by placing this model on a turntable and looking at it from every angle until all angles looked right. We also digitally painted 13 different spot patterns to be used to vary the characteristic shadings," he says.

This hero model served for nearly every CGI shot in the picture. "We did have to create a different model for one sequence," he adds. "At one point in the movie, several dogs slide through a drainpipe. Three are sitting, but one goes through lying on its back. We needed a different model for the back flop. In this configuration, the animal takes on an extremely distinct shape."

For Smythe and the ILM crew, one of the most intricate and amazing sequences was set in a library. "There was no way to get enough real dogs to race through the elaborate room," Smythe explains. "We initially planned to use only real puppies and some Henson animatronic dogs, but the scene was too lifeless. In order to do the splits, the dogs had to stay in one section of the room at a time. As Jon Alexander and Matt Wallin erased the real dogs and animatronic 'Stuffies' from the live photography, Mike Eames and Philip Alexy replaced them with CGI dogs doing more appropriate actions."

To do this, the team began by using a technique established on *Jumanji*'s stampede. Using simplified figures called pawns, they placed the figures on paths "drawn" on the virtual ground. As the computer created movement, the pawns would stick to these paths. Then, by carefully choreographing the actions with start and stop times and speeds, they created a multitude of puppies and paths. "As we built up the tool set, the shot became more complicated," Smythe admits. "Every time we thought we had clear paths, one of the pawns would crash into another or actually run through another – and we would have to redo the timing!" Then came the final touches, like nuances in head motion.

Lighting these types of shots was also difficult. Although they always started with the pattern cinematographer Adrian Biddle created, often times "Does it look right?" took over. "We sometimes had to move our light around to get the necessary effect," Smythe admits. "That's because, in computer graphics, we do not have the same illumination control with flags and bounce cards as is available on the real set. However, we can position our lights anywhere we want – behind props, as an example. If we don't want the floor to block the light, no problem. We just turn off the floor!

"The CGI lighting in the library scene was done by technical director Ed Kromer. Oftentimes, Ed would take several different lights to simulate what was done on the set," he continues. "Where there was one strong light in the live action, we might put two or more in a CGI area. By spreading the lights around, we were able to get them to soften each other, thus falling together to make one source.

"It's a calculation," he adds. "A 2K might come from half a dozen peppers. We can get the brightness of a 20K into a little Mole hole. We can even put filters in front without worry."

Although several shots were done with the four-perf camera, most were filmed with eight-perf, either locked off or with a simple tilt.

"Four-perf has less repositioning latitude," he says. "That means we can't add bobble or tilt to the camera move in post. Eight-perf allowed us to add a camera tilt or push in or something that would help give more interest or focus to a shot.

"The lifelike CGI puppies were used for many shots," he continues. "Sometimes it was lots of pups doing specific actions that couldn't be achieved on set. At other times, they were in shots simply too dangerous for a real dog.

"Like the shot of Wizzer slipping and sliding across a patch of ice, or when one of the dogs stands on the edge of a treacherous roof top."

Even if animal control would have allowed the live action team to coax Wizzer across the ice, there would be no guarantee he could have hit his mark without a massive case of ice burn. "There was no way they would have allowed the production team to put a real dog on the edge of a tall building.

"It was ILM's job to make this happen not only with no danger to our 'animals,' " Smythe concludes, "but with such reality that the audience really believes a real dog was in this kind of dangerous situation."

Daylight

"The idea was to make this film much tougher and more powerful than *Backdraft*," says ILM's visual effects supervisor Scott Farrar. A 15-year veteran of ILM's magic, Farrar started as a camera operator on *Star Trek II: The Wrath of Khan*. In 1985, he received an Academy Award for Best Visual Effects for his work on *Cocoon*.

"This film became an update of the old-style Hollywood disaster picture, like *The Poseidon Adventure*," he explains. "We had to find a way to shoot scenes that were supposed to be 14 or 15 feet under the water. We needed safety, suspense, and a setup that was violent and dangerous."

While ILM has done various fire effects before, and won much acclaim for them, visual effects supervisor Denise Ream and producer Joe Letteri were determined to give these effects an extra edge. "Some

of them were supposed to be quite 'explosive,' and some were supposed to be subtle yet interesting," he says dryly.

"We did some shots in real sets, blowing things up with light effects around the actors. Other shots were done in miniatures, in a fire tunnel created on our stage," he adds. The cars might have been miniatures, but the fire tunnel was rather large, encompassing a floor-to-ceiling 30-degree slant on one of ILM's largest stages.

"The tunnel was about 5 feet by 8 feet and 40 feet long," he says. "We had about 40 fire jets located at exact areas within the tunnel. We had an amazing plumbing system that could literally advance or retard a jet in 1/500-second. Using baffles, fans, and interrupters, we could create exact shapes for kerosene fire passes using microcomputer inputs.

"As the flames were turned on, the sound effect was huge. Fans would suck them up to the top, as if the wind was blowing the flames in that direction.

"We shot everything at different speeds," he adds. "This gave us a better control of more elements. When we finished, the final product was amazing and simulated the force we needed for the tension in the picture."

Making fire roll over a standing car, engulfing elements in flames, even chasing real figures through darkened tunnels – these were some of the more "elemental" effects done on *Daylight*. "With the new technology, we can refine things that have been done before," Farrar says. "The computer software is more sophisticated. We can do more things faster, allowing us to up the ante and add more complicated effects.

"Where we really broke new ground was with the water effects," he admits. "We tried a number of different things before we resorted to 100 percent CGI animation, however."

For Farrar and his team, the most difficult water shots involved a great deal of force and very brave actors. "There were times when we had to have divers stationed with pipes, ready to swim out before the water or mud slides came," he says with a straight face. "No, I'm lying. We found another way to make these dangerous shots!"

Knowing the film's director wanted to see things like turbulence, moving water, debris, garbage, bubbles, and the actors' faces in the shots, Farrar and his group began to explore various ways to make this work. "Initially, we built a water tank that was about eight feet by eight feet and was a good six feet high," he explains.

"We set up all kinds of things in that tank," he continues. "Using a variety of materials, such as spinach, for debris, we shot everything we could to make it look like strange particles were floating through the water.

"We then tackled the element of bubbles. At first, we blasted air/water/bubble combinations against a dummy's face. Instead of getting bubbles going around the figure, things began to puddle in the eye sockets and we would see goofy things around the face.

"There was no dimensionaly, no sense of volume. It was real, but it looked horrible."

In Rome, the team shot Stallone underwater. Closeups of his face were distorted. Not only did the force of the water move his skin around, it took weight off his eyelids. "He just didn't look like himself," Farrar says. "So, we had to find a way to show the force of the water but also keep the skin intact."

That is where ILM became new innovators. Many of the dangerous underwater sequences in *Daylight* were shot dry for wet! Both Stallone and Amy Brenneman were shot against a full-sized set, a blue-screen and a miniature background. Farrar and Joe Cotter, his co-visual effects supervisor, developed a recipe of materials to be used on the set for the underwater sequence. Using peat moss, ground chocolate, and finely ground charcoal as the basis of the supposed water particles, the actors dug their hands into the "surface" as they were swung about from a wire.

"The initial idea was great," Farrar says. However, most of the shots were lit in a certain way in Rome. Once the plates were created, the lighting scheme was set. As usual, things changed.

"There is a point in the story where Stallone's character sets off an explosion and he and Amy Brenneman's character are literally blasted through the tunnel ceiling, the riverbed, the Hudson River, and into the air," Farrar explains.

"We had to do simple things, like reduce highlights on him, to balance the density of the environment. Or, we had to add greenness to the flesh tones so that it looks like he is underwater.

"The most complicated shots, however, came with this blast," he adds. "The explosion had to happen, but the light had to be dimmed. We couldn't go back to Rome to relight, and we needed to see Amy shoot through the blast."

Using a more sophisticated version of painting Tom Hanks's arm back in, as Gary Sinese's "legless" body passes over him in *Forrest*

Gump, Pat Myers literally cut Brenneman's body apart, extracting pieces of her arms, legs, and torso, then animating the pieces back in.

"It's not technically difficult," Farrar shrugs. "It just takes a little timing, patience, and practical applications. It's as easy as shooting the actors hanging in one direction, then inverting the shot so the hair flows in the 'right' direction.

"Dry for wet has been done before," he admits. "But that included putting feathers into the set and blowing them around. Here, we used a variety of carefully controlled computer-animated layers to give a sense of depth, adding murky water effects behind the actors, in front of them, and around them. We even added computer-generated particles to enhance the great smelling elements we had on the stage."

It became a matter of balance. How much did the actors have to do, and what could ILM contribute to make it real?

ILM's people aren't tooting their horns, however they're betting audiences will believe their hero is really fighting the elements 15 feet below the Hudson River. They had better. Sylvester Stallone is not the only one counting on this kind of leap of faith!

Mars Attacks!

"Originally, the attacking Martians were going to be 15-inch puppets," explains visual effects supervisor Jim Mitchell and motion control cinematographer Pat Sweeney, of the *Mars Attacks!* evil aliens. For Mitchell, who joined ILM in 1990 and has participated in several Academy Award pictures including *Jurassic Park,* **Death Becomes Her,** and *Terminator 2: Judgment Day* - and Sweeney, who has photographed effects for *Indian in the Cupboard, Nightmare Before Christmas,* and *Hunt for Red October*, the real fun on this picture came with a few of the totally autonomous sequences.

"Some of the shots called on techniques developed for films such as *The Mask* or **Death Becomes Her,**" says Jim Mitchell. "We removed actress Lisa Marie's head and put her 'real' Martian head in its place, without motion control elements, but using operator Ray de la Monte's footage.

"That was a difficult shot for him," Mitchell admits. "With computers, you can be flexible. It is the talent of the operator that carries this kind of shot. He really nailed it on Lisa Marie's Martian

shot and when we had to take Sarah Jessica Parker's head off and put Poppy's (Tim Burton's dog) Chihuahua head in its place.

"That was probably the most difficult replacement challenge," he adds. "When you are integrating different images that don't belong together, it is tricky. What is harder is integrating the live action with the CGI."

At first, the team did attempt to work with the real Poppy. "He was great," Mitchell admits. "The barking was down to a minimum. The dog really performed. We just realized that the timing was so critical, it would be best to do the match with a CGI dog. This way, we could stretch the dog's neck to match the human configuration.

"Probably, the funniest part was animating the dog's 'excitement' and 'fear,' the quick steps and constant shaking. Fortunately, we had techniques developed on *Dalmatians* that helped bring these emotions across.

"Like all the stars who signed up for this project, Sarah Jessica Parker really got into the abandonment and the ability to play a scene for as much over-the-top value as she could add. She took this shot of her head grafted onto Poppy's body seriously, studying every angle. At one point, she added a little improvisation. When the dog gets up from the operating table, the natural movement was to scratch. She was so serious, and wonderful, when she added that little bit to the moment!"

It is clear that everyone had fun making up the reality of the Tim Burton fantasy. Whenever they were integrating the wildness into live action, even if it was the borderline of "gross" when they got to the death effects, the work was still the seamless blending of real actors and CGI. "How often do you get to be totally autonomous?" asks Pat Sweeney. "We had a chance to completely fabricate several sequences. That was totally different from anything we had done before."

When *Mars Attacks!* was first planned, the idea was to use 15-inch stop-motion puppets as Martian characters. However, in discussions with cinematographer Peter Sushitzky, director Tim Burton realized going anamorphic would allow them a wider palette but would make it very difficult to shoot the stop motion with anamorphic lenses. At first, the ILM team thought about creating both the characters and their ship through CGI.

"There were a lot of possibilities," Jim Mitchell admits. "However, total fabrication of a 3-D object so elaborate as a ship is difficult. It doesn't look 'real' enough, especially with the complicated lighting we intended to use."

"We found that there was a Martian ship already designed for puppets and puppeteers," adds Pat Sweeney. "We could use the 'real' ship for our CGI invaders."

It was like kids in a candy store, the day the 18-foot-by-11-foot ship arrived at ILM. "We lost about a foot and a half of wall height because it was covered by the floor surface that the Martians walked on," says Sweeney. "Still, we had about a 9-foot high space to create a ship no one had seen before and one where we could put our CGI Martians inside."

Since Sweeney, Mitchell, and the rest of the team were going to work with such a huge model in the large but limited space, they decided to make the one structure work for several areas in the ship. For the Martian main control room, they added a navigator system and a sphere in the center of the room. This is where the main Martians hung out. Much of the floor surface was grating, under which Sweeney could set lights.

"We knew Tim wanted a cool light for the ship's interior," says Sweeney. "He wanted the color to come from the Martians, a green/brown that would contrast with the silver walls. However, when we looked at this set, we saw a squid in a domed jar, an exotic glass bubble that would hold a captive Sarah Jessica Parker, and a spinning navigation unit. These set pieces cried out for some vivid colors, so they would not blend into the background.

"We did some initial tests with these added color elements and showed them to Tim. He loved the textures, so we decided to run with it. We put my favorite units, Inkies, under the grating to throw an amber light. We used at least 50 or 60 of them to light the entire set," Sweeney explains.

"Pat set it up so all the lights on the focus areas were neutral or cool. When we had a Martian 'walk' across the grating, we could see a slight falloff on the legs and the head. This came from the warm gels on the Inkies down below."

Sweeney took special care lighting the spaceship's console. Using his favorite tools, he placed various light sources in nooks and crannies, adding small lights with cardboard tubes attached to isolate the desired areas of concern in the set.

"Tim still wanted the feeling of the 1950s, using 1990s technology, even though we were going for a more colorful look," Sweeney continues. "For most of the picture, including these shots, we decided to go for very 'straight' camera moves. We wanted to avoid the

Steadicam look so we used the lock-off style typical of those 1950s and 1960s science fiction stories.

"Occasionally, we would take advantage of our motion control crane and follow characters through the set. When Tim's lock-off-type shots didn't work for us, we improvised."

"For the operating room, we redressed the set," Mitchell adds. "We took out the command center and the sphere. We added various supports and other elements such as operating tables, chairs, and hospital equipment."

"This light was harsher," says Sweeney. "We used Inkies with different colors, focusing on each element with a spotlight, a harsh backlight.

"For the wonderful giant brain, we used a yellow/green mixture off the brown. Don't ask me why – it just felt right. For the cow stuck in liquid, we put a bluish color and the white-and-black skin. I know, it is a kind of sick sense of humor, but it worked and it was fun!"

Even while Sweeney was figuring out the lighting scheme, everyone got into the act of "dressing" the set. Set designer Wynn Thomas visited Sweeney's set and began changing the architecture from his original design. "He really got excited," Sweeney laughs. "He kept looking around at the props we had in the studio. He would move strange things into the ship. What a case of women's shoes was doing in the ship, we didn't know. Maybe, the Martians collected them. It didn't matter it was wacky, but it worked."

Soon they had a huge cylindrical steering wheel, lights that blinked off and on through lighting cues, strange patterns blinking everywhere – and a wonderfully complicated pallet for the CGI invaders. "We had some storyboards from Warner Bros.," says Mitchell. "They provided a few lighting and timing cues for movements such as the leader moving from the console and walking through the ship. However, the timing was not right for the CGI elements, so we started from scratch."

"We did use the puppets, though," adds Sweeney. "It was the only way to give CGI references. I would walk the 15-inch figures across the floor and shoot a video. This gave CGI a visual guide of how long it would take to move through a scene and how fast the walk should be."

Sweeney even got into extremely complicated moves. He laid out a shot for the Grand Poopah. "We put in a motorized chair rotating and descending from the rafters and timed the shot out so we could

accurately frame up and follow the chair. We shot a reference with the puppet, which gave CGI an accurate direction to animate the action. The shot turned out fantastic! A lot smoother than if we had used puppets," he admits.

"To give us as much reality as possible," says Sweeney, "we shot the set as if we were doing live action. We didn't want to do multiple passes, so we used a lot of internal working lights. Motion controlling the lights to sequence the proper time helped. So did shooting at a lesser F-stop. Instead of the normal F-16, we did everything at a 5.6 or an 8. The idea was to frame for the character that would be there and let the background focus fall off."

Most of these scenes were shot with a custom VistaVision™ camera in the 2.35:1 format. Even though the shots might only be a few seconds long, the camera held 200 feet of film. "The beauty is that this computer-controlled camera can go anywhere," Sweeney explains. "We can go floor to ceiling, under, around, and above. We can even sneak through tight area! It is a lot different from live action. Here we were working with a camera and grip crew of three! (Sweeney, Michael Olague and Kate O'Neill) It was hard to do some of these shots with this small a crew!" Sweeney says with a smile.

Both Pat Sweeney and Jim Mitchell sound extremely confident about their ad-lib adventure creating a totally autonomous element to blend with the live/CGI action. However, push them just a little, and they will admit there were a few very strange moments. "We thought we had everything planned," laughs Sweeney. "We created some wonderfully odd objects for each of the sets.

"In the operating room, for example, we had different liquids encasing specimens or animals. They would look great the day we created them. Then, a day or two later, we'd come in and something was out of whack. The liquid had shriveled or melted the characters!"

That was easy. All they had to do was pull the elements out and drain the liquid. "Right. It became the burning cigarette theory," Sweeney smiles. "We would pull the elements out when we weren't shooting in that direction. Then, when we had to put them back, we had to make sure we had references. Changes in water level can be just as annoying as an extra inch of ashes on a burning cigarette between cuts. Audiences are too sophisticated to let those things pass!"

Star Trek: First Contact

Both director of photography Marty Rosenberg and visual effects supervisor John Knoll agree that this latest *Star Trek* adventure has a much harder edge to it.

For Knoll who along with his brother is the author of one of the most widely used Macintosh computer programs, Photoshop™, and who was the computer graphics project designer on *The Abyss*, which won ILM its tenth Academy Award some of the edge comes from the graphic elements. Although he enjoyed more than a few of the low-tech tricks employed on this picture, the Borgification of Picard and his crew added a new edge to the project. The intricate elements behind these mythical monsters run a fine line between beauty and grossness.

To Marty Rosenberg, who had done films such as *Mission Impossible* and dozens of commercials for ILM, it is the details added to both the materials lifted from past shows and the newly created and sophisticated elements of the newest *Enterprise* that stand out in his mind.

"We worked especially hard at creating this world's reality," says Knoll. "Many of the shots were really tough. Instead of trying to 'get away with' an easier element, we came up with unique ways to make what the story called for work, whether it was extremely high-tech or amazingly low-tech.

"One of our toughest shots was set in a *Titan* missile silo (see 'On the Set' with Matt Leonetti, August 1996 issue of *International Photographer Magazine*). There was no way to shoot a plate, yet we needed to have their point of view. The set was built around this real missile, and there was barely enough room to get a camera in, especially with the half-door welded in place.

"The only thing I could do is walk around the gantry with a still camera. I took photos of the walls of the cylinder. I then fed those images into a photo CD at home. We projected pictures onto the inside surface of the cylinder from the same angle. By stitching them together, we had a mosaic of what was inside. This allowed us to use rear projecting with a CGI camera. Amazingly low-tech, but highly effective."

"It is whatever makes the shot look best," adds Marty Rosenberg. "Sometimes the low-tech approach works. It can be as simple as choosing a longer lens, like a 50mm, instead of a 35mm to

shoot miniature spaceships. That little change allowed us to get a better perspective on our 10-foot model.

"We improved on it in other ways, like putting lights all over the model to illuminate the badges. That's something that could not have been done on the earlier pictures," he explains. "When the first one was done, the model sat on a pipe rig that did not move. It was lit by lights that could not move. Now, with the new technology, we are able to move the ship and the lights by doing separate passes with rigs holding the lights."

Mounted down below, these Dedo lights (cool to the touch, tactile, and light) are mounted on rods that come out of the model. "It takes longer to set up," Rosenberg admits. "However, once set, they add a dimension to the ship no one has seen before."

Rosenberg's challenge, on these shots, was as complicated as the silo shot and involved a few sophisticated devices. "With the model in the middle of the track, we were able to do flybys," he explains. "The challenge keeping the lights out of the lens and on the model. We also had to keep them off the moving 12-foot-by-20-foot blue-screen and up in the air.

"The more sophisticated lighting systems and motion control features allowed us to do things like blend real actors onto the area outside the *Enterprise*. By shooting the actors full frame with long lens on a huge blue-screen, we got little barrel distortion. We could then shrink the characters to fit in the computer. We could now blend these images with the 10-foot ship."

To do this, Rosenberg took quarter-inch tape made in the shape of a human "sort of," he laughs and placed it on the blue-screen. "The angle where the actors would hit was more important," he explains. "If we came around the edge of the ship and saw a shadow, it didn't work."

"This allowed us to integrate the characters into the space world as we have never been able to do before," adds Knoll.

"We created a few different elements in live action, to help John give the shots a harder edge when combined with the computer graphics," Rosenberg adds. "One of my favorite things to do is 'blow things up,' " he says with a slight laugh. "When we did the shots of the 30-inch model of the Borg's cube ship (which was supposed to be 2 miles long), John didn't want to do just a movie explosion.

"His idea was to put the flash inside the ship, to see the inner glow." This gave Rosenberg the chance to do what every kid would love to do: go out in the rain and blow up stuff! "We tried to make the

pyrotechnics work on the 30-inch model," he says seriously. "However, the small explosions did not give us enough detail. So, in addition, we made a 60-inch facade for the earlier small explosions.

"It took a lot of 'science' to make things right," Rosenberg laughs. "It's like John and the silo, whatever works. We didn't do a lot of intricate calculations – it was more of the 'a little more on that side,' until we had a balance and the right size for the viewfinder!"

Rosenberg's serious fun was in calculating the lighting for each of the story elements. "We had grain of wheat lights for some of the ship's surfaces, Dedo lights, sun sources, anything that gave depth to the shots. Just as John needed graphic detail for his Borgifications, we needed to have the detail in the ship's elements, so each technique would balance."

"It was important to all of us that the audience be able to see every detail, whether it is the decals on the ships, the elements inside the Cube, or the horrific aspects of the Borgification of our heroes," Knoll agrees. "One department was always feeding off the other's preciseness."

Knoll gets a certain manic glow in his eyes,when he starts to talk about the challenge of Borgification. "Doing this required us to refine a few multiple elements in CGI," he says. "We have a rather graphic shot of Picard, who wakes from a nightmare and goes into the bathroom to splash water on his face. The Borg technology pops out of his face and he wakes with a start. This sets the tone for the picture. It had to be startling and believable."

In another scene, a *Starfleet* crew member is assimilated by the Borg. When he is grabbed, cables shoot over and sink into his neck. Two shots later, he is lying on the ground, the Borg elements spreading across his face.

"These are hard to do," says Knoll. "In Patrick Steward's case, we started from a life cast of his face. Most of the time, we have the real actors sit down and we would scan their faces into the computer.

"We could then match the geometry of their faces to follow the motions of their heads. Unlike in *Alien*, which was done with prosthetics, the actors in this picture did not have to walk around with the gruesome stuff on their faces."

Growing the material over the actors' faces isn't an easy job. Matching performance to CGI is only half the battle. There is lighting and shadows to match, as well as a measured reality to the effect. "We start from artwork," Knoll explains. "We take a frame from the plate

and paint on it. When the artwork is approved, we can then replicate it in the computer. We literally have to handpaint the growth on one frame, then make it grow with computer computations. It is pretty deliberate and changes from each Borgification to the next."

The effects teams behind this new *Star Trek* project all agree that, by far, the most challenging effect looks very simple on the screen. This is the appearance of Alice Krige's character, the Queen of the Borg nation. "The audience sees a 'simple' move," Knoll says dryly. "Her head descends from above, as cables attach themselves to her body, and she walks away, whole."

This element was shot in two pieces. For the first part, Krige was positioned on a prosthetic device hooked to a descender rig. As she is leaning forward, she is lowered into the piece with motion control.

"We have a makeup change, and she appears in the Borg outfit," Knoll explains. "We then put up the shot and moved forward. It takes elaborate splits to make this kind of transition as the costume comes up and the chords come off."

To make the effect work, Knoll had to find the right angle for the transition of the head. He could then calculate the line of the split as it moved down her body. "We ended up with three segments of morphing," he explains. "The head, the neck, and then finally the body."

Krige's body is freeze-framed right before she walks forward. It is then projected on 3-D geometry, which can then be projected on the suit. To show the backside of the suit, Todd Masters built a prop inside and set up and shot stills. "As she moves forward, the effects are done," Knoll smiles.

"Simple, right? Maybe on the screen, not on the set. There are the blue-screen elements, the morphing, the 3-D geometry. . ." he lets his voice trail off.

"Of course, if you really want to get graphic, there is the shot where she is writhing on the ground as her whole body disintegrates, her head caves in, and flakes come off her skeleton.

"We set her up on a blue-screen floor, shot her performance as she wiggled across the set, camera booming down. We then digitized the performance, carefully matching her movements in the computer.

"In the final shot, the only thing that is real is her body. The parts of her face as they erode and everything else is CGI.

"I told you, this *Star Trek* does border on the horrific! There are more than a few 'gulp' scenes in this film. A lot more, we hope,

than there were when we agreed to do these intricate shots!" he says, only half-serious.

"The problem with everyone at ILM is that we believe we can do anything. That's our challenge – take what we have already done a step further, no matter what it takes.

"Sometimes, we can do it without a hitch.

"Othertimes, well, there is a learning curve.

"The Borg Queen fitting into her suit is similar to Jon Voight ripping off his face to reveal Tom Cruise. We agreed we could do it, then came back to the studio and took a big gulp. It was not until we shot all the pieces that we realized just how much work it entailed.

"When doing visuals that have not been done before, you do not have the benefit of hindsight.

"Looking back now, I knew we did a great job with all the elements. However, should we do a cable on the shoulders like we did with the Borg Queen, I'll make sure we include tracking marks in the plates! They can always be painted out later, and they make for a much cleaner connection."

In what direction are George Lucas and his 700-plus staff of technical experts heading for 1997? The only conclusion is tackling more and more sophisticated special effects and filmmaking wizardry, of course.

For Lucas, the first several months of this year have become a well-deserved celebration of 20 years of creative filmmaking. A few years ago, Lucas and several members of the team were brainstorming. What could they come up with for the twentieth anniversary of the company? The natural answer was to bring the production that launched Lucasfilms/ILM/Lucas Digital to a new generation of filmgoers. This began the arduous and fascinating behind-the-scenes struggle to re-release the infamous *Star Wars* trilogy.

It was a natural buildup to Lucas's film production company located at the famous Skywalker Ranch, making a series of "prequels" to the heroic adventures of young Luke Skywalker. This series of films goes into production this year and will be released in 1999, 2001, and 2003.

On the other side of town, at the low key-high tech ILM/Lucas Digital, the techno-magicians are breaking new ground on more than few hush-hush technical innovations. More sophisticated creatures are being created for *Lost World: Jurassic Park, Men in Black, The Absent-*

Minded Professor, and *Spawn,* as well as incredible action/stunt techniques for *Speed II* and interesting composites for Woody Allen's fall project, *Deconstructing Harry,* not to mention futuristic realities in mobility for the spaceships in **Starship Troopers**.

As usual, the techniques are hush-hush. It isn't that experts like those who work on the above-mentioned projects aren't being allowed to talk about what they are doing. It is simply what everyone calls an evolving project. No one knows just how much their tools will be refined,while they are finding ways to enhance the director's vision for each of these existing projects.

Note: The above piece appears with the permission of International Photographer *magazine. It was first printed in the February 1997 issue.*

George Lucas's Anniversary Present:
A Restored Star Wars Trilogy

The setting is Lucasfilm in San Rafael, California – 1993. An impromptu brainstorming session is the focus of the moment. "What are we going to do about the company's 20th Anniversary?" can be heard above the enthusiastic voices. Suddenly, there is dead silence in the room. It doesn't seem possible that the company is coming up on that big 20-year mark. What is remarkable is that it is still gaining momentum with every project.

A quiet voice breaks the silence. "I've been thinking about re-releasing **Star Wars**." With a few improvements, the voice adds.

The silence has been broken, sort of. "The possibilities!" "All the new technology." "Will audiences come to see it?" Chaotic enthusiasm. This is not a room filled with suits. No one is concerned with finances. Everyone is consumed with creative challenges.

Most of the comments didn't phase Lucas. His aim was to bring the films that launched the now famous ILM to a new audience. "All he wanted was to give people the opportunity to see the original film the way it was supposed to be seen, on a large screen," says producer Rick McCallum (*Young Indiana Jones Chronicles, Radioland Murders, **Star Wars** Trilogy: Special Edition*). "He wanted them to see and remember."

In 1997, spending (or maybe throwing away, if fans didn't come in droves) $10 million (or more) to bring back the picture that started this journey was now no big deal. A far cry from 20 years ago, when a young George Lucas, with a vision and a modest résumé (*Look att Life, Herbie, THX 1138, American Graffiti*), tried to sell the studios on his favorite movie genre, the western. Only this version was his look at the

mythical archetypes and their battle between the good and the dark side on mysterious planets in space.

Although the story had all the elements of a western plot, Lucas kept hitting a brick wall. The studios didn't think people would come to see "that kind of story." When he finally raised the money (rumored to be less than $10 million), the arduous process of casting added even more difficulties. At one time, Sissy Spacek was set for the role of Leia. Then Jodie Foster was considered. Before Lucas decided to cast Harrison Ford as Han Solo, Burt Reynolds, Christopher Walken, and Nick Nolte were considered.

When the cast was finally set, the execution of the story became the exciting challenge. Could they really make this space/adventure/western work, given the technology they had? Would the inventions they were pioneering really do the job? Motion control was unheard of. Compositing was crude and fooled few people.

For Lucas and his young crew, these weeks were the most exciting times in their lives. Men like Ben Burtt, Dennis Muren, Ken Ralston, John Dykstra, Richard Edlund, Pete Kuran, Carroll Ballard, Tak Fujimoto, Rick Clemente, Bruce Logan, Bruce Nicholson, and many others were at the beginning of their careers, taking on new challenges and experimenting with their talent. This was just a new project with fascinating never-tried-before possibilities. No one knew where it would lead.

The capper came when he insisted no credits be shown at the head of the picture. He wanted nothing to take the audience's attention away from the adventure. A proven maverick, he bucked the system, when the Director's Guild of America ordered him to recut the film and put credits at the beginning. Lucas stood his ground and prevailed.

On May 25th, 1977, a limited release of **Star Wars** finally hit the big screen. Soon, life as they knew it changed forever, for visionary George Lucas and young actors Mark Hamill, Carrie Fisher, and Harrison Ford. The new hero no longer rode a horse, wore chaps, carried a gun, and rescued helpless women. The new hero now flew in a spaceship, wore tight-fitting exotic uniforms, fought with lasers, and rescued spirited princesses.

Twenty years later, the struggles behind the making of this story have found their place in history. They were not to be dredged up with the re-release. He just wanted people to have fun. And, maybe enjoy the technology that revolutionized the moviemaking industry.

Bringing back a limited release of the original *Star Wars* stories might also build the momentum for his first directoral job in 20 years: his planned prequels, the first slated to be released in 1999.

"I guess in the back of everyone's mind was the thought that this would be easy, and exciting," says McCallum. "We'd pull out the old negative and use our new techniques to add the shots George wanted to do in the original but didn't have the technology to bring his visions to the screen."

David Tanaka and Tom Christopher (Lucasfilm's editor for the *Trilogy Special Edition*) look at each other. "All we had to do was find the negative," they say, dryly, almost in unison. That innocuous four-letter word, "find," turned the simple concept into a literal treasure hunt that took two years of Tanaka's time.

"You have to remember that the home computer wasn't a standard piece of household furniture in the mid-1970s," Tanaka explains. "There was no data on a computer system, there was simply a load of boxes with papers." When Tanaka and his crew opened the boxes, they found dust, binders that were falling apart, and a scatter of pertinent information.

Suddenly, the idea of "pulling out the negative and presenting it to the public" became rather complicated. "It didn't take long for us to realize that we didn't immediately know where the negative was to be located," Tanaka comments. "Many of the elements have become a trademark for the company. Over the years, some have been pulled to serve as advertisements, inserts, promotions, educational material, and so forth. Many of these pieces were not put back where they had been found."

To further complicate matters, the team found the terminology that is so much a part of the movie's mysticism hadn't really been mythologized yet. Instead of finding directions to "the Millennium Falcon" or "the Death Star" or "stormtroopers," words like "floating cars" and "pirate ships" as well as "soldiers" appeared. Often, these common names would change, and what could be dug out after hours, even days, of searching had nothing to do with what they were looking for.

Getting to the source of the original negative became quite a challenge. The tracking process became extremely complicated. "Either the element we were looking for wasn't where the book said it would be, or what we found didn't look like what we needed," Tanaka explains. After much back-breaking searching, the crew would find

what they thought was the scene of the Death Star surface, only to realize what they needed was going in a different direction from the negative."

Sometimes Tanaka got a little lost. He would find one of the many space backgrounds from the lineup notes and think he had a blueprint to work with. Then he would realize the paperwork he found had been created two months before the final shot. "We had no idea what happened between the first notes and the shot," he explains. "Fortunately, we had Dennis Muren, Bruce Nicholson, and several other people who worked on the original project available. They would help us track things through the terminology they recognized.

"You had to be a *Star Wars* fan to work on this part of the project," he admits. "The determination to go to any lengths to bring back the original was extremely important. One of my favorite shots was of the space battle at the end of the first picture. It ran 12 minutes and contained over 80 effects shots. The challenge became how to find the original elements. Some of the original storyboards were available, and the logs did have shot numbers. However, we'd find shot 105, 105a, then 105d. What was deleted? How did they get from one point to another? That was the mystery."

Tanaka tried to be as precise as possible. He would find a shot of Luke in the cockpit, then think he found the original background. He would look at the original film, and the two didn't match. "Sometimes, I had to be innovative," he admits. "I would put a print on the moviola, lay an animation cell over it, and trace the star pattern. I would then go through hundreds of rolls of shots and put the cell over it. For weeks, I was seeing starfields wherever I went!

"We would look at an element and try to make it work," Tanaka explains. "Perhaps if we flopped the image, skip-framed it so the shot would be twice as fast, and put it in the opposite direction, it would work." In doing that, the crew realized that was exactly what the original production staff had done. With the time crunch placed on the original production, the old optical printers, and lack of digital technology, this was the only way to save time – use single elements for multiple shots."

Tanaka and his group found that the effects crew had been extremely clever in these situations. They might shoot a single five second motion control shot along the model of the trench wall, and by flopping, enlarging, decreasing the size, and even change a little of the

optical coloration, they made 20 different shots. "It's the crude hand-tooled way of doing everything we do now, digitally," he adds.

"As David's team found elements, we started to check the prints," says McCallum. "We found everything had faded. Things had gotten into the negative. Three months into the project, we realized we were in deep trouble! We couldn't possibly produce what we wanted from the existing negative. No one was to blame. Even though the negative and YCM were stored perfectly, things happen. Although Kodak had made great pieces of film, the stocks didn't hold up. Even the sophisticated CD disks of today can scratch. The bizarre alchemy behind so many composites and opticals took a toll on the elements."

"The 5247 original negative had been shot under a variety of conditions," adds Tom Kennedy. "There were problems with streaking, discoloration, flicker, and some dirt embedded into the 47. During the original effects work using dupe negative stocks, there was a change from 5253 to 5243. When additional work was done on an effects shot, DRI or color-reversal intermediate stock – 5249 – might have been used to keep the grain buildup to a minimum."

Filmmakers often feel helpless when faced with the knowledge that so much of the industry's film history is dissolving before their very eyes, and they can do nothing to stop this. "Digital scanning is just too expensive, now," McCallum explains. "Hopefully, in 5 or 10 years, it will cost a few thousand to scan a picture like *Star Wars*, and not $6 million to $8 million. Hopefully, those negatives will hold up until then."

George Lucas and his team were undeterred. Lucas was determined to resurrect the project and "make it right." With the new technology, he could fix what had not come up to his standards, add back the shots he had to cut, and continue elements to add to the story.

With tunnel vision, they simply searched for ways to work with what they had. "Tom Christopher at Lucasfilm worked with Ted Gagliano, the executive in charge of postproduction at 20th Century Fox, and Leon Briggs, a restoration consultant," Kennedy explains. "The first thing they did was to separate the various negatives. Fortunately, *Star Wars* was an A-B roll checkerboard negative cut, which made this possible. The 5249 CRI stock was the least stable of the four stocks and showed the most fading. We had to replace every CRI shot."

An air of unusual excitement began to fill the air at the infamous ILM headquarters. Although there was a certain passion

behind each project – from commercials about cars to digitally imposed barking dogs, safe raging fires to tornadoes – the thought of coming full circle and re-creating the roots of the company brought out new feelings. Fear was among them.

There was a kind of self-imposed security on cleanup day. There was a peculiar smell in the air. The long-discontinued process of washing a film negative in a sulfur bath had been resurrected. "Leon supervised the rewashing," Kennedy explains. "He took great care to ensure that the right crew handled the hand-cleaning of this negative."

The elements were ready. Now they could make it look as it used to, 17 years ago. "Now we could make it right," says Dave Carson.

Then word began to trickle down from George Lucas's office. "What if we were to . . . ," Carson says, quoting Lucas. "Up until we release the first of the three films, we will probably still be working on 'the last two.' As time went on, George would think of what could have been and realize it could be now. His excitement sparked ours. We really enjoyed using today's technology to supplement a story shot 20 years ago."

"One of the most important things we realized in the very beginning of this project was that we couldn't 'bring up' everything. We had to use our new technology to match the look of the stock and filters used on the original," adds Tom Kennedy.

Although only four and a half minutes of new visuals appear in the newly released **Star Wars** (*New Hope*), what is far more significant is the knowledge gained from ILM's challenge. Used wisely, the technologies involved will allow directors and cinematographers to make additions and corrections long after a film has wrapped. Find a container that is full-empty-full – just fix it in digital. See tire tracks in a desert fight scene – CGI them out, if it isn't *Birth of a Nation*, that is. Find a room too confining – extend it on the computer. And do far more, hopefully keeping the integrity of the original creative process intact.

In this version, George Lucas can have his Jabba the Hutt nightclub more lively. Jabba can now interact with Han in a more effective manner. Mos Eisley is now a much bigger and busier planet. And, the view of the *Millennium Falcon's* departure of Mos Eisley has the power and strength he envisioned in this story. The *Death Star* battle sequence now feels the way a western climax should. Not to mention many of the scenes have the aesthetic balance necessary to

evolving this mythical story. Sandcrawlers have been added and platoons of stormtroopers fight Han and his crew.

"When George created Jabba, he thought he would shoot the footage with an actor in the Jabba suit, then later rotoscope it out or put a stop-motion puppet over it," says McCallum. When pressure to deliver mounted, he didn't have the money or the technology to get more out of the character.

"Now that we were slated to re-release the project, one of George's first desires was to finish the Jabba scene as he initially intended. That wasn't as easy as it might seem," McCallum continues. "We found that there was no negative available for this sequence. That meant we had to scan the inter-positive into the computer and spend weeks fixing the scratches and painting in the areas that were destroyed. Then, and only then, could we make a new negative IP, and a new work from that to create the CGI material."

"That was one of our most challenging shots," Tanaka adds. "It was originally shot as a four-perf anamorphic sequence and was never meant to be special effects. If we extracted Jabba from the background plates, we would have a hole in the film. Our hope was that the computer graphic artists could paint the background as it was needed to fill that hole. There was even a spot where the surgery extracted an actor's elbow. They could easily restore the elbow with the new technology."

When visual effects supervisor/animator Steve Williams began the task of replacing Jabba, he found the dimensions necessary for a relatively real CGI character did not fit the hole in the original film. "So much of this was done relying on the artist's creativity," adds McCallum. "Oftentimes, they would have to go against every instinct they had.

"Using no reference points and more of a mathematic calculation, Steve and his crew animated a character through aesthetic judgment. They had to give several layers the seamless feeling of being on a single focal plane. They even had to stretch the background to meet Jabba's dimensions."

Take a straw vote among the production staff and technicians behind the restoration projects, and the points weigh heavily on the side of the Jabba sequences as being the most challenging and fun. Their boldness grew, as they moved from project to project and sequence to sequence. "When we got to *Return of the Jedi*, we really went all out," McCallum laughs. "Jabba was such an important

character, we could now fulfill George's original vision and give him a spectacular sequence in his nightclub."

For a few members of the *Special Edition* team, the revamping of the Jabba sequences in England was more than a fantasy; it was time warp. "When we first shot Jabba's sequence, there was snow on the ground," Dave Carson recalls. "You would slide the door to the stage open, and snow would drift onto the sand. The first time I opened the door to the new Jabba set, I half expected to see snow on this sand. It took a moment to realize it was 1995, not 1980 something. This was now my second visit to Jabba's club, not my first!"

ILM's construction crew rebuilt a small chunk of Jabba's nightclub on one of the small stages in the middle of the multiblock complex in San Rafael. There was sand, tacky glitter, and a larger stage. "Now we could really make them rock and roll," McCallum says enthusiastically. "The shot was originally a minute and a half but, because of various elements, ended up to be only 45 seconds on the screen.

"At the time these films were shot, animatronics had limited movements. They could stay on the screen for a second or two, just to show the audience the essence of someone moving," he continues. "George wanted to expand the sequence so that Oola, our nightclub singer, really dances. He wanted bumbs and grinds. He also wanted a lot more of the band, and a new character called Yazzum."

In order to expand the sequence and create the scenes of the band and the dancing, they would have to re-create the live action elements for the CG artists.

A tall order, but do-able. With a little tenacity and a lot of luck, the crew found the actress who played Oola in the original picture. Even though it was 15 years later, she was still in shape. They brought her to ILM and dug out her bright and tight yellow costume, put her in green makeup, and tied her to her tether. They shot her against a blue screen and let the computer geniuses do their magic. "Now we had something fun and special," laughs McCallum. "The continuity is seamless, and George now has the story development the way he originally envisioned it."

Again, the technicians made sure their painstaking work fit the original print. "The hardest thing we had to do was hide the work," says Tom Kennedy. "There is always that 'I can make it better' we had to curb."

"There did come a point, for every one of us, when the tire tracks started to bug us," adds David Tanaka with a laugh.

"We still knew there were only certain things that we could fix," adds McCallum. The integrity of the project was most important to everyone.

As everyone culled through the cleaned footage, they would constantly find bits and pieces of the story that had never appeared in the final cut. "There was a scene where Ben (Obi-Wan) Kenobi, Luke, See Threepio (C3PO), and Artoo-Detoo (R2-D2) are walking down the stairs in a big shot of the Millennium Falcon," Tanaka remembers. R2-D2 is wobbling strangely. I'd seen the shot a million times but never knew why R2-D2 had that peculiar movement. When I took the masking off the film, we saw little bare feet. No wonder he walked strangely! The surface was uneven, and the poor actor was uncomfortable in the suit."

Of course, every one of the investigative team had their favorite unused shot. If they had their way, the running time of the new *Trilogy* would almost double. However, George Lucas stayed focused. The key word was to restore, not reinvent.

"There was so much we wanted to do," admits Dave Carson. "We had to keep everything in perspective. Every time I look at the pieces we found, I am still amazed at what risks George and the small effects team took, so many years ago.

"There is a daring battle sequence in *Empire* with Luke, Han, speeders flying through the air and a big walker. In the scene, Luke's ship crashes into the snow. We needed to recomposite the speeders and walker, an easy job in 1997.

"However, this shot was quite bold 17 years ago," Carson continues. "Then, it was a big challenge to composite models and miniatures into a live action background.

"When you composite those elements, you tend to get a black line around them. In outer space, it wouldn't be noticed. Against a white snow background, well, the lines would definitely be there.

"There were things that the technicians did back then. They played with the exposure in the optical printer to get rid of the black line. However, two problems showed up. The ships were no longer always the right color. And, quite often, you could see through the ships and into the background behind them.

"In the cockpit shots, for example, you could see the outside snow, inside."

For Carson, it was a pleasure to go through these shots and make them right. He was there, 17 years before, when the elements were shot and it always bugged him. Now he had the technology to "make it right, not improve it," he adds.

"These kinds of fixes fell into two different categories," Carson explains. "We had 2-D and 3-D. In 2-D, we took flat photographic images and recomposited them into a new scene, layering the images in a way that they were not visible.

"We took some scenes in *Empire* where Princess Leia is running down the halls in Cloud City. George wanted windows, to bring the outside inside. That was simple. All we had to do was take a single image, draw shapes where the windows would go, generate a new painting, then put it in the computer.

"The song number in Jabba's club, however, is a perfect example of the 3D challenges, which were far more technically demanding."

One of the multidimensional shots the team attacked was of the stormtroopers finding evidence of the droids in the desert. "In the initial cut, there was only a single shot of this scene," says Kennedy. "George wanted to extend it to include a wider, establishing shot and a second shot."

"That original shot was done out in the desert of Tunisia," McCallum adds. "It was 120 degrees, hazy, and intermittently sunny. ILM did even out the lighting. This helped us when we integrated the additional sand and added a few CG stormtroopers, right next to the real ones."

Of course, they also put in a few more fierce additions to some of the shots. There was a dewback and ronto or two, and a new speeder. "To keep the integrity of the shot, we had to erase a few people," David Tanaka adds. "It was the only way that we could follow the creature's actions as the camera tilted up. That also meant a digital matte painting of the skyline.

"There was even a point where we had to paint in a hat," he adds, with a smile. "It had been there before; we had to keep the continuity. And, we had to do it with 1990s solutions that still fit with the 1970s work."

One of the toughest things everyone on the effects team had to deal with was balancing the enhancement of the environment without changing the dialog. Even the replacement scenes had to fit the mold. If the original was 50 frames, the replacement had to be 50 frames.

"George began as an editor," says Tanaka. "He knows how to pace a picture. We couldn't change that. So, when we had to stick a shot between two existing shots, we had to make room with the pacing in mind."

The total number of tweaks and additions to the *Star Wars Trilogy* is still up in the air. Most of the crew still feel they will be on "the last two shots" for the rest of their careers – even after the three films are released. That's probably because they will soon begin work on the prequels. At this point, they don't want to think about that. "It is staggering, the amount of work we put in," Dave Carson admits, the childish enthusiasm that has infected everyone at ILM still in his voice. "We took over nine years of effects development on this one project."

"Our task was to bring it back to as near the original condition as possible and honor the original intent, not to create new visual effects that say 'look at this,'" Tom Kennedy adds. "We hope that what we've done is a successful integration.

"Audiences have changed. People are often looking very critically at visual effects," he continues. "Hopefully, the new audiences will have an appreciation of the film as a complete experience and not be distracted by any one effects shot. The fact that something was once a digital image should be transparent."

"There is still a sense of trepidation," Dave Carson adds. "Will the two generations be able to relate to the picture? Can what we've done and what we show bridge the gap?"

"All I know is that I was a kid in elementary school, when *Star Wars* first came out," says David Tanaka. "I saw the movie so many, many times. Now, today, when I hear people talk about the films, and how they have seen them on video so many times, I can top them. I've seen elements over a hundred times. And I'm still not finished. There is an enthusiasm in the movie-going public for these movies. An enthusiasm coming from kids of all ages."

The producers of the *Star Wars* Trilogy Special Edition are hoping that will carry over to the hard-nosed elements within the movie industry. "When these films were shot, there was a huge fear of technology within the industry," Rick McCallum says. "The things that ILM did back then were a turning point in filmmaking history. "The 'I don't want to know' fear was running rampant. They hadn't realized that these tools can make anything possible. All they saw was the big word 'change' and a lack of 'control.'

"As time went on, more and more filmmakers began to embrace what ILM did then, and what they can do now. Perhaps what we have done will help them realize what they can do."

With budgets skyrocketing and schedules shrinking, filmmakers of today are faced with so many decisions outside of pure aesthetics. When they struggle for their artistic integrity, too much can get in the way. "If they want Magic Hour, and they arrive on an overcast day, they have to weigh their options," says McCallum. "Do they wait, wasting time and money? Or, do they rely on what technology can provide? If they understand that technology, they will know they can meet their budget and still have that Magic Hour look.

"All it takes is talented artists who understand the technology – on the set, behind the camera, and in the effects postproduction process.

"What we are doing does not take anything away from a talented cinematographer or director it gives them the tools to make anything they want possible. Look what it did for us! We brought a very sick child back to life – back to its original life – so that millions of moviegoers can enjoy George Lucas's vision along with him.

"And it was achieved by the extraordinary talents at ILM – dozens of dedicated, obsessed, and slightly disturbed artists! Both George and I are amazed at what they accomplished.

"I can't wait to see what we all come up with in the prequels."

Note: The above piece appears with the permission of International Photographer *magazine. It first ran in the March 1997 issue.*

"Today, producers and directors are seeing visual effects people as an important element from the beginning. They cast their cinematographers, production designers, costume people early. They do the same with their effects people, giving that department the credence and level of respect an equal partner gets."

Scott E. Anderson

Junior high school in Springfield, Massachusetts, was heaven for Scott Anderson. As part of a select group of students with access to the media center, he did a daily cable morning show for the school. He got to learn about and play with computers, photography, and television. The darkroom became his home; between classes or study, he was pulling apart and rebuilding equipment.

"My first real experience in photography was when my family took a trip across the country," says Anderson. "One of the teachers I worked with lent me one of his old 35mm cameras. I was in heaven."

Unfortunately, in Classical High School photography and computer access weren't as advanced. However, Anderson still covered every event and oddity of the time, shooting photographs and serving as editor-in-chief of *The Recorder*, the school newspaper. After class, and in the evening, he worked for a photo lab in the city. He learned composition and framing and how to put stories together.

"Then it was time for college – Brown University," he says. "I liked the technical side of what I'd been doing, so I thought I would try engineering." Although Anderson didn't enjoy the focus of the engineering department, he became attracted to the advanced program in computer science.

"In artificial intelligence you build the world and see the results," he explains. "However, what we got was pages and pages of type I thought it would be more fun to see it in pictures. Then I found out that one of the premiere computer graphics professors was teaching in the lab next door, I knew that was where I wanted to be. Although Andy (van Dam) was teaching a graduate class, he took a few sophomores. I was lucky; I met with him and he let me in."

Anderson hit the industry at exactly the right time. Companies like PDI were forming. It was the first solid wave of computer graphics. "Not only had I thought of it, people were doing it," Anderson comments.

To find a way in, he began studying semiotics, focusing on film theory and art study. "I learned how linguistics and other related areas influence how images and thoughts are put together – and, most importantly, how they are understood by an audience. It is not always what you put together, but how it is perceived.

"My experience was primarily in Marxist feminist film theory. While not exactly mainstream, I loved it and I found much of what I saw and felt actually had a formal method of study. We looked at films from *Citizen Kane* to *The Terminator* and placed them not only as films but, as reflections of the society, mores and concerns of their time. For me, it was interesting not only to learn about what went into a film (shot selection, cutting, music, etc.) but the choice of genres and the intertextuality of the film and society."

Anderson began to study computer animation but realized he wanted to be in the thick of things, not in the "study" mode. "As I approached graduation, I called Robert Abel's company in California," he recalls. "They told me they didn't have anything at the moment, but to call back in a month – if they were still around. A month later they were gone. Next, I called PDI. After a number of interviews, and a recommendation from Andy, they offered me a job."

Anderson finally made the move to California, working in systems support, programming, and assistant animator at PDI. "It was the apex of broadcast-style animation," he explains. "They were doing network packages for two of the major networks and moving into the commercial field."

Part of the learning curve for PDI employees was to do personal projects as training programs. Anderson was at the company for about 14 months. During that time he helped on a short film, *Burning Love*, utilizing the in-house proprietary animation system, and several logo and commercial projects. "We were instructed in everything, from story-boarding and animation all the way to client lunches," he explains.

Scott Anderson wanted more, so he turned to looking at companies in Los Angeles and the Bay area. "It was one of those cases of perfect timing," he comments. "ILM had recently sold Pixar and had only six people in the computer graphics department. I called for a job

and was told they had nothing available. However, prodded by Mike Shatzis, an old friend with whom I did my final project at Brown, I made one more call to ILM, and I was told something had changed. They had a 'big' project and needed people right away."

Anderson walked into the ILM facility and the first thing he saw was the storyboards for *The Abyss*. "It was the early days of computer graphics and this was a unique project," he recalls. "When I started, they sat me down in front of a workstation, set me up with an account, and said 'let us know if you need anything.' "

At the time ILM artists were working with a few Sun computers, a couple of Pixar image computers, and the original Reyes rendering, the predecessor to Renderman™ software. "It was prior to Renderman™ as a product," he explains. "We were sending shots to a couple of prototype Renderman™ boards before purchasing the first two processor SGI machines. This was new, as most hardware, including the Silicon Graphics's machines, were special-purpose add-ons to other computers; here was a general purpose and fast machine."

Prior to Anderson's arrival, the company had already created fascinating images for the film *Willow*. They had used the first cinematic morphing techniques. "However, they didn't yet have the storage and the devices really needed," he explains. "To do things on-line, they had to cue one image on one tape and one image on another tape. They loaded them into the equipment, morphed the image, and wrote to a third tape that was sent to a laser film recorder.

"It was 1988 and the days of wire and glue and chewing gum in digital effects," he laughs. "We actually composited our shots optically because the technology and disk space weren't there to do it on line."

To do *Abyss* shots, Anderson would have to render the elements on the SGI, composite the digital layers, have them filmed on the laser recorder, and ship them over to optical. "I learned things like how blue-screen compositing worked optically, the composition of those mattes, and finally to generate digital mattes that worked perfectly in the optical department," he explains.

Anderson was lucky. He had people like Stuart Robertson and other traditional effects artists to educate him. "I learned quickly to understand what worked and what didn't work both technically and visually," he explains.

The crew at ILM explored other options in their pursuit of creating images for *The Abyss* and other projects. "If computer graphics didn't work, Dennis (Muren) was planning on other

techniques, such as water footage projected against stop motion, as a fall-back. There was belief but little trust of the computer graphics department. Given the risks, it was understandable, and I learned always to have plan B ready.

"In the end, we did all the pseudopod (or water snake) shots digitally – as planned. It was amazing to see those first images on film, but they took forever to do. Given the relative slowness of the computers, we would render the reflection, refraction, and highlight passes separately, combining them on the Pixar. Each render took four and a half hours to generate, so we didn't want to go back for any reason. We then balanced each pass, added little extras like Mary Elizabeth's hand reflection, and sent the result to optical."

Since it was the early days of digital, the technicians got to cross over to other departments. They spent a lot of time learning what other people did. "We were aggressive in pushing the new technology, but at the same time, politically and logically, we had to learn what others were doing before we said we could do something different or better," he says.

As the work grew, Anderson found that there was a certain power in knowing that he didn't have to do everything digitally. "I remember a small piece we did for PBS: *The Astronomers*.

"The piece was an accretion disk. To execute what was needed, I had a matte painter paint a glass painting of the rings within the disk then I photographed the painting, scanned it, and animated it in the computer. Now you would just paint it in the computer, but the lesson stuck. Only use the tool when you have to or when it looks better."

For Anderson, it is all about evolution. First, there were the traditional glass paintings that were touched up and scaled to the computer and then matched. Now, everything can be done digitally. "Even as late as *Terminator 2: Judgement Day*, we were still rotoscoping with pen and ink," he recalls.

According to Anderson, ILM was never a company that considered digital the only option. "We were very different," he admits. "We might have been the new kid on the block, but we never thought of ourselves as competitors. We were always learning what others did and adapting their techniques to our tools and abilities."

Anderson began working in the film and computer environments, finding ways to tie the two elements together. "I remember one of the plate shots I did at ILM," he says. "Scott Farrar was supervising a plate for computer graphics on *Star Trek VI*. He

tried to work me into the camera side, first showing the setup and discussing framing concepts. During the setup, I told him I'd done still photography, to which he responded." Farrar did not need to introduce the person "coming from the digital side of the studio" to camera. He already had a film-savvy worker. "It was easier for him, but it was also great that he was willing to help me understand both worlds," Anderson adds.

The key theory for Anderson and his coworkers at ILM was that they had to understand that the roll of visual effects was to tell the story. "This is where more of the film theory side of making movies comes out. We learned to look at films and break down the images and shooting or cutting styles. By doing this, we can better understand what the client wants."

For a while, Anderson went freelance. He looked for work on small projects that kept him out of the limelight yet allowed him to do digital as well as traditional effects. He would shoot plates, work with motion control, etc. "It was an equal exchange. We were both learning," he says.

This led to work on some commercials as well as *Stay Tuned, The Pagemaster,* and *Look Who's Talking Now.*

Then he got a "strange" call from Australia. "They wanted to make a talking animal movie," he recalls. "There would be some 400 shots, and at least 150 of them would be digital.

"That was an enormous amount of digital work for the time, even though it was the early 1990s I was skeptical until I met Doug Mitchell and Chris," he says. "I was fortunate. I was able to get involved in *Babe* very early." Anderson was one of the first 10 people to join director Chris Noonan's vision.

"I remember the first meeting," Anderson says. "Chris had several theories about how to make the film work. He wanted to do talking animals, but from a human perspective. He wanted to treat the animals like people.

"We went through a process of discussion, to develop the concept," Anderson continues. "I was able to share what was hard or easy in digital, and we could discuss that in conjunction with other solutions. Stylistically, there was a concept that we were visitors to a private animal world, one that we would have to adjust to and slowly introduce the audience to.

"One of the most important decisions was that we were not going to shoot down to the animals, but be eye level with them," Anderson adds.

The concept became the litmus test of what would happen. "Our ideas were roughed out and refined by what we called 'the audition test.' It was a cute bit of film dedicated to showing an animatronic pig interacting with an unseen casting director. Initially we had intended to do a digital part of the test, but after screening the rough cut, it was determined unnecessary."

For Anderson, the film was a joy. Director Chris Noonan was dedicated to the project. "He has an unyielding method of sticking to the concept. He wanted to get as much done with purity as possible. And, he was quiet and controlled. It was great to work with someone who really had a strong vision and with a crew that so completely shared in it."

That was an important element in making the story of *Babe* work. "We were always thinking about what the story was about and where the emotional elements would come from," Anderson continues. "I would always be asking questions like, 'Would I do this with a real actor?' If the answer was 'no,' then we wouldn't do it with an animal.

"For example, when the young *Babe* says 'Bye, mom' it was animated and played in a quiet almost unseen manner. Chris and I resisted overplaying our hand. The moment was about sorrow and saying goodbye, not proving how well we could make animals' lips move. A real actor doesn't have to show that he moves his lips, nor should we.

"This became a powerful concept; we chose the technology, be it digital, animatronic, live animal or stuffed puppet, that got the point across. No more no less. We also chose to mix up technologies, first as a concession to our very low budget, but then it worked just like a magic trick by changing directions technically, we never gave away the gag or allowed it to draw attention to itself."

It was more than lighting, matching, performance, or eyeline that won Scott E. Anderson the Academy Award for his work on *Babe*. "I think we developed a new world that worked with the traditional cinematic language," he says. "We were able to bring life to a world that existed below our knees, in a way that felt personal. Everyone identified with our characters, and our seemingly invisible effects got noticed."

To Scott Anderson, the world of effects was rapidly changing. He began to be asked to do larger projects with broader canvases. Following *Babe*, he signed on to be visual effects supervisor for *James and the Giant Peach*. "Henry Sellick is known for his animation work, and there was a huge amount of stop-motion animation on this picture, but the tools lacked the scope needed for the story," Anderson recalls.

Anderson understood that there was no money to make the picture, and that normal visual effects were costly. "To expand James's world, we needed to bend the tools and techniques of practical, visual, and digital effects," he says. "We, as the digital effects crew, had to adapt to this very colorful and stylized world. It is always about one world and one concept – no matter what the technology. It's about making the story work."

Anderson's theory of approach to *James and the Giant Peach* prevailed. His work on the shark attack sequence from this film garnered him an award at the 1997 World Animation Celebration and was included in the 1996 Siggraph Electronic Theater, a compilation of what is considered to be the best computer-generated imagery of the year.

From *James and the Giant Peach*, Anderson signed on to do another effects film, with a very different director. Paul Verhoeven approached Sony Imageworks in late 1995 about doing the visual effects for *Starship Troopers*, his story of a battle between humans and bugs. "Paul went through a real war," says Anderson.

"He has felt and seen things that Americans haven't. His view is somewhat an outsider's cynical view of how we treat ourselves, our work, and the difference between sex and violence. This is what he wanted to bring to the film."

Again, Anderson and crew were brought into the project in the elementary stages of preproduction. "We talked about what the propaganda films of the era were, how the films related to *Troopers*, and how we could use the modern technologies to make the best images for the film," he explains.

Verhoeven wanted to emulate in outer space the great Naval battles of World War II. To get these battles as real as possible, Anderson and one of his visual effects supervisors, Dan Radford, posed several questions. What would a battle in space really be like? How would these ships move? What do things look like in space?

These questions spawned hundreds more. To attack the project with the kind of gusto necessary to make it work, Anderson put together a team of about 250 artists and technicians. "At one point, we felt like we were going to burst at the seams," he says. "We would end up with 2,000 model shots, some 3,000 pryo elements on over 50 miles worth of film. Technically, we were going to use everything from blue screen and green screen to model, miniature, pyro, digital compositing, and computer graphics."

On each shot the team would ask themselves, What hasn't been done before? What would they want to do? And would it be possible?

One of the unique differences in this picture is that the images shifted from a single battleship to a series of vessels. "Dan says it gives us a gentler, longer-developing motion that lets the scene play longer in time, and let's you feel that these things are really big and desperately trying to maneuver," says Anderson, quoting Radford from Imageworks's press release on the film.

Knowing that the clarity of space changes the way we see, Anderson and crew asked what could cue distance in space. "We have darkness," Anderson explains. "As things go away, light falls off. So, things tend to gain contrast and become darker as they go into the distance. They don't quite drop away into the darkness of space because you do want to know that something is out there, but we allowed things to recede in a way that gives the impression there is even more out there than you are seeing."

The result of this thinking is that the space shots in **Troopers** have an infinitely deep focus and a stark clarity across the entire frame. "We decided to give the space shots what I like to call 'epic claustrophobia,' " Anderson adds. "Instead of infinity in all directions, we created a huge space, wide-open vistas, but you always feel boxed in by what's going on around you."

Instead of filling the screen with space, Anderson and crew created fleets of as many as 50 ships flying in tight formation, then placed stars or asteroids in the background, always pushing the planet up into the action framing the bottom of the screen.

With these decisions made, Anderson and crew spent four months in previsualization. "We choreographed each shot," he explains. "We then edited them with the live action, bringing us very close to a fine cut."

In essence, the film was designed and built before photography of the elements began. "Suzanne Pastor, one of our visual effects

producers, and I compared our approach to shooting a car crash scene in which, after each cutaway, the action has moved forward exactly as much as it should have, given the duration of the cutaway. Our trick wasthat our cars were supertankers, and we could only shoot one at a time with one camera." He said that this meant no "half measures." This was the only way to hold the audience.

Anderson's challenge on *Troopers* was that these cuts were between live action and effects. Each must match perfectly. "I couldn't even imagine how we would have done this without previsualization," Anderson adds. "It became the bible for everything we talked about day in and day out."

Imageworks assigned Thunderstone model shop to create the models at the same time the previsualizations were underway. "Phil Notaro put together a team of 28 model builders, who produced over 100 models for us," says Anderson. "We had everything from tiny 6-inch ships to seven 9-foot versions of the *Rodger Young* class ships to an extraordinary 18-foot Rodger Young, fully rigged with programmable fiber-optic lighting and animatable decks. Thunderstone also did the numerous models for the pyrotechnic work.

"The *Rodger Young* was truly the protagonist of our work. As the ship of our hero's, it defined the 'class' of the entire fleet and its struggle was the counterpoint to the action on the planet. Early on, Paul and I had discussed his desire that it not act like any other spaceships we had seen.

"Our entire fleet was to act like a naval fleet rather than an airborne craft. The small craft would work like air support, but the big ships were like supertankers in space. As such, we dressed them out in different personalities – some cargo ships, some troopships, some aircraft carriers. Both technical outfitting and color scheme were set up to complete the illusion."

Imageworks rented space at S.I.R. Studios where they set up the miniature photography unit. "They had three motion control stages going over 11 months," says Anderson. "This was one of the largest physical effects productions ever mounted."

Previsualization really began to pay off during this model photography. Anderson's goal was to create ultra-realistic battles in space, with natural camera moves and extensive interaction between ships. "One of the biggest challenges was the extraordinary number of motion control passes that we needed for each model," he explains.

Much of the stage work, however, was determined in pre-visualization. This enabled Anderson to use the computer data from this, inputted into the motion control rigs. "We were trying to shoot a car chase with super tankers, so you have to figure out where everything is going to go."

By the end, over 2,000 usable model passes were shot. "And, we did nearly 3,000 pyro elements in and around Los Angeles," Anderson adds. "With the pyro shoot, the biggest challenge was scale. The explosions had to match models that are supposed to be a kilometer long, and, as a result, many of the pyro events were extremely large."

Anderson's next step was to bring the pyro and model elements together and transfer them to digital. It took a crew of 70 digital artists and technical directors to get the final cut. "We added everything from smudge and glare on spaceship view ports to extensive interactive lighting within each shot," says Anderson. "When a ship explodes, the light of that explosion must be realistically reflected off all the ships around it. This was a huge, painstaking job."

The bigger challenge for Anderson and team on *Troopers*, was to create the main 3-D CG elements that would be placed in the shots. There were starfields, planets, ship thrusters, and the deadly bug plasma.

For the planets, Anderson's crew attempted a high level of authenticity and beauty. They looked at video images of planets in motion, and when Klendathu and Planet P came to be created, they made the effort to move the planets as well as change the atmospheres. "It goes back to making the elements fit the story," says Anderson. "They had to be characters."

Even more difficult was the creation of the thrusters and bug plasma. Almost every shot done had thrusters in it. "Each one had to be synced perfectly with the movement of the ship it propels," he explains. "This was an extraordinary job in tracking. And one of our biggest challenges."

The plasma created another challenging element. "We needed the same special shader software to accomplish the plasma and the thruster action," says Anderson.

Now came the challenge of putting everything together. "Typically, a visual effects shot will have 5 to 10 separate elements," says Anderson. "On *Troopers*, the smallest amount we had was 40 elements. Many went over 100 elements. We needed this complex layering to make the level of realism believable.

"Our second challenge was the length of shots," he adds. "A rule of thumb in visual effects is that the shorter the duration of a shot, the less precisely detailed the image has to be to work. An audience will notice many more things in a 12-second shot than in a 3-second shot. To make these long shots effectively realistic, the level of detail throughout the frame had to exceed what had previously been done." No wonder Anderson and crew received an Academy Award nomination for *Starship Troopers*.

The success of this picture resulted in a second pairing of Anderson with Imageworks and director Paul Verhoeven. In late 1998, they came together to begin *The Hollow Man*, Verhoeven's version of the invisible man theme, but in a horror/thriller mode.

"Paul contacted us the day he decided to do the film," says Anderson. "He knew we needed to be in on the project from the very beginning.

"Today, producers and directors are seeing visual effects people as an important element from the beginning. They cast their cinematographers, production designers, costume people early. They do the same with their effects people, giving that department the credence and level of respect an equal partner gets."

For Anderson, the biggest challenge of *Hollow Man* is the believability factor. "This is a fairly traditional horror/thriller, with an amazing twist," he says. "For a third of the film, the man is visible. Then, for the rest of the film, he is invisible. Our challenge is to show how the invisibility happens. And, to justify it. This is not a simple and clean film, where the invisible man is hidden. He has to be seen."

To do this, Anderson and crew viewed historical invisible man films. What he found that most of them were comedies. "If we were going to try to do a true horror/thriller on that level, no one would be scared," he says.

That level of reality spawned discussions. It took six to eight months of research and development, and preproduction, to get to the shooting style. "Again, we mapped everything out before shooting," says Anderson.

Anderson began with human animation. "Even though it is invisible, we have to see the man in partial stages of invisibility," he explains. "We began looking at wax sculptures that Paul heard were stored in a museum in Florence. They were done in the 1750s to the 1850s. When I went over to look at them, I was amazed at the detail and pure expression."

This helped Anderson approach the shock value he needed for the partially visible characters. "We needed a way to see the muscles and organs in a real and human animation development. We had to find a way to go below the surface of the skin."

At first, Anderson looked at motion capture for these elements. "None of those things done in the isolation of the set worked for the performance of the actor," he says. "We have one real and one invisible. I wanted to make sure that the real actor would be proud of the performance of the invisible actor, and that the invisible actor would mimic the performance of the real actor."

Motion capture would not work on another level. Anderson saw no way to make that actor interact with props and physical effects as well as fire, water, smoke, and camera work. "Could we add the props in postproduction?" Anderson says, rhetorically.

"We had to find a way to drive the technology to change, so that we could create an invisible character who rampages through and performs for the film."

Anderson realized one important thing – what he put in it was almost as important as what he didn't put in. "We realized that we needed to perform a slight of hand to evoke the feeling of this creature coming at you, rather than beating you over the head and selling it to you," he says

"Today, there is almost nothing we can't do in effects. The problem is, people have chosen to use the technology to beat audiences over the head. That's not what we wanted to do on *Hollow Man*.

"In the recent past, there has been a succession of films that exist more for the existence of the effects – not the story that needs to be told. Audiences might flock to the 'effects' film, on the first weekend. But, since they will be tired of 'effects' over 'story,' we find the attendance will drop off. What would keep an audience in the theater, at least for the first hour, pales to impossible to watch when it gets to video. Audiences are getting too sophisticated.

"Now, we are getting stories that incorporate effects – and that have effects as part of the story. Not an overshadowing element. We are looking at how to get the point across, without hitting the audience over the head. That's the challenge in *Hollow Man*. We have to find a way to shock the audience, and get the point across, without seeing an 'impressive effect.'

"If all you see is that impressive effect, you are going to miss what we want you to see – that is, the look in the eyes, the expression on the face.

"It's the balance that we want to see."

With Scott E. Anderson, it will always be the balance between technology and creativity. Being an integral part of the production is the future of visual effects – and he is a big part of that future.

"When you are dialing an effect on a computer, you have a lot of options at your fingertips. If you are not careful, all those options just give an exponentially larger number of ways to go in the wrong direction. The space of unsatisfactory solutions is a lot bigger than the space of what actually looks good."

Mat

Beck

"It's the study of the mechanisms by which we experience the world," Mat Beck explains, when asked about what his major was at Harvard. "Physiological psychology helps us understand how we interface with everything around us."

To demonstrate his knowledge of the science, Beck's thesis was a computer simulation of the analytical functions of the lateral inhibitory neural networks in the eye of a horseshoe crab. "You wouldn't think that crab eyes have much in common with human eyes, but they do.

"Also they have really big neurons, so it was easy for researchers to stick electrodes into them. As a result, there was a lot of data around for someone wanting to computer-model them," he explains.

"One thing they do have in common with our eyes is that both sets of visual sensors do a lot of information processing of visual data long before that data ever reaches the brain. The reality that we 'perceive' is actually a heavily edited and caricatured one that looks for certain 'important' features and ignores a lot else. It's actually kind of a humbling thing to realize. It's also a useful thing to consider when you try and fool the eye – it becomes easier when you know where some of the secret buttons are hidden."

In other words, physiological psychology was a great training ground for Beck to understand what he could get away with when fooling an audience with visual effects. "When you are dialing an effect

on a computer, you have a lot of options at your fingertips," Beck says. "If you're not careful, all those options just give an exponentially larger number of ways to go in the wrong direction. The space of unsatisfactory solutions is a lot bigger than the space of what actually looks good.

"That's where it's helpful to know something about how the camera works, and how our eye works. Then you can look for maybe three or four things that will actually make a shot more real, and stay on track."

Beck only did two things his last year at college, his thesis and a student film. He probably would have been happy designing computer hardware and software if it weren't for the impact of the *Star Wars Trilogy*. "On a trip to Los Angeles, I found out where the front door to Apogee was," he laughs. "I talked my way in, convincing John Dykstra, Al Miller, and Bob Shepherd that I knew what I was doing. I'm still grateful that they chose to believe me. I started out building electronic interfaces for their optical printer and camera controllers.

"It was a cool time to join the industry," he says. "Things were changing and expanding so rapidly that a lot of people from a variety of fields were drawn in. They seemed to have in common the ability to play hard and work harder and never knew when to go home."

It wasn't long before Beck asked to do more than build the equipment. He wanted to use it. Within a month, he got his wish. The good news was that he was given his own stage, really just a corner lined with black curtains. The bad news was that he now found himself writing software, maintaining electronics, and caught up in the frenzy of production – all at the same time.

The first effect Mat Beck worked on at Apogee was for the movie **Star Trek**. The script called for an alien energy probe to come aboard the *Enterprise*, move around the bridge, and take over the ship. "They had shot the probe on the bridge in a clever way," Beck recalls. "Someone carried a glowing xenon tube around the set so that all the interactive lighting came from just the right spot. The problem was that you could see the elbows and feet of the guy carrying the tube.

"Someone (I don't remember who) came up with the idea of re-photographing the original 65mm image and distorting it in order to remove the offending body parts. So, we ended what must have been the world's first computerized fun house mirror. Jonathan Erland built this beautiful flexible mirror by stretching aluminized Mylar over a frame. Bill Shourt and Dick Alexander built a translator rig that held

the mirror rigidly and allowed a small motorized bar to move to any x-y position in back of the mirror and then push into it from behind.

"By pushing that bar into the back of the Mylar mirror, you could distort the image in a controlled region, making part of the image so skinny that it disappeared. The plan was to project the 65mm image of the *Enterprise* bridge onto a rear projection screen, bounce it off of our flexible mirror, and then shoot THAT image, frame by frame, onto a VistaVision™ camera.

"The whole thing was assembled like a bizarre optical printer on this high-tech rigid table designed for holography. Al Miller built a controller that drove all the stepping motors that moved the pressure bar, and I built an interface card and wrote the software that allowed our high-powered computer to drive the motor controllers.

"Our high powered computer was, God help us, an Apple™ II with 48K of memory. The high-powered software was written in Apple™ basic, and was stored as a series of tones on a $49 Sony audiocassette player.

"To load, you pressed return and then play on the cassette, and after about 10 minutes of beeps and boops the software was loaded. Somehow, it worked. With a few additional features like in-betweening and shoot-on-the-move, it turned into what was likely the first motion control system on a microcomputer."

Beck and crew shot this transition with VistaVision™ onto 5249 CRI color-reversal inter-negative stock, "and the purplest color filter pack I'd ever seen," he comments. "Because this stock had never been designed to record positive images.

"When the rig removal was complete, all we had to do was animate some cool energy patterns over the shot, and we had our *Star Trek* energy probe effect! Harry Moreau and Bob Swarthe generated some intricate moiré patterns on the animation stand, and Roger Dorney assembled the whole thing in optical. It's funny how quaint it all looks and sounds now with so many more tools at our disposal."

Once Beck's crew showed producers they were up to the task of making *Star Trek* effects gags work, they were given more complex challenges. "The next thing we had to come up with was a way to show the transporter malfunctioning and screwing up, when crew members were being beamed from one ship to another," Beck recalls.

"We had to reproduce the famous 'beam me up, Scottie' effect in a more interesting way, and then we had to make it 'malfunction' in a credible and scary way. Enter the Mylar distortion rig again and the

poultryflex camera. (The poultryflex was the same 40-year-old VistaVision™ we had been using, but by now it had a rubber chicken mounted to the front for good luck.)

"That was the same rubber chicken that was later immortalized posing with Clint Eastwood in Greenland on *Firefox* and adorned by Robert Redford's autograph on *The Natural*. (There was a period where all the camera reports were coming from stage with notes like 'Make one print, over easy' and 'Process normal – Pullet one stop.')

"To get the transporter effect, we ran a laser through some broken glass to get a shimmery specular pattern. We then animated the pattern by rotating the glass with a stepping motor. To give the pattern the look of a cylinder, we projected it onto a vertical wire that was moving around in a circle.

"With our new motion control system, we made the wire turn once around the circle for every frame, thus reading on the film like a translucent cylinder. When the optical department put that over the transported actors, it looked like they were within a pulsating cylindrical energy field.

"Of course, nowadays, we would use a procedural texture combined with a particle system and mapped onto a surface, but then in those days we also had to walk to school 20 miles and back, uphill in both directions. . .

"The problem now was to distort things in an interesting way to imply a system gone wrong. Reenter the distortion rig. We removed the bar that pressed from the back – it was too orderly. For this effect, we needed something more random and chaotic.

"The perfect solution was. . . Astroturf! When we pressed it against the back of our flexible mirror, anything reflected in it had these weird little blobs of distortion. We built a 'belt sander' rig out of a stepping motor and two 65mm film cores.

"When we wrapped a belt of grasslike floor matting material around the belt sander (the black nubby welcome matte stuff worked well too), then pressed it against the mirror and rotated the cores so that the 'belt' moved, we got the little cells of distortion in the mirror that changed constantly as they migrated upward.

"By varying the pressure and speed, we could vary the pattern over the course of the shot. When we re-photographed the actors through this mirror, they looked like they were having a really bad day. I asked Roger Dorney, in optical, to print the effect on top of itself three

times, each a few frames out of sync (an old psychedelic trick that gives trailing images of moving objects) and voila, transpoultry malfunction!

"The next effect that we did was the bomb that V'ger sends to destroy earth. I had noticed that when Jon Erland was mixing metal flake paint, you got some really cool turbulent effects within the solvent. The effect was swirling, sparkling, convective cells, very organic, very interesting.

"It was even better when we heated it slightly. After someone had put the effect on film, when we needed a scary, dangerous-looking effect for the V'ger bomb, we projected that footage onto a translucent hemispherical screen. That gave it dimension and resulted a spherical bubbling ball of energy. (The spherical screen was Jon Erland's idea, one of many elegant solutions.)

"So, we modified the poultryflex motion control system to move down a track shooting this translucent salad bowl, while a projector mounted behind the rig advanced frames of boiling paint! Voila, V'ger bomb.

"The only problem was that in a paroxysm of ambition, I decided that wasn't quite enough. I decided to superimpose a second pass with the salad bowl turned around (concave toward camera) and slightly larger, so that instead of being confined into a neat sphere, some of the boiling bubbles seemed to shoot streamers out into space.

"It worked great except that, for some mysterious reason, the motion control system lost position and stopped a few feet short at the end of the second pass. We sent the film in anyway as a test. To my surprise, (1) everyone loved it, and (2) there was no time to fix it, so now anyone who looks closely will see that when a proton bomb comes very close to camera, it tends to separate into two pieces.

"That distortion rig reared its head years later when I was trying to come up with something cool for Richard Edlund on *Poltergeist II*. We needed the image of mist rising out of the ground to form the image of a ghost. Again, this was pre-CG so we had to create a ghost out of mist. Or as you might expect, make a ghost dissolve into mist and play it backwards.

"We dressed an extra in a white leotard with lots of filmy gauze and poured a ton of cold steam over her through a hose connected to a bicycle helmet on her head. She then stood on a seesaw and, on cue, scrunched down to a little ball, as the seesaw dropped and the mist poured out and the camera ran at high speed.

"Running backwards at normal speed, we had a ghost forming out of nothing. But, to make it appropriately ethereal, we had to give it a dreamlike wavery effect. Out came the Mylar mirror. This time deliberately out of focus. We shot the live action through it while massaging its back with a dust broom.

"When the mirror was just the right amount out of focus, the effect worked great. The only problem is that the original test had been done with a Panavision lens that was out of adjustment. When we went to production, Panavision wouldn't give us the lens back because they had found a problem. *Of course* they had – that was *why* we liked the lens. It was a struggle, but they finally let us have it.

"Nowadays, we solve most of these kinds of problems with digital techniques, but we might also shoot some elements onstage. I'm a big fan of hybrid technologies. The best and most elegant solutions for an effects shot are not likely to be limited to only one technique.

"We've been pretty shameless about the stuff we've used over the years to make effects. For some reason there seems to be a heavy influence from the culinary arts. We've used breakfast grits (energy vortex in *Solar Babies*), charcoal briquettes (glowing lava chunks in **Volcano**), milk shake thickener (flowing lava), food coloring (eye goop in **The X-Files**), kosher salt (ice/snow on **The X-Files** glacier). We have also, of course, used less edible stuff, like wax, soap, magnetic fluid, micro bubbles, every imaginable kind of smoke, mercury, cotton, argon lasers, steel wool, real ice, water vapor, Dippity-Do hair gel, aluminum, and magnesium powder.

"On **Firefox,** we wanted to create the sense of extreme acceleration in a hypersonic airplane. So Dick Alexander, Bill Shourt, and Don Trumbull (Doug's dad) built this VistaVision™ camera rig that mounted on the nose of a Lear jet. Al Miller built a controller that varied the speed of the camera from 24 down to about 1/2 a frame a second. As it varied the speed, it compensated the exposure by moving the iris on the lens so that the film was always exposed the same.

"I wrote a program that computed various camera speeds that would correspond to a fighter in afterburner acceleration and loaded it into a ROM on the controller. At the same time we had a computer recording the roll, pitch, and yaw information for every frame of film so that we could play it back later on a motion control stage. (That information on the plane's altitude came from a huge inertial navigation system that we installed in the extreme back of the jet in a

hangar – in Louisiana – in the height of summer – after a night on Bourbon St. I wouldn't wish that experience on anyone.)

"Some of the footage was pretty dramatic. When you're flying in a Lear jet doing rolls and twists and turns 50 feet over a glacier, it's pretty dramatic already. But when you view VistaVision™ footage shot through a 15mm wide angle lens and the camera suddenly slows from 24 frames per second to two frames per second, the effect is that of a plane suddenly zooming to 3,000 mph – that will get your attention, and sometimes churn your stomach. On another job we were just clearing a ridge top when I felt the plane drop from a strong downdraft. I looked up from my controller out the window and saw the wing tank kicking up snow – now, *that* was stomach churning.

"We also used the Lear photography to generate footage for a number of projects including *Never Ending Story*.

"In **Rumblefish**, where I had the pleasure of working with Bob Primes and Steve Burum, we used a similar rig to go from full-speed live action to time-lapse, one-frame-per-minute photography. We used it to get time-lapse shots of clouds and shadows moving across the landscape.

"Unfortunately, one of the coolest shots didn't make it into the movie. It was a shot where we followed a group of beautiful young women running from a swimming pool and then subtly change to time lapse to watch the day end, and then begin again. The shot didn't work because a gate to a tennis court in the background was swinging imperceptibly in the wind. Of course, in the accelerated time scale of time lapse, it was whacking back and forth like a weather vane in a hurricane and was too distracting. Too bad because it was the only motion control shot I was ever involved in that included naked women. No wonder no one noticed the gate.

"It is interesting that in the effort to imitate reality, we end up perceiving other realities that are normally hidden from us. This applies to extreme close-up photography of course (e.g., a drop of pond water.) But it applies to time scale as well – there are all kinds of amazing things going on around us to which we are totally oblivious but which jump out at us when we magnify or compress time.

"We are just now doing a rock video for *KORN* in which we are combining still photography with ultra-high-speed photography with a CG bullet to create an altered three dimensional reality.

"I think that good effects, like good filmmaking, is a mixture of technology and mystery, of preparation and planning combined with

abandon and an openness to serendipity. On **Big Trouble in Little China**, at Boss Films, I was directing the puppeteering crew of about 15 that was controlling the flying eyeball. This was a kind of supernatural flying surveillance head that had eyeballs all over it, including the end of the tongue. It was gross, but cool. The trick was to get some convincing expressions out of it that matched the voice-over dialog.

"I remember spending time looking at the mirror trying to figure out exactly what muscles move to show anger, fear, smug satisfaction, evil. We got some wonderful performances pretty quickly because the crew was so talented.

"But some of the best expressions came by accident, when we would call a break – the face would sometimes go nuts as some of the puppeteers would just loosen up, and every once in a while it was like 'wait, hold that right there! THAT's perfect.' You always have to be open to the unexpected and unpredictable."

The unpredictable is exactly what Beck encountered on **The Abyss**, when he was sent up to Washington to try to grab extra footage on an oceangoing model shoot. It involved some pretty hairy days on a zodiac and on a fishing boat in huge waves off of the Washington coast. Toward the end of one day on the ocean, the crew was trying to rig a buoy to pop up and start signaling.

The waves just kept getting bigger and bigger and the crew eventually announced that the sea was too strong and they would have to wrap. Beck pointed out a gorgeous nautical sunset to the production manager and asked if they could just shoot some film and call it a test.

Suddenly everyone was rushing around to try and set up for a take as the seas got higher and higher. Beck ended up on the stern of the boat with a rope lashed around his waist with waves breaking over his thighs on deck. Beck handheld the camera, trying to keep the horizon level as he pointed it at the setting sun, guessing at the exposure because all three of his meters had gotten soaked. The buoy popped up on cue and the shot looked great.

Beck ended up serving out four months onstage at Dream Quest Images shooting the submersibles in long passes in smoke. "It was definitely a case of adversity building character. Yancy Calzado was doing stop motion on a shot of 'flat bed' reaching for a cable connection.

"Eleven hours into a 22-hour shoot, we had just come back from a meal break when Yancy took me aside and told me that there was an

angle gauge left sitting on the model and that he wasn't sure whether or not we had taken a picture of it on the last frame. We walked once around the building and decided that it was too much of a coincidence that such a mistake happened on the last frame before lunch, so we forged on.

"Two hours later the smoke density gauge failed. Without it the smoke in the room would vary slightly over time and look more like a flickering rock show than the floor of the ocean. So we took the light box used for looking at film clips, stuck it out on the stage, and read it from 30 feet with a spot meter. We spent the next eight hours manually reading and adjusting the smoke. The shot came back flicker free and gaugeless, praise the Lord."

The unpredictable was certainly prevalent in the 1991 comedy *Defending Your Life*, directed by Albert Brooks. "It was a fun set to be on. Albert would do 12 takes, one after another, making it up on camera – different every time – hilarious every time. It was an effort not to ruin the take by laughing. Mike Grillo was producing and assistant directing at the same time, also an amazing performance.

"The premise of the movie was that after you die, you go to a sort of reincarnation processing center where they decide where you spend your next life based on what you did in the last. It was great working with Allen Daviau in this because he was so technically savvy. I worked with Bob Scifo in the matte department to create an environment, which looked like a mixture of Orange County and the Midwest.

"For a couple of the shots, Hoyt Yeatman and I set up a couple of latent-image original negative matte paintings – doing it the old fashioned way, shooting the live action and then the matte painting on the same piece of film. It was a good discipline and a good education, but scary. If the matte and the color balance and the exposure all fit, you have a first generation image on the original negative. If not, you better hope that take two or three is in good shape because that's all the film you're likely to have.

"In the story, the recently deceased could amuse themselves by seeing images from their past lives. Each guest stood at his or her individual screening booth to watch his or her former self appear. The joke was that the show was introduced by Shirley MacLaine.

"The trick was to dolly past all the booths, looking past each different guest to see an identical ghostlike Shirley in each booth, saying, 'Welcome to the past lives pavilion.' First we used a locked-off

camera to shoot Shirley standing against black. Then, we used a real time motion control dolly that moved past the row of actors and the front half of each booth, all in front of a big blue screen. We then repeated the move shooting the back part of the booths.

"We then went back to our stage and repeated the move again shooting a white screen on which we projected Shirley's image, one for each booth. Then we sandwiched all the elements together with all the Shirleys halfway down the booths, slightly transparent. So in the composite, we look past one visitor after another at Shirley after Shirley after Shirley, all in perspective. It looks real and funny at the same time."

For Beck, however, the most memorable shot was the final shot where Brooks and Meryl Streep are kissing. The camera starts on a two shot, then pulls back to see that they are riding inside a little tram car pulling away from us. The camera pulls back farther to reveal that they are traveling in parallel with other trams on an eight-lane highway. As the trams disappear into the eight tunnels, we rise to see the array of all the tunnels going into the mountains, with a glowing night sky beyond. That was the last shot of the movie and had to have impact as well as verisimilitude.

"This was a combination of live action, miniature, and rear projection – all done in the camera," he recalls. "Dave Goldberg built a huge tabletop miniature of our highway, complete with forced-perspective mountains and a glowing night sky. We shot Albert and Meryl inside a tram car, kissing. We mounted a small projector inside a miniature tram and projected that image onto a small screen inside the miniature.

"The miniature was mounted rigidly to a motion control track under the tabletop by a thin piece of metal that sliced through a very narrow slot on the surface of the highway. We were able to disguise the slot by gooping over it, then shooting the shot backwards, so that as the blade sliced through the highway, it was coming toward camera and hiding the damage behind itself. Some of the tunnels had little mirrors mounted at the end so that they looked twice as long.

"We did one beauty pass to show the environment and all the other trams. We did three color separation passes to get the best possible image in our little rear projection rig. The shot was done completely in-camera, and the projectionist at the screening asked where we'd found that location."

By this time digital technology was starting to prove itself. "Kodak invited a bunch of supervisors to Rochester to display their plans for digital compositing and to find out what the industry was looking for. Hoyt Yeatman and I went and saw an impressive demonstration of the quality of their laser output. It made a good argument that it was time to build an in-house system at Dream Quest.

"Now that the Cold War was over, there was a sudden gratifying influx of imaging and image-processing technology from the defense industry. We built a scanner based on a Photometrics camera and an old optical bench and did our compositing on a Sun computer. We did the first digital shots on *Toys* for Barry Levinson and on *Hero* hanging Dustin Hoffman off of a hotel ledge. (I still treasure a VistaVision™ frame of him in his harness over a blue screen looking up and giving me the finger.)"

"***Hot Shots*** was another chance to work with a great comic in Jim Abrahams," says Beck. "Effects, for a comedy, can sometimes be more forgiving, but it can also more difficult to walk the line between comic outrageousness and believability. It's like an actor trying to decide how broad to play a performance. We had one shot where Charlie Sheen screeches his plane to a halt in midair, then pulls a U-turn. It was interesting working to make a motion control move 'funny'; it wasn't until we made the rear end fishtail like a GTO leaving a stop light that we got laughs. Jim's credo was one of economy. If a shot wasn't funny or didn't move the story along, it was gone."

In 1993 Beck was asked to create visual effects for a quirky television pilot called ***The X-Files***. What started out as a computer generated vortex of leaves turned into a couple dozen effects shots done in a very short period of time. When the series was picked up, Beck accepted it with the understanding that he would continue to do feature film work at the same time. His three years on ***The X-Files*** taught him how to be fast, budget-conscious, and creative at the same time. "The biggest curse of working in television is that there is never very much time to work on the effects. The biggest blessing is that there is never much time to work on the effects, so you don't have time to noodle or be indecisive. You have to make it good, get it done, use what you've learned on the next episode."

What was most enjoyable about ***The X-Files***, besides the fact that Chris Carter was making it into a cult classic, was that there was a huge variety of shots that had to be produced over a season. Anything from CG worms, to spaceships, swarms of bugs, lightning, nosebleeds,

crowds of cultures, clones, morphs, alien sentient blood to complete locations had to be generated.

As he looks back on those days, there are a few effects elements that stand out as especially fun to do. There is the episode where Peter Boyle appears as a rotting corpse that disintegrates into powdery bones. "This was an exercise in cooperation between practical creature stuff and digital work," he recalls. "I shot a variety of passes, starting with a nervous but willing Peter Boyle, followed by a series of different stages of nasty decomposition built by Toby Lindala's shop, ending with a CG skeleton combined with dozens of complex morphs done by Edson Williams at Light Matters. The end result is kind of creepy and peaceful at the same time."

"Then there was the cockroach that was composited so that it appeared to be running across the outside of the TV tube. We just comped the bug over the top of the cut sequence so that as the action changed in the screen, the bug still appeared to be there. Easy and scary.

"Some of the best effects were those that were the opposite of supernatural; they were invisible – added to establish a location or alter the story in some subtle way. There was an episode where the editor didn't like a line delivered by an actor in the scene. We tracked the actor's mouth throughout the shot, zipped it shut, and replaced his line with another read from off screen. I wondered what the poor actor thought when he saw his performance."

Then, of course, there was also the episode that took place in the desert of New Mexico, which made things awkward for a series still being produced in the verdant province of British Columbia. "That was the only episode in which we actually used a motion control system.

"We did a bunch of hand-operated moves in Vancouver hoping that we'd be able to find a location later on that we would be able to match. The most ambitious shot was of Mulder and an Indian boy riding a motorcycle down a path on the edge of a cliff overlooking a vast desert canyon. We actually painted the side of a Vancouver rock quarry red and shot David and the kid there on a motorbike. Then I went to Sedona, Arizona looking for a location where we could match the move and lighting. We ended up hauling a motion control camera out onto this 'Roadrunner'-style table rock balanced on a narrow spire over a cliff edge, the kind of rock that looks like it will tip over any second.

"We'd been assured that this rock hadn't moved in a thousand years, but I asked the local grip to tie off the camera assistant just in

case something unheard of happened. He promptly tied the guy off - to the rock itself! If it went, he damn sure was going too! Wile E. Coyote would have been proud. Anyway, we got the shot shortly after sunrise (the local campers were puzzled but accommodating) and Mulder ended up in the Painted Desert without ever going through customs."

One of the films Beck worked on during the second season of *X-Files* was the Jim Cameron feature *True Lies*. He served as VFX DP on a number of sequences, including the opening sequence, the horse/motorcycle chase, and, most notably, the bridge explosion in Key West.

"Russ Carpenter was the main unit DP," he says. "He was terrific, especially when I was whining for more stop on a green screen. John Bruno was the overall VFX supervisor.

"For the bridge explosion, he wanted a big miniature to be set in the same locations as the real bridge, in the same waters in the same tropical lighting, and he was right. It worked beautifully. Mark Stetson and Bob Spurlock built a great 1/5-scale miniature, and Joe Viskocil blew it up real good! Mike Chambers was the VFX producer who put up with all of us.

"We had six cameras, each with different F-stop and speed to accommodate the different angles. It was a real adventure trying to get everything armed and ready, while waiting for the tide and sun to be just right, adjusting the stop on all the cameras as the light changed, while shooing away a curious pelican that tried to land on the bridge (someone muttered that if the explosion went off now, we could call the film '*Brief Pelican*').

"Finally, everything was ready and we rolled cameras, then suddenly had to yell cut at the last minute because one of the cameras jammed – of course the one I was operating! We opened the box and found 200 feet of film accordioned into about 8 cubic inches! Hang on, Jim. We grabbed vice grips and pliers, ripped out the film, cleaned the mag, started the camera, got on the radio and yelled, 'Let's GO' – all in about 45 seconds. The truck went flying down the track, blew into the air beautifully, and landed on the other side of the explosion. It looked great."

The only problem was that because the miniature truck had landed on the other side of the gap, it was necessary to digitally add a truck to the full-size location. Enter Beck's new company – Light Matters, Inc.

"We did a number of shots on *True Lies*, including a couple that no one wanted. John and Jim were great to trust the shots to a start up like us, but I think Jim was pleased giving us one shot in particular. That whip pan that I did to follow the truck as it exploded, well, I kept following the truck as it flew beyond the explosion, and Jim wanted to use the part where the camera saw beyond the model into open ocean, and then into the matte box of the camera next door. Edson Williams and I had to digitally synthesize ocean, sky, bridge, mist, and flying debris and track them all to the existing plate. They were pleased enough that we ended up doing a total of seven shots, and Light Matters was born."

Light Matters had started to develop a reputation for doing shots that other people had turned down. In 1995 they did a shot for *Strange Days*, which involved putting the Bonaventure Hotel into a dramatic crane shot that had not been designed as a visual effects shot.

"The camera cranes up past this frenetic New Year's celebration, with fireworks and balloons and flying confetti to see the Bonaventure Hotel in the distance. The problem was that the hotel (which is notoriously difficult to light) was too dark to be playing properly in the scene. So, we had to shoot a new Bonaventure and track it into an unsteady frame, behind all the graffiti, balloons, etc. In the last output before final, we had pored over the film for 20 minutes in the screening room to find three little flaws that no one would ever see. Jim Cameron looked at it on a dim flatbed viewer in editorial and found every single one in two minutes."

On the Eddie Murphy film *The Nutty Professor*, Light Matters was called upon to do about one-third of the visual effects shots. "We did a lot of shots that involved putting Eddie as Sherman's dad in shots standing beside himself as Sherman's mom, including helping her off the floor.

"We also had fun putting hamsters in some inappropriate places, and blowing up Westwood with a nuclear explosion. Jon Farhat was the overall supervisor. The most fun we had was computer-generating the out-of-control 'belly from hell' that breaks through a window and swallows a doctor in its folds of fat.

"By now, I had hired Greg Strause on *Black Sheep,* and he claimed that his kid brother, Colin, in Chicago could do some 3-D. Before I could say 'Forget it, we've already got people working on it', I was looking at a very promising test. It wasn't long before the images were flying back and forth over the Internet.

"It was fun being so outlandish but still trying to make the image believable. The texture of the sweatshirt and the stretching wrinkles and a LOT of rotoscoped breaking glass helped a lot with that."

Beck's next big project was as VFX supervisor on the 1997 film *Volcano*. "The challenge in *Volcano* was to create a credible villain – the lava – to drive the movie and do it in a super-compressed schedule. The schedule was made even nuttier because we were put into competition with another volcano movie, which had started before us. Things were so compressed that we were doing pre-production, production, and post-production all at the same time. In other words, while we were trying to figure out how to do stuff, we were already doing it, and trying to put together stuff that had already been done."

Beck decided early on to move on parallel paths in trying to develop the lava miniature and CG. "We figured that at least one approach was likely to work, and we got lucky – they both did. It started out like a race – first the miniature looked promising, then the CG leaped ahead, then the miniature lava, which a group of us (Dave Drzewiecki, Joe Viskocil, Scott Valdes, and Tom Zell) worked on started looking really complex and scary.

"It ended up looking terrific and appearing in about 80 percent of the lava shots. The short version of the recipe is a layered confection of gooey food additive, ultraviolet pigments, paint, and at different times, stearic acid, cork, and flocking. When blasted with conventional and ultraviolet light, it glowed a convincing nasty orange red. The ultraviolet light made it self-illuminating like the real thing. Dave's crew built a series of underlit clear plastic lava tables that tilted and rolled to make the lava flow exactly where we wanted it to go. We had a bunch of 1/8 scale plastic curbs, benches, etc., for the lava to flow over and around. All necessary streets, curbs, etc. were lined up through the camera to match up with each individual background.

"The resulting element (shot at very slow camera speeds – around three frames per second) would be digitally scanned and composited over the background with lots of digital color correction, heat distortion, and CG fire and would look like it was really burning down a chunk of L.A.

"This show was a tough one, with a lot of tough shots, made tougher by the changes in concept and schedule. One of the more difficult gags had to be the infamous WF-18, in which the camera flies behind a host of helicopters as they cross over a plume of steam to drop

water onto the sea of lava, burning cars, and buildings that Wilshire Boulevard has become.

"In the distance, we see pockets of the burning city surmounted by a volcanic cone spewing lava and smoke. The shot was modified on the set the night of shooting, as they often had to be. The director, Mick Jackson, a true gentleman with a painter's vision, knew what he wanted – we just had to figure out how to get it for him."

This challenge – nightmare – was difficult because of the multitude of elements and the need to have perfect tracking. "Sometimes what makes a shot difficult is exactly what makes it cool. In this case it was the sheer scope of the scene and the movement of the camera.

"One of the cool things was that we were really flying through a cordon of burning buildings. One of the problems was that because they were burning so enthusiastically (thanks to the wizardry of Clay Pinney and Company), the air was incredibly turbulent as we flew through with our real camera.

"There was a shocking blast of hot air as we crossed over the set and our camera ship was bouncing noticeably from the convection currents. And of course, they weren't really buildings, they were sets; thus you could see from the air that they were hollow. So, before we ever got to add the volcano in, Greg Straus and Edson Williams and Erik Liles of Light Matters had to do some pretty elaborate three-dimensional tracking to add roofs onto our burning 'buildings.' Even the slightest bounce made the reality of the shot bounce apart before your eyes. But, it is the very shakiness and immediacy of the shot that gave it its life and energy.

"It's a good thing to tell yourself, when you are struggling with the shot from hell. Colin Straus by now was generating CG lava that was indistinguishable from the glowing miniature lava. He built a river of lava, complete with slowly rotating burning buses, leading back to a distant volcanic cone.

"At the same time, we were supplementing the four real helicopters with eight CG ones and putting the lava behind real steam in the scene, then adding digital steam and falling water over the top of that. All told, the shot consisted of about 130 elements layered over one another."

Mat Beck has an odd idea of a vacation. After finishing **Volcano**, he went right onto two more film projects. One was helping out during the push to finish the shots for *Titanic*. Light Matters/Pixel

Envy (a newly formed partnership) composited the shots of the approaching iceberg that sank the ship. "They were interesting shots," observes Beck. "Their very subtlety made them difficult to get just right.

"Jim was insistent that the iceberg seem to credibly appear out of nothing. So, we had a lot of film tests to make sure the berg initially hovered right at the edge of perceptibility with some subtle animated shadows that lined up with the horizon and acted like camouflage. We had to CG quite a few reflections and water foam and shadow elements to really tie the berg to the ocean and the ship and sailors into the scene."

At the same time Beck was beginning as VFX supervisor for *The X-Files* – only this was the feature film. Here he had more time, but also a lot bigger scope of work, and a bigger canvas to view it upon. Ask Beck which shots stand out in his mind, and he will say they all do. Ask cinematographer Ward Russell what stands out in his mind, and he will say he doesn't know how Beck pulled off two particular sequences – the interior of the spaceship and the ship rising out of the ice field.

"They were both challenging," Beck admits. "As is often the case, we had to decide early on what approach we were going to use and then adjust when the needs of the sequence change.

"The interior of the spaceship was a good candidate for CG. In concept the ship was an enclosed arena 1,200 feet across. To match the dramatic sweeping moves that Rob Bowman, the director wanted on the full-size set would have been very difficult inside even a partially enclosed model, leaving aside the problem of lighting it convincingly.

"By having Colin Strause model the ship, we were able to produce an enormous amount of complexity (over 1,100 lights) as well as the ability to modify the design quite late in the process. By synthesizing over 90 percent of the environment we were in effect building a virtual set. The trickiest part was showing enough detail to give the sense of depth and complexity but not so much that it lost its mystery.

"Again, a very short prep cycle meant that its design was evolving even as it was being built. By starting the CG model building early on, it meant that we could produce test renderings that would be useful to the art department and the construction department.

"We were able to design some of the more elaborate moves in virtual space and get signed off on them. So, we knew where to place the crane, where David Duchovney should walk (David got pretty could

at imitating the goofy walk of our low-resolution test dummy), how much we had to build and not build.

"By contrast, the exterior of the spaceship lent itself more to a miniature. Lighting it was easier (make it look like sunlight). And of course it is a lot easier to move around outside a miniature looking in than the other way around. The miniature was built by Scott Schneider and shot by a crew supervised by John Wash.

"We put a lot of surface detail on the outside of the ship using brass etching and lithography techniques – the idea was to hint at levels of detail that you can't quite see. That is where a miniature is still great; once the detail is built in, a new shot is simply a matter of moving the camera.

"The avalanche of snow was another project we did mostly in miniature. Scott and Bob Spurlock built a 40-foot-by-60-foot glacier out of hundreds of pieces of styrofoam covered with salt and paper and baking soda. We had three huge hydraulic tables that literally pulled the floor out from underneath it in an expanding circular pattern, while we pumped steam out of miniature geysers and filmed the whole thing at high speed.

"The backgrounds were digitally tiled from stills shot on a real glacier in Canada. John Wash supervised the effect for Blue Sky/VIFX. Eventually we CG'ed some cracking patterns and wide views; the combination of CG with the real interaction of falling particles gave a lot of scale and complexity. When we composited in two tiny images of Scully and Mulder running for their lives, the scene took on a bit more immediacy too.

"I think my favorite shot of the movie is the one in which the camera rises up a boy's body as oily worms crawl up under his skin on the way to his eyes, then brain. What was fun is that this was a genuinely creepy moment in the film, and it was created by a mixture of leading-edge CG and good oldfashioned goop in a jar.

"We used a MoCo system to move upward along the kid's body, but only so that we had a smooth predictable camera move in order to more easily track his gyrations. The worms moving up the boy were pure CG – in fact virtually the whole boy was CG. We created a virtual boy tracked to the real boy's performance. Everything, but his shorts and eyes and forehead were modeled in *Alias*.

"To this virtual boy we added worms that discolored and deformed the skin as they slithered along it; of course, they tracked perfectly because they were all part of the same model. The stuff in his

eyes was a pigment in water gag that Dave Gauthier and I had figured out in the TV show. For the movie, Ian O'Connor improved on it. We shot it and texture mapped it onto the eyeball's surface. There was a funny moment when editorial went nuts and accused us of using the wrong take because when they checked for sync, they couldn't find their reference frame. The reason was that Colin had changed the facial expression slightly, and that frame no longer existed. We knew the effect was starting to work when one of the sound guys complained that we should be running this particular scene *after* lunch."

So where does Mat Beck go from here?

"Well, in the last year, so far the company has done work on four features, a TV show, a pilot, a rock video, and we're talking about a surprising variety of other stuff. What makes it remarkable is how the field keeps redefining itself – our new bag of tricks keeps expanding and changing the boundaries of what is possible.

"The increasing power of the technology is not only helping to expand the scope of possible images, it is impacting other areas of film-making as well. Sets used to be exclusively drawn on blueprints and built with wood and plaster. Now they are often designed in cad cam and rendered partly in virtual space.

"Actors and stuntmen can stay safer while they look like they're in greater danger. In some shots we have preserved the performance and inserted a virtual actor to suffer the consequences. The old boundaries between film and video are starting to crumble as well. Video used to be quick and low-resolution. Film used to be slow and higher quality. Well, now video is getting to be more like film because Hi-definition delivers so much more information and impact.

"Film is getting to be more like video because with our new software, which is VERY fast and resolution independent, we can display full-resolution film images at real time on the computer monitor, over a high-speed network – just like standard video.

"We already have the technology to digitize the entire film, cut it, and then output release prints without ever touching the negative again. That is, of course, for theaters that will still NEED film instead of a signal for their digital projectors.

"But the tools are never the main point – they're just pipelines into our imaginations.I think that we experience the world by reconstructing a model of it inside our heads. That's why a good story can move us so profoundly, whether it's played by live actors or cartoon characters.

"The images hook into the same mechanism that we use to build our own experiential reality – so they become real to us emotionally even though we know they are illusions. That's how we can care so deeply about what happens to our heroes while simultaneously admiring the virtuosity that generated their predicament.

"The best images are more than visually real; they are lyrically and emotionally real. They resonate and change us and teach us about ourselves. Those are the images I'd most like to produce."

"That moment really reinforced to me the benefit of identifying these little enhancements and planning for them in advance. There are ways to increase production value, often with no additional money, if you work with the director and impart your knowledge to help make the planning easier and more effective."

Eric

Brevig

At the age of six, Eric Brevig was doing split-screen shots with an old 8mm home movie camera. "I was fascinated with moviemaking and storytelling," he admits. "I loved the films of Ray Harryhausen and the classic Disney films of the 1950s and 1960s."

When he got out of high school, Brevig mistakenly thought that "you could get into the movie business through film school," he laughs. "I was admitted to the UCLA film program, where you were pretty much left to your own devices to make your own films.

"The process was not easy. I got to deal with everything from grumpy actors to camera rentals. My student films were written to take advantage of, and help me increase, my knowledge of effects. I built a front-projection, stop-motion setup imitating Ray Harryhausen's work. An unexpected benefit of going to such a large university was that I got very good at taking tests!"

Which, ironically, prepared Brevig for probably the hardest test of his life. In 1980, he heard about the camera apprentice training program (the same as in the DGA) and applied. "There were 1,500 applicants. I didn't think I had a chance," he recalls. "I couldn't believe I was one of the 5 chosen. And, I got to work as a camera intern in special effects."

Brevig interned at Disney's effects department, Apogee, Doug Trumbull's, Universal Hartland, and Howard Anderson's company. He

combined his internship with a teaching assistantship, as he worked toward completing his master's degree. By day, he carried magazines and slates at Disney, while at night, he continued work on his master's thesis film. He learned about fades and dissolves for television shows like *Laverne and Shirley* at Howard Anderson. While at Universal Heartland (at the time of *Blade Runner*), he learned about miniature and motion control photography.

At the completion of the internship, he was asked to return to Disney for a real job. It was at the time the company was working on Disney's *Magic Journeys*, a double 70mm 3-D motion picture for Epcot, Florida. "It was great. In addition to effects, one of my hobbies was 3-D photography," he says.

Although he started out lugging giant 70mm mags over sand or mountain, he eventually showed he knew the overall process. "My chiropractor was happy when I moved from lugging the equipment to supervising its use," he laughs.

"3-D photography was and still is a challenge because you are working with additional visual cues," he explains. "When you are working in 2-D, anything in front that blocks another image looks like it is in front. In 3-D, spatial depth cues are different. Your depth perception can tell if it is in front of something or if it isn't.

"There is a lot of preplanning involved. You are dealing with two different strips of film, one for each eye. Each one contains many elements that must be precisely composited in 3-D space. You have to take into consideration the 3-D space and draw each element, whether they are miniature people, computer graphics, flying elements, blue screen, and such, and ensure that they fall into the proper depth plane of 3-D space. "When that doesn't work, the viewer will feel eye strain. This can be caused by each eye seeing an image that is out of alignment, causing the viewer to be cross-eyed, trying to view the image."

The expertise Brevig established on this 3-D project has stayed with him over the years. In 1986, and again in 1994, when Disney began additional 3-D projects, he was called on to supervise the work. "Nothing has changed," he says. "Sure, we use more synthetic imagery and computer graphics these days. But, the process is still the same. You shoot the same way."

From Disney, Brevig went to Dream Quest. "It was the time of *Buckaroo Bonzai*," he recalls. "The company was small. We did a lot of things hands-on. "They needed a person to handle the matte camera.

So, I began shooting live action and working with the matte artist on the matte painting images.

"I began working with Hoyt Yeatman. We both shared the desire to understand and improve upon the various effects techniques in use at that time. We did some experiments, trying to improve on those techniques.

"The trick about blue screen is finding the way to separate the background from the foreground, in a flawless manner," he explains. "You can light the background blue screen evenly, with pure blue light, or choose to get by with an evenly lit screen, contaminated with other colors of light. The first is wonderful to work with. The other has to be manipulated forever."

Brevig and Yeatman were effects supervisors together on Steven Spielberg's historic television series *Amazing Stories*. Not only was it a time when Brevig was exposed to every different style of directing, he also got a chance to work on a variety of stories. "It was a time to refine the working tools," he says. Each show – each shot – was different. They often called for experimentation and pushing the limits of the tools.

"One episode sticks in my mind," he admits. "It was a show directed by Burt Reynolds, where Dom DeLouise played the devil. Dom is to appear to be six inches tall, and standing in front of a frosted cake on a plate, in a gap where the slice was removed.

"On the day we were to shoot Dom against the blue screen, I remember looking at the shot and wanting to get something more out of it. As Dom stood in front of the screen, I thought, 'If I could put a piece of white cardboard off to the side and get his shadow in the shot, it would look like his shadow, which would have fallen on the cake.'

"Of course, today, you'd just animate the shadow on the computer. However, that was then.

"When everyone looked at the finished product, we were complimented on the shot. 'It looks great. He even casts a shadow on the cake.' That moment really reinforced to me the benefit of identifying these little enhancements and planning for them in advance. There are ways to increase production value, often with no additional money, if you work with the director and impart your knowledge to help make the planning easier and more effective."

While still working at Dream Quest, Brevig was on loan to Disney to work on their second 3-D film, *Captain EO*. At that time, the work was being split between Dream Quest, Disney, and ILM. Although

he didn't know it then, he was forging a relationship with the company that would serve them both well in the future.

It was while supervising the effects on *Big Business* that he became involved in some of the most complicated split-screen process work in the industry. It was 1988, and Jim Abrams was directing. "He was concerned about the whole process, but extremely open to anything that would improve the scenes and make them more interesting and funny," Brevig recalls. "Dean Cundey was an incredible asset to the cinematography on this project. And, Lily Tomlin and Bette Midler were troopers. We really pushed the envelope – but we also got stuck with one of the biggest nightmares in effects I'd ever seen!"

Until then, split-screen work was rather rigid. Split lines were hidden in the design of the set and rarely moved during the shot. Architecture, tabletops, direct lines were the common thread. Cameras were strictly locked down. "We made the effort to not lock the camera down or restrict its movement in any obvious way. Then we had a scene with a Harpo Marx-type mirror gag that was the centerpiece of the entire film," he recalls.

The scene is in the bathroom of a hotel. It is where the Bette Midler twins first meet. The camera dollies along with one of the Midler characters, past big full-length mirrors with gaps between them. A second Midler walks, unaware, along the backside of the mirrors and is visible to us in the gaps.

At one point, the foreground Midler suspects something is not right with her reflection and stops, then leans out, looking at her twin. The second Midler, coincidentally, copies her. They start with small gestures, which escalate to large, crazy dance gyrations.

"Finally, one reaches over and tweaks the other's nose," says Brevig. "To do this, we prerigged a blue screen behind the back of the set, which was designed to break away and reveal the screen.

"We filmed the shot with a computer-controlled camera, on a motion control dolly track," Brevig explains. "At that time, it was a big procedure to shoot a live-action motion control shot like this, synchronizing the camera with the video assist and the motion control program.

"We shot the foreground action with Bette, establishing her movements. We did a series of different takes, one funnier than the other. Our video person handed Bette a videotape of the chosen take, which she took back to her dressing room to precisely memorize the

movements – just as one would learn a dance number – while we took the set apart to reveal the blue screen.

"When the set was made ready for her, she returned and we rehearsed the blue screen portion of the shot. When we looked at the video composite image of the two Midlers, we could tell that something was terribly wrong – she was out of sync.

"We didn't know if it was the image on our video, the camera, or what. It was our worst nightmare! Finally, we broke the elements down. She'd perfectly memorized the take that she had been given, but it turned out that she had been given the wrong take!

"Obviously, we couldn't make her go back and memorize all of the different motions, so we had to live with the take that she knew! We all learned a valuable lesson on this one!" he says. "Don't stake the success of your work on someone else's ability to follow instructions, without verifying them for yourself, or you will get caught!"

Brevig moved on to another project, this time a version of the Christmas adventure called *Scrooged*. "This project involved a lot of miniatures," he recalls. "The most difficult shot was in the beginning. It required us to tie a miniature set to a full size set as flawlessly as possible.

"In theory, we were to start on the North Star, which appears to be a helicopter aerial down through the clouds, past the North Pole to Santa's house.

"We shot the full-size set of Santa's house first. We studied the live action, then lit the miniature to match. We used a big Christmas tree to mask the point where the camera segues between full-size and miniature photography. We thought it would be easy – essentially a motion control shot into a live action one.

"However, when we looked at the shot, it looked too much like a miniature." Brevig needed a way to fool the audience into believing the miniature was real. "I shot a little silhouette of myself with a pillow under my shirt, an elf cone of paper on my head, and some of our cotton clouds crudely formed into a beard. I then projected it into one of the windows of the miniature house," he explains. "That little addition gave the shot scale and was the tool that tied both elements together."

Eric Brevig was getting to know the limits and when to push them on visual effects. In 1989, he tackled an even larger and more challenging project, *The Abyss*. "I supervised the effects elements, which we actually shot underwater in a 7-million-gallon tank," he recalls.

"We did the wide shots of the divers outside of their underwater habitat, on the surface of the crippled sub, and Ed Harris's character as he meets the aliens," he explains. "Jim Cameron thought it was important to get this footage with real people under the real water, to build the believability of the sequences. Seeing real breathing divers was important."

Les Dilly, the production designer on the film, built the bottom 40 feet of the underwater habitat, as well as 60-foot sections of the sub in the seven million gallon tank that was used for the live action underwater shooting.

"The tank was actually a partially built cooling tank for a nuclear reactor, which was never finished," Brevig explains. "They patched the giant holes in the tank and built the sets in it, then filled it with water."

Although he admits the actual experience was an adventure, it was difficult in every respect. It was like being in the Marines and making a movie at the same time. "From August to November, we were working 30 to 50 feet underwater every day," he says. "Just getting the VistaVision™ cameras into position was a challenge. Then you had to be careful not to run out of air before you got the shot!

"We had special underwater housings built for the VistaVision™ cameras, and, while they were neutrally buoyant in water (they would neither sink nor rise), they weighed several hundred pounds when they were out of the water.

"My camera crew and I were all wearing full scuba gear and wet suits, so every aspect of the camera work was very cumbersome. Jim Cameron, the director, was wired with a microphone in his scuba suit, so that he could talk to us under the water, but we could not answer him. When pantomime failed, I would frequently have to swim several hundred feet underwater over to get to him and write my answer on a tiny diver's slate for him to read. It made every shot painfully slow to accomplish."

To make it appear as if the shots were filmed at the bottom of the ocean, all natural sunlight had to be kept out of the tank. "The production found that if they floated half-inch, pea-size plastic beads on top of the water, they would effectively block out all the sunlight.

"Also, the air bubbles from the divers and crew would filter through, so if the camera looked upward, it wouldn't see a shimmering mirror of trapped air bubbles.

"From the top, these black beads floating in the tank looked like newly paved asphalt. This, occasionally, caused a few stray dogs and unwary visitors to the set to unintentionally go for a swim, as they attempted to walk out onto the beads," he laughs.

"And, unfortunately," he grimly recalls, "after a while, these black beads became saturated with water and would slowly drift down into frame wherever we set up the camera. We would then have to leave the camera, and hover 40 feet away, until they SLOWLY floated back up. Of course, once in a while they would end up in a diver's ear, and we'd have to have a doctor get them out!

"When that became too much of a pain (no pun intended), we tried to block out the sunlight with a tarp. Then, the wind blew that away. We finally gave up and shot at night for the rest of the shoot, using hot tubs to thaw the crew in between setups.

"Once we finished, we basically agreed – the shots looked great, but if we were to do it again, we'd try to do more shots dry for wet," he admits. "By flying the actors on wires and filming them in slow motion in a smoky environment, you can frequently imitate the look of being underwater, although you must composite in the missing bubbles from the divers exhalations.

"This was done for many of the miniature shots, which were filmed by Hoyt Yeatman, using motion control cameras back at Dream Quest.

"After we finished our underwater shots, I moved on to begin a project that I would supervise, which would eventually allow me to win an Academy Award – *Total Recall*."

When Brevig moved on to *Total Recall*, he knew most of the work was to be done photochemically. "We did shots like a giant pull back from a subway train as it cruises along the Martian surface, where we started looking in the window at Arnold, and pulled out and up and away, revealing the Martian exterior landscape, until the train is just a speck on the horizon.

"The one shot that was to use computer-generated imagery was the x-ray scene," he recalls. "The CG image was farmed out to another company. It is the sequence where Arnold and assorted bad guys and passers-by walk behind an x-ray, screen and you can see their skeletons continue to walk as they pass behind the screen.

"We thought about using animated stop-motion skeleton puppets but decided to use CG animation to create the images of the skeletons because this would give us more control to manipulate the

skeleton imagery. Computer graphics, at that time, frequently looked a little electronically processed, but that was okay, given the subject matter."

The elements were shot in Mexico City and Churibusco Studios. "I had the production designer incorporate large panes of black glass into the set to represent the x-ray screen surfaces.

"The CG company wanted to use an early motion capture process to animate their CG skeletons. The actors would reenact their performances while wearing skintight outfits, covered with reflective ping-pong ball shapes, and special cameras and computers would record and analyze the precise movements of the balls.

"This would automatically give them the animation, which would match the individual actors' movements. Now, when we filmed the scenes with our main camera, you couldn't see the people walking behind the black glass. We would be relying on the motion capture to match their actions perfectly," Brevig explains.

As one who always worries about something that has never been tried before, Brevig wanted a little insurance on the shot. He had the film's production designer punch small holes in the back of the set and placed a witness camera behind the scenes.

"Weeks later, the guys came down and they shot Arnold, re-creating his actions, with reflective balls attached to his body," Brevig explains. "He was a trooper, moving around on the stage, looking like a refugee from the Main Street Electrical Parade!

"When they finished shooting, we eagerly awaited the imagery," he continues. "When I went over to see what was happening, I found out that we were in trouble. It seemed that the motion images that they had captured were too complicated in nature. The computer couldn't keep track of the individual balls that Arnold had been wearing.

"I told them I had filmed the original action from cameras hidden behind the set, and that they could use that footage," says Brevig. The only way to save the sequence was to project that footage frame by frame on a video monitor and move the skeletons by hand – stop motion into the computer graphic program! They used an old Bob Abel and Associates rotoscope projector and a 10-year-old Evans and Sotherland™ monitor. Old equipment, but it worked!

"Although the rest of the effects relied on nondigital techniques, we really used every existing technique to create shots that were so visually convincing, audiences would not be able to tell how they were accomplished.

"One of my favorite shots appears to be filmed from a helicopter," he continues. "The shot starts on Arnold's face, looking out of the window of a speeding train. The camera pulls back to reveal that it is tracking with the train, as it speeds along on the surface of Mars.

"The camera continues to pull up and up, until the train is just a speck on the Martian landscape," says Brevig. "I felt that it was very important to make the shot appear to be one continuous pullback, to give the Martian landscape a sense of scale.

"No single model would allow us to start in tight enough to resolve one person's head and still be able to pull back and up several hundred feet, seeing all the way to the horizon.

"So, we made several models, in different scales, and disguised the handoffs between them. The first miniature was the train, which was about eight inches tall, and we could rear-project footage of Arnold, which I had shot in Mexico, into the window.

"As the train went briefly into a tunnel, we switched to a tiny one-inch model and followed it to reveal the Martian miniature landscape, which surrounded it. A matte painting filled in the sky, and various atmospheric elements were added on the optical printer as it was composited."

Brevig's favorite, and one of the most complex shots, in *Total Recall* is the climactic sequence where "Arnold goes into his mind and he regresses and has visions of flying through the cavernous center of the planet," Brevig explains. "We designed the sequence as a continuous shot, which would last over a minute and feel like a simulator ride at an amusement park.

"The shot is a study in using traditional techniques, but taking them a step further," he explains. "We filmed several pieces of the shot on full-size sets in Mexico and connected them and blended them together with wonderfully built miniatures, shot on a motion control back at Dream Quest.

"As the camera appears to career vertiginously throughout the underground cavern, it passes several groups of scientists and various control rooms, which were shot on full-size sets. I think when we were through, we had at least 40 or 50 elements blended together."

Having done a lot of work with projected images in 3-D and 2-D, Brevig was familiar with the complexities of making these complicated elements fit together. "We used an unusual technique to incorporate live action elements into the miniatures," he says.

"Instead of rear-projecting the elements into tiny flat screens in the model, which would have revealed the 2-D nature of those elements when the motion control camera moved, we front-projected them onto a three-dimensional surface. This gave us an apparent change in perspective, within the projected areas, which matched the camera's changing perspective.

"Of course, today we would do this with digital corner pinning," he adds. "But, that wasn't available then."

Brevig faced an additional glitch on these sequences. When the sets that would be shot against blue screen were designed, he was promised that there would be nothing in them that would be black or shiny – two surfaces that do nothing but reflect the blue screen. "Of course, when we got there, it was all black and shiny," he laughs. "So, the challenge was to find a way to work with what we had and establish a good look.

"We had no choice but to shoot," he continues. "When we got the footage back, it was unusable. It had nothing to do with the camera, but we hadn't been able to keep the blue from reflecting on the shiny surface."

Out of desperation, Brevig suggested they look at the levels of blue in the footage. His idea was to separate the intended blue screen from the unintended false colored reflections. "We then did garbage mattes to separate areas out," he explains. "Those areas became transparency windows. We then flashed the color of the Martian background in those areas."

Brevig's technique became the primary solution for all of the reflections on shiny objects in front of a blue screen throughout the film."

From Dream Quest, Eric Brevig moved to ILM. His next big challenge was the Spielberg blockbuster *Hook*.

"I sort of jumped into the fire, with the company's biggest client and a very splashy movie."

Brevig immediately tackled an emotion-filled flying sequence with Robin Williams as Peter Pan. "I tried to bring the magic of the original Disney animation to the 1991 live action footage," he says. "We relied on traditional techniques for most types of effects."

To capture the moments, Brevig and crew shot Williams against a blue screen with a specially mounted camera. "We had the camera mounted on various devices, from a gyrosphere to a cable-controlled flying rig made for actors. This allowed us to move the camera instead

of Robin Williams for most of the flying shots. By doing this, Robin was able to look (somewhat) comfortable and exhilarated, in his flying performance, without having to travel very far, while the camera actually did the flying.

"We then shot the rest of the sequences at ILM, with miniature fields of clouds – made out of fiber material and photographed with a motion control camera.

"We blended the whole thing together by adding in a few CG-generated clouds. These elements were fed into the computer and married."

Sounds simple, but the challenge came in creating the correct perspective for each element, deciding what to do in physical shots and what to do in computer, and finding a way to marry the elements with an appropriate background. "It was very difficult to track.

"The most difficult element to create, however, was the background image of Neverland. We knew that the island was too complex to be created as a wholly CG model, but with just a matte painting, we were missing the slight change in perspective that you see from a moving camera in the air," he says.

"We found the ideal solution was to create the island as a traditional matte painting and then scan the painting into the computer and map it onto a simplified CG model of the island shape. This gave us the gross three-dimensional changes in perspective that we needed, yet let us use all the fine details that a matte artist can paint into the image."

In 1994, Brevig became visual effects supervisor on a character-driven story of corporate corruption and personal manipulation, *Disclosure*. "There is one pivotal sequence in the movie that involves CG," he explains. "It is the sequence where Michael Douglas puts on the equipment to travel in a virtual reality world.

"I felt sorry for Michael. Because of time constraints, we had to shoot the sequence a week before principal photography began, so he didn't have any time to establish his character for the scene. We painted little 'x's' on his face (which were later painted out), so that we could add a CG virtual reality visor to it in post.

"What was worse for him was that we had to shoot in an empty blue screen stage at Warner – with no props or sets, only a few C-stands, and director Barry Levinson and myself telling him where to look and what to do.

"He was a real pro," Brevig continues. "We had a virtual reality visor with an 'x' on the face (which was later painted out). He would have to point at C-stands, as objects that would be on the screen. It was a test of his patience, and he really did great!"

Once the live action footage was done to Levinson's satisfaction, Brevig went off and built the virtual reality world – a world according to Michael Crichton's descriptive novel. "We asked ourselves, 'What would this fictional VR world be like, and how would the technology be designed?'

"In the story, Douglas's character walks through a great hall of libraries to find the critical piece of information he is seeking. So, we designed something that looked like a classical art museum, only there would be no limits to the size of it. Everywhere he walked, you would always see it forming up ahead of him, stretching out to infinity. It would, in reality, be extremely inconvenient to devise a software where you had to walk for miles just to look up a piece of information, but it looked great, visually!"

Several years later, Brevig's perfection of his talent with visual effects caught the attention of most moviegoing audiences – and several international award committees, including the British and American film academies. In 1997, Tommy Lee Jones proved he could be a great straight man for Will Smith's comedy – and *Men in Black* took over the box office.

"There were lots of different kinds of effects on this picture," Brevig recalls. "By the time we got good at one kind of sequence, we would have to move on to the next, which would require us to face a whole new set of challenges. We had everything from CG aliens running through the desert, to miniature pyrotechnic effects."

Ask Eric Brevig what sequences stick in his mind and he'll immediately land on the shots where a head is blown off and reformed, the supercar is driven through the tunnel, the saucer crash, in the meadow of the New York World's Fair, and the Edgar Bug fights.

"The shot of the alien man's head reforming is a good example of the state of the art in synthesizing a human character," he says. "Actor Tony Shaloub played a pawnbroker named Jeebs, whose head is blown off by Tommy Lee Jones's character, for refusing to answer his questions.

"While Will's character looks on in horror, the headless Jeebs stands back up while his head amazingly reforms, all in one continuous take. He complains about how much it stings!

"To create the illusion of his reforming head, we shot Shaloub rising up and delivering his line, arriving in the final position for the end of the shot. We then digitally erased the image of his head and replaced it with a series of CG models, which were constantly transforming from a tiny alien shrunken head to a synthesized likeness of Shaloub's own head. These models had to be painted and lit to exactly match Shaloub's filmed image so that we could invisibly switch to his filmed head at the end of the shot.

"It took four straight months of model design, animation, lighting, and filmed image to achieve what is on the screen for less than 10 seconds, but it was worth it because the transformation from talking CG head to photographic actor's performance is completely seamless, and a wonderful visual joke!"

At the other extreme of the effects spectrum is the sequence in which the **Men in Black**'s Ford LTD transforms into a rocket powered supercar while traveling through Manhattan's Midtown tunnel.

"After initial attempts to secure a real tunnel location for the sequence proved too costly, we built the tunnel as a miniature," says Brevig.

"It was filmed, one frame at a time, with a special motion control camera on a crane arm, which could move through the two-foot-tall tunnel set. We filled the tunnel with over 60 miniature cars and photographed two different takes for the tunnel backgrounds.

"The second take was lit only by special interactive lights, which traveled where the car would go and simulated the effects of the rocket's glow, lighting up the miniature cars and tunnel walls. These were combined to give a realistic look of the car's rocket engines, racing through the tunnel.

"The supercar, unlike the tunnel, never existed in reality," he continues. "It was built as a CG model, with over 500 moving parts, which actually could unfold from the Ford LTD shape into the super-car!

"We decided not to build a physical version of the car because we knew it would never be able to look as cool or move as perfectly if it were an actual prop. And, we would only have to match the flaws in our CG version if we did that. For this reason, it changes back to the real Ford at the end of the sequence.

"We filmed the actors in a mock-up of the car's front seat, in front of a blue screen. We photographed them as though they were

speeding along in the car, and the camera was on another car racing along in the tunnel next to them.

"We then analyzed the camera moves on the blue screen shots and animated the CG car around them, doing exactly the same motions.

"The final step was to composite them and their car, complete with blazing rocket engines, into the miniature tunnel.

"By contrast, we created the sequence in which the flying saucer crashes into the site of the 1964 World's Fair in New York's Flushing Meadows without the use of CG models at all.

"This sequence was accomplished as a 1/8-scale miniature, which was shot at ILM.

"A nine-foot saucer was built and rigged to crash at high speed into a miniature landscape of the Fair site, complete with pyrotechnic explosions. The ground was prepared to allow the saucer to plow up a giant wall of dirt as it dug its way toward where the *Men in Black* would be standing.

"We then shot Will and Tommy in front of a blue screen, with wind and dust blowing toward them from a matching camera angle, and composited them into the foreground. This gave the shot a great sense of scale, as well as becoming the iconic image of the *Men in Black*, as they stood their ground in the path of the oncoming giant saucer.

"The Edgar Bug fight at the end of the film required very sophisticated computer graphics and character animation," he adds.

"As we filmed the movie, we realized that we needed a more exciting confrontation between Will's character and Edgar, the giant bug-like alien who was the villain in the film.

"I knew that to allow us the most flexibility with the character, we would have to make Edgar Bug a completely animated CG character.

"With literally no time to properly plan the sequence, we met on the set at Sony Pictures in Los Angeles. Saturday, before we started filming the sequence, we choreographed the fight. Then we shot the scenes of Will shadowboxing a creature who wasn't there. The first unit traveled on to New York, but I stayed and directed the action coverage with the stunt doubles and the backgrounds, for the single shots of Edgar.

"In postproduction at ILM, we spent almost a year perfecting the computer graphics model of the giant alien, animating him and compositing him into the shots."

No wonder Eric Brevig was nominated for so many awards!

In late 1997, Brevig began working on the latest television series turned to feature – *The Wild Wild West*. "We're doing some interesting things," Brevig says, mysteriously.

Unfortunately, the studio (Warner Bros.) has put a gag order on any information about this latest project done in conjunction with ILM. So, the work has to be surrounded in mystery, until the movie is released – and the next *Art of Visual Effects* book is written.

"You have to be adaptable, to be able to design the resource to fit the storytelling requirement. It isn't about using the latest computers or sophisticated mechanical devices. It is about storytelling."

John

Dykstra

John Dykstra started out as a student of photography and industrial design. "Several of my friends in school were working for Doug Trumbull," he says. Dykstra got lucky and joined the group, destined to make their own mark in effects.

The first project Dykstra worked on at Trumbull Film Effects was *The Andromeda Strain*. But, it was the Trumbull-written feature **Silent Running** that really started Dykstra's creative bent toward effects.

Dykstra started working on a team designing the spaceship and robots for this picture. Trumbull wanted to create a robot that would leave people scratching their heads and asking, "Where did they get that robot?" He wanted a robot that could walk, not roll. At the time, there were no robotic devices that could balance themselves, let alone walk. He also wanted a shape for the robot that would obviously not be a 'man in a suit,' " Dykstra explains.

"Doug Trumbull is an innovator, ahead of his time," says Dykstra. "Doug's solution to the challenge was to use bilateral amputees. He contacted several organizations that worked with amputees and set up interviews. His concern was that the amputees would not feel as if this was exploitation. Doug offered them the opportunity to become actors and create the personalities of the robots. They responded very positively, and soon we had a team of fledgling actors working hard to become Huey, Dewy, and Louie.

"I had the opportunity to use my industrial design background as a contributor to the robot designs. Creating a 'face' was an important facet of the design," Dykstra explains. "We tried to give the robots eyes, noses, and mouths.

"Doug provided an environment where you could learn by doing. I got to work on the construction of the 'Valley Forge' spaceship miniature and the development of the actual robot costumes. We created light weight mock-ups of the robot costumes custom-designed to the individual actors. Because of their unique body mass configuration, the actors were capable of unusual gymnastic positions, and the costumes had to be configured to not limit their range of movement."

Trumbull had the actors wear the costumes for an extended period of time before the actual shooting began. This not only familiarized them with the costumes but also gave them time to develop a physical "body language" personality for each of the robot characters.

The finished costumes for the robots were built out of vacuumed-formed styrene plastic and painted to look like metal. "As it turns out our amputee actors brought much more to the robot characters than anyone expected," Dykstra explains. "They were a hell of a precursor to R2D2 and C3PO.

"As work progressed on *Silent Running*, Doug gave me the opportunity to use my photographic skills to shoot some of the miniature shots of the Valley Forge. Remember, this was pre-computers," Dykstra says. "No computer cameras allowed.

"Well, there were computers," he amends. "But they were these monstrous things that worked in machine language. Doug had one at the Canoga Park facility that was being used to manipulate a 2,000-line video system, but it was in early development and we didn't use it on *Silent Running*.

"With Doug, it wasn't so much an issue of what technology he could use, but the issue of what the story required," Dykstra explains. "That was one of the most important things that he taught me and probably one of the most important things about this business. You have to be adaptable, to be able to design the resource to fit the storytelling requirement. It isn't about using the latest computers or sophisticated mechanical devices. It is about storytelling."

Ask John Dykstra what his favorite shot in *Silent Running* is, and he'll immediately say the pod release. The domes are blown, and the audience sees a shot from inside and outside the tube as the latches pop open and the pod flies away from the camera. There is dust and debris floating in the zero gravity of space. "We had built a small scale

model of the Valley Forge, about 24 feet long," he explains. "The model was meant to represent a ship 2 or 3 miles long.

"We used that ship for all the wide shots of the Valley Forge. For the dome release shots, the dome and the mating tube for the domes were built in a much larger scale.

"The dome mating tube on the original model was about three inches in diameter. The scale model we built for the release detail was a foot in diameter. We built a mechanism, springs and cables, on tracks to one side of the tube and mounted the tracks so that the camera was looking up into the tube opening.

"Putting the camera on its back with the photographic subject directly above it was one part of creating a zero-g effect. When the mating tube blew apart, the dust and debris fell toward the camera as opposed to the bottom of the frame.

"We also photographed the pod action at 120 frames per second. The slow-motion movement of the miniature and the debris was the other part the zero-g effect.

"It wasn't very technical," he admits. "It was me, laying on the floor looking up through the camera and a couple of guys who would actually trigger all the events. On 'one' the pyro would be set off to represent the explosive bolts. On 'two' the air cylinders would be fired to open the claw devices. On 'four' the air lines that blew the dust would be turned on. On 'five' the long-duration flashbulbs would be triggered. And, lastly, the release that allowed the two tube segments to separate was triggered. The camera would roll up to speed. I'd go 'hit it' and they would count off one two three four five six, as they triggered each event in the sequence.

"We got to make a lot of stuff up as we went along," he admits. "We figured out flashbulbs would be a cool way to make bright lights. So, we found some flashbulbs that would burn for a long time. They would have a flickery white bright light, almost like an arc welder. It was a lot of guessing," Dykstra adds. "But that was half the fun of the film and of the time."

John Dykstra had his taste of movies and effects. The natural progression would be to make that his career. However, the industry was new, and he had a certain kind of knowledge that worked in the real world, as well. After *Silent Running*, he went to work at University of California, Berkeley, on a project called the Institute of Urban Regional Development, a study done on Marin County.

It was a project to determine whether or not architectural models could be photographed in a way that would be realistic enough to use them "to evaluate potential architectural alternatives," he explains.

"It was perfect for me – a psychological study of how people perceive reality as opposed to how they perceive reality when photographed on motion picture film versus how they perceive a miniature simulation of reality as photographed on motion picture film.

"We took a control group of people over a specific route and recorded their responses to what they saw. What buildings impressed them? Did they see landscaping? What made what they saw credible or not credible?

"We took a 16mm camera and drove the same route. We then showed the 16mm film to a separate group of people and asked them the same questions.

"Finally, we photographed a miniature of the same route as if we were driving the real route and showed that film to a third group. We asked the same questions of this group. We then compared results from the three groups.

"The result?" he laughs. "No one knows for sure.

"What did I learn? A lot about the inconsistency of phsychological research."

Dykstra also learned about using a computer to control a photographic environment. The computer was a PDP-11. It was big – 12 feet by 8 feet and 4 feet thick. "You didn't just turn it on," he says. "You had to put in a binary bootstrap, which means you had to put in a code address on a series of toggle switches to even start the machine. It was a very complex system, and things would regularly go awry.

"That's how I came to know Al Miller and Jerry Jeffers. This was the beginning of the legendary ILM team. These were the guys who came to Los Angeles to help me set up the fledgling Industrial Light and Magic tech group," Dykstra explains.

With their help, Dykstra was able to take the camera match move concept that Doug Trumbull began so elegantly on *2001* and refine it to a technique that came to be known as motion control.

"I thought we could improve the match move concept," he explains. "The old system used one motor over here, another motor over there, all synchronized to a main drive motor. The moves couldn't be memorized. As a result, once you made a setup, you couldn't move anything until you shot all the elements for that shot.

"From my experience in Berkeley, I got the idea that somehow we could build a system that was modular. We could record separate axes, and drive those axes back individually. Using microprocessors, we could vary the speeds of the various channels relative to one another, ramp speeds on individual channels up and down and synchronize all of those motions to camera frame count and speed.

"We could record, store, and edit that information. This was a design for a system that would allow us to do production line work, rather than tie up a stage for two weeks on a single shot. Because we were able to store the information about camera moves and subject moves and then recover that information at will, we could use one stage and motion control system to work on several shots simultaneously.

"For *Star Wars*, we could do all the X-Wings for four different shots, then do all the Tie-Ships for those same four shots, and then do all the stars, planets, and other elements for the same four shots. This technique allowed us to do four shots in the time it used to take to do one shot of similar complexity. This fourfold increase in efficiency made it practical to do 240 shots in a year's time.

"My experience on S*tar Wars* started with a meeting with George Lucas and Gary Kurtz in a bungalow at Universal Studios," Dykstra explains. "George explained what he wanted conceptually for the film. We spent some time waving our hands through the air as if they were dogfighting spaceships.

"In pilot lingo this was known as 'hand flying.' George specifically wanted 'gun camera' points of view. The gun camera is the camera that is mounted next to the gun in a fighter plane that runs whenever the gun is being fired," he explains.

"This point of view is to confirm shoot downs.

"As a result, the camera is constantly moving, as are all the subjects within the frame. Every shot was to be a complex, moving camera, traveling matte composite. I felt that to make this revolutionary kind of film possible, we would have to abandon conventional wisdom and invent a new effects studio from top to bottom.

"I knew that we would be taking some risks, but my inexperience thankfully kept me from realizing how many risks until we were past the point of no return.

"Sitting in that same office, I started calling the people who would become the core ILM crew. Al Miller and Jerry Jeffers had done a couple of things with me for Doug (Trumbull) at Future General

when I returned from Berkeley. Bill Shourt, Grant McCune, Dick Alexander, Bob Shepherd, Doug Smith and Don Trumbull (Doug's father) all came out of relationships developed at Doug's facility. Richard Edlund came out of Bob Abel. Robbie Blaylak was developing new optical printing techniques. Dennis Muren was a burgeoning 3-D stop motion cameraman. Jim Nelson was given the unenviable task of production managing this unlikely crew.

"With the exception of Don and Jim, we were all in our early to mid twenties – when we walked into that empty warehouse, ready to try something that no one had tried before. I'm sure that there were plenty of old hands telling George that he was crazy to make this film. If it wasn't for George Lucas's vision and faith, we would have never found the backing to make what was to be our contribution to George's wonderful movie.

"We had a great advantage," Dykstra admits. "We were approaching this thing at a time when most of the cameras in use were designed before we were born. Most of them still used mechanical footage counters. The idea of high technology and sophisticated electronic controls for cameras was not yet evolving.

"When we began to build the facility that would be used to produce the effects for *Star Wars* we needed a name that had some cachet but, would not attract a lot of attention. Because we were in an industrial area near the airport, we decided that the place should have industrial in the name we were acquiring all sorts of photographic lights for stages, and obviously what we were going to produce was going to be magic.

"Or, maybe we were going to need a lot of magic to pull the whole thing off, I'm not sure which," he laughs. "Industrial Light and Magic was born.

"We began scavenging technology from all sorts of other applications in industry. We needed to figure out how to produce 200 plus traveling matte shots in about a year and a half. The techniques that existed at the time could not have produced shots of this complexity in any time frame. So, we were going to have to invent a new miniature photography system from the ground up.

"We had to build models in a small scale that would allow us to get huge size changes on a limited-size stage. Those models had to have detail accurate enough for us to enlarge 3 inches of model to fill a 50-foot motion picture screen.

"We had to use optical printers to combine separate pieces of film into a single shot using traveling matte, blue screen technology because there was not enough time to have a camera and stage dedicated to a single shot for two or three weeks.

"We had to improve the existing blue screen technology to allow us to shoot high-speed photography against blue. We had to design and build a camera system, both mechanics and electronics, that could make precision repeatable moves and that was easily programmed.

"The camera system had to use larger-than-conventional-format film to allow for the quality loss in the optical composite step. The camera had to be small enough to get close to our very small scale miniatures and had to have a tilting lens board for adjusting depth-of-focus on these same small models.

"We had to commit to all these ideas at the same time and begin building all elements at the same time. If any part did not work, the entire system would fail. I guess in retrospect that the M in ILM was really the 'Miracle' that it was going to take to save us from certain disaster."

John Dykstra admits that the crew was strange by business standards. "I think you would call us obsessed," he laughs. "From the very beginning, we sort of had this reputation.

"I remember, we were working in a warehouse in Van Nuys, California. We had no air conditioning, and during the day it was hot outside and even hotter inside that warehouse. We spent a lot of time in the redwood hot tub filled with cold water that we had under a tree in the parking lot.

"When the studio people came to visit and found us in the tub during the day, that was not well received," he laughs. "They were pouring their money in there, and all we had to show them was a bunch of wires, some aluminum pieces, and a couch, most often occupied by my dog.

"From their point of view, this was nuts, and at one point we were known as the 'country club' because they would find us in the tub during the day. In fact, I understand their anxiety. All the elements were being created at the same time, so they were spending most of the money before there was a single part complete.

"I don't think any of the studio people really understood what we were doing after we were finished, which made it highly unlikely that they could take any solace from any of the work in progress. I think that, in a perverse way, they liked the fact that we were

unconventional. It meant that one way or the other they were going to get 'something unlike what they had ever seen before.'

"The truth of the matter was that we were all obsessed," he admits. "If they had shown up in the middle of the night, they would have found everyone working wildly away through the cool early hours of the morning.

"It took nine months to build everything for **Star Wars** – the cameras, motion control systems, the models, blue screens, and optical printers."

The first real element John Dykstra remembers shooting was the Star Destroyer. This was the smallest model they built. And, the simplest thing to do – the opening shot.

"This element was the kind of work that was going to become the signature of the **Star Wars** series," he says, getting serious.

"Conventional techniques would not allow us to use the three foot-long miniature of the Star Destroyer for close-up photography.

"Our very small camera and our tilting the lens board and very slow photographic rate allowed us to adjust our field of focus and get amazingly close to the three-foot Star Destroyer model.

"The detail on the miniature looked good on screen.

"Another test of the motion control idea was when we discovered that we had to shoot a separate pass on the Star Destroyer to record the engine lights. The camera had to run at a drastically different speed because of the exposure needed. I remember looking at the first double pass test. It fit perfectly. It looked like this mad motion control idea might just work."

For Dykstra, the gun camera epic, as he calls it, was the most challenging sequence because the camera was constantly moving. "There was never a static camera in any of the shots," he recalls. "We were constantly pressing the limits of the movement of the motion control system and model.

"These were the shots that George used to define the dogfight sequence above the Death Star," he explains. "Gun camera shots from actual fighter aircraft and action sequences from such already released films as *Tora, Tora, Tora* and the *Dam Busters* served as reference footage for the visual effects crew.

"Because the cameras were moving so fast, one of the biggest challenges was motion blur.

"A big difference between our approach to photography of the miniatures and existing stop motion technique was that we moved the

camera during exposure. Conventional stop motion of objects moving this fast would have strobed. Our motion control system moved while the shutter was open. As a result, even the very fast-moving fighters had a smooth motion on the big screen.

"Not many people were using optical printers extensively, at that time," he continues. "They were used mostly for title work and on a very limited basis for traveling matte photography.

"Now that we had cracked the original photography portion of the work, we had to prove the concept that these individual elements of film, each with a spaceship, stars, or a planet, could be combined into a believable final shot.

"VistaVision™ was the large format that we had chosen to give us a larger original negative. It was horizontal 35mm film that moveshorizontally through the camera. Optical printing involved projecting the original negative through lenses onto a new piece of film. This process results in a dupe negative.

"The dupe negative was lower-resolution and higher-contrast than the original negative. As a result, optical shots, as they were then called looked different from the original photography that they were intercut with. The larger VistaVision™ negative made our optical shots look almost as good as the original live action shots in the sequence. We had to develop VistaVision™ printers.

"The projectors, the cameras, and the electronics to run them were constructed or adapted from existing equipment to suit our special needs. In some cases, they had to run as many as 60 or more pieces of film through the printer to make the single negative that finally was cut into the film.

"Part of the success of the composite or optical shots was the custom blue screens that we developed. Traditionally blue screens had been lit with incandescent lights. But even for 24-frame-per-second photography, these screens suffered from contamination of the blue from the red and green light that was in the lamps used to light them.

"Because we needed to do high-speed photography, we needed to boost the brightness of our screens by 400 percent, and because we had motion blur where the red and green contamination was a big problem, we developed fluorescent bulbs that emitted only blue light. These screens were also special because they used high-frequency ballast that eliminated fluorescent flicker.

"The models built for **Star Wars** were unique not only in their size and level of detail but also in their construction techniques. The

model shop made extensive use of multipart molds and even injection molding to produce the large number of ships that were used on the motion control stages. We also exploded quite a few of each. The moulding technique made it possible to maintain the high level of detail needed without having to spend hours of handwork finishing the models.

"Hundreds of shots, in a limited period of time . . .

"Sounds labor-intensive, yes. But, at the time of the birth of *Star Wars*, it was revolutionary."

So revolutionary, that it won John Dykstra, John Stears, Richard Edlund, Grant McCune, and Robert Blaylac a 1977 Academy Award for *Star Wars*. It also won him (along with Alvah J. Miller and Jerry Jeffress) a Scientific and Engineering Award for what came to be known as the Dykstraflex camera and the Electronic Motion control System.

John Dykstra gave the industry the motion control camera. Instead of having to move the model through space, the camera, mounted on a precise, programmable platform, could move in virtually any direction with film running through the camera at any speed. The motion could now be created by the camera instead of the ship or other elements.

Dykstra's next challenge was, of all things, bringing the effects world to television with the groundbreaking *Battle Star Galactica*, from his newly formed company, Apogee. "We went into this with the idea of bringing some of the technology to the small screen, of doing things that would hold up, only on the small screen.

"Television doesn't fill your field of view," he explains. "If you want something to have impact, to feel as though it's coming close to you or give you a sense of scale, you have to make it really big on the small screen. Movement is exaggerated. Objects that read well on television are out of proportion on the big screen and vice versa. You have to make big stars for them to show up on television, but put them on the big screen, and they look like tennis balls."

With *Galactica*, Dykstra and team tried to do something different. "We wanted to create a library of motion control elements that could be recomposited and used to make new shots for subsequent episodes.

"We also tried to come up with some new story technology – the launch tube for fighter ships, the robot dog that was actually a chimp in

a robot dog suit, and a new laser gun effect, replacing animation with a strobe lamp that was built into the prop that was used onstage.

"We used electronics to provide a flash that is synchronous with the camera," he explains. "Originally, our concept had been to add an electron pulse using animation, but using filtration we found that we liked the raw lens flare better. "What we came up with, in conjunction with the sound of laser fire, worked out well."

The strides John Dykstra and team made in this television series won Apogee an Emmy for their work.

In the next few years, the team went to work on *Star Trek: The Movie*, which won an Academy Award nomination for Dykstra, Douglas Trumbull, Richard Yuricich, Robert Swarthe, David K. Stewart, and Grant McCune.

Ask John Dykstra about other movies in his long career in the industry, and he will skip a few years and land on the **Batman** series of features.

"We worked on lots of movies in the intervening years and developed lots of new film techniques, but the real breakthrough came when the computer was actually able to create photo-realistic images from whole cloth."

In the **Batman** films (**Batman & Robin** in 1997 and **Batman Forever** in 1995), Dykstra's team also introduced CG **Batman** figures. "The first time was the shot where **Batman** leapt from the balcony of a hotel and fell 60 stories into a construction site, literally through a manhole," he says.

"It was a pretty good shot. It was generated using a motion capture system. I took a gymnast performing on a set of rings. He had points defined on him that allowed us to track the motion of each segment and joint in his body. An image of the points was recorded by a multicamera video system and interpreted by a computer. Those points then allowed us to animate a figure sculpted to match Val Kilmer in the Batsuit.

"The people at Pacific Data Images edited the motion, added some animation, modeled the figure in motion, then lit the computer-generated figure to match the background, and finally composited the character into the background. The background was also computer-generated by the folks at Warner Digital. Several vendors worked on this shot."

It was probably the most challenging shot in the film.

In **Batman & Robin**, Dykstra picked up where **Batman Forever** left off. "In **Batman & Robin**, we did the majority of the skyboarding sequence with Batman and Robin riding the escape doors from the rocket down to the ground. Except for a couple of close-ups, all the shots of Batman and Robin were CG.

"We had originally considered trying to do some of this sky-board stuff as a stunt," he explains. "We went to the vertical wind tunnel in Las Vegas to test our theories. We found that when you tied a cape around the stuntman's neck ,it created so much drag that it would choke him.

"Again, we used motion capture to give us the basic body motions. We had the good fortune to gain access to the Golden Knights vertical wind tunnel. Our stunt man/professional sky boarder wore the same reference dots on his body as he performed the maneuvers that we wanted our heroes to perform.

"We again worked with PDI. The moves were edited together and modeled using George Clooney's and Chris O'Donnell's bodies lastly the capes were added and the figures were composited over a matte painting of Gotham."

Another of John Dykstra's favorite shots in **Batman & Robin** was the destruction of the Planetarium. "This was done with very large models," he explains.

"The model of the Planetarium was 45 feet above the ground. The model of the dome of the Planetarium was 15 feet in diameter.

"We used over 130 charges to produce the destruction. Each charge had to be synchronized, very specifically, to one another in order to produce the sense of the building collapsing on itself.

"Just like the demolition charges that they use to drop an abandoned building into itself, each of our charges had a specific job. Some of the charges actually cut structural members, while others blew lightbulbs out. Still other charges blew debris out the windows.

"As large as our models were, we still needed high-speed photography to create the proper scale for the building. Miniature explosion sequences are some of the most fun things that we get to do in the visual effects world.

"Another fun sequence was when the Batmobile and the Freezemobile leap through the neck of the statue," he says. "The models of the car were six feet long. They were launched with air rams. The pyro had to be precisely timed to open the hole in the side of the

statue model to allow the Freezemobile to pass through. Again a high frame rate gave us the sense of scale," Dykstra explains.

"The Batmobile was one of the most complex miniatures I've ever been involved with. It had its own rocket engines. The colored flames that came out of the back of the car were fueled by gas cylinders and valves carried in the radio control model. It had a spinning engine detail, just like the big car. It also had the lit wheel covers, and an animatronic figure at the wheel whose movements were geared to the steering wheel.

"It was a quite sophisticated model," he says proudly.

It is his knowledge of miniatures that helps John Dykstra do what he does in the computer world. "I still love miniature photography," he says. "You get the texture, detail, and most importantly the aging and dirt all built in. There is a wonderful marriage between computer imaging and miniatures – previsualization.

"In the case of *Batman*, the production designer created the design for Gotham City in a computer. Then, with the version of the city in the computer, I could then design the shots in this virtual world where I could move a building at the touch of a keyboard. What this meant to me was the ability to try 10 or 15 different camera moves and different building configurations per shot.

"Before this pre-vis technique, I might get to try two maybe three different variations of a shot layout before I had to commit. Iterations are the key to quality work, and pre-vis on the computer is truly a breakthrough tool.

"We then took the plans for the miniature construction directly out of the computer.

"We knew what models were going to be seen close up and what models were only going to be background. We knew what configurations of the model city were going to be needed and when."

John Dykstra's work has really come a long way since the hot tub days in Van Nuys. As excited as he was doing the *Batman* series, it is nothing compared to the latest incarnation of his work. In 1999 Columbia Pictures will release a live action version of the classic children's book *Stuart Little*, featuring the work of the artists and engineers at Sony Pictures Imageworks.

"I came to this project as a bit of a skeptic," Dykstra admits. "I wasn't sure we were going to be able to produce a realistic character, an animal with fur. I was concerned about the possibility of a near miss, a character that turns out *almost* real.

"But with any movie that is going to be cutting edge, you have to take risks," he adds. "You have to set out to do things you are not certain you can achieve. Creating a mouse with fur and wearing clothing is a challenge."

A challenge that the team at Imageworks is making work.

"When you see this guy on the screen, you are really going to believe that we shot a real mouse. He is a dramatic character that is pivotal to the story. He is the protagonist, no doubt. When people see the first finished shots, even the men can't help but go 'ahhhhh, isn't he cute.' "

The character creators, under the direction of animation director Henry Anderson, are delivering a consistent personality. "In the beginning, I wasn't sure that several people, even working closely together, could get the performance consistency that makes Stuart real," Dykstra admits.

"Now that we've had a little more time to work on *Stuart Little*, I'm finding that the process has become, as with all processes, more mature; we are much more able to dictate to it. This flexibility is critical, and Stuart is truly coming to life before our eyes."

It was a daring move on John Dykstra and director Rob Minkoff's part to go digital and not animatronic for *Stuart Little*. "There are a very limited amount of things that you can do with animatronic characters," Dykstra says, "especially the size of *Stuart Little*. They are good for some things. But we're getting a range of personality and body language out of this character that would not be achievable with animatronics.

"Obviously, everything starts with the concept that is taken from the script," he adds.

One sequence that fascinates Dykstra, and shows just how far the computer world has come, is when Stuart mimics George. "In this sequence, the two characters wake up early," he explains. "They struggle their way, sleepily, down the hall to the bathroom, and George goes to the sink, to do his morning ablutions.

"Stuart climbs a small ladder up onto a footstool, right next to George and begins to copy George's actions.

"They go through a sequence of events, staring in the mirror, kind of looking at themselves, ruffling their hair, brushing their teeth, gargling. The kind of things that kids and mice do early in the morning."

Dykstra and team started with the premise that Stuart will mimic George. First discussions were about the design of the bathroom. What kind of place is this going to happen in? "We determined, of course, that there would be a mirror over the sink, so it would seem appropriate that Stuart would have an environment similar to George's and have a mirror over his sink.

"We discussed all kinds of things to simulate that sink. Would it be a cup, a thimble? Eventually, we decided on a small dollhouse sink because it seemed a more appropriate thing. It was a more immediate read.

"The design of the set, to a certain extent, dictated what the action was. That set design is interpreted into storyboards, which really specify the action, the number of shots, the angles that those shots are seen from, and the specific things that happen in the shot.

"So, we have now, by our design, George at the full size sink in the bathroom, and next to it the footstool, and on that footstool a miniature sink with a miniature mirror. So, we have duplicate environments for our two characters.

"The components are the live action environment and the scene in which George and Stuart enter the bathroom (a full-size set with Jonathan coming in), being photographed by a regular camera and a regular motion picture crew.

"On the set, there was no Stuart," Dykstra explains. "He is added in the digital world. During the live action shooting, a small miniature of Stuart is animated through the scene. He is moved through the scene in the position, direction, and speed that he will go when he is animated.

"Once we photograph the scene, the editor will then select the take he likes, the one where Jonathan does his best performance, and we do what is called a match move, which allows us to literally construct a complete frame of reference for all of the camera movements in the scene.

"In order to put our digital character in, since he is made from whole cloth and placed into the scene, we have to be able to duplicate the camera motions so that when we electronically photograph our character, he fits exactly into the same space.

"Measurements were made of the set when we did the original photography, specific geometry, things like the squares in the tiles in the floor, the corner of the sink, the edges of the mirror. Things that were very specifically visual cues were measured in the real world. The

squares were eight-inch squares. The mirror was three feet above the floor. The corners were two feet six inches apart. Whatever.

"Now, armed with that original information about the set and the digital copy of the negative, the match mover sits down and creates a virtual version of the set. Now, it is not fully detailed. It is a very simple geometric rendition of the environment."

Why is this necessary?

"Our character, *Stuart Little*, is a computer-generated character who is going to walk on the real floor. He has to interact with the real stool that is in the set. He has to walk up to and interact with the real sink that is in the set. So, we create those in computer form."

To achieve Stuart's performance, Dykstra works closely with animation director Henry Anderson and a talented group of digital artists supervised by Imageworks visual effects supervisor Jerome Chen.

"The animation director sits down and talks with Rob, and they decide what the character must do and say. The animators are like actors; they give Stuart his personality.

"The elements of this are, to a certain extent, also defined by what the character is interacting with. Things like the floor and the sink, which are fixed in the real world, are pretty easy for CG characters to interact with, because they don't really have to move them.

"Things like the ladder that he climbs and the toothbrush he uses to brush his teeth are CG rather than real props, which they used in *Roger Rabbit* (where they took real things and put them on sticks and then animated the character's hands to match). We are generating those objects from scratch.

"The reason that we make these objects CG is to allow the animators to create the personality of the character without being tied to movement that is built into the original photography. Stuart's foot is going to step on the rung of the ladder, and the ladder wants to bounce a little bit as he walks up it. The pace that he climbs the ladder and how he heavily he steps can be determined first, and because we are building the ladder, we can animate that to match the moves the mouse makes.

"The toothbrush also became a computer-generated object because he has to hold it in his hand and he has to brush it against his teeth. There was no real sensible way to make a mechanical version that would react in the way it needs to react because when we were

doing the shot, we weren't even sure what Stuart's teeth were going to look like. So, we decided that we were going to make the toothbrush also from whole cloth as well as the water that sprays out of his mouth, etc.

"Those elements, the original photography plates of the background, the CG version of Stuart, and all the objects with which he interfaces are then composited into the scene as an electronic file. This is then scanned out to final negative and it becomes part of the movie.

"It takes weeks from the rough character against a background plate to a full-fledged character with fur and cloth and a complete range of emotion, expression, and vocabulary. It's all about convincingly integrating the character into the environment and the clothes and the real world.

"The thing that is so exciting to me about the industry right now is that I have been forced to become a student again," Dykstra says. "When I started doing the work that we did for the *Batman* films, we relied more heavily on the computer than we relied on our more traditional techniques. I became a student then.

"I became even more of a student when I embarked on this voyage at Imageworks. The creation of this character for the *Stuart Little* film and the things that I discovered are twofold.

"One is that, in fact, my feeling that I was going to have to become a student was heavily reinforced because I have the same feeling today that I did when we were working on *Star Wars*. We're taking enormous risks on things that have (at this point) never been done before.

"Also, there is a real reward in always being a student. That is, when we set out to create fur and clothing for this character from whole cloth, we hadn't expected the success we have had. It is the kind of reinforcement you need, so that you continue to be seduced into these extreme risks because the reward is so pleasant.

"It is not only pleasant for us but for the people who will see the picture."

"There is something about serendipity and the 'happy accident' that you can't get on a computer," he says. "Animation is great, but the computer is very precise. Every result must be thought of and programmed. It is often that unexpected happenstance that makes the shot real, and organic, and truly satisfying."

Richard Edlund

Richard Edlund's first photographic adventure was with a spy camera – not the vast adventure projects of today, but little candid pictures taken with a Minox™ in junior high school. "A friend's father was the distributor for Minox™," Edlund explains. "He lent me a camera and I shot a roll at school one day. Miraculously most of the pictures came out and when I saw what I'd captured, I was hooked."

Who knew that this interest in art, gadgets, and technology would lead to one of the most prolific careers in movie visual effects – and four Academy Awards as well as six more nominations?

"I wanted to become a photojournalist," he shrugs. "Then, when I joined the Navy, I was lucky enough to be stationed in Japan. The Fleet Air Photo Lab which serviced the 7th Fleet, had every kind of photographic paraphernalia I could imagine – press cameras, aerial cameras, a photostat camera, even an 11 by 14 Deardorff studio view camera. Then I discovered a brand new 16mm Mitchell stashed away in the camera storage room!"

He then found the only book on movies – *A Grammar of the Film*, Raymond Spottiswoode's 1935 intellectual treatise on the silent film – at the base library. Edlund rooted around and found an old 16mm processing machine, which he rebuilt, and that was the start of

the motion picture division in the lab, which had a staff of about 40 people.

Edlund began shooting training films, but in the low-camera, wide-angle-Orson Welles style with sketchy Greg Toland lighting. This hooked him on making moving pictures.

While in Japan, a full-blooded Cherokee – marine staff sergeant – suggested he go to the USC School of Cinema. When he was discharged, that is where he went, registering for night school. Three years of school packed into two stretched on. Working as a truck body designer by day, Edlund then decided to try to get into the business. He bloodied his knuckles on the doors of the studios, only to hear the catch-22: We can't hire you unless you're in the union. When he went to the union to seek entry: You can't get in unless you have industry experience.

Edlund left his résumé at the Department of Employment and moved to Hollywood. By a quirk of fate, Joe Westheimer called the Employment Department and they gave him the résumé. Joe offered Edlund a job at his optical house that specialized in titles, inserts, and optical effects for television shows and features.

Edlund was on his way doing hand lettering for television, titles like *Burke's Law, The Big Valley,* and *The Patty Duke Show*, lighting and rigging and shooting, making lab runs and sweeping up, too.

"We also did inserts and special shots for features, so I got to work with top Hollywood heyday cameramen like Ernie Haller, ASC (*Gone With the Wind, God's Little Acre*), Hal Mohr, ASC (*Watch on the Rhine, The Wild One*), and James Wong Howe, ASC (*The Rose Tattoo, The Old Man and the Sea*)," he adds.

"Our commercial work was booming as well. We did the *Gillette* marching blades campaign, the *Hunt's* tomato dropping in the catsup bottle, and all sorts of effects. The marching blades were front-and-backlit blades that had to be lit very carefully. We created many 'beauty' product tag shots for commercials. Joe Westheimer was a master at this kind of lighting, and as my mentor he gave me so much knowledge."

Edlund learned a lot about effects during his four and a half years with Westheimer. However, that time ended and he became a working hippy – a rock and roll photographer, shooting album covers and song films (precursors to music videos). He began to develop a reputation in this area, shooting *The 5th Dimension, The Association, The Grass Roots, The Ventures, Seals & Crofts,* and many more. "I was

set up to do a film on *Jimi Hendrix* at the time he died," Edlund says, sadly.

While shooting rock and roll, Edlund became interested in music. With a partner, he developed the "Pignose," a small, portable battery-powered guitar amplifier that is still made today. It was an interesting sideline, but his focus was still on photography. "The world of business and lawyers and contracts was interesting and educational, but I was mainly interested in photography and film," he says.

"After that sideline, I met Bob Abel, Con Pederson, and Richard Taylor and got into animated graphics," he says. Edlund began developing a photographic look based on an early motion control system using teletype machines with typed-in-on-punch-tape mathematical programs. "We produced Clio winning commercials, such as the Uncola campaign and *7up* 'Bubbles,' that way," he recalls.

"We had developed a particular look to our spots," he says. "It was dubbed 'candy apple neon' by Abel. I would get an idea and shoot a wedge, and Bob would grab it, fly to New York with it, and sell a whole campaign. Now, we had to figure out how to do it in motion. We would then produce backlit artwork that would be multiple-layered, with highlights and outline. This gave form to the letters, which were later photographed with various doo-dads, diffusion filters, and color defraction.

"We used all kinds of devices that I could find at C&H Sales, a technology surplus store in Pasadena. This was a shopping mart for ideas – you could get every kind of electronic stuff, prisms, gears, anything."

Using a Mitchell rack-over, a single lens, and a 14-foot track, Edlund would set up c-clamped rigs to get the shot, often bi-packing the film, even taking the latent negative from one camera to another for special passes. "We'd come up with incredibly complicated shots that took 80 to 100 passes through the camera, but for quality it was all on original negative – no dupes.

"Once it was all set up and ready to shoot, all the lights went out except for pinpoints of light coming through the backlit art. It was like being in a sensory deprivation chamber," he says. "At times, being somewhat absentminded, I would forget where I was and even if I had shot the last frame or not.

"Bob finally agreed to hire an assistant who could keep presence of mind during those sometimes 18-to-20-hour shoots and never make a mistake – a godsend."

Edlund located a VistaVision™ printer from Howard Anderson's company and suggested that Abel buy it. He was even willing to throw in several other VistaVision™ cameras. Lying dormant since its last use on *The Ten Commandments*, Anderson was willing to sell all this equipment cheap. Edlund's theory was that "by using VistaVision™ (a format with twice the image area of standard 35mm), we could shoot many individual elements and composite them without generation loss – infinitely increasing our horizon of capability." However, Abel was not interested in pursuing the idea.

"About this time I heard about a film called **Star Wars**," says Edlund. "John Dykstra and Gary Kurtz, the producer, offered me the post of director of photography of what was to become Industrial Light and Magic.

"I had seen *THX 1138* and *American Graffiti*," he explains. "And, I read the script for **Star Wars**. I wanted to do feature film work and effects, so I jumped at the chance to sign on for the project.

"I first thought it was a 'teenage' script. But later on when George cast Alec Guiness for the role of Obi-Wan Kenobi, I knew in my heart that we would ultimately 'unseat the shark' – *Jaws* – from its throne as top-grossing movie of all time."

It took Dykstra, Edlund, and the rest of the team almost a year to build up the studio in Van Nuys. "It was an incredible period of invention. We had real money to do this work, so I could design a photographic system that previously I could only dream of. I worked on a four-by-five yellow pad, creating sketches of ideas from which Don Trumbull would work out engineering drawings that we'd see a few days later."

Executives at the parent studio, Fox, were getting nervous. Who are these people and what are they doing? Close to a million dollars had been spent, and there wasn't a frame of film yet to show. "We finally got it all humming, and the late Linwood Dunn, ASC (1904 – 1998), came out to the facility with his partner Cecil Love, to check us out. John and I gave them a tour and demonstrated the newly invented motion control cameras, VistaVision™ printers, and DC fluorescent blue screens to them. They were duly impressed.

"Lin gave us sage advice, and they gave a good report to Fox management."

During all this prep, the first unit was shooting near London at EMI Elstree Studios. "At first, Gary and George wanted to do all the cockpit action battle scenes with front projection," Edlund says. "I tried

to talk them out of it. Tommy Howard had his rear projection equipment in England, with the rest of the company, and I was convinced they wouldn't get the extremely short composite shots of background action in acceptable sync with actors' reactions."

Edlund's plea to them was to cover themselves by putting a blue filter in the projector and shoot extra takes of the foreground action with a blue background. "We could then matte whatever we wanted into the shots," he explains. "That frustrated George," he continues. "All he would see in dailies was the acting, and an otherwise useless blue background. What if the composites weren't be good?"

But, Edlund was confident that it would work.

The front projection idea was abandoned for the reasons Edlund had warned about, and soon he was on his way to England to supervise the shooting of the plates against a huge blue screen lit with 50 arc lights – during the worst heat wave to hit England since they began to record temperatures. "It was 106 in London!" he recalls.

As it turned out, many of the cockpit scenes were extremely short, some only 16 to 30 frames in length and the background action could be slipped a frame or two to get the desired match.

"I remember when George came back from shooting *Star Wars* in England. It had just about killed him," Edlund relates. "He told me he started out wanting to be the captain of his ship but instead wound up as admiral of the fleet. He rued the idea of losing control of the fine details. But the first unit production was now in the can, except for the famous cantina scene for which many of the shots were done back in the USA – with monsters and characters done for the most part by Phil Tippett and Jon Berg.

"ILM was humming with activity, and it was time for George to spend a week with me so I could work with him and explain the extremely facile yet lugubrious and complex system we had built to get him the shots he needed – so he could know its capabilities and limitations.

"It was necessary to develop a language to communicate the progress of the work in specifics," Edlund goes on. "Since George would be editing the movie up in Marin County, we could only talk on the phone. So, I developed a 22-field grid system. This was common to all of our cameras, animation and rotoscope systems, and printers.

"George spent about a week on the ILM motion control stage, and I would set up a shot (based on the storyboards and the16mm film he had provided that had WW II footage from films like the Battle of

Britain, which displayed the desired action) and then proceed to program the camera, axis by axis, until it seemed ready. I would then shoot a test on black-and-white film.

"I'd installed a little processing machine, the 'Prostar,' so we could save time on such tests – it only took about 15 minutes to have the shot ready to look at in negative form on our custom-built VV viewer. George could see the shot; we could then discuss it, make changes, and reshoot the test right away. Soon we were speaking '*Star Wars*-ese' and on our way to shoot the thousands of elements necessary to composite the required 365 visual effects shots."

Ask Richard Edlund about the most challenging shots on the first *Star Wars*, and he'll immediately go to the opening shot. "George kept talking about building a 50-foot model on the wall, and running the camera right next to it. Keep in mind that the secret of producing 365 complex composites for *Star Wars* lies in the use of extremely small models -the X-wings were less than a foot and a half long - and the speed at which they could be set up and shot," he recalls.

"We had only two motion control rigs. The 'Dykstraflex,' a boom camera with follow-focus and tilting lens board, and the 'trojan helmet' under-slung camera gear head of my design on a 42-foot track, was our main camera unit. An old modified Technirama eight-perf camera, with a huge pan-tilt head and follow-focus on a 14-foot track, was used for shots with less demanding action.

"We got to a point that there wasn't enough time or money to do the huge model, furthermore, the 42-foot track we had wasn't long enough to shoot such a model. We had a 4-foot long *Star Destroyer* available that was finished on one side, intended for long shots. Grant McCune made a tiny 2 ½-inch *Rebel Blockade* runner and I hung it out in front of the model on a paper clip."

To test the feasibility of this approach, Edlund created a test shot. "With the model upside down, I could use the tilting lens mount to maintain focus with the 24mm Nikkor lens that was almost scraping the surface," he explains. "The model needed to be detailed to an extreme since, for example, the launch bay at about its center would fill the screen yet was only about four inches square!

"The next day we were all collectively awed by the shot in dailies and breathed sighs of relief – George was happy with it, and our last big problem was solved."

The shot worked. From the opening frame, the audience was hooked and so were Academy members. Edlund, Dykstra, Grant

McCune, John Stears, and Robert Blalack won an Academy Award for Visual Effects for the 1977 blockbuster.

Once the new effects company finished *Star Wars*, they had a crack team of wizards put together. They began to look for another project to do. Soon, television producer Glenn Larson came along with a series of three 2-hour television projects, under the umbrella of *Battlestar Galactica*.

"When we were doing *Star Wars*, George Lucas was focused on very specific shots," says Edlund. "When Glenn came to us, it was more like, 'Here's the script; figure out the shots.' We would have total freedom to do what we wanted. This included flying dogfights and a mass of new problems to solve, including one 'snow planet,' which came in the second episode, a near copy of the legendary WW II film, *The Guns of Navarrone*."

One of the first things that Edlund and team did was convert their effects cameras and equipment from VistaVision™ to 35mm. Not only would it cut costs, it would allow the team more flexibility.

Richard Edlund immediately began adding a few finesses that he had been unable to do on the first feature, simple things like shadows from the smaller vessels as they flew past or around the larger ship. "Remember, this was television, so we were working for a smaller screen, we thought. That meant we could push the technology further, without certain things showing on the large screen."

The show was filled with fun stuff, and a few physical perils. "We built a snow mountain outside the studio," Edlund recalls. "It was about six feet square, and incredibly detailed. We used barrels of tiny glass bubbles for texture, shooting 360 frames per second, at 100 ASA, at a 5.6, with the Photosonics™ high-speed camera. We had to watch our steps carefully, as we slid on the little bubbles, which were like billions of tiny ball bearings all over every floor, but it was worth it. I can look at the shots today, and I am still proud of them. They have the scale of the Alps."

Of course, three 2-hour projects turned into one of the first and most successful television series. "I remember, as we were doing the work, the guys from the new company called Hartland were scurrying around, watching what we were doing, and photographing our tools and equipment. We knew we were being copied and ripped off, but there wasn't much we could do about it."

About this time, Edlund, John Dykstra, and a few other ILM alumni decided to open a new company, to be called Apogee. Although

Edlund was one of the founding members, it was with the understanding that he might be called back to ILM to do a new project called *The Empire Strikes Back*.

"By this time we'd realized *Star Wars* was like falling off a log. We'd made the mistakes. Now, we could go back and really do something. In *Star Wars*, for example, the shots of ships against black space with stars could be done with little worry about matte lines. However, in *Empire*, where we were dealing with a lot of 'white' – a snow planet, white costumes, gray ships – any matte lines at all would show."

One of the first things that Edlund had to do was re-form a new ILM creative team, which included many talented young effects people. Of course, Dennis Muren, Ken Ralston, and Phil Tippett as well as Joe Johnston would be there. Bruce Nicholson would head up the optical department, Loren Peterson and Steve Gawley in the model shop, Conrad Buff in editorial, Neil Krepela and Michael Pangrazio in the matte department, Thaine Morris in mechanical effects and pyrotechnics, Garry Waller in animation, Rose Duignan as production coordinator, Jerry Jeffress in electronics, Mike Bolles in engineering, and the machinist Gene Whitman. An incredible crew some who have stayed there; others went on to other great accomplishments.

One of the important new tasks was to create a revolutionary new optical printer. "The entire lens system was one design," Edlund explains. "Before, we might have a $5,000 lens in one place and a ten $10 lens next to it. This created an optical mish-mash of the mattes and would never have sufficed for the sophisticated composites required for the snow battle scenes and other demands of *The Empire*.

"The answer to the problems became known as the 'quad' printer. It had four projectors – two pairs of aerial projectors at right angles – combinine the VistaVision™ images by means of a beam splitter on their way through an anamorphic lens to a 35mm camera. The optical system, designed by David Grafton, was 'telecentric' and had virtually no chromatic or geometrical distortion.

"The printer was an extremely precision machine – keep in mind that the image is only the size of a postage stamp, but will be projected on a 50-foot screen. A matte line of one-thousandth becomes almost an inch wide on the screen. Not acceptable."

With all of the mechanical sophistication of the equipment, still it was necessary to do things like taping a little piece of cellophane from a Marlboro wrapper to the film gate, or gently smearing a microscope

slide with a dab of Vaseline to get a shot to work. "Since we were then in the analog, photochemical world, it was often necessary to 'kick the coke machine' to get a bottle out."

In addition to the optical printer, Edlund and team built a reflex high-speed and sound-speed camera with a blimp, along with perhaps the first portable motion-controlled filed-recording gear head, which accompanied the first unit to Norway. "On *Star Wars*, we were still working with an old Mitchell camera from *The Ten Commandments* era," he explains. "It must have weighed about 120 pounds and had four handles for four grips to schlep around. It would have been impossible to shove something like that around the glaciers, where we were shooting *Empire*.

"So, we reduced the size, used carbon fiber, and even added a heating system to keep the equipment warm. The new camera weighed about 20 pounds and worked great on the ice."

For Richard Edlund, some of the most interesting and fun work on *The Empire Strikes Back* was in the area of stop motion. "The Walkers were an idea 'borrowed' from a Syd Meade concept painting," he says. "It was something that Syd had designed for a corporate brochure. Escentially, we had a tank on four legs. Our shots of the 15-inch-tall snow walkers had the unavoidable herky jerkyness of the stop-motion technique. But, for these 15-inch-tall snow walkers, which were, after all, mechanical contraptions, it worked perfectly."

The project won Edlund, Brian Johnson VI, Dennis Muren, and Bruce Nicholson a 1981 Special Achievement Award from the Academy for Visual Effects. The Academy's Scientific and Technical Committee recognized how Edlund's Quad printer and the *Empire* camera system had changed the face of visual effects for feature films by awarding them both with the Scientific and Engineering Academy Awards.

With these several projects, Richard Edlund felt he was operating in a vacuum. Each day, he would go to the ILM secret studio and do his job. Year in and year out, it was all about making the script work. When he finally finished *Empire*, he took a long needed vacation. "It was then that I realized just what kind of a phenomenon we had created," he says. "I went around the world, to rest. But, when I got to Tokyo, I was interviewed by literally hundreds of reporters. George had really touched a universal cord.

"As I flew home, I looked down out of the plane and saw all the city lights. It began to dawn on me. Each light represented one, two,

even four pairs of eyes – each of which were watching what we had been doing day in and day out for all those years!"

When Edlund returned home, he found the script for **Raiders of the Lost Ark** waiting for him. Here, he would be dealing with semi-realistic material and not fantasy. It was going to be an interesting challenge.

"I remember when we were doing the flying boat sequences," he says. "One of the production people at Lucasfilm discovered an old solent flying boat that looked somewhat like a Pan-Am China Clipper. And, it was in nearby Alameda – but, on dry land. We went over and shot a plate of people entering it from a mocked-up ramp, and then I shot a scene inside when Harrison Ford is taking his seat (of course, with Steven Spielberg directing).

"At one point in the shot, he looks over his shoulder and sees a suspicious-looking 'spy' in a trench coat, looking over the edge of his *Life Magazine*. That's Dennis Muren, as the spy, by the way!"

The most challenging sequence was the ending, where the wrath of God envelopes the bad guys. "I remember we started the shot in England and finished in Marin," Edlund recalls. "We had only one day to do the ending scene long shots with Harrison Ford and Karen Allen on the opening of the ark set, with the Nazi soldiers surrounding them.

"When we finished the scene, I walked around the set with the production designer, Norman Reynolds, and picked the sections of the set that we needed to finish shooting the scene so he could cut them out and send those sections by sea van to Marin.

"A month or so later, we reassembled the set and hired Marin County 'Nazi soldiers' to play in the close-ups. I'd created a rig to be worn under the shirts of each of our 'Nazi' villains. It consisted of a front pair of suspenders that went over the person's shoulders. This held an asbestos pad in the back (we didn't know how bad asbestos was back then), with a special three-second-duration flashbulb attached. In front, about a foot or so away from the person, there was a little halogen spotlight on a bendable aluminum wire, and a switch for each Nazi running down his sleeve.

"This allowed each individual 'actor' to set himself on fire, so to speak. He would pull the wire for the light and then set the flash off. This gave real light to the faces and a real flash behind. By the time the animators added their work, we had 'the wrath of God.'"

To make the shot work even better, Edlund made a special 'wrath of God' filter. It fit over the camera lens and had fanned out

grooves. So, instead of the flare going straight out from the source, it gave a winged flair when the flashbulbs went off." He recalls. "The Wrath filter worked great – and has never been used since."

Richard Edlund and team were really proud of these shots in *Raiders*. "Even with the little glitches," he laughs. "I remember, in the screening room, when we were looking at the shots and looking at the shots, and looking at the shots. At one point, one of the guys had us stop. There is a sequence where a team of Nazi cameramen were filming the capture of the prize. They were in costume, however, they were shooting over the ark, toward the Nazis; We all of a sudden noticed that there was a production camera crew in the shot! After watching this shot maybe 50 times, and it was ready to be finalized, Gary Kurtz noticed the glitch. We all laughed – and George said if we haven't seen it by now, let it go . . . ' "

Another favorite shot in *Raiders* was the melting of Toht's head. "We did that with a time-lapse camera and a heat lamp after several mock-up tests. Chris Walas had built up the flesh over a Plaster of Paris skull, with many layers of dental alginate dyed the colors of musculature under the skin. Really easy," Edlund recalls. "We shot at about one frame every three or four seconds. It was just enough to get the right rate of melt, but not to see the drippings.

"We then had to blow up Belloq's head – the sculpting style was similar, except the skull was very fragile since it had to blow up! We added a little kick – like pieces of liver exploding from the figure. They were, of course, helped along by one of my favorite tools – a shotgun. By putting a light smokeless charge in the gun and setting it off at the right time, the shot stirred the pot just enough to get the explosion effect we wanted."

Of course, Edlund agrees, today many elements such as these could be done digitally. But, given his penchant for total reality, he would probably still want to go as much as possible with the real elements. "There is something about serendipity and the 'happy accident' that you can't get on a computer," he says. "Animation is great, but the computer is very precise. Every result must be thought of and programmed. It is often that unexpected happenstance that makes the shot real, and organic, and truly satisfying."

In reality, the biggest challenge in *Raiders* was the nonstop action. "Working with Steven Spielberg was a different experience," he says. "And, the wrath of God sequence at the end of the movie had to follow his act! It had to live up to and consummate what was one of the

most exciting strings of action ever done. And I think, honestly, that *Raiders* is the best of the *Indiana Jones* series.

"Spielberg was pushing himself," Edlund admits. "He was doing this project and was in preproduction for *E.T.* and *Poltergeist*. There was no time to take. The projects had to be done, and that was it."

The challenge was worth it. In 1982, Edlund, Kit West, Bruce Nicholson, and Joe Johnston won an Academy Award for Best Visual Effects for *Raiders of the Lost Ark*. Edlund also won a Scientific and Engineering Award for the *Empire* motion picture camera system.

By now, ILM and the main crew of effects wizards were firmly planted in Marin County. The projects just kept pouring in. Richard Edund seemed to move from one groundbreaking effect to the next.

Poltergeist was pressure, from the very beginning. The production was faced with a deadline. The film had to start by a certain date, and it had to finish by a certain date. The industry was facing a strike by the Directors' Guild. "We didn't want to start with one crew, then go into hiatus, and end up with another crew when the strike was over. We needed to follow this film through with the same people," Edlund explains.

"This was in 'the house next door,' with no 'fantasy' locations or sets. So, we had to ground everything in reality.

"Our first question was, 'What does a ghost look like?' What does the audience think when they visualize about ghosts? Sure, we have the kids in the white sheets at Halloween. Then we have what's in our dreams."

There were two major ghost sequences to deal with on this picture. The idea, according to Richard Edlund, was to make the whole movie eerie – set, effect, and music. "Jerry Goldsmith came up with this great music," he says. "We timed the effects to the feeling from that music."

When the audience first sees the ghostly figure, they would either buy it or not. It was up to Richard Edlund to create a ghost that the audience would buy. "The first time she comes down the stairs, we've got the parapsychologists, sleepy but still intent on their equipment. So, when the ghost finally appears, Steven has the audience hungrily waiting for an eerie visual treat!

"We couldn't let them down," Edlund remembers.

"Having been involved in natural lighting effects before, I knew what would work and what wouldn't," Edlund interjects. "So, I felt that when we first see her, there have to be things like shadows to tie her in

to the scene. If you see someone walking along without a shadow, you don't notice the shadow isn't there, but you do feel something is wrong. In this case, she was a light source, so she had to affect the lighting ambiance.

"Working with the cinematographer, Matt Leonetti, ASC, I worked out a scheme. We shot a plate with the ceiling pulledout," he continues. "We had a grip walking above on a catwalk over the stairs, which had a steel railing. He had a 5,000-watt bare lightbulb hanging on two thick wires. As he walked along, he dropped the bulb in frame, in the position the she-ghost's heart would ultimately be. The point source cast eerie shadows across the room – just what I wanted!

"Of course, it also created nightmares in the composite – flares from the lens!

"These things are important, though. It's like seeing a forest without moving leaves, or the ocean without moving waves. These are the peripherals that sell the shot," Edlund relates. "These are the elements we needed to sell the ghost."

To create the illusion, Edlund and team needed to shoot two plates: one with the ceiling in place and one with the ceiling out. A crew member knew of an actress familiar with wirework, who was playing Peter Pan in San Francisco. She was hired to do the ghost.

"We moved the horizon 45 degrees down, to use gravity in our favor," Edlund explains. "We released the woman in the costume from above camera. As she 'floated' down the stairs, the costume trailed. When we ran the film in reverse, the gossamer fingers looked as if they were leading her.

"To get the effect, I shot it in 16mm at 500 frames a second, and we got a terrific image. Then, we had to clamp a 16mm projector up onto the 'Kluge' printer, to convert it to a VistaVision™ for compositing. It was a hassle, but it is my all-time favorite ghost shot.

"The movie had genius casting, with Craig T. Nelson, JoBeth Williams, little Heather O'Rourke, Oliver Robbins, Dominique Dunne, Zelda Rubenstein, Bea Straight the famous Broadway actress who was so good at convincing us and James Karon (as the smarmy real estate salesman)," Edlund adds.

Another memorable and groundbreaking shot in *Poltergeist* was the house implosion. "When I read the line in the script, it simply said, 'The house implodes.' I turned to producer Frank Marshall and said, 'That's a $250,000 sentence.' But he wanted it.

"So, the model shop built a house that was about five feet wide. They then came up with a material mixture that would break like stucco," Edlund explains. "We ran several tests, until it was the right consistency.

"We then built a model about four feet wide. It had hundreds of wires built into it, running down to a yoke in the bottom of a black Formica funnel. The wires were taut and hooked up to a pulley that was on a forklift.

"I was standing on one side of the set with one of my favorite shotguns, a Purdey. And, we had another person on the other side, with another of my shotguns.

"When the time came, with our fingers crossed, we signaled the drivers of the forklifts. They had to burn rubber, to pull the house in. It was a one-shot deal – at 300 frames per second.

"As the house was 'pulled,' we helped the implosion with the shotguns, for that extra organic tempo of the shot.

"The take was over quickly, and without a hitch," Edlund says, "although we were just beginning. It took literally months of work, to rotoscope the shot – that is, making the matte of the thousands of fragments, frame by frame." The background was a matte painting of a vacant lot, with a dazed Jimmy Karen in the foreground witnessing this supernatural event.

The effort was obviously worth it. In 1982, Edlund, Michael Wood, and Bruce Nicholson received an Academy Award nomination for their groundbreaking work on the film. *E.T.* won.

It didn't matter to Edlund that someone else won. He was already into the next project. For **Return of the Jedi**, George Lucas's third film in the **Star Wars** trilogy, Edlund and team really had their work cut out for themselves. This was by far the most complicated of the three pictures. It featured some 900 effects shots. "However, we were already an experienced team. We knew we could pull it of, in the time available."

The most fun the team had was stonewalling the general public. By now, people were trailing anyone remotely connected with a George Lucas project. The trash around ILM was being sifted. Groupies were everywhere. So, when the **Jedi** team moved to the Yuma desert, everyone was walking around with caps that read *Blue Harvest*. "As long as we all stuck to the story, no one could prove the opposite," Edlund laughs.

"Someone got into the art director's trailer and saw a sketch with *Jedi* on it. We denied, denied, denied.

"It didn't matter that the 30-foot-high platform for Jabba's ship was in plain sight. Nor did it matter that an open truck was taking Anthony Daniels, dressed as C3PO and Luke, also in costume, to the set each morning. They couldn't break the wall."

Nor could the hundreds of off-road vehicles that played just below their set, which was 30 feet in the air with dunes surrounding it, that blended with the dunes in the distance.

As Edlund said, that'd already developed a crack team.

Ask Richard Edlund what shot was most interesting on *Jedi*, and he will quickly mention the bike chase sequence. "At first, we thought about this complicated setup, where we would do wire rigs and tracks with removable trees. However, the vibration wouldn't work. So, we thought and thought, and Dennis Muren and I came up with a simple solution – Garrett Brown and a VistaVision™ camera on his Steadicam, shooting one frame a second – slowly following a string through the woods.

"Simple, elegant, and it really made the sequence work!"

The techniques developed on this project worked. In 1984, Edlund, Dennis Muren, Ken Ralston, and Phil Tippett won a Special Achievement Academy Award for *Jedi*.

Richard Edlund was ready for a change. When *Jedi* was finished, he made a break from ILM and returned to Los Angeles. He'd met Doug Trumbull at a Women in Film event, and Trumbull had told him he was ready to get out of the movie effects business. Edlund made a deal to avail himself of Trumbull's old equipment and established his own company, Boss Films, in Marina del Rey, California. "I had gotten tired of the *Star Wars* style of effects," he comments. "There are special effects movies that are, to me, very self conscious because every time you cut to an effects shot, it is absolutely classically composed, done with a locked-off camera, elements placed perfectly, and probably a 'castle on the hill.'

"These effects become self-conscious," he continues. 'It's the 'look at this shot!' mode."

Edlund wanted to do "reality-based" special effects.

By the time the lawyers were finished with the paperwork, Edlund had contracts on two projects – the future fantasy *2010* and the reality-based (sort of) comedy *Ghostbusters*.

Boss Films' first job fell somewhere between fantasy and reality-based. "We had 10 months to design and execute all the effects for *Ghostbusters*," he says. "But, I knew in my heart it would be another blockbuster!

"When I read Dan Aykroyd's first draft of the script, it ran some 200 pages and every page had a huge effect. Ivan Reitman and Harold Raimas began a rewrite. We discussed the idea of the effects as they were rewriting. They knew that they needed to be careful with what they wrote. Effects were expensive. Part of the art of visual effects is in the art of spending money – because you never have enough of that."

The script was trimmed – sort of. And, the crew had 10 months to rebuild the studio, and to design and execute the 147 effects shots. Little did they know that Ivan Reitman would add 50-odd more shots about six weeks before the delivery deadline!

"The responsibility of the Marshmallow Man was a pretty heavy one," he recalls. "But I really love the character. The shot of him coming into Columbus Circle is my favorite. I have always been a lighting guy, and working with Laszlo Kovacs was a pure pleasure. A few years ago, we did *Multiplicity* together, and I really admire his sense of story and lighting."

This finale was Dan Aykroyd's invention. "Who else could think of having a 150-foot Stay-Puft Marshmallow Man stomping down Broadway, climbing up buildings and accosting our heroes!"

Bringing Aykroyd's strange character to life was tricky. "There is an effect that happens in composite photography I call postage stamping," Edlund explains. "It is when something looks like it is stuck on the screen, and not part of the scene. Avoiding this is a real art."

To shoot a 6-foot man in a suit and get his movements to feel as though he is 150 feet tall was one of Edlund's first tasks. "We had to create this lumbering marshmallow creature that would walk down Broadway, lit by the odd sources of lighting on that kind of street, in a situation like that," he explains. "So, we first had to make him look like he was there, then composite him into the shot."

Edlund credits Boss Films' photographic wizards Neil Krepela and Bill Neil for "selling" the effect. "They designed the first shot of the Marshmallow Man so that the audience would see him through a crack between buildings," Edlund explains.

"Then, as the camera is panning along, you see just a glimpse. Everyone always laughs when they see this, just a little glimpse (in about 12 frames), as the head walks by. The head then bobs up. But,

because of the painting in the background across the street and the water tower in the foreground, there is a sense of depth that immediately sets the credibility factor."

If the audience buys the character from the moment it is on the screen, then the effect works. "The main difficulty is coming up with the right idea and the right way of handling it," he says. "It all goes back to shot design, the art direction, and the experience in the crew that had worked together before.

"One of my favorite effects in this picture is the neutrona wand emanations that could take out or capture ghosts," he continues. "It is the rubberized light that we came up with," he explains.

"The effect was done with animation and backlit art. We created a 'wanky' and funky movement, animating different levels of shapes and colors, as the neutrona stream wobbled over the scenes. We shot spark elements using an arc welder and pin-blocked them over the tips of the wands to give an organic origin to the stream of light."

While his crack team was feeling the pressure of finishing *Ghostbusters*, models were being built for the future fantasy, *2010*. "This project was completely opposite in character to *Ghostbusters*," he explains. "At first, we didn't want to look at the first movie, *2001*.

"I didn't want to review Kubrick's *2001* because *2010* was really a different movie. Besides, since the 1968 release of *2001*, everyone had seen real space footage from the *Apollo* and *Voyager* missions. *2010* had to look realistic and be true to the real images of space travel.

"I did call Stanley Kubrick and ask for a few props and set design drawings, but he said someone had cleaned out the warehouse where he had stored everything and everything was gone. So we used film clips from *2001* to recover the look of certain set pieces such as the manned probe vehicles."

For Richard Edlund, *2010* was a wonderful experience. What was fascinating to him was the effect of juxtaposing the claustrophobic feeling Peter Hyams had created inside the ship with the vast openness of the outside shots.

"Inside, he used a relatively grainy stock – either 5293 or 94. When we got outside, the effects shots, done on 65mm 5247, were grainless and as crisp and sharp as possible. This really created a sense of the vastness of space for the audience.

"The shots were very carefully designed and artfully composed. Peter Hyams is quite visually gifted, and it was rewarding to work with him. I feel it is among the most beautiful space films ever made."

Richard Edlund was having a great year. His work on *2010* won him (along with Neil Krepela, George Jenson, and Mark Stetson) a nomination for an Academy Award. His competitiom was John Bruno, Jark Vargo, and Chuck Gaspar, and himself for *Ghostbusters*.

Following these two projects, he took on a very low-budget film called *Fright Night*. It presented an interesting problem. The budget could afford only about 15 or 20 shots, but they all had to be the key shots, necessary to making a vampire/werewolf film work. There could be no reflection in a mirror with the werewolf transformation, etc.

"One of the more interesting challenges is the sequence where Chris Sarandon turns into a bat," Edlund recalls. "Even with the best of tools, you can't sell a man turning into a bat right in front of your face. Besides, that kind of shot tends to interrupt the pace of the movie.

"So, we came up with the idea of seeing a woman on her front porch, facing the vampire (Sarandon), then cutting back to her, with Chris's shadow on the wall. We changed his shadow into a bat shadow through animation. And, he flies away. That, the audience would buy."

That was followed by a 1987 nomination for *Poltergeist II: The Other Side* (with John Bruno, Gary Waller, and William Neil). "The effects in *Poltergeist II* were quite amazing, though the movie didn't have the audience of the original," says Edlund. "There was an astral dimension sequence featuring the family floating around fighting 'the great beast,' as well as an exhausting wire shoot against bluescreen with a magical background shot in a cloud tank, layered with cumuli and mist. H. R. Giger was involved in visualizing the various creatures that were realized in the Boss Films 'rubber shop.'

At that time, he also won another Scientific Engineering Award, shared with Boss Films' Gene Whiteman, David Grafton, Mark West, Jerry Jeffress, and Bob Wilcox, for the design and development of the 65mm Zoom Aerial (ZAP) optical printer. This was built for the production and was, perhaps, the finest printer ever built.

"This printer was created to do extremely repeatable off-center zooming shots – absolutely exact elements," he says. "We could do off-center zooms with motion control and repeat the move for the three separations, mattes, and cover mattes.

"The Quad printer we invented on the *Star Wars* movies was close, but once set, the printer had to remain locked off. This one was reliably motion controllable. We could tame a sequence where we had everyone flying around on different planes, in different dimensions, and sell the shot."

For Richard Edlund, the next innovative project (after a series of been-there-done-that films) was the first *Die Hard*. "That was because it was a reality-based job," he explains. "There were a lot of models to be blown up and models where we could fly miniature helicopters around and blow them up. The location building was in an area where real helicopters were not allowed, so the action was staged with the actors reacting to nothing, and either real helicopters shot at night or miniature helicopters were composited in.

"The criterion for this film was simple – Either it looks real and gets your attention or you have to fix it," he says.

"I think the most interesting was where Alan Rickman falls away from the camera," he adds. "By the time the Rolex gets peeled away from Bruce Willis's wife's hand and he falls away, you hate this guy. It is a really good dramatic point in the movie, and we wanted to make the most of it.

"Director John McTiernan actually talked Rickman into falling into a blue-screen bag backwards, about 25 feet below," Edlund says. "Most stuntmen won't do that!

"The main photographic problem was that the shot started in a close-up, with the gun in his face. We had to maintain perfect focus on his face, and we didn't expect Rickman to do this more than once. Shooting at 300 frames per second meant we would need a lot of light on the blue screen, and still we would shoot at a T2.8. Not much depth of field."

To make the shot work as perfectly as possible, Edlund developed a system designed by Mark West – a rifle scope on a fluid head with encoders. With this, they could follow Rickman's fall from a distance. The system transformed the data from the custom tilt-head, keeping sharp focus on Rickman's face as he falls to the screen.

"It worked great," he adds. "This was basically a digital to analog kind of thing. As this thing tilted down, the focus changed. The shots were sharp, and we wound up using the same tilt apparatus on *Multiplicity*, where we followed Michael Keaton's feet around (with a laser dot)."

Edlund agrees that most of the shots on *Die Hard* were carefully planned however, a few were "throwaways"!

"It is always better to have some sort of story action, so that it brings the effect in with the movement of the story instead of stopping everything for a moment and looking at something, then going back to the story. That was the idea in *Die Hard*."

The establishing shot of pandemonium at the end of *Die Hard* was just that kind of shot. It should have been simple, but there were a few "contingencies." "The location was the then brand-new Fox Plaza on Sunset," Edlund says. "The place was surrounded by imported marble. We couldn't do anything that might damage the building.

"We had to start on a shot where the roof is all mangled up on the building and fire is burning, as thousands of sheets of paper, negotiable bonds were wafting through the air.

"To accomplish this, the camera started up on a miniature of the top of the building on fire. As the camera tilts down, mounted on a titan crane with a free head, it is also booming out. It is not a lock-off.

"So much for motion control!

"The problem was that we had to start tilting down on a miniature (that was like a grid) and then transform in the middle of the shot to the actual building. On a boom."

Edlund and team shot the scene with their "fingers crossed," he laughs. The location was done first, then brought back to Boss to put the top of the building on.

"Our neighbors weren't too happy with us," Edlund recalls. "Our condo neighbors didn't like the sound of the many loud explosions Thaine Morris was setting off, coming from the model shoot going on in our parking lot!"

Once Edlund was satisfied with the miniature explosion and the location footage, the elements were projected and plotted frame by frame, testing opticals after opticals. When they had it "almost perfect" in motion control, they then let the printer with its own motion control system do the final tweak.

"The biggest problem was getting the grids and angles to be right," Edlund explains. "We would have liked to do it without lights on the building because the lights would have had to be matched in miniature. Boss's D.P. Bill Neil figured all these problems out as he shot the miniatures.

"Surprisingly, when we saw the finished product, you could not tell where the real building ended and the miniature began, or rather, the other way around."

In this shot, it is technology and "good old brain power and quick thinking that makes the shot."

Another exciting scene in *Die Hard* involves a helicopter crashing into a building. "Now, logistically, you could never use a real

helicopter simply because you couldn't get close enough," he says. "The wind factor comes into play.

"So, we were doing another scale model for the shot." This is where the FBI helicopter crashes on top of the building and comes flying out of a fireball, then falls toward the camera as the helicopter blows up.

It is another parking lot shot. "We found one of the best radio control helicopter pilots available, then built the top of the building.

"We did one mock-up and wasted the helicopter," Edlund recalls. "Then, with Thaine Morris on top of the building, we flew the helicopter into it. To get the sequence, we were shooting at 12 times the normal speed. The actual shot took about a second or so. The helicopter had to come out of the fireball, blow up, and land. It had to miss the camera.

"We did one take and it was almost perfect," he adds. "The next was perfect. Then Thaine realized at a certain point that the helicopter wasn't going. The man has always been a quick thinker. He took a broom handle and shoved it out into the fireball!"

So much for sophisticated technology!

Another nomination for Best Visual Effects came his way — along with Al DiSarro, Brent Boates, and Thaine Morris.

In 1990, Edlund and the Boss team took on the ending for a "little" film starring Patrick Swayze and Demi Moore called *Ghost*. No one knew yet what kind of a hit it would be. And, the studio couldn't do a test screening with the end sequence as it was shot because it was just Patrick Swayze walking up a ramp in front of a blue screen — with rigging, even grips standing around in the shots. And, this would be the magic moment at the end of the movie!

Edlund talked to Howard Koch, the producer, about a strategy he had come up with. "I wanted to do the sequence in video and transfer to film," he recalls. "I proved it would work, by doing a test and showing it to the producers.

"That agreed to, I figured it would cost about $45,000 to do the entire sequence in temporary form, using work print on the Harry Quantel's video compositing system.

"If we were to proceed that way, the studio would quickly have a presentable end sequence for previews, and I would also be able to save time and money on the final sequence because I would already know where the director, Jerry Zucker, wanted to creatively take the sequence.

"Howard saw the value of this approach and approved it. I then went into the Harry bay with Jerry, and we produced the entire sequence of 25 or so shots in three days. The studio saw the temp sequence and thought it was final!

"The scene that everyone remembers – which kind of became the poster shot – is the kiss between ghost Patrick Swazye and his love Demi Moore. Film kisses video," says Edlund. "We had a VistaVision™ plate of Demi and a video composite of Patrick in his ghostly guise. A split screen, as they lean forward to each other and kiss.

"Adam Greenberg had done a great job with the live action. The shot looked wonderful. It was our job to put the 'glow' around Patrick."

Before going to the expense of a full effects shot, Edlund asked to do a test. "It would cost about $45,000, but when we had the final idea, the shot would go much faster," he explains.

"Essentially, what we did was build the shot on video. We then composited it with the VistaVision™ of Demi Moore. It looked so great, we actually ended up crossing the boundaries of formats by using video and film in one shot on a final product."

By 1992, the world of effects was changing. Effects supervisors were preparing to make the leap from photochemical to digital. However, there were still enough bugs in the system to warrant caution. Edlund and team took on *Alien 3*, with the idea of doing the elements in the tried-and-true manner.

"This was the last project we did photochemically," he says. "To get the sense of motion needed for our alien, we needed to take the audience on a ride with stop-motion-rod puppet techniques.

"We studied tigers and gazelles – the puppeteers could assimilate the motion of these creatures. After many tests, Laine Liska, our master puppeteer, came upon a style of movement that worked for the director, David Fincher.

"The shots were a bit of a nightmare," Edlund admits. "We did the elements against blue screen with wide-angle lenses, then composited them onstage by means of a laser disk system that we had built for the movie. Often, the blue screen was too close to the creature. At times, the rods would cross over the puppet.

"Since we were pre-digital, we had to rotoscope the rods out, and the rods were painted to match the puppet because they would inevitably though, momentarily, cross over parts of the alien."

A challenge, or not, Edlund and crew, which included Alec Gillis, Tom Woodruff Jr., and George Gibbs II, did a great job. In 1993, the

team was nominated for yet another Academy Award for Best Visual Effects. It was the last movie Boss did that was composited photochemically and included only one (their first) digital composite.

By now, effects had taken a huge step into the digital world. A lot more creativity was possible. In 1995, Edlund created an even more complex creature for another science fiction thriller called *Species*. "We created an incredible asset for the picture," he says. "Unfortunately, a lot of it wasn't used as well as it could have been, mostly because the ending of the film kept changing."

Edlund's approach to shooting the creature was very clinical. First, the idea was to create a semi-transparent digital creature. "You could see her musculature through her skin," he says. "The finished creature, when she was modeled, consisted of over 500,000 polygons. This resolution enabled us to do extreme close-ups."

In addition to the complexity of these species elements, Edlund's crew created a new technological approach using a 1/3-scale electronic puppet. "We used a character animation process where we captured the movements of an electronic puppet, which had about 40 encoded joints that would give positional and dynamic data, all of which was sent on the fly to a supercomputer, which would make all calculations and create a low-rez representation of the creature.

"It would then be composited on a plate background in ream time," he explains. "The puppet moved within an 8-foot skew, allowing us to create movement within a 20-foot real size area. We could then place a virtual camera (POV) anywhere we wanted. The main advantage of the system was that we could quickly do many takes with the director right there. We could get a sign-off on the animation immediately."

By 1996, the digital world had taken hold, and Richard Edlund made full use of the benefits of this technology for the Michael Keaton film *Multiplicity*. "This is probably the most fun I have ever had on a project," he says. "Putting four Michaels into a shot was a complex job, but perhaps the biggest challenge was for Michael. He was carrying the entire movie with his four characters."

One of the most important mandates for this picture was that the effects technology would not show. While other films with multiples of the same actor had locked-off cameras and used architectural boundaries, such as door frames for split lines, Richard Edlund, the film's production designer, and cinematographer Laszlo Kovacs ASC,

were determined to create environments where they could do moving splits.

"We carefully storyboarded every sequence," says Edlund. "But, each day, we would go through the scenes to be shot as the film was developing and redesign the shots to fit. But, Harold Ramis, the director, was financially responsible, and the shot couldn't grow during the process.

"The film was done in Panavision. We had a specially modified Panavision camera for the effects, with a special video system, and it was set up for SGI workstations and other technology necessary to produce animated moving split screens, and green-screen composites on the fly.

"At Video Village, Harold saw the takes comped on the monitor, which looked a little different from normal production. Of course, with multiple Michael characters, every shot had motion control – even lock-offs, which would always have programmed focus. With the sopuistication of the computers and programs like Elastic Reality™, the only restrictions were what Michael put on himself.

"Take the scene where the motherly 'three' is in the kitchen talking to 'his' wife," Edlund explains. "At one point, he is having a discussion with her about folding the meat into neat tinfoil packets. He is wearing a dark purple sweater. He sees 'two' gesture outside the window, to get out of the way. He wants to come in.

"As she turns away for a moment, 'they' switch places in a rather complex maneuver. It requires 'three' to cross over 'two' and then 'two' to cross over 'three' – a series of green screens, moving splits, and 'clean' plates.

"She looks up and is now talking to the construction worker, 'two.' She looks at his shirt, which is now a dark blue color, and asks if he's changed clothes. Of course, he denies it. And, the conversation continues, but no neat little packet kind of talk."

The shot was so complicated that Richard Edlund can't remember the elements offhand. "I know, at one time, we had a green screen in one corner and then another corner, and numerous little touches," he laughs.

"The whole idea was to create an atmosphere that wouldn't restrict Michael from doing what he did best.

"That's where the focus device we used on *Die Hard* came in. It found a new use as a means to track Michael's movements. On the first take, we would have someone follow Michael's feet as he moved around

during his performance. A stand-in would shoot the performance with a Sony HandiCam from the position where the next Michael would be.

"For Michael's second performance, the HandiCam shot would then be plated back on a monitor, carried by a talented stand-in actor, who would follow the playback of the motion-controlled laser dot on the floor. This was for Michael to play to for his second performance. This way, his eye line would always be perfect. And, so on, if there were three or four Michaels in a given shot.

"Crucial to making everything work here was the eye line. If he always appeared to look himself in the eye, our audience would suspend disbelief and accept the several Michaels in the shot (even though in the back of their minds they knew he played all of them)."

Effects had come very far since the first *Star Wars* film. Not only were they now seamless, they became useful for a picture that was not an "effects" picture. "Our mission was to enable Harold to make the same type of film he would make if he had four real Michaels," says Edlund. "And, not try to make an 'effects' statement with our work.

"I knew we had been successful, when I saw the movie with an audience and got into it, forgetting the 99-day shooting schedule and the year or so of work on *Multiplicity*."

Edlund's next challenge was completely different. For the action/adventure *Air Force One*, he created complex flying sequences – without real planes. "I started out by discussing the sequences and holding up small models of all the featured planes with Wolfgang Petersen, the director. This was to develop the visual ideas."

Some storyboards were created, but Edlund saw that they wouldn't be much help for the shots they wanted. "Jamie Price, my co-supervisor, and the Boss Digital Animation crew developed low-rez models on SGI workstations, and we proceeded to develop the shots in motion and then to output the shots on video.

"When they looked good, I'd take them to Wolfgang and get sign-offs."

This technique was crucial to the success of the effects. Dave Jones (Edlund's other co-supervisor) built, among the other models, a magnificent 21-foot-wingspan miniature Air Force One, which was a bear to manipulate and program. Set up in a 75-foot-high airplane hangar and hung from a gantry with a specially designed six-wire motion control rig, it gave them plus or minus 45 degrees of tilt in any axis. "About 20 feet up or down," Edlund explains. "With the camera

on a 20-foot boom and over 100 feet of track, it was backed with a 60-by- 100 foot red screen.

"The beauty pass had to be shot separately from the matte, for which the model was sprayed with talc to avoid the red spill," he adds. "Everything was slippery, and I slid and fell one day, winding up with a hairline fracture in my foot! Just another battle wound – it healed up!"

Everything on this shot was huge, time-consuming, and expensive to set up. "Thank God for the preapproved video sign-offs," he says. "Garry Waller, the effects D.P., used them to position the model for programming, and thereby virtually guaranteed sign-offs on the beauty shots, when I screened them for Wolfgang.

"Everything had to look real," he reiterates. "The requirement was total realism," he adds.

"The cloudy sky backgrounds were shot day-for-night with a motion-controlled periscope system from a Lear jet. Our engineering staff worked with Bob Nettmann to motorize and calibrate his periscope system.

"I believe that this was the first time such a technique has been actually achieved. Usually, wild backgrounds are picked and the shots designed to fit them. But, we felt that such a backward approach would have been creatively restrictive."

The programs were based on the pan-tilt data gleaned from the actual model shots. For the many shots that had only digital aircraft, the research and development crew worked out pan-tilt data for the cloud shoot. Every shot worked, and "amazingly, we only shot about 500 feet of film in the sky!" Edlund adds. "Because we only shot exactly what we needed.

"We were fortunate to have local storms that coincided with our schedule and we got almost every background in one flight. We used the budgeted extra day to get a few wild elements, in case of any last-minute added shots."

The exciting aerial rescue sequence was shot on Stage 16 (the largest soundstage in America) on the Sony lot. It was all green – "probably the largest green screen in history," Edlund adds. "They brought in a complete flying 'boxcar' aircraft to be shot, tracked, and matched to actual flying craft shots by David Nowell in the skies.

"Our pyro shoot, where we would blow up along with several F-15s and Russian MIGs an 18-foot-wingspan DC-10 refueling plane, was another adventure," he says. "With my Cinerama 300-frames-per-second-high-speed camera pointing straight up in a pickup truck, at 50-

miles-per-hour, while driving under, we blew two DC-10s hung from 100-foot cranes in one night!

"Take one was the choice, and in composite, we added a 'helper' explosion, just at the end of the shot, along with some animation techniques. This gave us a streaking effect for the fire, to take it over the top.

"If you look close, you'll notice Harrison's legs dangling over the edge of the ramp! I think it's my favorite shot in the movie!

"The last of our shots was the crash of Air Force One into the water. This was done completely digital, on live water plates; though they were the most expensive shots, they were adequate but not completely successful.

"We thought of taking miniature AFOs and attempting to shoot them live at sea, but the cost and risk of failure were too daunting.

"In the waning days of the photochemical – the Paleolithic era – I was getting bored with coming up against the same analog brick wall of restrictions and impossibilities.

"We had pushed the cantankerous photographic means as far as it could go.

"I was to the point of thinking 'what else can I do?' The digital – Neolithic era – changed all that! The white canvas continues to draw me in.

"In terms of success, perhaps *Multiplicity* is as close to perfection as I have come. But, there are countless more things to do, and as long as our audience continues to have an appetite – so many effects, so little time . . ."

"It's all part of the process though. I like to refer to CG like I refer to miniatures and a camera – it's just a tool. It's the hammer that knocks the nail in. In the end it's all about the team that uses these tools. If they know what they are doing, if they see the big picture and are able to communicate their opinion, that's where the fun starts."

Volker
Engel

When Volker Engel was growing up in the small town of Bremerhaven in northern Germany, his passion was for shooting stories of his fishing town with his Super 8mm camera. When he could get his hands on a film projector with a handle, he would sit and analyze old Walt Disney films by cranking the handle forward and backward.

"Seeing *Star Wars* at a local theater, when I was 13, was the big wake up call for me," he says. "My older brother (five years his senior) read science fiction. Although we knew the world he read and what I saw on the screen wasn't real, it still fascinated us."

With Bremerhaven 500 miles away from Munich, where movies like *Das Boot* and *The Never Ending Story* were made, there was little chance for the young Engel to get into the movie industry. There were no Germans to introduce him to the world, and he had no way of meeting the American or English technicians. So, he took a chance and started studying graphic design at the Academy of Fine Arts in Stuttgart. "Here, you could specialize," he explains. "One of the specialties was traditional drawn animation. I thought it would be my way into the movie industry."

At this time Oliver Scholl began working with Roland Emmerich on a project called **Moon 44**. Scholl had done concept designs on different Centropolis Company projects, including one called *Nekropol*,

which developed into *Stargate* 10 years later. Emmerich asked Oliver, then a 25-year-old industrial design student and science fiction illustrator, to be the production designer on *Moon 44*.

"I didn't know it, but as a student I was living some 200 feet away from Roland Emmerich's office at Centropolis in Stuttgart," Engel recalls. "When I met Oliver, I showed him a project I'd been working on for five years – my approach to visual effects. I had created spaceships and laser torpedoes as well as satellites and moon landscapes, all shot with a Super 8mm camera."

No small task for this inventive young man who had no background in visual effects, just an extremely creative mind. His technique was to do multiple exposures of shots to include all the different elements. "I would expose the miniature of a satellite to fill the left side of the frame, rewind the film, expose for the starfield on the right side, rewind, expose for a laser torpedo, and finally for a rear-projected explosion that I had shot earlier," he explains.

"I had my own crude optical printer or animation stand, if you will. I could rear-project single 8mm frames onto a small glass screen – or use that device to create backlit animations for laser blasts. I also used it for the starfield, which, of course, was black cardboard with holes in it."

With few books on visual effects available in Germany at this time, Engel was left to his own devices. "I practically had to invent everything," he says, in a casual voice. "The only material I saw was about Italian Neo-Realism in the 1930s and a poor German translation of the first two issues of David Hutchins's editions of 'Special Effects' from *Star Log* magazine. His explanation of how the ship in *Battlestar Galactica* was built might have been correct in English – but the German translation was impossible to understand. In the chapter about animation, they would translate 'cel' with the German word for 'prison cell' – I never saw a more ridiculous translation of a book in my whole career again."

Still, Engel had absorbed enough to garner him a job in the model shop for *Moon 44*. "I learned some very important basics, while working on *Moon 44*," he says.

"One day, I would show up at work in this ugly little warehouse and my office, which of course had no windows, was full with these wooden crates that said 'ARRI.'

"Roland had rented a 35mm ARRI-III camera. I opened the crates – everything was in pieces, the camera body, the magazines, a set

of lenses, etc. Roland would walk by and say, 'Let me know when you are done putting it together.' Of course, it didn't come with a manual.

"There I was, 23 years old, with some 8mm experience, hired as a model maker, and they wanted me to quickly assemble the 'Rolls Royce' of German camera engineering. (Engel later became visual effects supervisor, with front credit.) But that's one of these qualities of Roland's; he would trust you and immediately give you some responsibility. What can I say? The camera was assembled 30 minutes later. In an improvised darkroom, Roland showed me how to load a magazine with film. We started shooting tests right away."

The first lesson Emmerich taught Engel was that the secret for good miniature photography lay in three elements – good depth of field, slow motion, and a smoked-in stage for atmosphere. "Except for shots in outer space, of course, which have to be crisp," Engel explains.

"I found out that those were the three elements the guys from the old *Godzilla* movies never seemed to care about. Their shots usually had foreground elements that were out of focus. And their background was usually too crisp. Of course, this is part of what makes the charm, when you look at these movies today – but it was certainly not the look we were going for in *Moon 44*.

"When we shot a troop carrier flying past the camera and into the distance, you could bet that it was in focus all the time and would look big. We shot it in slow motion on a stage with a high smoke-density. The use of the newest ARRI wide-angle lens also helped – and I'm talking about miniatures that are 10 to 15 inches long, suspended from four pieces of 0.03mm thin fishing wire."

Moon 44 was an experience, for Engel and the rest of the German crew. The B-picture, made for about $3.2 million, featured Michael Pare and Dean Devlin (when he was still an actor) as prisoners who were doing their duty on a planet protecting valuable mining resources. "There was a lot of flying shots of specially designed helicopters weaving through the canyons on that moon," Engel recalls.

"Besides hand carving all the canyon walls on the moon, one of my first model assignments was the establishing shot of a gigantic corporate structure called 'Galactic Mining' on earth," he says. "Roland wanted to see this huge array of seven towers – at night. He also wanted to see thousands of tiny windows in the towers."

To create the towers, Engel cut seven Plexiglas tubes in different sizes and sprayed them black. He then placed four or five fluorescent lights inside each skyscraper and covered them with sheets

of white, translucent plastic gel, to soften the lights. "All I had to do was scratch away the black paint, and the scratch would become the window backlit by the light tubes," he says. "The challenge – get the scratches done in time for the shoot!"

As with any overeager neophyte, "impossible" was not in Engel's vocabulary. When the line producer came in and saw what Engel proposed, he told him he was out of his mind. That task would take him two weeks, at least, to finish. "I put a 1mm drill bit into a small hand drill and scratched around 70,000 windows in 48 hours. I stayed up for 2 nights straight," Engel laughs. "I wasn't going to be beaten!"

Opening shot of the Roland Emmerich movie *Moon 44* – Volker Engel scratching 70,000 holes in the miniature skyscraper.

Engel persevered. By the time Emmerich was ready to shoot, he had a model made with the plastic parts bought cheaply from the Kibri Factory (a company that specialized in plastic model kits for railways) ready. The ARRI camera, shooting Kodak stock, shot a three-inch model of a transport glider flying past the structure - and sold the setup of the story.

"Roland's next challenge was to find a solution for a lot of helicopter shots," Engel recalls. "He wanted to see POVs or see it fly in front of the camera. He also wanted to see the walls on both sides of the canyons they were flying through."

To accomplish this, the effects crew built an endless wall. "Basically, it was a carousel that was about 20 feet around – one of Roland's many ideas to simplify things and squeeze the most out of a single setup. It was a way of thinking that helped me to come in on budget when doing *Independence Day* later," he explains.

"By hanging the camera inside the walls (and having the walls rotate, instead of the camera), we could simulate the POVs from the choppers. We could also hang several helicopters inside the carousel and rotate the walls, to simulate the flying movement. Bursts of CO_2 from fire extinguishers created the clouds the helicopters were bursting through."

Engel's work on *Moon 44* won him a place with Roland Emmerich's team. When Emmerich was set to do *Universal Soldier* with Jean Claude van Damme and Dolf Lundgren in the States, Engel came along.

"Oliver Scholl had done some very interesting conceptual drawings for the high-tech cameraheadset the soldiers would wear in the movie. Based on that design, I started to go shopping at 'Radio Shack,' 'Circuit City,' and 'Toys R Us' to come up with an array of objects like headphones, video game devices, swimming goggles, and children's binoculars. I salvaged bits and pieces and built a new device that looked somewhat similar to Oliver's drawings. This became the prototype.

"During that time I met Joe Viskocil, who had just finished his work on *Terminator 2* – so it was his team of specialists who built the actual headsets you see in the movie, based on my $25-prototype.

"I built some more gadgets for the soldiers, including their 'temperature watches' and some 'voice-simulation' devices for the opening of the movie."

Engel's other job was to build two miniatures for the shoot. There was the truck, also designed by Scholl, which became their mobile command center, and a prison bus, which was chased around the Grand Canyon. "The truck eventually pushes the bus into the Canyon and both vehicles explode at the bottom of the canyon," Engel explains.

Of course, Roland Emmerich wanted to shoot the sequence at the real Grand Canyon. "To this day, I think the shot works amazingly well," says Engel. "We created a tabletop miniature of the Canyon edge for the chase. We set it about three feet above the ground, in front of a specific area of the real Grand Canyon.

"We decorated the miniature tabletop, which was about 20 feet by 20 feet, with sand, small rocks, and little bushes. Roland would crawl on top of the table with a pair of scissors to trim the bushes – so they would have the right scale! By adding dust cannons for impact, we had the feeling needed. This way, when the truck pushes the bus about 30 real feet across the set (with the Grand Canyon in the background), it really looks like full size. It cut perfectly with the live action."

For Engel this became the perfect lesson in the subject "foreground miniature." "We didn't even have to simulate any lighting to have it match the live action footage," he says. "We actually shot it at the exact same location, where a couple of weeks earlier the live-action part was shot. The sun was at the same angle – the match is dead-on."

After *Universal Soldier*, Engel returned to Germany to make his degree in graphic design with a focus on drawn animation. He studied two semesters at a newly opened Filmschool in Ludwigsburg (near Stuttgart) and was then asked to take over the animation department of the school. It was here that he met another teacher, Nico Hofmann, who was also a director. "He was prepping a television movie called *The Last Cosmonaut*," Engel says. "I took on the job of creating the effects at the school for the picture."

Engel and a team of students were to build the MIR Space Station and a tabletop of the Space Center in Russia. He picked a gifted camera student to be the DP. The student's name was Philipp Timme. "One of our first challenges was to determine just how small the miniature could be – to fit the budget of the project." Through a series of experiments and mathematical projections, Engel and crew determined the space station could be a maximum of five feet in diameter.

"Thorsten Schrecke, who later built the prototype of the Alien Attacker in *ID4 (Independence Day)*, got the assignment to come up with the cheapest way of building the MIR. He used cardboard tubes, wrapped 1mm sheet-plastic around them, and detailed the station with pieces from salvaged model kits.

"In the end, the MIR was so perfect, the German Museum in Munich wanted to have it on exhibit," Engel says, proudly. "On *The Last Cosmonaut*, I was working with a tight budget because I chose to pay the students like a real film crew. The rotation of the Space Station was done by hand with a handle – it was still shot in front of a green screen so we could composite it with a starfield and a simple matte painting of the earth, which I had airbrushed myself. In the end we delivered 17 shots with a per-shot cost of around $2,500. The producer of that show loved us!"

By 1994, Engel's reputation in the German effects world was solid. He worked on a bigger German feature called *The Brother of Sleep* which was not very effects-oriented but did introduce him to another budding effects camera person – Anna Foerster. "One of the big sequences in this picture involved burning a village," Engel recalls. "The problem – it was winter in Germany when they were planning to burn down the village film set, but they would still need to shoot another village sequence in the springtime. Our only solution - do the shot in miniature. And, of course, for a minimal budget."

The team created the miniature set out of cardboard boxes and "roofing material" from Ikea. "We bought the wood venetian blinds from the store and used the slats for rooftops," he recalls. "We lined the miniature up to the real village, by using a single frame of the live-action footage, which we put in the camera viewfinder – and then burned it down at night.

"Of course, we had no permits. The police came by and watched us for a while setting the whole thing up. We just waved friendly, and burnt the whole thing after they had left."

Not long after, Roland Emmerich decided to do a big-budget American project called *Independence Day* he phoned Engel in Germany to helm the visual effects.

"Roland's timing couldn't have been better," Engel recalls. "I had already announced my resignation from the teaching position at the film school and started looking for a new job in the effects industry. He sent me the *Independence Day* script and asked me if I knew some talented young filmmakers whom we could include as members of the visual effects team. Eventually, I chose nine students to be part of the team immediately – three more CG artists joined them a couple of months later."

After his arrival in Los Angeles, Engel met his co-visual effects Supervisor, Douglas Smith. "We had a perfect chemistry from the

beginning," he recalls. "I found Doug and I have very similar personalities. Attacking a shot with a good plan, share all essential information with your crew, and of course – no yelling."

Anna Foerster and Philipp Timme, the two camera students, were chosen as directors of photography for Engel's team. The initial idea was to call Timme the "lighting DP" and Foerster the "camera DP." "In the beginning, that split really made sense," Engel admits. "But, after a couple of months when things got more hectic, each of them had their own camera crew.

"One of the earliest shots in the picture involves the Lunar landscape," Engel explains. "Creating that, we needed to see the astronauts' footprints in the moondust and then have them erased when the huge mother ship passes by the moon. This was a very visual metaphor about the possibility of mankind being erased from the planet."

To achieve this effect, Engel and team attached a motor to a small section of the 20-by-20-foot lunar tabletop. "The motor was attached to a separate piece of plywood, and through the high frequency vibrations, the half-scale footprints we had stamped into a layer of quartz sand, were slowly erased. It took model shop supervisor Mike Joyce and crew some time to figure out the right amount of shake – but once it worked, it worked perfectly.

"I bet the next time we see a similar shot in a movie, it was done with a morphing effect in the computer and has cost five times the amount of shooting it for real. Nothing beats the real thing. Besides – it's also more fun to do it that way."

Another of Engel's favorite shots is where the shadow of a big destroyer as it came over the city and enshrouded the Washington Monument. "We wanted to keep it really simple," Engel says. "The 6-foot tabletop miniature was pulled out into the sunlight. The camera was rigged on top of a scissors lift for a perfect bird's-eye view.

"We put a white muslin over a steel frame and then attached it as an outrigger to the roof of our lighting truck. The truck was slowly driven backwards toward the tabletop miniature, and the blocked sunlight cast a perfect shadow.

"Months later, a second unit crew shot some extras from the same angle, running above a part of our parking lot, that was covered with green-screen material. Pablo Helman, our supervising compositor at Pacific Ocean Post, finally combined the green screen people with our in-camera miniature element."

Engel's favorite shot in **Independence Day** is the one of Air Force One, where the President's plane can be seen in an establishing shot in front of a dawn sky with some accompanying jet fighters. "Air Force One is a 40-inch off-the-shelf model of a 747 that was altered a bit in color and design, hung from 0.03mm fishing line in front of a 10-by-20-foot photo backing," he explains. "The jet fighters were 4-inch metal toys and also hung with fishing line. The backing was on dolly tracks and was slowly moved left/right during the shot.

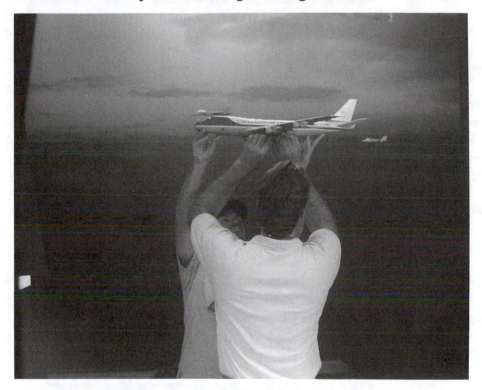

The cheapest effects shot in **Independence Day**. Air Force One hanging from fish line in front of photo backing.

"Anna was operating a so-called zero gravity arm on which the camera was mounted. This device works with counterweights and gives you a free-floating camera. Anna's subtle moves simulated the view from an accompanying airplane.

"Philipp had this great idea of attaching a small lightbulb to the upper side of the camera mattebox, so it would be just out of frame. When - through Anna's camera move – the sun on the backing became visible behind the plane, a technician dimmed up the lightbulb and we

got this beautiful, subtle lens flare – which made the shot look so real. This was right out of the schoolbook from the in-camera effects for *The Right Stuff*."

When Engel is asked about the work on **Independence Day**, the single most mentioned shot is the one over New York – where a destroyer emerges out of a big, glowing cloud. "Besides depending on the expertise of highly talented compositor Conny Fauser, this shot consisted of the following elements – a cloud tank element where a 30-inch wooden destroyer rim stand-in gets pushed through a white cloud consisting of tempera paint, a 12-foot destroyer carried by a forklift and being pushed through a white cloud onstage, and of course a New York background plate."

Another element in the film that captivated Engel was setting up the Grand Canyon (again, but on a bigger budget) for a chase sequence between a UFO and a jet fighter. "We used the whole book of visual effects on this one," he explains. "It's a shot-by-shot mix of real canyon backgrounds, shot by Doug Smith – with composited elements of motion control miniatures or CG jet fighter – and a 15-foot-tall miniature canyon walls with a fighter plane on a bungee cord." (see Foerster and Timme chapters for more information on the above shots.)

Ironically, Emmerich and the crew on **Independence Day** received little or no support from the military on this picture. This made the work harder and more challenging. Engel and his team had to come up with a lot of material that would have been easy with access to military installations. "The only real airplane that was shot for the movie is the crop duster in the beginning," he says. "Everything else is either a miniature, a CG-model, or a wooden mock-up."

"Simple things like pilots running to their jet fighters became effects shots," Engel recalls. "We set up a 10-by-20-foot tarmac tabletop and equipped it with 16 1/72-scale fighter planes – that was all we had. Shot in magic hour in our parking lot, this cheap little setup was later combined by compositor Mitch Drain with running green-screen pilots and dry-ice smoke elements. Frankly, I've never seen more convincing 16-inch fighter planes on a big screen!" (See photo on previous page.)

Even with all the challenges, *Independence Day* was a highly successful picture. The effects were seamless. Even when the events were outrageous, Engel and team brought them off. This was really a "what could be" story – and it was frightening on screen. That balance won Engel (with Douglas Smith, Clay Pinney, and Joe Viskocil) the Best Visual Effects Academy Award for the 1996 feature.

Engel's next project, also with Emmerich, was again a "what could be," but it was couched in myth – an updated version of a classic horror genre film, *Godzilla*. "Only this time we were using all the latest CG technology and a new breed of creative talent for the project," Engel says.

When Engel met with Emmerich and co-producer/writer Dean Devlin, he was told that this *Godzilla* was going to be faster and sleeker. They did not want the creature to move the way audiences perceived the old creature – as an effect. "One of the first things we had to do was determine where the creature would be CG and where it would be miniature," Engel explains.

For Engel and team, the challenge was scale. "The process was different from that in *Jurassic Park*," he explains. "Although that T-Rex was huge, they could still build a life-size dinosaur. Here, there was no way to get a life-size *Godzilla* – we had to do scale models. It was different with the baby zillas; they were about seven feet tall and were built in real size. Because they were so limited in their walking capabilities, they ended up being used for the hatching sequence only. All the other Babies were done CG."

Although it was used very little in the end, there was a 1/6th scale of the upper torso of *Godzilla*. "Even that was huge," Engel recalls. "We did a few shots in closeup on a motion control base, but that was it."

Creating the CG *Godzilla* was fascinating for the effects team. "One of our vendors, Visionart, started experimenting with a motion capture approach," Engel explains. "In the beginning, the results looked quite promising. Steffen Wild, *Godzilla*'s CG supervisor, never believed in that approach, and to his credit I have to say that ultimately he was right.

"Technically, Visionart had a great setup – it was the human movements of the performer, that made it look like a CG man-in-suit. A human spine doesn't work for lizard movements. Steffen built an amazing CG-*Godzilla*, which became the movie's lead actor. He incorporated more than 500 expressions, meaning the skeleton was fully interactive.

"If an animator moved the head and neck, this translated down to the movement of the tail or the legs. Andy Jones, our young animation supervisor, did the animation for half the *Godzilla* shots in the whole movie. To me these two guys and my associate visual effects supervisor, Karen Goulekas (*Apollo 13, 5th Element*), who led us through the digital jungle, are the true stars of the movie."

To Engel, many of the interesting shots did not involve the creature. "I have my favorites and my not so favorites," he admits. "If it had been my call, I would probably show the opening sequence with the ship capsizing a little longer.

"Of course, this might be because of the amount of work involved in getting the effect right," he adds. "This was one of the trickiest sequences – and it was done in the first two weeks of the effects schedule. Anna Foerster did a great job on camera, even with all the difficult circumstances we had to deal with – night, wind, rain, waterproof equipment and a remote shooting location." (See Foerster chapter for more details.)

Engel was present during the New York location shoot at all times. So much of the success of the difficult shots was calculations on the part of first team and effects. They worked extremely closely. "When D.P. Ueli Steiger shot the live action on the Grand Central Station sequence where Hank Azaria stands firm and *Godzilla*'s foot comes down, in a near miss – it all became a question of positioning the camera and the actor," Engel explains.

"I would sit with Roland in front of the video monitor and discuss the camera angle. He would explain that he wanted Hank to stand between the toes and said to me – 'Now you tell Hank where to stand, so the measurements with the CG foot will be dead-on.'

"Of course, I had to use my imagination – but that was enough this time. We taped a white cross on the asphalt, so Hank knew his position. What I especially loved about it was that in a shot like this Roland would also trust me with the right amount of stage fog blowing through the scene. With too much fog in the foreground, it becomes a pain to insert the creature later. So after everybody was on their marks, a hundred crew members were staring at me – and when I yelled OKAY!! Roland would say 'Roll cameras' and the whole circus began."

Besides this background plate, a lot of elements had to be filmed to make this shot complete. "When *Godzilla*'s foot comes down, it smashes a couple of taxicabs. For that effect we shot two real cars being squashed by a 12,000 pound weight. The cars were set up in front of a green-screen in our parking lot, and the weight was simply dropped from a 50-foot crane." Other elements included water splashes for the impact, shot against black, and some miniature taxis to fill up the background.

"Our in-house CG effects team came up with the buckling pavement and the flying asphalt debris. The hardest part for me was to give them an idea for the scale – so the CG elements would look massive and not like a tiny model."

After Roland Emmerich okayed the impact deformation of the CG foot, compositor Mitch Drain got all those elements on his Inferno™ and did the final composite.

Some of the shots Engel likes the best on this picture are the ones that are simple and elegant. "There is a scene where cars are hopping up and down as *Godzilla*'s power hits the ground," he says. "To do this, Clay Pinney, and his practical effects team, rigged two dozen cars with a pneumatic device that made them jump on cue. When we see a building collapse in the background of the same scene, that is a 1/24-scale green screen element of some piles of rubble being pushed off shelves by stage technicians with brooms."

For Engel, the Brooklyn Bridge shots in *Godzilla* are the most powerful and tricky. "There are two that stick out in my mind," he says. "The first is where the head of *Godzilla* breaks through the street. We see a POV of our heroes in a cab. The challenge here was to create the shot completely in miniature, and to have the correct depth of field and frame rate." (See Foerster chapter for more information on this shot.)

The second bridge shot was where *Godzilla* breaks through a tower in the end. "This is where *Godzilla*, after jumping on the first

tower, breaks through the second one and gets entangled in the suspension cables," he says. "This incorporated the best of both worlds – miniature and CG. The tower was a six-foot-tall 1/24 scale miniature built by Mike Woolaway at Cinnabar.

"First, we were ramming a green screen colored metal *Godzilla* through the tower and shot it with high speed. In postproduction, the CG-*Godzilla* took over the place of the metal one. A lot of frame-by-frame rotoscoping was still necessary to extract all the falling debris and get it in front of the creature. Software specialists and Centropolis Effects worked long nights to create the CG cables that had to interact with the creature's movements. And, of course, everything had to look wet."

Engel admits that he likes being onstage working with a large crew better than spending long hours in the CG realm. "It's all part of the process, though. I like to refer to CG like I refer to miniatures and a camera – it's just a tool. It's the hammer that knocks the nail in. In the end it's all about the team that uses these tools. If they know what they are doing, if they see the big picture and are able to communicate their opinion, that's where the fun starts."

". . . I am not embarrassed to ask 'stupid' questions because their answers influence my (creative) decision about how to do or not to do a shot. I think, if you can prevent reinventing the wheel and prevent making some of the same mistakes others made for the last 50 or so years, you have more time to work on new solutions and new mistakes."

Anna Foerster

When Anna Foerster was 16 years old, she announced to her parents that she wanted to be a DP. "My baby-sitter was a film student at the time and did his film short in my parents' garden," she explains. "I saw the DP work with the director, electricians, and grips, and I was impressed. Next thing, I wanted to leave school to become an assistant cameraperson/clapper loader."

Of course, Foerster's parents were concerned. They wanted their daughter to get an education. So, they made her a deal. They would write excuses so she could work in the industry at times, as long as she finished school. She started on no-budget and low-budget films, first as a clapper/loader, then as an assistant cameraperson. One of the first projects she did was ***Moon 44***, with Roland Emmerich and Volker Engel. It was before her soon-to-be effects teammate on ***Independence Day***, Philipp Timme, joined the team.

"My teachers were a little suspicious – so many 'sick notes,'" she says. "Then, when they saw my credit in a short on television, well, it was a little embarrassing."

Foerster finished school and began working at the "Filmhaus" in Munich, Germany. At the time, this was the leading commercial production house. After a year and a half, she applied to film school in Ludwigsburg, Germany. "Philipp Timme was a fellow student and Volker Engel was teaching animation," she says.

It didn't take long for Foerster to get into the thick of things. In Germany at the time, there was a great deal of film production, but very little in visual effects. "I was fascinated by the work environment,"

she recalls. "It was a bunch of young people working together in an old abandoned factory, dealing with Fullers Earth, smoke, pyro, high-speed cameras, scale issues, depth of field, and all that exciting stuff that goes with effects work.

"When Roland brought Volker to the States for *Independence Day*, Philipp and several other's of his team went along," says Foerster. Engel, Timme, and Foerster did the stage work. Conny Fauser and Hartmut Engel dealt with postproduction (CG and compositing)." Engel and Emmerich brought close to a dozen people with them when they came to the States for this film.

"I remember walking into the Hughes Airport facility, Hangar 45, in Los Angeles," she recalls. "It was *Moon 44*, only bigger in terms of budget, crew, and equipment. I was concerned – would this crew accept a woman, whose English wasn't that strong yet? And who wasn't familiar with 'the Hollywood way'?"

That wasn't a problem. Foerster was quickly accepted. Her expertise in visual effects showed. When she didn't understand, she found the crew was extremely willing to bring her up to speed. Her first days with people like Jeff Sturgill and gaffer Roger Sassen set the tone and began another long-term relationship. "The crew made me understand, very early in the game, that the responsibilities of each crew member are clearly defined. This is very different from Germany, where, for example, the line between grip and electric is very flexible.

"They made me understand, in a friendly but definite way, that it is not part of my job to move a light, change a filter, or fiddle with some cutters. That opens a space in your mind for ideas and creativity. Before, I could be afraid to a certain extent because I was chasing the illusion you get that when you do everything yourself, you are in control.

"Jeff Sturgill has an enormous background in dealing with high speed cameras that means he came across all kinds of camera problems that had to be solved from a technical point of view.

"Gaffer Roger Sassen played a big role in the way I developed and expanded my performance in lighting a set and evaluating the necessary time and equipment requirements. We have done very different projects together (*Godzilla* and *Pitch Black*).

"Jeff and Roger are some sort of temperature gauge, when I come up with some wired, crazy idea and I am not absolutely sure it is going to work. It is their reaction that, most of the time, gives me a pretty good idea if we can go for it, or if I should stick with a

conventional solution. I trust them; that is why I am not embarrassed to ask 'stupid' questions because their answers influence my (creative) decision in how to do or not to do a shot. I think if you can prevent reinventing the wheel and prevent making some of the same mistakes others made for the last 50 or so years, you have more time to work on new solutions and new mistakes."

With relationships solidified, Foerster began working on the mega-budget *Independence Day*. "The film involved every kind of effect imaginable," she says. "We had motion control, cotton clouds, pyro, high speed, forced perspective, plates, tiny setups, cumbersome miniature sets, and of course green/blue and orange screens, and even cloud tank photography."

Foerster and Philipp Timme already had experience in cloud tank photography. Before they got the okay to come to Los Angeles for *Independence Day*, the two were on hold. "We couldn't take another job in Germany because we had promised to be available for Roland and Volker. We were also waiting for our work visas to be approved," she says. "So, we built a little cloud tank lab in my mother's kitchen.

"We knew the script and figured cloud tank photography could be the solution to the shots where the destroyer ships enter the atmosphere. At that point, we thought that the cloud tank could even be used for parts of the destruction wave.

"This one was later done with high-speed pyro photography.

"We experimented in that two-by-two-by-three old fish tank, with all kinds of different layering techniques or the water (saltwater/ freshwater/ cold water/ warm water/glycerin). We studied the different pressure techniques and consistency of the injected color. It was pretty messy, but we took pictures and made a Super 8mm film, at different frame rates, and sent it to Volker, who was already in Los Angeles.

"Because of this, by the time we arrived in Los Angeles, we had an idea of what would work and what didn't, and in what direction the look should go.

"Of course, by the time we shot the sequence, the fish tank was much larger, and the film was 35mm."

There were two big air fight sequences in *Independence Day*.

"The whole air fight takes place between an 18-foot diameter tabletop with desert mountain ranges and a 12-foot model of the destroyer ship. This was motion-controlled, rotating 12 inches over the model.

"We had to squeeze a camera and two axis motion control heads into those 12 inches, to simulate the fighter planes.

"We ended up with a so-called 'low profile' camera," she says. "Only two of them exist. They are seven-inch-high Mitchells cameras and are custom-made."

Even with these tools, the crew had to literally move mountains for every shot, to allow the camera movement without crashing in the model desert.

"Lighting was a challenge," she says. "We had two rows of 12 or so Leko lights. One row was raking in very controllable narrow streaks over the mountain tops. The other row was lighting the underside of the destroyer.

"Around one side of the round tabletop, we had a sync with painted sky. This was lit from under the table by conventional strip lights. The tricky thing was to hold the lights out of frame and lens because we were shooting underneath the model with as wide as an 18mm lens. The camera was moving, and of course, everything had to have that backlit look.

"As good as the Leko lights were to accentuate the mountains, the downside was that they created beams through the heavy smoke necessary to create a sense of perspective.

"It is great to have all those toys available," Foerster concedes. "However, there are times when you can forget or lose sight of the really simple solutions.

"For example, on the big destroyer model, which was 25 feet and more like a wedge or slice of cake (see photo on preceding page). Some of the movements of the destroyer were done with a motion-controlled camera. We simply could not move the model. It was too big and too heavy.

"That meant the key light, simulating the sunlight, had to be moving during the shot so it appears that the model is moving in relation to the horizon. Theoretically, we should have motion-controlled the key light. Instead, we mounted the key on a doorway dolly and our key grip George Palmer pushed it on a given line and in a given time.

"It worked for this shot, and the producers liked the effect. Especially since they did not have to order more equipment!"

For Foerster, it is often about finding the right camera speed for the model size, especially if the camera moves and there are lighting cues involved. "If you shoot small models and elements, you have to decide at what frame rate to shoot," she explains. "There is a formula to calculate the frame rate for a certain scale or speed. But, in real life, it is more about finding the best compromise. The way to hold the model and the scale, without slowing down the action.

"This is especially tricky for models combined with fire or flames and for small-scale models in water. I guess this is some kind of unsolved visual effects problem at times.

"Shooting the fish tank sequence for *Godzilla*, for example, gave us the exact same problem. We had to shoot a 32-foot-long model ship in the water. To make the water appear in the right scale, we should have shot at around 96 frames per second. But man and equipment can reach a limit, very quickly.

"The camera was mounted on an Akela crane that had a definitive arm length. The idea was to simulate a helicopter shot over the model ship. At 96 frames per second, the camera move would be relatively fast. For example, on the screen, if you want to travel over the ship in five seconds, shooting the action at 96 frames per second means the camera move in real time would be 1.25 seconds.

"That is nearly impossible for the remote-controlled camera mounted 35 feet over the water, being blasted with 35-knot winds from the Ritter fans! Operating at such a speed in those conditions was dangerous. I believe pushing equipment to its limit is sometimes the

only way to get the shot. But you definitely don't want to have a crane go out of control.

"After modifying the move, the next step was to compromise the frame rate," she explains. "On *Godzilla*, we ended up shooting at 60 frames per second.

"There is another ongoing struggle," she adds. "That's depth of field and exposure. Many sets have an enormous depth. A street, for example. You want to hold a certain amount of focus from the foreground to the background because otherwise you give the model away. You have to consider a certain stop, to keep everything in focus.

"Of course, for every additional stop, you basically double your light order. And, production constantly tries to convince you that holding focus is not as big an issue as the lighting bill."

Smaller sets often require high shooting stops as well. "If you are already between a 16 and a 22, for example, just to hold focus, and then shoot at high speed – let's say 360 frames per second, to get the right impression of scale – you have to compensate for another five stops.

"Very quickly, you are looking at a couple of 18K HMIs as key light – and that is on a model.

"After you are done lighting the whole set with all the fill light, the persnickety practicals, reflections, lighting effects, and so forth, you have to be careful not to melt the set! And it happens: warping facades, bending streetlight poles, cracking spaceships."

Sometimes it is much more convenient to take a model outside and use the sun. "Most of the time, that gives you the time stop you need, and it has a very 'natural' look," says Foerster. "You don't have to deal with light 'falloff' that is always an issue when lighting a big set at a high light level.

"On *Independence Day*, we took the 40-foot-long Grand Canyon model outside. It consisted of several wild wall pieces that could be arranged differently for each shot to give the impression that we are in a different part of the canyon on each shot.

"What we had to figure out was where to position the model in relation to the sun, for the time of day, that was ideal to light the inside of the canyon for a backlight situation.

"We always had the camera a little bit to one side of the model, so we could have gaps between the separate wall pieces that allowed the sun to rake a little deeper in the canyon. We could then position 6k HMIs, if necessary.

"The critical thing with taking a model outside was timing," Foerster explains. "There is only a very narrow time frame where the sun is in the right position. And you better not miss it.

"Some of the shots we did in the canyon model were pretty complex in terms of rigging and timing. One shot was storyboarded as a point of view of the fighter pilot. He flies through a narrow part of the canyon, followed by the alien attacker ship. The ship shoots at him, misses, but hits the pinnacle ahead of the fighter plane. There is a big fireball as the pinnacle falls, and the fighter plane just makes it through the falling pieces.

"The believability factor was zero, as director Roland Emmerich use to say with a boyish smile," laughs Foerster. "Being a pilot myself, I realized how far-out these flying sequences are, but that is half the fun!

"To get this 'believability factor zero' shot, we decided to mount the camera on a wire that was spanned through the length of the model. To do that, we had to strip down the Arri-3 to the bare-bones minimum. This reduced the weight. We then wrap it in a fire-retardant cloth.

"A bungee cord was then attached to the camera. A trigger attached to the tension cord released the bungee. This launched the camera, which went down the wire toward the pinnacle at about 50 miles per hour.

"On the way the camera triggered the pyro and the falling pinnacle by passing over triggers.

"You can imagine that this took quite some experimenting with the timing!

"Another challenge was to stop the camera in time before it crashed in the dead end of the model. We solved that with the same principle – a bungee slowed the camera down after passing the falling pieces, and some foam donuts attached to the wire brought the camera to a more or less soft but safe stop, inches from the canyon wall."

Another example of taking a miniature outside was a similar shot in *Independence Day*. "Here, dozens of fighter pilots are supposed to walk to their planes in a slightly overhead shot," she explains. "And, it is early morning just before sunrise.

"The problem – they wanted to see the huge part of the airfield. Live action had a lot of extras as fighter pilots, but no fighter planes except one F18 mock-up. This was used for a closer shot, where Will Smith is climbing in the cockpit. So, we took the model piece outside and used the natural light.

"We arranged the F18 models and a piece of the control tower with all kinds of antennas in the foreground and part of a lit taxi way in the background.

"You should have seen Volker personally arranging little air compressors, maintenance charts, miniature work lights, etc. It was a pretty neat-looking playground.

"When doing something like this, it is important to take exact notes on a shot. It is only an element, and there will be other parts added later to the shot. Sometimes, it won't be the same unit shooting the next element.

"Later, when the live action pilots had to run over an empty field to their imaginary planes, they have to line up perfectly. There are a lot of things that play an important role besides the light that have to match – lens, stop, camera height, tilt angle – all in relation to the set.

"Mostly, the different elements have a different scale. That means you have to translate measurements for different set-ups. In the above example, full-size people in a scale model, with bigger-than-life-size smoke elements had to fit underneath the miniature airplanes, for the final shot.

"Sometimes, it is not possible, or rather it is not in the budget, to shoot elements that line up perfectly," she explains. "There are ways to cheat, by using different lenses and so on. But, it always comes down to the fact the more you cheat and compromise that the more they have to 'fix it in post.' "

Foerster's experience on *Independence Day* also introduced her to the fascinating and complicated world of pyrotechnics. "I had done some rather generic pyro shots in Europe, and I thought I knew all about it," she laughs. "But then I met the 'king' of pyro – Joe Viskocil. He opened my eyes to a whole new dimension of fire work.

"One of the first things I realized was that there are many more different kinds of explosives and fires than I had seen before. Toward the end of *Independence Day*, we were experimenting with some new techniques and combinations of explosives. We continued that experimenting at the pyro shoot for *Alien Resurrection*.

"They brought us in to shoot the explosion of the spaceship as a seperate pyro element; they also needed some generic pyro elements that were still missing in the movie. There was no clear concept about the look for the explosions. They said something like 'give us some different stuff to choose from.'

"Great!! Joe could hardly contain his smile. He said 'different stuff, okay, sounds good.'

"We had some fun! And, they got what they needed for the movie. We walked away with some valuable notes. I've promised Joe that I would not give away his secrets – and I don't want trouble with the king of pyro!

"But, there are things that everyone knows," she adds. "Even if you know the exposure difference between 'Benny,' gasoline, magnesium, rubber cement, gas and all, there are those secret mixtures. There are many more factors that play a role in how to shoot a pyro shot.

"The way the flame develops, and the brightness changes with the environment you are shooting in, is a factor. Then you need to know if you are adding oxygen. Are you shooting overhead, down to the explosion, or are you looking from underneath? What is the scale to be?

"It is important that you know what kind of pyro will be used before you start lighting a set. The brightness and size of the pyro determines what stop you have to light the set to.

"A big issue is how not to cook the camera. Either you are so close to the set or you are overhead and the flames are engulfing the camera. Of course, everyone has to clear the set for the explosion, but you still have to make sure the camera is safe and ready to go, especially at high frame rates.

"There is a lot involved to make sure the camera runs properly, as well. The time between leaving the camera and the action always seems to feel like forever because you can't get back in there, and you can't change anything once it is set.

"In my head, I always see the worst-case scenario – camera doesn't run, lights get bumped, something moves in front of the lens. Then there is the area – is it black enough, or will the fire light up all the rigging? Did we calculate the frame rate right? Does the focus hold, as good as you expect? Did I pick the right exposure? And so forth.

"Then, after the big bang, everybody is glued to the monitor and tries to figure out if it was a good take or not.

"Only if you use a high-speed playback, an you get a pretty good idea of how the timing worked and if the pyro developed as expected.

"The hour of truth is the next morning at dailies. That is when you see every little detail you don't like.

"If the decision is to 'go again' do it but, differently. The film gets thrown on the Kem and we start analyzing the take frame by

frame, playing it back and forth, counting frames, looking at details. Then, every department makes adjustments. You walk away from the camera with the same worst-case scenario in your head . . .just a little worse, because it is take two.

This was great preparation for Foerster's next big film, *Godzilla*. "We were prepared for fire, any kind of fire," she says. "Joe and I had taken great notes, from *Independence Day* and from the *Alien* tests. So, when we got to the fire sequences in this film, we were prepared!"

When asked what shots in *Godzilla* stand out in their minds, both Volker Engel and Anna Foerster will talk about the opening shots, with the fish tanker. "This shot is opposite the ones where we were in fear of melting the set, putting in so much light on a miniature," she says.

"Here, we were fighting the cold and wet environment.

"This was a really challenging sequence," she admits. "And, we shot a lot more footage than you see on the screen. But that's what always happens. Edits have to be made. And, it is usually on the shots you seem to work the hardest on."

The miniature was set up in a water tank, in the Acton desert. The model was 35 feet long and mounted on hydraulics, which were under the water. This simulated the capsizing. "There were three 400-horsepower Ritter fans blowing the spray on the set," she explains. "That meant, of course, right at the cameras and the crew and the lights.

"One of our biggest concerns was to keep the cameras dry, and the filters and the rain deflectors from fogging. Also," she adds, "we had to find a way not to blow the lights up in that 'weather'!

"We spent hours in wet suits at night, in the desert, in a water hole that was constantly being blasted with waves and rain! Key grip Tony Whitman did an amazing job rigging and securing equipment and crew.

"That's when you realize you are working with the right people," she says. "You have to learn to trust them. They hang in there with you. No matter what the pressure!

"You have to imagine this model has tons of detail, light fixtures, fittings, and ropes. There were also cables, antennas, and more. There was one shot where the ship sinks. It is supposed to be the point of view of someone on the ship.

"We had to mount the camera on the deck of the ship. Because it was so damn cold, we were wearing those waist-high fishing boots over the wet suits. And it was one complicated dance to work on the ship deck without breaking everything on it.

"The model crew must have hated us!

"I ended up operating the camera, secured with a rope, so I didn't sink with the ship!"

Evidently, working together under such pressure really does make creative minds such as Foerster's and Engel's go in the same direction. Prodded to come up with another tricky, interesting, and fascinating shot in *Godzilla*, and both will promptly go to the Brooklyn Bridge sequence.

"The bridge sequence consisted, from a shooting point of view, of three different approaches – the collapsing tower, the 1/6-scale piece, and the 1/24-scale bridge.

"The collapsing tower was a typical element shoot.

"The 18-foot tower was built with many different materials, and had to be literally soaked before the take. That guaranteed a realistic looking crumble of the blocks.

"Godzilla was a metal construction that had the shape of Godzilla, when he breaks through the tower. The whole setup was shot in front of green screen, and the metal Godzilla was painted with digital green as well. He slammed in the tower precisely controlled by pulley cables and weights, riding on a track.

"The 1/6-scale bridge was combined with the 1/6-scale Godzilla head in front of green screen; this was pretty straightforward in terms of shooting technique.

"The time-consuming thing was the whole setup. We are talking of roughly a 12-foot-by-30-foot model, which had to be rigged 18 feet off the ground. That was the neck height of the 1/6-scale Godzilla.

"When the bridge actually breaks down and the radio-controlled 1/6th scale taxicab just makes it by jumping off the falling part (another believability factor zero shot), we shot that in-camera.

"That meant that we had to make the space behind and underneath the bridge into a foggy, rainy New York night, with the lights of the shore creating a warm glow in the fog.

"We did it the 'poor man's way.' We smoked the stage heavily and shot in the 'limbo.' We didn't actually see the other side of the shore, but we could 'feel' it was there because of the city glow in the smoke.

"The fine mist that drizzled in front of each camera setup helped the illusion. It now came down to a matter of timing between the mechanical effect, the cab driver, and my camera move following the flying taxi.

"The rather tricky shots we had on the 1/24-scale bridge. The set consisted of the 150-foot-long bridge that was assembled lengthwise in Hangar 15 at the Hughes Airport. The rest of the space in the hanger became our 'limbo' – smoke, city glow, and neatly arranged Christmas lights as city lights. We also had a 1/24-scale building facade in the immediate foreground. This actually lit the bridge itself.

"We had to build a catwalk about 60 feet high to hide the 18ks. One of the shots was supposed to look like that – point of view from inside the taxicab. We were driving fast on the ramp of the bridge, passing underneath the street sign. This tells us we are driving toward Brooklyn. The taxicab then slows down and comes to a halt just in front of Godzilla's head. It breaks through the street from underneath the bridge.

"The idea was to shoot all that in one shot, in-camera. The challenge was to first of all bring the lens close enough to the model street, as if we were sitting in a car. Then we had to take care of the focus problem. We are talking five inches in front of the camera to infinity.

"Both those issues, we solved by using the Frazier lens from Panavision. The ability of physically putting the lens lower than the camera body by rotating the mount solved the height problem. The slant focus lens made the depth of field work. This is a pretty amazing piece of equipment," she says.

"The next thing was to build a sloping ramp next to the bridge, so the camera could 'drive' down the street. The street sign had to be yanked away in the split second between clearing the lens and getting destroyed by the camera.

"The fun part of this shot comes now – the breakthrough of Godzilla. We wanted to shoot at 200 frames per second. but it would be impossible to accelerate the dolly with the camera to a speed where we would still think the taxicab is racing over the bridge. The solution was to start the shot at 48 frames per second and accelerate the dolly, while the frame rate increases steadily to 200 frames per second.

"So, when the camera move gets slowed down and comes to a stop inches away from the 1/24-scale Godzilla head breaking through the street, the frame rate reached 20 frames per second.

"This involved some technical finesse because changing the frame rate requires a constant and precise adjustment of the stop. So camera assistant Jeff Sturgill modified the 'Preston Speed aperture computer' with Howard Preston's help to fit the Photosonics™ high-speed camera 4ML with the Fraser lens. It was to be controlled manually during the shot. It is a great feeling if everything comes together and you realize your idea is finally on film.

"That is once again a team effort.

"The last touch as two MR11 lights that we mounted directly on the lens. This way it seemed the taxicab headlights were throwing their beams on the wet street ahead.

"The great thing about shooting for visual effects is the broad range of the field – one day you spend counting frames and lighting with peanut lights; next day you shoot a full-size fishing boat that gets dropped from 50 feet by a crane. One day you shoot miniature tanks firing, next day you are looking at 25 'full-scale' soldiers that shoot their machine guns at you. If you wonder one day about how slow things go (motion control, for example), next thing you know, you're shooting something that moves faster than you can keep up with."

Foerster's next big effects project was the 1998 feature *Pitch Black*, directed by David Twohy. Although the major shooting units were located in Australia, the Chandler Group was contracted to do the effects in the States. A company called HGI developed the models for the different shots. "It was an interesting way of working," Foerster comments. "We would be shooting 5:00 AM to 5:00 PM, then the film got rushed to the lab. The negative was transferred and then sent via satellite transmission to Australia.

"I tell you, it is not the greatest feeling to know that the director and the visual effects supervisor Peter Chaing see the dailies before you do," Foerster admits. "A lot can happen between the States and Australia! And, with a negative transfer in the middle of the night! The communication was essential, especially because some of the setups for the crash sequence on a foreign planet, with several suns, were lit in really saturated colors!

"The reentry shots got an extremely hot and over exposed look, at times.

"We were always concerned that someone at the lab, working at two in the morning, thought he should correct the weird colors and dial the overexposed stuff, to save me. Fortunately, I don't think that happened!"

By 4:30 AM miniature supervisor Ian Hunter, miniature producer Scott Pourroy, and Foerster were waiting for the call from Chaing, the VFX supervisor on location in Australia, to review the work via Internet or television/telephone transmission.

For Foerster, there are several sequences that are both interesting and challenging on **Pitch Black**, which is the story of a group of marooned space travelers struggling for survival in a seemingly lifeless sun-scorched world.

"There were some rather conventional motion control moves that we had to do," she says. "However, the really exciting things came 'in-camera'.

"For example, the reentry of the craft had to be really violent. The camera was rigged on a three-axis head from a jib arm. This gave us the range of movement the audience would expect from an air-to-air shot.

"The nose of the craft was rigged at an angle.

"The nitrogen blasting out of several hidden nozzles in the model moves around the contours of the craft by at least seven air movers. This gives a feeling of direction and speed.

"The antennas on the tip of the craft are supposed to start glowing with heat and then crumble away," she adds. "Every light source from the outside would have mainly lit the nitrogen, so to make the antennas glow, we had to find a different way.

"Ian Hunter, the miniature supervisor, let his model crew build a layer of Scotchlight™ material on the antennas. It was the leading edge of the craft.

"Gaffer Roger Sassen built a ring light out of MR11s, with two circuits on a dimmer. The lights on the first dimmer were gelled with orange. The lights on the second circuit stayed white.

"So, on cue, the orange part of the ring came up slowly, giving the treated edges a subtle glow. Then, the white part of the ring light overpowered it, until the antennas were four to five stops over-exposed before they crumbled.

"During the take, we moved the camera and were shaking it to get some roughness.

"Back in Australia, they weren't totally sold. They wanted it wilder. More violent! So, we shook and wiggled and rattled that camera as much as four men physically could!

"The next day, they liked the concept, but they wanted it – again – much, much more violent!

"Okay, we had to come up with something a little more nasty!

"Conventional lens shakers are great for live action. They give a good sense of speed and movement. But, even the fastest shaking speed on the dial wouldn't have done much for us because we were shooting at over 60 frames per second.

"Key grip Pat Van Aukan built two really 'bad' machines. He replaced the saw blade in a saw with a welded on metal rod. And added an air-powered orbital sander, welded to a metal rod. The rods got mounted perpendicular to each other.

"Imagine, two grips holding onto those mega-shakers, fighting each other in direction – with me holding onto that camera on the jib arm that wanted to go everywhere but where I did!

"It was literally lifting me off the ground! It was out of control – and they loved it!

"Of course, we were concerned about how the old Mitchell camera would survive. But, the steadytest was as steady as it could be, given the circumstances.

"It is probably not the best shot we did for **Pitch Black**, but it sure was violent!

"Sometimes," Foerster adds, "when you are not really involved in a project and you come in only to shoot some green-screen elements, you barely know where it belongs.

"You don't have the whole picture in your head. It seems rather meaningless. But, then, for example, there is this great little shot next week!

"The titles for a movie – over 90 seconds – all in-camera. Tilt down from cotton clouds to a night desert landscape, as you are driving along a road. Las Vegas, in the distance as you move around 16 or so Billboards with the titles.

"No tweaking it in post.

"That's exciting stuff!

"That's what I love about visual effects photography.

"It is the range of uncharted territory.

"Every time you start a new project, it is almost something like an expedition. You are as prepared as possible. Go with the right people. Take the best equipment affordable. And, try not to lose sight of your plan – when you get stuck in the jungle!"

"In the end the choice is made in the best interest of the client. What's going to deliver the best bang for the buck? You shouldn't decide to use a particular technique just because that's a technique you want to use; the choice should be made on the basis of what can most efficiently deliver the client the image he's looking for."

John Knoll

It is a long way from creating clay stop-motion movies in his basement to head of the team on the very secret futuristic effects on *Star Wars: Episode I*, and John Knoll is enjoying the ride. "I was really fascinated with what could be done in those 'crude' stop-motion effects I created as a kid," he admits. "However, even then, I didn't think this kind of work would be a potential career. That is, until 1977 when *Star Wars* came out and everyone saw the potential of effects in the movie industry."

A year later, his father – a professor at the University of Michigan – attended a conference in Anaheim, California. The young movie buff hitched a ride. A call to Grant McCune, the then head of the model department at the fledgling ILM (then located in Van Nuys, California), invited him for a visit. "For a 15-year-old, it was better than a kid in a candy store," laughs Knoll. "I spent a whole day watching dailies, seeing shooting on the stage, the model shop. It had a profound effect on me."

Knoll went back to Michigan determined to get into the industry. "I still wasn't sure doing things that I read about in *American Cinematographer* could be a real job, but I was determined to try," he says.

Knoll got into USC and, while studying film, gained a rounded education in moviemaking. While doing a final project in the animation department, he became hooked on this phase of effects technology.

His lessons in animation led to Knoll's first real job as an animation camera operator at ILM. In 1986, the state-of-the-art effects

on movies like his first project, **The Golden Child,** were by slit-scan photography on a motion-control camera. For three years, he created images for movies like **Willow** and **Innerspace**.

"While we had a fledgling computer graphics department, the software we had in place at that time wasn't especially user-friendly. We didn't have very good modeling tools, animation tools, or lighting tools. Creating an element in CG at that time was a lot more like writing a computer program. It was very slow, indirect, and completely non-interactive. Because of this, CG was used only occasionally when it was the only option. The department was pushing forward, making the tools better. But, in the mean time, ILM produced work using the tried-and-true techniques of miniatures, motion-control, matte paintings, puppets, blue screen elements, and optical compositing.

"I spent a lot of time working on a motion-control animation stand. It consists of a camera on a motorized boom, pointing straight down onto a light table that itself had a number of motorized degrees of freedom. It was a very flexible machine. We used it for all kinds of things.

"We would rephotograph film elements on a 'pin block,' a motorized camera movement with a backlight and take-up spools. With it, you could treat a piece of running footage like any other piece of artwork, moving it around in frame.

"That's how we did many of the shots of the 'Brownies,' the 12-inch tall characters. They were shot as blue screen elements on stage, and then we re-photographed the elements on the animation stand, moving them around in frame to match the movements of the background plates.

"I shot a lot of slit-scan elements on that machine, everything from the *Star Tours* hyperspace effect, solar flares for **Star Trek 4**, the THX logo 'tunnel,' the 'warp drive' star effect for **Star Trek: The Next Generation**, to twanging ropes in **Willow**."

In the late 1980s, Knoll found himself working on one of the first movies to feature computer graphics – **The Abyss**. "It was awkward and tedious," he admits. "We didn't have enough throughput on our input scanner or enough on-line storage space to composite the shots digitally, so the pod elements were filmed out with a matte, and the composites were done on an optical printer."

At times, this approach was not practical. "On an optical printer, it's very difficult to composite a shot where some mattes are hard and others soft in the same image. In particular, we had a shot

where the pseudo-pod is severed by a closing door and falls down in a splash on the floor.

"Because of the mixture of hard mattes and soft splits needed, digital compositing was the only real option. This was harder than it sounds. At the time, computer disk space was at a premium. We had three disks for picture storage, each 300 megabytes. That wasn't enough space to hold all of the background images for the shot. We had to keep the backgrounds off-line on Exabyte tape. The composites were done on a Pixar image computer.

"Our Pixar only had 8 megabytes of RAM, not enough to hold both of the two Hires images necessary to perform a composite. Our solution was to composite only half of the frame at a time. We had an elaborate script that would read a background frame from one tape drive, configure the Pixar frame buffer memory to be the width of half of a Hires frame but the height of two Hires frames, perform the left half of the frame composite, save that as a temp file, perform the right-side composite, save that as a temp file, reconfigure the memory of the Pixar to the full height and width of a hires frame, read both temp files into the frame buffer to make one complete image, save that to disk, write that image to a second tape drive, clean up all of the temp files, and then start the process again for the next frame!

"One of my first tasks on *The Abyss* was to capture reflection environments," he continues. "The idea was that since the pod reflects everything around it, we needed to photograph everything around it.

"For each setup, we had to photograph the set from all different directions – not easy, since as a working set it was crowded with lights, c-stands, grip equipment, and dozens of busy crew members hurrying to complete the current setup or get ready for the next.

"It was not really practical for me to ask everyone to clear the set and wait for five minutes while I took my stills each time, so I would just get what I could when I could. Often this meant having lights, stands, and crew in the stills. Most of the time the set was only lit for the particular direction we were shooting, so I had to photograph the set in pieces as we shot the coverage.

"Once all of this raw material was collected, we scanned it all into the computer, and I used a beta version of Photoshop™ to stitch all the stills together to make clean seamless reflection environments."

By 1990, Knoll's knowledge of the new computer system and his grounding in animation work led him to become visual effects supervisor for a movie called *Space Invaders*. "Our biggest worry was

how to deliver 56 motion-control shots without an optical printer as cheaply as possible," he laughs. "Today we could have done the work with a simple desktop computer faster and cheaper.

"For reasons of cost and efficiency, I was trying to avoid shooting separate elements that needed to be composited on an optical printer. I put all of the shots together in-camera, winding the film back again and again, and double-exposing all of the passes onto the same piece of film. While this approach is a bit tedious, the advantage is that when you are done, you send the film in to the lab, and a finished shot comes back. The disadvantage is that any mistake at any point in the process will ruin the shot. That's especially frustrating when the mistake comes late in the process, say after five hours of complex shooting.

"Sometimes it's more complicated than simple double exposures. I had one shot, which was of the Martian ship flying through an asteroid belt," he recalls. "Because of all of the machinery required to move the asteroids and ship, I couldn't just put a starfield behind all of that on the stage, since stars would disappear behind all of that machinery and spoil the effect.

"Still trying to avoid an optical composite, we shot a matte for the asteroids and ship on black-and-white, high-contrast film. The matte (clear with black areas where the ship and asteroid were) was developed, and bi-packed in the camera with unexposed color negative film.

"The starfield was photographed through this matte, so it didn't expose where the ship or asteroids were. The matte was removed, the film wound back, and all of the normal color passes were double-exposed onto the film.

"Of course today, shots like this would be done on desktop computers faster and cheaper. In *Star Trek: First Contact*, as an example, we had a huge battle scene with a starfield and armada. All computer graphics. The only thing we did in miniature was the Borg cube.

"The reason? Even with the technology, we found that it was faster and cheaper to build the model than use the computer time.

"When do you use a model and when do you use computer graphics? The choice is not always obvious. Sometimes the nature of the model itself dictates the technique. If the model has to change shape or has complex articulated parts, it's probably better done as CG. If it has to crash or explode, perhaps a miniature is better.

added to a live action scene and made to look real," he continues. "Here, we photographed actors in front of a blue screen and created the entire environment around them. This is the first large-scale and realistic use of the 'digital backlot' that is expected to play an important part in the future of filmmaking." (See Doug Trumbull's chapter for further information on this digital backlot.)

The next problem Knoll faced was how to know what to shoot. How do you compose a shot when the most important compositional elements are going to be added later? How fast do you tilt up a camera to follow an action you can't see?

"We decided that the entire sequence should be previsualized using low-resolution computer graphics," Knoll explains. "Not only could we design what shots would be necessary and their pacing, but by using proportionately accurate models and real camera focal lengths, we could also figure out the sizes of blue screens required, how much of the locomotive to build as a set, and the types of camera rigs necessary.

"Animatics were done for every shot and delivered on video to Paul Hirsch, the show's editor. Paul and Brian DePalma edited the sequence on a LightWorks™ system, and we went through several rounds of revision, where shots were modified, added, and deleted. Once Brian was happy with the sequence, it became the template for the work. As we were building the shots, the animatics were retained in the cut where no work had yet been completed, which preserved a much better continuity and pacing than 'scene missing' slugs."

Once the design of the sequence was agreed upon, Knoll and team shot the background plates of empty tracks, which were shot in Scotland, from a Wescam-equipped helicopter and from a diesel locomotive. "Since the helicopter's top speed was about 90 miles per hour, and the diesel locomotive's was 45 miles per hour, all the plates were undercranked at between 6 and 12 frames per second," Knoll explains. "This simulated the desired speed of 160 miles per hour."

Because every shot would be a visual effect, the background plates for the exterior portion needed to be very carefully selected. "Not only to work correctly in perspective and lighting with the blue screen foregrounds, but also to work in continuity with each other," Knoll explains.

"If a front view showed a stand of trees approaching on the left of the track and it cut with a side view, the background for the side view was carefully chosen so that the trees would whip by at the correct time. Many of the plates were extensively modified to work in the

sequence. A number of skies were replaced for continuity reasons, CG trees were added, unwanted background objects were removed, and 3-D matte paintings of the tunnel entrance were added to the approach shots."

The blue screen foregrounds were carefully lit for realistic daytime exterior. Multiple shadows were painstakingly avoided, and the entire set was surrounded by enormous muslin bounce cards. This provided extremely soft fill light. The plates were lit to F-8/11 to provide realistic daytime exterior depth of field.

For the interior portion, a series of lightning strike strobes mounted 10 feet apart were programmed to fire in sequence, one per frame, to make it appear that the train was moving at 160 miles per hour past regularly spaced lights.

Realistic wind effects were provided by a stationary parachuting fan located outside the shooting stage and ducted onto the stage via a two-meter-diameter pipe. "This fan was able to produce 140 mile-per-hour winds," Knoll says. "This made the actor's clothing, hair, and even skin blow realistically. Understandably, most of the plates had enormous amounts of motion blur.

"George Murphy dealt with the considerable compositing challenges posed by *Mission Impossible*," Knoll adds.

"The plates were shot 'wild,' " he continues. "No motion-control was used. Motion-tracking reference cubes were placed in the scene during shooting, and were used to recreate camera moves later.

"CG helicopters, trains, and tunnels were created and added to the shots. Creating those elements fell to Joe Leterri," Knoll interjects.

"The explosion and crash of the helicopter were executed in miniature," he continues. "A 600-foot-long track was built on which a camera and 1/8-scale helicopter model could be accelerated up to 50 miles per hour, traveling through 120 feet of tunnel, and be safely stopped again.

"After the camera entered the tunnel model, a micro-switch on the track triggered a trapdoor on which was mounted a photographic print of the receding tunnel to slam closed over the open end.

"The camera and helicopter were supported on pylons that extended up through a slot in the floor of the tunnel and were removed from the final shots. Great care was taken to match the miniature helicopter and tunnel to the CG versions used in the rest of the sequence.

"Now, to Joe Letteri's challenges," Knoll says. "To achieve the lighting style we wanted, he introduced a new technique that transformed established principles of cinematography into an effective tool for digital lighting design."

This technique allowed the teams to develop a lighting scheme that carried the action from the exterior shots to the tunnel interior. The teams worked out the lighting scheme in preproduction, allowing them to have a singular lighting environment for miniature and CG.

"Let me give you Joe's overview of his challenges," Knoll continues. "As he explains in our papers for Academy presentation, 'in bright daylight, the train and helicopter are seen approaching the Chunnel, with the actors clinging to its roof.

" 'The actors were photographed on a full-size replica of a single train car, while the rest of the train was extended with a CG model and set in motion along the tracks. Since a real helicopter could not fly at such a high speed, or perform any of the stunts that were required, we chose to build a custom CG model to animate for the sequence.' "

The exterior shots provided them with an opportunity to address some of the most difficult problems in replicating outdoor lighting in CG. To do this, they needed to design new lighting models for sunlight, skylight, and a fast-changing scenic environment. By photographing the real helicopter in the same setting, they were able to make a film match.

As soon as the action entered the tunnel, they created a completely realistic-looking 3-D interior set for a feature film – in CG. One of the keys to this reality was designing a combination of CG and practical lighting. This allowed them to apply interactive lighting on the real train set, which blended with and ran continuously along the length of the CG train extension as the action raced through the tunnel.

In addition, the ambient lighting in the tunnel itself was built around the setup. It simulated lighting fixtures and other real-world lighting elements.

"One of Joe's first tasks was to design the tunnel in such a way that we could maintain the illusion of the speed," Knoll adds.

At a speed upwards of 160 miles per hour, the spacing of the main tunnel lights became the primary visual cue of how fast the camera was traveling, as Knoll indicated. Once the pace was established, the team could coordinate the timing of strobe lights on the blue screen set and lock the elements together.

In the final shots, the interactive lighting is seen racing over the actors and continuing down the length of the tunnel along the CG extension of the train. Overhead lights were then added for visual interest.

While the CG elements were being developed, a miniature team built the 1/8-scale tunnel prototype for the final sequence. The design of the CG tunnel and miniature had to match. To do this, the team outfitted the miniature with practical lamps, duplicating them in CG. They then measured the ambient light in the miniature. This gave them the information needed to make the CG light-field match.

"Early on in preproduction, we realized we needed to build a CG helicopter for the interior tunnel shots," Knoll says. "Joe's group had a real helicopter available to them, which they filmed on location with the idea of switching to the CG helicopter once inside the tunnel."

The problem – they could not get the speed or the performance from a real helicopter. That meant using a CG helicopter from start to finish. The filming of the real helicopter provided them with the reference material needed for the simulation.

"The key to photographing the CG helicopter in full daylight was to concentrate on the ambient lighting," says Knoll. Part of the image was in direct sunlight. It was the dominant visual element. The quality of the ambient light was a challenge to capture.

The photographic reference of the real helicopter allowed them to develop lighting models to balance the interplay of sunlight, skylight, clouds, and the environment.

Once the team determined the correct way to light the helicopter for the exterior, they were able to use this as a basis for the interior lighting – without a film reference. Still, everything worked. The miniature and CG matched perfectly. The added element was photographing the pilot against blue screen and digitally placing him in the cockpit.

The next photographic challenge for this team was replicating the exterior of the last one and one-half train cars for principal photography. It was constructed on a stage platform, built in sections that could be removed to work with the shooting requirements. This meant they could extend the real train with the CG model at any of several points.

For the interior shots, this was the most effective way of doing close-ups along the side of the train, where the blend occurs in the middle of the car, close to the camera and principal action.

For the interior shots, the train extension was connected with the set train, traveling along the tracks in the background plate as the action moved through the countryside.

They also used the extension technique to produce the establishing shots of the train as it passes over the stone bridge. "When we first see the train, it is the CG model in its entirety," Knoll explains. "But, by the time we have the helicopter in close enough to watch the clandestine action through one of the exterior windows, the blend is to the live action set."

A third team tackled the computer graphic elements. "George Murphy's team created intricate virtual sets and props as well as seamed all of the source elements (digital and real) into one continuous seven-minute sequence of nonstop special effects action," Knoll continues.

The challenge was to sustain the believability of a sequence that happens in a synthetic environment, without intercutting of live action sequences.

"George Murphy and Tom Hutchinson divided this train sequence finale into two main portions," Knoll explains. The first involved placing a synthetic train and helicopter, along with blue screen stage elements, into live footage of the Scottish countryside. The footage was manipulated to suit modified camera angles and lighting. The second portion of the sequence takes full advantage of the digital backlot, with the actors and computer-generated train and helicopter playing out their scenes inside the synthetic Chunnel environment.

The original aerial footage of Scottish countryside served as a jumping-off point. Once the elements that were needed, based on lighting, camera angles, and natural continuity, were selected, the team began manipulating the elements so that the plates would work back to back. The most important manipulation was to smooth out the variety of elements (i.e., varying weather and lighting conditions).

The team found that the usual methods of creating continuity would not be enough for *Mission Impossible*. Normally, timing was done in advance. However, with so many elements coming into play, the only solution was to wait until plates were scanned for the best information, then conform them as the sequence developed.

In many cases, the plates had to be flopped, reversed, or even split apart and warped to create a smoother sense of location and timing. Since the original footage was undercranked to create the desired sense of speed, any visible automobiles or farm tractors would

have to be removed manually by the digital touchup artists, frame by frame, from the aerial footage.

"As these manipulations were being done, George's crew molded the blue screen action footage of Tom Cruise and Jon Voight, which had been shot indoors in the London soundstage," Knoll explains. A 140-mile-an-hour wind whipped across the blue screen actors, as a color scheme of blacks and whites combined with large areas of flesh tone, and areas of fine detail alongside areas of heavy motion blue were all working together in the composites.

"They also had to deal with the wildly fluctuating lighting conditions of the interior of the tunnel," he adds.

For the first half of the train sequence, the team integrated the blue screen actors with the exterior shots of the passing Scottish countryside.

Color-matching the actors into their new environments often required color-correcting skin tones separately from the neutral clothing. This was done through special isolation mattes, pulled from the skin tones. Normally, they would have tried to move the entire foreground element as a whole through a color shift, but the need for scene continuity fought the internal color demands. The solution was to manipulate portions of the blue screen elements to bridge certain plates with surrounding shots.

Because changes were so subtle, the team had to develop a proprietary process that allowed them to monitor the shot progress on a daily basis.

With color balancing and matching film elements to lighting, and rendering of 3-D computer elements done, the team moved to final composite. "We still didn't feel that all the elements really lived in the same space, when composited in a straightforward manner," Knoll says.

To solve this problem, they decided to handle both computer-generated and live action foregrounds in the same way. They needed to degrade and blend edges naturally, matching grain and sharpness and introducing natural color contamination of the background environment into the foreground colors.

Another aspect of the full integration involved fitting each motion element into the "reality." Sequences had background plates of wild aerial footage as well as locked-off blue screen elements and computer-generated train elements.

The idea was to match the motions of the rendered train elements to the original live-action by starting with an educated guess of the actual topography and aerial camera position. The final fitting was done in a composite using 2-D translational tools that would allow tighter tracking.

The final elements were shadows and environmental blending techniques.

"It was important to us to give the camera a point of view," Knoll says. "While viewing the train sequence, the audience must feel as if they are riding on top of the bullet train, right along with the characters or hovering in the air just above the train in a small helicopter."

This was accomplished by introducing specific camera motions to the composites. It could not feel "locked off." So, key-framed motion curves with animated vibrations and drifts were added as well as varying speeds and intensities. "The idea was to add what a real camera operator would do in these situations," Knoll concludes. "We had to have the feeling of reality no matter what effects trick we used."

This was one of the most complicated jobs John Knoll and his team have taken on. Not as complicated, however, as the new episodes of *Star Wars*. Unfortunately, since George Lucas has put a block on any information on the techniques used to make this future block-buster, except to licensed Lucasfilm publications, Knoll can't talk about what he did. He does, however, promise that it really will push the limits of the technology even further.

"That really is the key to doing many of these jobs. You don't have the time, rarely have the money, but you do have your creativity. It's all about opening up to ideas and making them happen with what you have."

Peter

Kuran

Peter Kuran used to irritate his New Jersey elementary school teacher because he was a one-note student. Every time he had to do a book report, it was on one subject – astronomy. At one point, the teacher suggested he write about something else – like photography.

Kuran's focus turned to the new subject, especially the technical side of the art. His interest in photography quickly turned to film, after reading a copy of Forest A. Ackerman's *Famous Monsters of Filmland*. He was now hooked on special effects.

"I set up a workshop in the basement and started working with 8-millimeter and Super-8, shooting clay model animation, experimenting with double exposures, using mattes, and becoming completely involved in my new hobby," he says.

At the same time, Kuran got a job at a nearby movie theater, where he studied the film techniques of different directors. "I tried to recapture them on my own equipment and whatever equipment I could find at the local high school," he says. "I used to get good grades by making video tapes for class papers and reports. I even purchased a 16mm camera and worked in that format too, even processing the film myself."

Now addicted to effects, Kuran enrolled at the California Institute of the Arts, largely because of its proximity to Disney Studios. He signed on for a course that had him working in the optical department at Disney. He was hooked. He would spend at least four days a week at the studio.

When a friend told him a "new special effects studio" was hiring, Kuran contacted George Lucas's Industrial Light and Magic. "They

were doing an obscure film called *Star Wars* and were creating optical and laser effects," he recalls.

At age 18, Kuran left Cal Arts and jumped into the world of special effects. "I had told John Dykstra I would work for free," he says. "Anything, to learn about the world of effects."

Originally, the department Dykstra put Kuran in was going to do cartoon animation explosions. However, department head Adam Becket (a Bob Abel veteran) wanted to figure out alternative approaches. For him, the explosions looked animated.

When George Lucas came back to the States from England, he recommended they look at a film called *This Island Earth*. Although Becket was reticent about using this technique, they looked at the film. It gave them an idea for a different perspective on lasers.

"We did some tests involving shadows and interactive light," Kuran recalls.

The team was trying cell animation on the old machine that was created for *The Ten Commandments*, and rotoscoping with the same ancient devices. "We worked with an image that was projected from underneath the stand," he recalls. "We would turn on the lights and shoot the image down. It was a bizarre piece of equipment, but at least it was multidimensional."

When ILM's Van Nuys staff broke up in 1978, Kuran began working freelance in the photographic effects department on movies such as *Piranha*. "I remember the first effects tests we did," he recalls. "They were of fish against a screen, moving through a shot.

"The idea was to shoot them against a white screen, dupe from a negative to an inter-positive, then build up the shots, layering them into shots of underwater backgrounds.

"The concept worked, but we simply couldn't get all the shots through the MGM optical printer on schedule," he adds. "We didn't have an optical printer at the studio at the time, so we had to hand the material off."

With the department's limited abilities, Kuran's team was in constant piecemeal mode for a while. This is when he decided to rejoin George Lucas at that new San Rafael facility. "I remember walking into the new building, as the seats and equipment were being installed," Kuran laughs. "At the time, none of us realized just how innovative a world we were walking into."

Kuran's group faced a new challenge. They were to work in *Empire Strikes Back*, with a prime directive – get many rotoscope

shots done in the time period that their director set for them. "We made some innovative roads into doing rotoscope work," he recalls. "We worked with lasers and shadows and interactive light, doing the garbage mattes on the ships.

"Before this, rotoscoping was camera and projector working together to accurately identify where something is and provide the ability to draw it. The camera would project the image onto a piece of paper. You could then draw on the paper, then shoot the image back into camera, without moving it."

While working on the George Lucas projects, Peter Kuran began forming his own company on his off time. He was commuting between Northern California and Los Angeles. Soon, something had to give, and Kuran finally settled in Los Angeles, opening Visual Concept Engineering.

One of the first projects he did was called **Dragonslayer**. "What was neat about this project was that the animation effects had to be subtle," he says.

"It was not possible to do this on **Empire**," he says. "The equipment wasn't refined enough at that time. For this film, we wanted to find a way of being able to improve the techniques. Today, things like lens flares can be added with the flip of a button. At that time, a person had to put them in.

"This was a tough experience," he admits. "Before this, animation effects were bright and very unsubtle because of the film stocks that we were working with.

"We went out and found the widest lens that we could find – widest and with the most flare," he explains. "Lenses are usually painted to avoid the flare. However, the older the lens, the more paint has disappeared.

"By shooting pinpoints of light in different positions, with the older lens, we could match them with the parts of the film at the right place and the right time – and get the flares we wanted for the film's effect."

By now, the company had its own printer, and Kuran was able to coordinate the flare shots with the necessary material, finessing the two pieces with rotoscoped finishes. "We finally had a little more control of the process," he explains.

Suddenly, Kuran became a "flare" specialist. "I started getting assignments for main title animation," he says. "I did a project called

The Howling. Title sequences were beginning to be treated like coming attractions.

"There wasn't much money in trailers or promotional materials, so trailers cost the same as title sequences. If the film didn't have title material, we would be making something up.

"When the producers brought the material in for *The Howling*, they kept waving their hands and saying 'scratching, scratching, scratching.' It was our job to take that 'information' and create an effect that would fit.

"For this picture, we came up with a box, 3 feet by 4 feet, 20 feet in the air. We put a piece of glass on the bottom of the box. We then put the title on the glass. Then we added light and smoke in the box above. To create the glass breaking toward camera, we dropped two ball bearings out of sync with each other at the glass, smashing it."

Whatever Kuran did, it was successful. He might be in a rut, of sorts, but title sequences were becoming popular. So, the work kept coming. "The main titles for *The Thing* were interesting," he says. "We did motion control photography and executed a design based on the original.

"The idea was to create a spaceship that was saucer thin and had running lights over it," he explains. "Susan Turner built us a ship where we could get wires inside to create the chasing light sequence around the spaceship."

The material was shot at Apogee, and Kuran did the opticals. "The title was basically done in a 2-foot-by-3-foot wide fish tank, with lettering painted behind," he laughs. "We put smoky fog from the effects machine in the tank and pointed a light behind and up. We then stretched a piece of a plastic garbage bag over the plane and used a match to poke holes in it. As the holes were poked into the plastic, the bag was eaten up by the flame from the match!

"Photographed properly, this looked like a majestic title sequence, with very little time and money spent. That really is the key to doing many of these jobs. You don't have the time, rarely have the money, but you do have your creativity. It's all about opening up to ideas and making them happen with what you have."

Over the next few years, Kuran did more titles and more bits and pieces on different projects. One of the most ambitious was a small picture called *Dreamscape*. "It was a story that was supposed to take place in Eddie Albert's brain," he recalls. "The idea was to go into other

people's dreams and affect them. If someone was killed in the dream, they would die in real life."

One of Kuran's most memorable shots was in the beginning of the picture. "It was where a city is blown up with a mushroom cloud and wall of fire," he says. "We shot a figure against a blue screen, for a city background as one element.

"Then, we created a 6-foot tube of cardboard and painted it black with stripes and images or patterns that, when put in optical printer, with multiple images, would look like fire. We then rolled it toward the camera. We photographed it, with smoke from dry ice inside.

"The background is the devastation. Without motion control abilities, I had to push dollies and sync the movement between the passes. This gave the illusion of a background fire burning behind the buildings and traveling past them.

"By syncing everything and running down the dolly track with the camera going 96 frames, we got the timing and the effect. Going six times normal speed gave us the right mix, for each element to match the other.

"Of course today, you could program one element in one place and match-move, but that wasn't available to us in 1984."

Kuran was now developing his own effects style. He was stretching the limits of the technology of the time. When he took on work for the quirky *The Adventures of Buckaroo Bonzai*, he began expanding the use of the optical printer. "We did some weird things on that printer," he admits.

"This was the time before there were ever techniques for wire removal or cosmetic touch-ups on the computer," he continues. "In *Return of the Jedi,* for example, we got rid of the wires in the shots by looking through the optical printer and painting little streaks of Vasoline on acetate that would remove the wires.

"On *Bonzai*, we did animation effects."

One of Kuran's next jobs was "cleanup" on another science/fantasy picture called *Innerspace*. "We were getting these great little jobs," he recalls. "Something goes wrong in the major shoot, and the studios would look for a company to do cleanup.

"On this project, there was a shot where one of the actor's eye-glasses picked up the image of light or camera when he looked around," Kuran explains. "We had to go in and clean the shot up, so that you never knew what had happened.

"This was a tough shot," he adds, "because it had to be subtle. If we showed what we did, then the shot wouldn't have worked."

At this time, Kuran was working on animation stands and optical printers. "It was extremely difficult to do at this time. Little subtleties today are easy. In *Jedi*, there was a shot where Luke is walking and it is moody and dark. People were sleeping. I had gone in and added an animated shadow of Luke's body crossing over an area in order to take something out that had appeared on the wall but that wasn't supposed to be there."

In 1991, Kuran and company began work on a feature series that has become an icon of crossover production. Years before, television audiences were glued to a program called *The Addams Family*. This quirky group lived in an alternate universe, where cobwebs were in, the rack was a form of relaxation, and morbidity was the proper emotional state. Makeup and set design had done a lot to make the show a success – so did one of the quirkiest servants to ever take care of a family – *Thing*. "In the television show, Thing resided in a box on a table and rarely moved from that spot," Kuran says.

"For *The Addams Family* feature, we were charged with creating an effect where Thing could interact with the sets and the actors like a real character. The idea was to make the 'hand' move as humanly as possible and be able to integrate it seamlessly into the shot."

When Kuran tested the idea, he was looking at the concept of shooting a hand against a blue screen. "It became obvious that, even shot against the screen, the hand wouldn't be able to run in its own environment. We would have to do cleanup anyway."

The alternative was to shoot the actor who was playing Thing moving through the environment necessary to the sequence, then shoot a clean pass. "We still had to do an optical, rotoscoping out what was unnecessary to the shot," he explains. "The idea was to make it as clean as possible, so we could limit the optical work.

"Back then, doing opticals was a lot tougher," he adds. "When we put something like Thing on the optical printer, we were working blind. We would hope that when the material came back, that it would look good. You have to remember that we didn't have the computer screen to look at yet. At that point, if we were even 1/100 off, it would mean the difference between success and failure."

That same year, Kuran joined the group of effects specialists to work on *Star Trek: The Undiscovered Country*. "One of our tasks

was to come up with a transporter effect," he recalls. "We came up with a basic transporter effect, testing whether it would work better with vertical or horizontal lines.

"Eventually, we realized the vertical lines worked better," he explains. "It was purely a esthetic," he adds.

At the end of this year, VCE began working on another screen version of **Bram Stoker's Dracula**. "We used a $99 morphing program to do the work in this picture," Kuran laughs. "There were shots where the director wanted a soft, low-contrast, but grainy look.

"We looked for old film stocks still in the Universal vaults," he says. "We found undeveloped Kodak 5224 – a 4x – the grainiest stock they make. It's about 20 years old. The challenge was to find both grain and contrast at the same time. Normally, you get grain and high contrast.

"The idea was to get a special look for his point of views, as Dracula walks down a street. We filmed the shots with a hand-crank camera (like the old D. W. Griffith equipment), which would give us the classic old movie look.

"We then printed the original negative into a grainy stock in three passes of red, green, and blue. That made it extremely grainy, when you increased the contrast."

Kuran and company moved on to another project. For **The Dark Half**, a 1993 feature, the trickiest shot was to create a sequence with thousands of sparrows. Their shadows were supposed to light the lead actor. "Of course, the first idea was to film some 5,000 sparrows against a blue screen," he says. "That didn't work, so we tried shooting them against white.

"We continued to shoot blue screen, but put fewer amounts of birds into each pass because of the way the birds moved."

At this point the industry was finally moving into computer graphics work, generating images in post instead of first unit or composite. "The first time we used a piece of computer imagery in 1991 was on a film called *Drop Dead Fred*. We generated an eye element and composited it on an optical printer."

On **Addams Family Values**, Kuran began experimenting with computers. This was really the first film where he could start and finish shots in the computer. "Although," he adds, "sometimes we did cut back and forth between computer and opticals."

For him, the most interesting and effective shot was a sequence where Thing is roller-skating in the house. "He spins on the skates,

races up and down the walls, and so forth," says Kuran. "The first thing that we had to do was to decide what would be computer-generated and what would be done in opticals.

"Shots like going up the walls and turning around were impossible to do as an optical," he continues. "There would have been too much patchwork.

"However, when he is spinning on the skates and when there is a blur from the movement, it was better to do those in the computer, even though it was a bit of a chore."

This was the early time of computer work. Kuran was working on the Mac system, laboriously feeding the computer codes.

With VCE solidly in the add a little here and there and "fix it" mode, Kuran was able to take on a side job or two. In 1995, while the company was putting Anthony Hopkins into shots with *Nixon*, creating visual effects for *The Shadow*, and doing other projects, he worked on a labor of love.

Trinity and Beyond was a 90-minute documentary that he wrote, produced, and directed. "Photography was and always will be a passion," he says. He went into research mode, gathering information on the technical side of photographing classified government tests.

"I found that many projects were shot with MF stock from Kodak," he says. "It is a gamma ray-resistant stock threaded through cameras housed in lead-lined boxes. The shots had to be taken from at least 4,000 feet away, or the film would fog."

Kuran wanted to put together a documentary on one of the most horrific moments in American history – the unleashing of the atomic bomb. To make this happen, Kuran created a new process that is patent pending. The Restored Color Image (RCI) brings back the original color of film shot 10, 20, even 30 or more years ago. "I have a strange way of viewing film properties," he says. "My process has enabled me to make shadows neutral and bring highlights up. It also gives me an intermediary step, a masking technique, which makes a duplicate negative.

"The process will enable filmmakers to help keep a color balance on a severely faded negative and take it back to film."

With ***Trinity and Beyond*** premiering at AFI, Kuran was free to work on other projects. ***Men in Black***, the tongue-in-cheek alien adventure buddy picture afforded Kuran and crew the opportunity to do some interesting state-of-the-art visuals. "We went into 'fix it and add a little here and there' mode," he admits.

"We put a few shots together, did another 'title sequence' job, and created one or two cool elements, including the 3-D bug that gets squashed in the beginning.

"The bug was created in LightWave™ by Joe Conti."

In 1997, Kuran's crew was brought in to do laser effects for the training sequences in *Starship Troopers*. "We did 130 shots – everything everyone else didn't do. We got, 'Oh, gee, this is a visual effects shot. We need to give it to someone.' When they were whipping Casper, for example, we put in the whip and the slash. We took the arm out in the classroom shot. We also did the first motion control underwater shots."

With *Troopers* finished, Kuran and crew moved on to a new project. "It is a horror/comedy," he says. "It's the story of a boy whose hand becomes possessed by evil.

"It is good to be working with Chris Hart," says Kuran. "He played Thing in the *Addams Family* pictures. Now, with the new technology, we are able to get Chris to do things like severed arms and heads that continue to emote emotions after they have been dismembered."

Pete Kuran's company has survived the destruction of houses can't keep up with the changes in the industry. As "a fixer," he is known for being able to come in and do what has to be done – with the equipment and knowledge of his house. "We may have a narrow focus, but it is a focus that will always be needed," he says. "Large houses like ILM take on the big picture – we are there to pick up the pieces when the load gets too heavy and someone with knowledge needs to take up the slack."

"When you discuss a sequence that involves effects, the first thing you have to understand is how the shot fits into the fabric of the film. You can't use effects as a be-all and end-all, but as a tool to advance the story-telling process. If it feels real, then the audience will accept it even though they may intellectually know better."

Rob

Legato

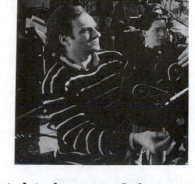

When Rob Legato decided he wanted to be part of the crazy world of moviemaking, he thought he would become a director. However, there really weren't many "classes" in directing, so he thought he would study cinematography, then get any job he could in "the business."

That desire to "direct" proved to be one of the most important focuses of his life. For him, the 1997 Academy Award (shared with Mark A. Lasoff, Thomas L. Fisher, and Michael Kanfer) for *Titanic* came about because of the way he has learned to treat "effects."

"For me, visual effects should not be treated as a separate entity, but just like any other second-unit footage that needs to be properly directed as any other shot or sequence in the film," he says.

When Legato began his climb to the Academy stage, in 1980, the easiest entrée into the business was commercials. So, he began working in the industry as a producer for Hagmann, Impastato, Stephens & Kerns (HISK). "Back then, there were no commercial effects companies. So, every time we got a spot that had effects in it, I would have to find a way to do it," he explains.

"On a particularly difficult job, I asked them to just 'give me half an hour of stage time' to prove what I was saying would work.

"I remember being fascinated by the Introvision™ process. On this particular job, I tried a blue screen version of the same idea. It was a spot for *Toyota*, where a man jumps up and magically falls through a car roof, landing perfectly in the driver's seat.

"I got a large piece of glass and had the art director paint where the car would be with blue paint. As the actor (also on blue screen) jumped into the driver's seat, he would be behind the glass and disappear behind where the car would ultimately be.

"We then viewed the final composite with the Ultimatte™ (live video blue screen process) on stage. The effect was completed in less than half an hour, without the need for postproduction or any other live action shots to complete the sequence."

Legato's creatively simple approach to the effect pissed a few people off. The effects experts hired by the agency said the job couldn't be done – and the young upstart proved them wrong. It was something Legato would have to get used to. He was showing how a new eye and an open mind could take jobs where they had never gone before.

"The client and the director liked the shot, and it was used on the spot," Legato recalls. "The cameraman working on the *Toyota* commercial realized I had some sort of 'potential' in this area and called Bob Abel's company for me. It was a perfect time for me to move on."

Abel was just getting into live action work and could use another creative person to produce the live action – a person with an open mind when it came to approaches to new styles of shooting. "I soon discovered that there wasn't much we couldn't do," Legato explains. "It just became thinking things through."

Legato's motto was "Give me a camera and let me show you that it can be done." He began doing all kinds of live action-oriented seamless type effects. Matching models, live action and blue screen with camera moves, low-key lighting, as well as subtle effects became a specialty.

"Just like with any field, as soon as you do one thing that works, you are then the new expert," he says, ironically. "Suddenly, I was developing a reputation that I could do difficult jobs. I really wasn't an expert – how can you be an expert in something that hasn't been done yet? I just became competent on the stage, and more importantly, I wasn't fearful. 'No' was not part of my vocabulary."

Expert or not, Legato was working in commercials – and not totally enjoying it. It was time to move into another area. Soon, that opportunity came along with the new version of the television series *Twilight Zone*.

He began working on episodes that used video postproduction for the effects. He strove for a realistic film look because he didn't like

the quality of video. "This was my introduction to the digital world," he explains. "I did a few episodes that involved feature-film, optical-looking, blue screen, miniature, ghost, and space-film effects, totally shot on film and composited on tape.

"For me, the story is everything and not about effects or any other singular process," he explains. "It is all about getting the audience to enjoy the moment, using all the cinematic tools at your disposal.

"Too often, people will find a moment and want to illustrate it with a larger-than-life approach. I do the opposite. It's all about subtle elements – where you would have to stop and think that there must logically be an effect there, but you just aren't sure.

"I remember one simple sequence on this series, where we had a guy daydreaming," he says. "While riding in a train car, he magically goes back in time.

"We shot the sequence against a green screen, using smoke, and everything that you weren't 'supposed' to do at that time. The film stock wasn't particularly sensitive to the green screen process, acerbated by high levels of smoke and a moving camera.

"When we got to printing in the train footage out the window, we treated it as naturally as possible. We carried the smoke element through the whole shot, and wherever it would have naturally blocked out or obfuscated the green screen, I let it do the same to the background plate.

"The final result was that you could only see the background very sketchily through the smoke, just like it would have been if shot live. All I was after was the impression of movement and chose not to feature the background. The sum total of the shots together created the proper feeling."

That simple decision made the shot seamless. Although Legato's compositing was subtle, and the audience could just barely make out the element, it tied the shots together as if they were done live.

"When effects transitions happen subtly, they appear real and not like effects," he explains. "That really gives the emotional effect more weight because it isn't predictable.

"It really is all about psychology," he continues. "You have to know where the eye is going to point because that's the place of interest in the shot. You then have to direct all the elements so the eye is properly focused on that certain point.

"Then, you can start to change things around. And, by the time the eye catches the change, the next effect starts in another place. By doing things gradually, you can direct the eye properly. If you change things all at one time, then the eye doesn't know where to go and the effect becomes obvious. You have to meld one into another, somewhat like dreams that go from one moment to the next."

This goes for all effects, as far as Legato is concerned. It is not just in digital terms. "Take miniatures, for example," he explains. "If you shoot and light them subtly enough and then take advantage of shadows and other things that most people might not consider, it looks to your eye like you have built this realistic huge set."

This had become Legato's trademark. "It's not the effect but the story," he says over and over again.

In 1987, when the new *Star Trek* television series went into production, the studio (Paramount) needed a visual effects supervisor. Since Legato had directed film commercials and had worked in live action as well as extensive video postproduction, he was a natural choice. "I accepted the job if there was a chance I could also direct a few episodes," he admits.

Legato knew one of the most difficult jobs in effects, or in any intensely creative department in the industry, is being able to take the endless discussions and still turn out quality work within the time frame. "In the effects realm especially, you can get caught in endless discussions with people who have no business talking about effects," he says frankly.

"It takes hours. You draw up a storyboard. Everyone who looks at it has an opinion. Suddenly, that opinion becomes paramount. Everyone has to sign off on the board. Then you bid. Inevitably, as boarded, the job is too expensive. So, you are back to square one, with all those same intermediaries again. The valuable time needed to execute the work is soaked up by discussion.

"When I signed on for *Star Trek*, it was with the idea that the producers had to forget all those steps. 'If you want to do all this work per week, then forget the traditional way; one person will have to do it,' was how I presented the job. I was the cameraman, designer, and producer for Paramount. It was one person, telling the story in the best way I could within this impossible time frame."

This approach allowed Legato and staff to do about 100 shots a week. "If we tried to do it the conventional way, we might get 10 done," he says, adamantly.

One of Legato's first challenges was to create one of the most memorable icons of the old series, the "transporter" effect. "People's memory of it was so much further enhanced than the reality of it," he says. "There were several different approaches to this effect from the old series already. The producers were convinced that it was perfect as it was. They thought we should not stray too much from the original in an effort to update it.

"When we looked at a few of them for inspiration, none quite stood up to their recollection. I had to search every old episode for that perfect transporter effect. I had to sample each one from all the episodes to prove that the great transporter effect was not as great as their memory of it."

The job became to capture the effect not as it was but, they remembered it being. "This idea became a very important lesson for me, and something I would use time and time again in the features."

His challenge – come up with something that could be done over and over again. He had to find a way to practically create this effect in an hour of edit bay time (for budget considerations), and still have a distinctive look and a surprise for the audience.

"If you do any process in a step-by-step process, you can get a lot of creative work done in a short period of time. If you try to combine everything into one piece, it is impossible to decipher and organize in the time allowed," he explains. "So, I had to devise a layered approach that moved quickly and efficiently.

"That meant having to create several generic film streak elements (for low angles, close-ups, and wide shots) soft-edged silhouette people mattes, inner sparkle elements and leftover residual sparkle elements.

"Next step was to then create the programmable settings for the transparency level during the six-second event. Then, we had to determine when each subsequent wipe element would produce the proper transitions from stage to stage.

"The next step was to create the whole process in a paint-by-numbers way, so that it could be repeated exactly and still be practically produced in a hour or less."

Legato created the elements on film and then layered them together in videotape. "I will always choose a film element over tape," he says. "It just looks better. You can see things generated on film clearer. You don't cut steps out. You just use the video process as a way

to facilitate the composite. In reality, I don't like video quality. It's a personal choice."

Over the years on **Star Trek**, Legato made a few changes. He shifted the emphasis to lighting the ships at a low level. He made more use of the dynamic range of film to create bright hot spots and dark shadows, creating a more natural filmic look.

He also changed the miniatures. "They were originally designed without surface detail," he explains. "That gave us a problem in lighting. With no detail to work with, the lighting was flat. What makes these miniatures look real is the surface detail."

Legato also changed the color of the ships from hospital green to blue/gray. He took advantage of the raised surface detail and reflective areas of the ship. He also added much smaller ships to the shots when possible, to enhance the scale. He extended the **Star Trek** vision of space, with wider-angle lenses, contrastier lighting, and more radical 3-D crane moves.

He also had a newer *Enterprise* model created. "The large model was six feet across," he recalls. "It was a little too bulky to work with and cumbersome to light. By scaling down to four feet, we could also get more perspective.

"The new model had a state-of-the-art electronic lighting system that allowed us to do light passes much faster. We could now do five or more setups in a single day."

Legato found television work fascinating. Rather than being constrained by just money, he was constantly dealing with time. "It wasn't how much money we had to spend on a shot necessarily, it was how much time we had.

"If we had a certain amount of money to shoot with, it didn't matter whether I got one, three, or five shots at a time, budget-wise, but production value-wise we gained quite a lot." Efficiency means more production value and increased quality.

As Legato refined the approach to **Star Trek**, he was always looking for ways to make the effects more pertinent to the story and to do more in the budgeted time allowed. "I remember looking at a script describing the planet's incredibly powerful power station and thinking that, as described, it was going to look cheesy," he recalls. "It was described as just a two-foot-square glowing black box, and storywise it would have been just ridiculous.

"I could have had the art department build something complicated, but that would take too much time and money. So, I tried to figure a way to do it – cheaply and effectively.

"I ended up taking a two-and-a-half-foot black model, built out of spare parts with a fluorescent tube stuck in the middle, and shot it in my basement. With backlit smoke and proper perspective, the slowly revolving power station looked 200 feet tall."

He then moved to the live action stage and shot the actors through an open doorway on a blank stage. "We had them totally back-lit and created long dramatic shadows obscuring the fact that we had no set," he explains.

"When I combined the elements, I was able to make it look like the actors were on a huge ledge overlooking a power station that was 15 to 20 stories high. It looked like a major set.

"The illusion was created mostly with smoke and lighting, taking advantage of your mind's eye to conjure up what it doesn't see.

"It just shows that you can be clever. You don't always need a lot of money. For $3,000, you can make an element look like it had a $50,000 budget. That was half the show's effects budget, as it was!"

This ability to make things work simply and elegantly – within a small budget – became Legato's signature. Suddenly, the material shot for the series was being compared to the *Star Wars* features. Legato's reputation was now established. From the late 1980s to the early 1990s, he was pushing the television envelope with feature quality effects for *Next Generation* and *Deep Space Nine*.

In 1994, he bridged the gap and moved into features. For *Interview with a Vampire*, his credo was the same – story before effect. "We did a lot of different effects in this picture," says Legato. "Burning miniatures, blue screen, elaborate vampire transformations, long evocative crane moves through charred miniature ruins, live action crane shots completed with matte paintings, and even the dancing on the ceiling 'Fred Astaire' sequence.

"However, for me, the shots that are most effective are the ones that are subtle. You aren't sure what they are. But they are creepy.

"There is a scene where Brad Pitt has just become the *Vampire*," he explains. "We wanted to create a peculiar feeling for the shot. He was in the cemetery, and he walks around the statue of his wife. He then thinks he sees the eyes open and follow him.

"Now, we just see the eyelids open and follow him, then the element becomes pure statue. It's tricky, subtle, and creepy."

Legato chose to make just one element come to life for several reasons. The statue coming to life has been done. It is a "big" effect. It is too obvious and steps on the emotion of the story. "We wanted the feeling you get in a museum, where you feel like the eyes of a portrait are following you around," he explains. "What is great about doing it this way is that it transcends the trick. It feels like something else."

To bring the effect to life, Legato asked the woman who had posed for the statue to come back into the studio. He made her face up like the gray statue. He then lined her up against a blue screen and shot her and the real statue with a repeat pass motion control camera (and then ultimately fine-tuned and tracked the element in the computer). She was directed to move nothing more than her eyes.

"It was really more in the execution than the trick," he says. "When the elements were married to the live action, the shot was so subtle, some people caught it and some didn't. When they did, it was far more unsettling than anything you might predict. It is a lot more poetic than the other more obvious effects shots."

Subtlety had fast become Legato's style. He was now consciously adding new and reality-based elements to every effects shot. In **Vampire**, the smallest details became a consideration. If he was doing a matte painting with a group of people in front of it, he made sure the painted illumination fit the live action people and the place.

"We would shoot people against green screen, then match the shadows and light direction, add extra interactive fire elements, and so forth.

"We would also direct people to do simple ordinary things in front of the screen that would directly relate to the painting. When the elements were matched, there was so much interaction that the effect didn't have the normal patina of an old-fashioned matte painting.

"There were silhouettes of people getting dressed, people hugging and kissing. Everything and anything that would bring the painting to life and take the edge off the 'effect' would be happening.

"It's all in the details," he comments. "I remember one shot where we had someone walking a dog along the street. We made sure the shadows of the person and the dog were cast on the uneven painted street and curb. We also had a fire element in the shot flickering on the walls as well as the added people and roaming animals.

"To do things like this, you design the light specifically on the matte painting to take ultimate advantage of the interactivity possible with the live action. Then, you have to make sure what is on the screen

matches the painting exactly in terms of quality of light, shadow, and intensity."

Another element that stands out in Rob Legato's mind, in **Vampire**, is the "Fred Astaire dancing on the ceiling" sequence, where one of the characters walks up the wall of a Paris tunnel. "This was more about how the physical effect was directed than any trick in camera or computer," he comments.

"It was all about performance. Stephen Rhea was terrific. He worked out the difficult physicality of hiding the shifting balance transition point so well. We built it into the choreography and his performance so that when he flips his cape, it distracts the eye from the moment his balance changes and makes the transition from the floor to the wall seamless.

"We built the largest rotating set in London (not counting the *2001* anti-gravity set) that was about 30 feet long and over 20 feet high. We mounted a motion-controlled camera on the set and matched the same move with Brad Pitt standing upright.

"The illusion on screen was Stephen Rhea dancing upside down while Brad Pitt is standing upright in the foreground, all photographed with a fluid, moving camera."

With all the effects tricks in place, the test would be in the execution. "Stephen was incredible," says Legato. "He knew just where to shift his weight, how to flip the cape, how to perform.

"The idea, as he knew, was to keep the audience's eye pinned on his performance. If the attention wanders out of his performance and telegraphs the trick, the magic is lost.

"He had to move from one point in the set to the wall and back again (to belie the trick), then at the last cross, trigger the set rotation. He had to hide the sudden start-up in his movement as well as the ramp up of his balance shift. By coordinating his steps with the forward and reversing motor speed, we were able to make the trick work – and he performed it perfectly!"

In 1995, Legato moved on to do another fascinating feature called **Apollo 13**. Although the film featured many elements used in a typical science fiction space picture, the added wrinkle was that this story was totally real. What he did had to match what people had seen, and will continue to see, on television and in newsreels of the era. That was uppermost in his mind – and was one of the key elements that figured into the minds of the Academy committee, when they chose his

work (shared with Michael Kanfer, Leslie Ekker, and Matt Sweeney) for a nomination for the Best Visual Effects honor in 1995.

"For me, the shot that epitomizes the feeling we wanted for the whole picture is where the audience sees the earth revealed as the last stage of the rocket falls away," says Legato. "We didn't want it to be an imitation of an existing stock shot. We still wanted it to be something like what people remember for real, but on a grander and more impressive scale qualitywise.

"Our memory of the event, of any event, is always grander than the actual footage," he explains. "That's kind of what happened here. When we went back to look at the footage from the news, it was good – it just wasn't as emotional as we needed to portray on the screen.

"So, the thing we didn't want to do was to go in and match the original frame by frame. That wouldn't impress the audience since the footage does not match our heightened perception of the first time we saw those magnificent images.

"We had to create something that would say, 'This is just how I felt the first time I saw it!'

"We tried to tap into how our memory enhances the experience much more than the footage allows. We collected all of the available stock photography we could, screened it, and then asked everyone to describe their favorite shot.

"What we found was that we all described the shots as grainless, higher resolution, color, lighting, composition, and all with nonexistent camera moves. What we came away with is that we needed to match our memories and not the actual shot. It is still reminiscent of what we have seen before but actually only exists in our mind's eye."

For Rob Legato, his most memorable, most favorite, shot in *Apollo 13* was the splashdown. "It is truly where all the elements came together as well as we planned," he says. "We did this in miniature, with miniature parachutes that we followed with the camera, straight down to the splashdown. It is one of the magical moments, which came from the right idea and the right execution.

"At first, it was budgeted as a CG effect," he adds. "However, I didn't want to do it that way. We found that not only was the miniature less expensive, it proved to be a much better technique all the way around. It had more of a reality-based feeling simply because it was real.

"Also, a CG shot is a singular preplanned and pretimed shot. If shot for real, you couldn't predict exactly where it will land or how the

lighting would play on the rippling fabric, and you would have to use multiple cameras to capture such an unpredictable event.

"Essentially, we were trying to re-create what it was like when the original capsule came down. You do the best you can operating wise and hope to keep the damn thing in frame. This quality is exactly the kind of realism we went for.

"The multiple cameras gave us a sequence instead of a shot, a happy accident instead of preplanned precision. I'll tell you that when those chutes opened for real out in Catalina, we had the same feeling of exhilaration shooting it that the audience felt at that same exact moment in the film. We organically captured on film what we felt, and it was a pretty cool feeling."

Rob Legato can go on and on about what he loved in *Apollo 13*. "It was wonderful subject matter, a film with great people in front of and behind the camera, and just the kind of project you want to do your best for," he says. "Every shot had a different challenge – and we had a great time, finding the right elements to make the sequence work."

That meant choosing CG or miniature, live action, and any other element needed to make the emotional value as high as the material warranted.

"Sometimes, we would fall into a setup that looked exactly like the drama of the moment should, and other times it took weeks and weeks of work to get in the ball park," Legato recalls. "But, at times, that is the beauty of effects – you never know what to expect!

"There is a sequence where the crawler is going to the launch pad. It's a simple shot. The plate was photographed with a helicopter. We added the Saturn V rocket to the empty crawler (huge tractor that carries the rockets to the pad). The rocket was an off-the-shelf Revel model and worth every penny of its $24.50 price tag. We lit it with four Chinese lanterns (the same ones used to match the lighting on *Interview with the Vampire*) and tracked the 4-foot model with tracking software and motion control.

"Even though we used the cheapest-looking model, the design of the shot made it look real and very effective in the context of the sequence.

"There was one particular shot that came out much better than we imagined," he adds. "It was a long-lens tracking shot of the rocket just before it stages. We imitated the long lenshand held quality, with motion control, interactive lighting, and atmospheric conditions.

"We had a digital artist replicate the flaming rocket blast with CG, rephotographed that element off the CG monitor with a serious amount of overexposure and diffusion filters, and then re-scanned that footage.

"The rephotography took the fake CG patina off the element and created a natural photographic glow complete with film grain. These improved elements were seamlessly tracked and composited onto the stage rocket. The talented CG artist and the rephotography matched the look exactly. The compositer did a great job marrying the elements together and, the shot was just about perfect.

"The result looks more like an authentic stock shot than any other, only much more exciting. It is as close to a perfectly realized shot that I saw in my head as I've ever had. Something about it is very magical for me."

When Rob Legato lectures at different film schools, like New York University, it is these sequences from *Apollo 13*, as well as several of his favorite shots from *Titanic,* that he talks about. "I am constantly driving home the concept of making things not only look real but feel real for the specific scene," he says.

"When you discuss a sequence that involves effects, the first thing you have to understand is how the shot fits into the fabric of the film. You can't use effects as a be-all and end-all, but as a tool to advance the storytelling process. If it feels real, then the audience will accept it even though they may intellectually know better.

"Look at acting performances, as an example. When you see Marlon Brando in *The Godfather*, you are convinced that he is 'the Godfather,' even though you know he is just an actor playing a part. Of course, he is not 'just' an actor.

"It's the same feeling the audience should have, when they are watching a film with effects – especially effects that are to be taken as reality. In *Titanic*, for example, you know in your heart some of the shots aren't real, but they are just real enough so that you don't really care they were artificially produced, just like any other performance, set, or prop in the film."

It is always something that moves the audience that works the best. It is a careful manipulation of live action, CG, models and miniatures, smoke, fiber optics, and anything else that is necessary – to sell the point. "If you say, 'Oh, that's an effect,' then you missed the story the shot was trying to tell.

"The idea is to absolutely believe the moment – even though you know it couldn't have happened that way. For me, it is the simple shots that really work. In *Forrest Gump*, for example, my favorite shots were from the Ping-Pong sequence. You absolutely believe Tom Hanks can play professional-level ping-pong. It's the – know it can't be Tom playing at that level, yet it definitely is him' moment that makes it magic.

"That's Ken Ralston's gift – to make the magic believable – in ping-pong, or removing Gary Sinise's legs. He knew exactly what effects elements to use to make each scene work."

Legato did the same thing in *Titanic*. Admittedly, he has his favorite shots. "A lot of people collaborated to make these shots work," Legato prefaces, as he begins to speak about the elements that are most important to this Academy Award-winning job.

From the very first thought of producing a modern film version of *Titanic*, the main drive was to tell this story in a way that has never been seen before. If it was as simple as retelling *A Night to Remember* in color, then what would be the point? The 1958 movie was not only fondly remembered as a film classic but also as the most definitive and faithful re-creation of the *Titanic* story to date.

Based on new information (discovering the wreck in two halves on the ocean floor), Jim Cameron created a film that tells a different but now incredibly faithful and realistic version of the most famous navel disaster in history. Simply put, it is a *Titanic* story the audience has never seen before.

"Conventional technology would never do this updated story justice. In essence, the modern audience has been so educated visually, that any pictorial falsehood would not be as easily tolerated as with the previous films," says Legato. "Since the 1950s, how many audience members have seen the spectacular helicopter flybys daily seen on Princess and Carnival cruise line commercials, not to mention modern films and television?

"What was once the largest and most impressive technology-advanced ocean liner ever created is now dwarfed by the ships that go on daily low-cost cruises to Catalina and Mexico. To impress a modern audience with the same sense of awe and grandeur that the 1912 ship inspired would require the most difficult visual effect ever created – emotion.

"Emotion puts the audience in the right frame of mind to accept the 'suspension of disbelief' that they are witnessing the real thing. The

skill of the director to weave a story through all facets of emotion is the groundwork needed to allow the visual effects to fool the eye and move the audience. Jim Cameron created such a story that required the effects not only to seamlessly blend in but to enhance the emotional story he was going for.

"What we tried to tap into was the fact that the audience naturally wants to see the ship live again," he explains. "If you look at a photo of the wreck, your brain naturally imagines what it must have been like in 1912. The effect of the transitions reinforces your own desire to see it happen.

"If the effect was created with that in mind, the moment could be very powerful. The same is true in reverse. If you are totally enthralled with the 1912 period and the narrator (Old Rose) pulls you out of it, your brain naturally imagines what the ship must look like now. This helps reinforce the sadness we feel over the inevitable and fateful circumstances of the tragedy.

"If this idea is pulled off successfully, then the audience is totally with the story as the visuals are simply a reflection of what they themselves are feeling at the moment."

To pull off this type of imagery, total control of all aspects of the various elements was required. This created the need to invent this control where previously none existed. This manifested itself primarily in the area of people and water.

"To create the epic feeling of a glorious flyby of the grand ship we would need to see the thousands of people enjoying and exploring the decks of a real ship," Legato explains. "The moving camera would naturally reveal multiple camera heights, obscure angles, and natural-looking human interaction with the working ship. That meant that the people could not simply be photographed conventionally, reduced in size and placed on the ship in 2-D compositing.

"The camera would reveal the tops of their heads, sides and backs all in the same shot. A motion control rig would have to have been created to replicate the helicopter move of people from the height of 100 feet or more above their heads to anywhere from 5 feet away to 880 feet away (the size of the ship).

"The rig, of course, would be impractical. So, we created those same dynamics of 3-D motion on the computer. To create the look and feel of real people moving and behaving like the 1912 passengers, we turned to a technique called motion capture.

"In essence, what motion capture does is capture the coordinates of a person's limbs, head, and body but not a 2-D image (like a motion picture camera does). Since the coordinates capture the person's performance only, camera lens angle, height, and position are immaterial.

"The raw motion, once captured, can now be photographed by the virtual computer camera from any angle, height, position, etc. This allows total freedom to place the people anywhere in the scene using the model, live action, or computer-generated ship as a background.

"We could now place any number of realistically captured virtual people to flesh out and match an existing live action scene or a totally artificially created one. In short, we could create any reality that the story dictated in terms of people. Once this level of fidelity could be achieved, the next obstacle proved to be the background.

"We needed the same freedom in terms of creating a realistic, moving and artistically rendered backdrop that we achieved with the people."

Water was once considered the most difficult of the Holy Grails of visual effects. A company called Arete created the computer code to realistically render water during their work for the government. Up until *Titanic*, that code was limited its uses by the fact that a graphic user interface and total artistic freedom had not yet been implemented. Digital Domain, in essence, hired or partnered up with Arete to help develop and mature their program to the point that it could be used for a full-blown production.

"This required that we could easily specify wind speed, swell height, wake, reflection, ambient and direct kick light, all with a compatible multiprogram motion-controlled interface. We could directly import our motion controlled moves from our model stage, use the actual image for a natural 3-D reflection in the water, import CG-created geometry for the wake, and a real or painted sky as the backdrop and natural reflection.

"This basically gave us the ability to create any type of ship shot from any angle and camera height at any time of day, while exactly matching the lighting conditions of the live-action (stationary) ship coverage."

With the creation of the wreck model (an exact duplicate based on Cameron's real wreck photography), Legato and team had all the elements they needed to seamlessly blend in and out of the past. "We developed a technique of in-camera flashing to re-create the natural

look of underwater photography," he explains. "We had to match the actual real footage of the *Titanic* (directed and photographed by Cameron during the deep dive) and cut back-to-back seamlessly with our model photography.

"Once we could blur the line and suspend disbelief as to what was actual footage and what was fabricated, the sum total was that it was all real on an emotional level. I believe it is the same phenomenon as with a gifted performance by an actor.

"Intellectually, you know he or she is an actor playing a role, but you still believe you are seeing the real person. His or her skill has transcended the mechanics of film acting and created an actual living breathing person you now care about and are absolutely enthralled with.

"Visual effects rarely attempt this same sort of verisimilitude, but if they were to aspire to that same level, the emotional impact would be no less magical or believable."

The next step in the evolutionary process, after they believed the ship lives again in the mind of the audience, was that the audience would naturally have more of a heightened emotional reaction to it when it gets destroyed.

The total destruction of the dream ship required every effect imaginable. A CG-created ship, 1/20-1/8-1/6-1/4 models 100-foot-by-80-foot water tank; 30-by-30-foot indoor water tank; hydraulic rigs, computer-triggered dump tanks; motion captured and hand-animated digital stunts; real water – CG water; animated birds; digital matte paintings; special 3-D tracking software; and instant survey gear are only just a small part of the many objects and techniques created for this film.

From in-camera, large-scale miniatures in water digitally set extended live action (complete with CG stuntmen) to the total recreation of the ship breaking in half and any combination in-between were fully developed and realized. "We developed these techniques to allow someone of Jim Cameron's caliber to organically create the dramatic destruction of the ship in the editing process," says Legato. "By being able to mix one image with another and using added water and people animation to establish a seamless continuity from shot to shot he was able to re-create the moment as dramatically and realistically as possible.

"As often happens in the effects business, the circumstance of what is currently possible starts to dictate the creative outcome of the sequence. It directs you instead of the other way around.

"It is interesting to note that it takes the collective creative and technological genius of various artists, like Mike Kanfer, Erik Nash, Mark Forker, Mark Lasoff, Cari Thomas, Richard Hollander and literally hundreds of CG artists, model craftsmen, and production staff to help create the appearance of a singular vision.

"Their work allowed the filmmaker to single-handedly direct the sequence to fully explore what it must have been like to be physically on that ship, on that particular night, till the absolute bitter end. I think the success of the film was helped in part by this organic and unusual approach to the filmmaking process. If I had to pick what was the single most innovative thing to come out of *Titanic,* I would have to say it was that."

"The most important thing any effects person can bring to the techniques used is a part of himself (or herself)," Ralston says adamantly. "If the character doesn't have a part of you in it, it isn't going to work. There is a lot of brilliant animation out there – but it doesn't have the spark because the animator hasn't 'breathed life' into his or her work."

Ken

Ralston

It is a long way from "messing around" with makeshift stop-motion techniques, building models and miniatures, and shooting 8mm adventure stories about being shipwrecked on an island to winning five Academy Awards (*Forrest Gump, Death Becomes Her, Who Framed Roger Rabbit? Cocoon, Return of the Jedi*) for innovative effects – and Ken Ralston has enjoyed every moment.

"I was hooked from the start," Ralston admits. "In sixth grade, I talked a few friends into shooting an 8mm movie. It was set on an unknown island (our backyard), and we used a stuffed alligator I'd bought at POP (a California amusement park) to 'attack' my cast. We even did amateur makeup! Anything that would look somewhat like what I'd seen in Ray Harryhausen's movies."

Addicted, Ralston wrote Forest Ackerman, of *Famous Monsters of Film Land* magazine, and the editor surprised the young man with an invitation to his home. It was like a kid in a candy store! Ralston saw movie props from every imaginable source. He also met Jon Berg, who worked at one of the earliest visual effects commercial houses, Cascade Pictures.

By now, Ralston ate, slept, and literally breathed the world of effects. Through his high school years, he used his allowance to shoot his own film –*The Bounds of Imagination*. A Walter Middie-type story, Ralston admits, "It was an excuse to play with as many effects as I could create."

It was an exciting time – a youth filled with wonder and magic and learning. "I could fake my way through the effects world and have fun at the same time," he says.

Ralston's "faking" won him an award from Kodak. So, upon graduation from high school, and with the 45-minute film and his contact at Cascade, the young effects fan set up a screening – in hopes of winning himself a job.

"I must admit my partner and co-conspirator, Glenn Anderson, and I played a dirty trick on some 30 effects gurus, who had gathered to watch our project," Ralston laughs. "Before we rolled the real 8mm film, we showed them some 50 feet of junk. We had a model of Godzilla, a phony rubber hand, cardboard writing for the titles – all wrapped around the real reel.

"The first 50 feet rolled off the spool loose. 'The film broke – We apologized.' While we were 'fixing' the reel, these great effects men hemmed and hawed, trying not to say we were 'awful.' We finally let them off the hook," Ralston says. "They were totally blown away at what we had done."

Despite the dirty trick, Ralston's talent landed him a job at Cascade. His first real effects job was stop motion on a film called *Adventures in Underland*. "I have no idea what happened to it," Ralston admits. "However, I learned to love doing stop motion and miniatures.

"There is an elegance and an art to stop motion that I admire. The basic techniques that I learned back in 1971 are essentially the same. However, the technology surrounding stop motion has made it easier to do. Today, there is video assist to help check overlaps and motion. It's far easier than using the circus of gauges we needed back then. And, many of the principles fostered in the stop-motion world have made a relatively smooth transition into the digital character environment of today.

"I remember one of the first jobs I did was on an old *Pillsbury Doughboy* commercial, where we had to create a creature with different mouth positions on the head. It's the same technique that was used on *Nightmare on Elm Street* and *Night Before Christmas*."

By the way, it is Ken Ralston's hand pressing the *Pillsbury Doughboy's* stomach – although he hasn't seen fit to put that on his "acting" resume!

For Ralston, the "trick" to doing effects with characters – from *Doughboy* to the *Green Giant* and more – is to think like an actor and be an artist. "You have to be able to totally concentrate on what you are doing because so many things can distract you," he says. "When we were doing an *MD Tissue* commercial, we had to build and animate a

Cheshire cat. Not only did we have to concentrate on perspective and color, we also had to think and feel how the cat would react and look.

"How we sculpted the armatures was also vitally important. If the cat didn't move correctly, we couldn't sell the story we were telling or the character.

"The most important thing any effects person can bring to the techniques used is a part of himself (or herself)," Ralston says adamantly. "If the character doesn't have a part of you in it, it isn't going to work. There is a lot of brilliant animation out there – but it doesn't have the spark because the animator hasn't 'breathed life' into his or her work.

"Look back at the original *King Kong*, as an example," Ralston says. "People look down their noses at it. But it is brilliant. It is alive with energy. The animation is fearless, bold. It takes no prisoners. You feel that character. Ray Harryhausen and Willis O'Brien's stuff was 'alive' because they took chances."

For Ralston, playing with stop-motion animation was fun – a child's fun. Something that he loves to go back to – to remind himself how lucky he is to be able to be in a business where he can be a child – and never grow up! "There are people like Tim Burton who are trying to keep the fun of stop-motion puppetry alive," says Ralston.

Ken Ralston is very vocal about what works and what doesn't work in movies – effects or otherwise. When he first started in the business, he had a passion. He still has it today. That is the prime directive of making a movie work. "Any movie made without a good story and without characters that say something to you isn't worth watching," he says adamantly. "I've seen a lot of films that don't work. And, it isn't just the effects. Sure, effects can be blamed – and sometimes it is true. They can become an 'exercise' instead of part of the story. However, there has to be a story (and characters) first! People have to want to believe what they are seeing."

His tenure at Cascade Pictures was the best of all training grounds for Ralston. He worked on everything from pyrotechnic visual effects to building sets, sculpting models, creating optical effects, and performing stop-motion animation. In total, he worked with Cascade on more than 200 commercials in the early 1970s.

But, it was time to move on. And, his knowledge of the effects world – as well as his emotional commitment to reality – was exactly what George Lucas was seeking for a crew to do *Star Wars*. Ralston

was brought on board, starting as a camera assistant to special effects supervisor Dennis Muren.

"By then, I was way beyond obsessed with effects," Ralston admits. "I was always trying to find someone to teach me more. In Dennis, and the night crews at ILM, I had everything I could wish for."

Although his days were confined to motion control operation, the young Ralston had his nights free. It was then that he would sneak onto the sets and watch the work. "I learned so much," he says. "I learned that an artist has to know how to light. I learned that you have to base visual effects on something that audiences can connect with, emotionally. If the audience can't connect, it is gobblyedgook!"

Ralston learned from the best. Muren and his cohorts showed the younger effects fan what works. For them, *Star Wars* had to have a story – and a sense of humor. "I think that sense of humor we were all trying to capture was one of the greatest selling points of the picture," he says. "The core story is serious, but how the actors, and even the effects people, approached their work was just a tinge light.

"That balance can make a story work – or not work.

"A few years ago, I was invited to a screening of a fellow effects master's work on another space fantasy, this time sent in the future. The effects were wonderful – they were eye candy. However, the audience didn't care for the story. It didn't work. It was a design flaw. Art Direction overtook story. The effects supervisor did great work – but the audience didn't buy the total result for a moment."

As Ralston continued to work camera on *Star Wars: The Empire Strikes Back* during the day and haunt the stages at night, another job came in to ILM. "They needed a dragon and baby dragon for *Dragonslayer*."

Ralston became involved in creating a version of the baby dragon. "With soul," he would say. Phil Tippett did the adult dragon. "I worked *Empire* during the day and resculpted the baby at night. I know, I was nuts working those hours. But I was younger then."

Ralston's lesson on *Dragonslayer* was the art of compromise. The ultimate look of the baby was not exactly what Ralston had proposed. "I developed something more classical, a very reptilian, serpentine sort of dragon that did not exactly mesh with the filmmaker's ultimate vision for the character. We came up with some great stuff," he admits. "I did some good work, but the best was really Phil Tippett and Dennis Muren's go-motion work."

What Ralston also learned on this project is how to choose and when to meld different effects elements to make a shot as believable as possible. "Take the quick shot of Ulrich standing on top of the peak at the end of the movie," he says. "The dragon moves up and is blasting in flames and flapping his wings. We have a closeup of his big head."

The shot melds four major effects elements. "We had a plate of the actor standing on a rock, which we shot against blue screen, without flames or anything," he explains. "We had some fire effect lighting. We had clouds shot in Hawaii for the background. We also had added a few stars for twilight. And, the whole scene begins with time lapse.

"We had to do a flame pass on the same rock, where Ulrich is standing. This was done with a big flame thrower rig, blasting the rock and moving around it, against black.

"Then there were the blue screens of the flying dragon element, which had go-motion rod work, operating the wings on a screw rig that would move through the frame."

For Ralston and the crew, the hardest part of the shot was the dragon's head. "It was less than two inches long," he says. "We had to match-move this little microscopic head to the flame that was moving on the set! This took a lot of frame plotting, and we placed marks within either side of the camera for frame reference."

The flapping of the dragon's wings was also tricky. "What we did was not enough to keep the dragon up, but just enough to make it look like the wings were doing something," he admits.

"Then we had the lighting rigs frontlight and backlight passes, so we could frame the dragon with light – and turn it on and off, when we felt it was needed. This was necessary because you can manipulate the elements more later, which is hard to do on blue screen passes. The separate elements allowed us to manipulate the light effects, without manipulating the dragon itself.

"Of course today, we would do all these elements in CG," he sighs. "For all the work that this dragon did in the movie, had we had the CG techniques, it would have been the smartest move. Though rendering time would be monumental because of the detail, we would be able to scale everything correctly."

Ralston might not have been completely satisfied with what he did on *Dragonslayer*, but the Academy seemed to think that Ralston, Dennis Muren, Phil Tippett, and Brian Johnson VI did a great job. It gave them a 1981 Academy Award nomination.

And, it allowed him to move up to visual effects supervisor on *Star Trek: The Wrath of Kahn*. "It was the most fun I'd had so far," he admits. "Looking back, the only thing that might beat it was *Forrest Gump*." The reason – Nick Meyers, who directed the film, didn't care that much about the effects. He wasn't a micro-manager. "One of the producers, Bob Salen, came to ILM and we did our work independent of Nick.

"We did extensive storyboards and really had time and tools to work things out without someone watching over our shoulders," he admits.

Prod Ken Ralston about the shots in the picture, and he will come up with his favorites. "I'd have to say the shots in the nebula," he says. "We took our time and made them work. Then there was the *Reliance* blowing up – where we shot a model at high speed and imposed that on the other elements."

Ralston's next project won him a Special Achievement Academy Award (and the British Academy of Film and Television Award) that he shared with Richard Edlund, Dennis Muren, and Phil Tippett. *Return of the Jedi*, done in 1983, was not Ralston's favorite project – simply because of the volume of work the ILM team was charged with doing.

"We tried to set it apart a little more from the previous *Star Wars* adventures," says Ralston. "It gave it a little more acrobatic quality and insane action. We were always trying to do something different," he admits.

The chase sequences were paramount. "We wanted to give them life – have some fun – do something unique and special with the modeling and motion control."

The challenge – the *Falcon* was about 1,800 pounds and couldn't move without a forklift! The solution was to create one that was about a foot and a half long. Still, that was a major motion control job!

When the ILM team put their 15-minute reel together for the Academy, they chose to show pandemonium and mayhem. "We wanted to show the flexibility of the camera at that time," Ralston says. "It was all motion control, with an edge.

"We included a selection of shots done with the Dykstraflex motion control unit that really showed what we could do," he explains. "We had one major camera running 24 hours a day with millions of passes – multiple passes of the ship, for instance, done separately from light passes. We would blend them together later.

"The challenge was that we did not have video then. We tried to choreograph shots blindly. We had RERs, where we could shoot a black-and-white negative of the refined action and run it through a Pro-Star. This would spit out a negative we could then put in the VistaVision™ moviola and bi-or-tri or quadruple the elements in VistaVision™ as a sampling. Although it wasn't built for that element, it gave us a multi-level reference. We could then go back out and shoot the elements as fast as possible."

Ralston and team began to show audiences and industry people what the camera could do. They also challenged the optical departments to take model work another step forward. "We began to broaden the field," he explains. "Optical departments no longer were confined to a small area of what they could use to pull elements."

Ralston's next challenge, which received Academy acknowledgment, was *Cocoon*. For Ralston and crew, it was the bringing together of elements in a more simultaneous manner that set the film apart.

"Take the example of the spaceship flying in at the end to rescue everyone," he says. "There is a shot where the ship is soaring down, comes up right over camera, and the lighting starts to work – stuff comes blasting out. I like that one the most because it has all the elements together."

It's not difficult – he would say. The difficulty was building the model that could do everything they wanted it to do. The motion-control was straightforward – it was the animation of the lighting that made it work.

Another of his favorite shots is the funeral scene, where the young boy is looking up at the sky. "There is a cut where a spaceship is coming through an interesting nebula and flies under the camera," he says.

"It is pretty and enhanced by great music."

Ralston used an "interesting oddball technique" for the nebula. The ship was a large model, with millions of optic elements. The flyby was relatively simple. "The flat part of the nebula toward the camera was a matte painting," he explains. "The bottom section was a black-and-white swirling thing on the floor.

"We laid it out carefully and did a motion control pass. We put the pass into the optical and colored it, softening some of the elements. We then added different stars, glowing inside the nebula, to give it a warm and fuzzy edge."

Prod him a little more and he admits some of the "alien" shots were "cool stuff." One of his favorites is the large scene in the pool. "There is an object that bounces around the room. We did that with flatbed animation and motion-control and I liked it a lot," he says.

"The techniques for the aliens were relatively simple. We did them in a flying rig. We projected her figure up on a card and re-photographed the element. We added movement coming into the room. This was matched to a plate we shot, without the actor on the stage. We then rotoscoped the robe away from the alien so the robe wasn't glowing and added effects around the face, shoulders, and legs.

"It took what felt like a zillion passes, but it was effective!"

Why so many passes? Because Ralston wanted to separate the elements to give his team artistic flexibility in the look. One simple pass would split into many, to give him layers. "On an optical printer, we could zoom in on the alien, where it starts to enlarge," he says. "We did multiples of this, so one layer would fit on another, giving us the ability to pull little bits off of each and build a softened and filtered look that became the glow. This also allowed us to build sophisticated elements, like her reflection in the pool.

"Motion control gave us the soft and humanistic floating motion that was more based on reality than an arbitrary movement of a computer generated element."

Although Ralston worked on films like *Cocoon* (another Academy Award) *Back to the Future, Star Trek IV: The Voyage Home,* it was the 1988 film **Who Framed Roger Rabbit?** which exhibits what he feels were new and different techniques. It was here that the team began to take things that had not been done before and refine the elements in a gigantic way.

Ralston and crew began by reviewing old MGM films to see the "big production numbers." He found that scenes with Gene Kelly and the mouse from *Tom and Jerry* cartoons and other dance sequences were a perfect setup for many of the elements he needed to use with the live action cartoons.

"It was a matter of separating the elements and putting them together correctly," he explains. "We shot Roger passes without shading. We then shot separate effects animation for shadows and other rim lights as well as lighting gags that would be added later in optical. This gave us a little more flexibility. We would also do a few more things that would give us better illusions, like adding neutral

density filtration in some scenes so we could start to gradually darken the figures toward the floor."

The film featured monster rotoscope work as well as rigging. "The rigging wasn't hard to do," he admits. "However, there were so many places where things could go wrong!"

There is a sequence that is in the beginning of the picture at Desilu Studios. It is after the *Dumbo* scene, where Bob Hoskins leaves the studio and passes an Ostrich, a frog, the hippo from *Fantasia*, and other animals. He sees a bicycle coming out of the studio. He follows a pelican. There are the brooms from *Fantasia*. The shot turns around to see a car crash, then a cattle call, with real cattle. Elsie the cow joins the crowd. The camera then comes around and follows Hoskins. "It is one thing after the next without a break," says Ralston. "There were at least 180 elements, all animated to blowups of the background. Each had to match the next precisely."

As with **Jedi**, it was the size of the work on **Roger** that was almost overwhelming. And, it was the locations. Even the best of organized minds will have a problem when locations are spread between California and England.

"We did most of the animation in England but created Toontown in Los Angeles," he says, still tired of the logistics. "It took two years of constant attention to detail, but it was worth it. Just working with Bob Hoskins – who is at the top of my list along with Tom Hanks for actors to work with – made the time worth the work!"

And, of course, everything seemed to fade into the background when Ralston, along with Richard Williams, Ed Jones IV, and George Gibbs II, won the 1989 Academy Award for their work on **Who Framed Roger Rabbit?** "Don't ask us what we submitted to the Academy, pulling 15 minutes was next to impossible!" he laughs.

In 1990, Ralston, Michael Lantieri, John Bell, and Steve Gawley were nominated for an Academy Award for **Back to the Future Part II**. Although Ralston enjoyed the project, it was a little bit of déjà vu. It was the 1992 project **Death Becomes Her**, however, that was far more difficult, challenging, and, ultimately, exciting.

"Everyone wants to know about the head!" Ralston laughs. "It was a challenge, for the actors as well as the effects crew.

"The simplest way to do the shot was to do live-action motioncontrol," he explains. "We began with Meryl Streep and Bruce Willis passes. She had to wear a weird hood and act backwards, doing

all the action stuff she had to do. When we got the take Bob Zemeckis wanted, we did a blank pass with no one in the set.

"Bob then cut the sequence more or less the way he wanted it to be. Then, we sat and looked at each scene to figure out what coverage we would have to get on Meryl for each cut. Then, by eye, we tried to figure out where her head would be and where the action would be."

Ralston admits it was a rather archaic system that was used. He had a big chair in her position. By marking it for each movement, he could calibrate the shot. "Each cut had a mark to see where her body position would be and where we had to have the head," he explains. "We ran a tape, with Ian Kelly doing the movement. It was looping pass for Meryl. She could do the scene, listening to what she had done.

"We then shot her head, with her body in a blue leotard, emulating the movement we needed. She was great!" he adds. "It takes a lot of patience to do what she did."

When Ralston got the elements needed, he then rotoscoped out her ponytail, which had hit the leotard. "We got a fake ponytail and shot it – with me manipulating it as if it were attached to her head – in front of a blue screen! We then matted it to her head and match-moved it to the other elements. We then CG'd in a neck and a little chest. We were now in the computer age!

"Of course, the final work was to color-balance for all of the elements! And, adding the correct shadows of her head on her neck, etc.

"Thank God for computers," he adds. "We couldn't have done this shot any other way.

"Of course," he adds as an afterthought. "Bob did complicate the shot, just a little. He had her sit down at the piano – with a mirror that reflected her head! Not only did we see the back of her head, we also saw her reflection!"

To do this, Ralston had two cameras in the same position. "Shooting two different versions of a shot is complicated," he admits. "We then had to spin both heads, of course!

"If anyone can complicate a shot, it is Bob! He doesn't do it on purpose," Ralston adds. "He just does it naturally. And, because he wants cool stuff that adds to the comedy, you go ahead and find a way to do it! It's funnier, but inevitably, it is much, much harder!"

Harder was worth it. In 1993, Ralston, Doug Chaing, Douglas Smythe, and Tom Woodruff Jr. won the Academy Award for **Death Becomes Her**.

How could he top that? The groundbreaking blockbuster film *Forrest Gump*. Although Ralston dealt with a variety of techniques, including sophisticated blue screen work and new stop-motion technology, the theory is the same – believability. It is the ability to infuse "soul" into his shots – to make the audience believe the moment, even though they know there is effects technology in place – that won him a 1995 Academy Award, (shared with George Murphy II, Stephen Rosenbaum, and Allen Hall II).

Everyone knows the feather is CG, but they buy it because they are intrigued, fascinated, entranced. Putting Forrest in archival footage of the Civil War, well, that's fascinating. Forrest doing Dick Cavett and talking to John Lennon – that was a little more tricky. It was here that Ralston used a new technique called "mouth-morphing."

For this, and other footage where Forrest talks to well known figures, Ralston and crew scrutinized miles and miles of archival footage. They needed to understand the physical subtleties of each character. "We had to learn how features moved with each phoneme of conversation," he explains.

After breaking each shot down on an animation sheet, Ralston moved to a computer. Using a software called Elastic Reality as a starting point, he was then able to paste pieces of archival footage together with the facial manipulations on the computer. This was then married to a soundtrack of words drawn from old interviews and/or sound-alike actors. "Then we had to match the grain and lighting direction of the archival footage with the film shot by cinematographer Don Burgess," he explains.

Over the years, Ralston has developed a unique relationship with Bob Zemeckis, a filmmaker whose understanding and vision for vision effects consistently challenges, stimulates, and inspires Ralston to explore new frontiers in the application of visual effects in the storytelling process.

Not one to rest on his laurels, so to speak, Ken Ralston took the award in stride and moved on to other projects. Following *Forrest Gump*, Ralston accomplished visual effects at ILM for *The American President* and *Jumanji*.

In 1995, Ralston was approached by Sony Pictures Entertainment to lead Sony Pictures Imageworks into the future of visual effects and digital character creation. For the artist who began as an animator and pioneered countless new techniques, the opportunity to provide leadership and vision in a company built by and

for artists was irresistible.

Ralston brought new creative vision and leadership to Imageworks. For Ralston, digital effects must be organically connected to the whole of the movie and not merely eye-dazzling flash. Though technology allows the visual effects artist to accomplish the impossible, for Ralston, "storytelling is still what it's all about." In bringing this philosophy to Imageworks, he has led the way to producing state-of-the-art visual effects that blend seamlessly with live action components.

Sony's commitment to building a visual effects house from the ground up was a key factor in Ralston's decision to join the company. Ralston saw Imageworks as the perfect opportunity to bring his personal stamp to an entire facility.

He says, "I wanted to create a place where you could really push beyond the boundaries of everyone's imagination, a facility that had the technology and the artistic talent to really achieve the most amazing images that any director or storyteller could come up with."

Phenomenon and *Michael* were the first two projects he supervised at Imageworks. Both were heralded and provided Ralston with valuable insight into the operation of Imageworks that helped to prepare for what would be a monumental project: his 1996 collaboration with Bob Zemeckis for **Contact**.

"It was a lot of hard work, but worth it," says Ralston. "The opening shot was extraordinary to look at. But, by far, my favorite and most complicated shot was when Jodi Foster's character supposedly lands on a beach in a distant reach of the universe.

"There were so many layers to the shot, the first challenge was to determine what techniques should be applied to achieve the director's vision. The techniques had to be flexible enough that whatever Bob Zemeckis did on the set, I could move on the background."

Interestingly, the plates were shot in Fiji, for logistical reasons, before the live action elements with the cast were shot on a blue-screened soundstage in Culver City, California. While the final sequence creates the illusion that the entire scene was shot on location, the reality is that only Ralston's five-person visual effects camera unit set foot on Fiji's white sand shores.

In the scene, Ellie, played by Jodi Foster, wakes up to find herself in a surreal setting reminiscent of her childlike drawing of Pensacola, Florida. On the beach she finds her father and learns the meaning of the machine and herself.

"Because of the crazy schedule, we had to shoot our raw material backgrounds before we did the blue screen shoot of our actors," he explains.

"We devised a way of shooting massive amounts of static footage of our location in Fiji and tiling together a 360-degree synthetic virtual world that we could match-move to any camera action shot months later on our blue screen set. Because our window of opportunity to shoot was limited by tides and weather, we shot two VistaVision™ cameras simultaneously on 48 stock.

"The first problem with seaming the tiles together was that the most appropriate tiles were shot on a day with scattered clouds over many hours. It made color balancing the water particularly difficult, since the clouds' shadows would change the color of the water.

"The next main technical problem was figuring out a way to get the blue screen matched-move data to work with the tiled background. The solution had to be capable of dealing with shots with different lenses and that could include viewing practically all the tiles.

"Our digital artists built the beach environment as a 3-D virtual set that would produce accurate perspective distortions, as if a motion-control camera had been on location. This worked particularly well for the beach and water."

The virtual set was created from multiple elements. The background plates were projected onto a simple 3-D model of the jungle, beach, and water. Each plate had to be keyed and rotoscoped to remove the sky and then balanced to get the plates to match each other. "Finally, we had to work out how each plate would overlap."

Other elements include a replacement for the sand, as well as a complete replacement of the sky, with starfields, nebula, a large galaxy and some distant clouds. These elements were created from artwork and enhanced, using morphing or compositing tricks. In total, about 60 gigabytes of textures were created for this scene. These elements were rendered into separate layers and composited together before being combined with the blue screen element.

There were 39 blue screen composites in this sequence, some of them showing a complete 360-degree camera move around Ellie and her father. "We played the water backwards, the tree shadows were sped up, the color was bright and oversaturated. We wanted to create a sense of *un*reality. . . as though what we are seeing is maybe a dream, maybe a virtual environment, maybe heaven," Ralston adds.

"We concentrated on our artistic techniques, creating

complicated layers of subtle effects, such as glowing flesh tones, a slight overall diffusion, and a shallow depth of field. We tracked in the background tiles, changing the focus on them as it suited the action. Reflections of the stars were added into the water, and animated glints of light danced on the waves. Keying Ellie's blond wispy hair complicated the sequence, as did continuity of color, look, and the long shot lengths.

"Within the sequence, we also had to create a rotating galaxy, which was composed of several large matte paintings combined together as rendered elements to give the galaxy a volume that the original artwork couldn't provide on its own.

"Another important part of the sequence involved creating a series of 3-D ripples designed to give the impression that the environment that Ellie finds herself in is not all that it seems. The ripples had to give the appearance of being on a surface surrounding Ellie, as if she were inside a sphere. This was achieved by match-moving her hand, constructing a 3-D sphere around her, and then applying a ripple controlled by the movement of her hand.

"A similar technique was used for the reveal of Ellie's father. The beginning of this reveal was supposed to look unrecognizable, but gradually forming her father as the 'thing' moves toward her. This was achieved by rippling the original blue screen of David Morse in a similar method to the 3-D ripple. The final effect of the sequence was a swarm of shooting stars created using particle effects."

Yes, it was a complicated job to pull off – and worth every moment! Where does Ken Ralston go from there? As the President of Imageworks, Ralston provides guidance and leadership for all of the company's artists and projects. In that capacity, he has seen Imageworks complete a variety of projects including *Starship Troopers* (which brought Imageworks artists their first Academy Award nomination), *City of Angels, Anaconda, Patch Adams,* and *Snow Falling on Cedars.*

Ralston's roots as an animator have inspired Imageworks to develop its digital character capability, with *Stuart Little* the first project to showcase these talents (helmed by John Dykstra).

Ralston's calendar includes several other major projects. In his capacity as visual effects guru, Ralston is again teamed with Bob Zemeckis on two new projects, *Cast Away* and *What Lies Beneath.*

Fullfilling a lifelong ambition to direct, Ralston is developing one of his favorite stories, *Mysterious Island,* based on the Jules Verne

novel. A 1961 screen adaptation of the book featured visual effects created by Ray Harryhausen.

What elements will be effects? That is yet to be decided. However, whatever they are, they will follow Ralston's credo. "Visual effects have to have a sense of history," he says. "They have to be full of subtle nuances that give them life. Most of all, they must resonate and make you want to feel and experience the vision yourself." Although technical prowess is important, for Ralston, "storytelling is still what it is all about."

"Today, there is no limit to what we can do, providing we have the tools to work with once we get to the computer. When I am on location, if I have a camera available, I will shoot elements – just to have something to pull out, once we get to the post-effects."

Steve

Rundell

Just because his father was a well-known cameraman, or that the family had first run films as evening entertainment in their home, didn't mean Steve Rundell was destined to be "in the industry." Although he was making his own home movies on a Bolex as a youth, and would watch his father shoot specialty projects, the young Rundell rebelled against the industry and went to college to get a bachelor's degree in business.

"I never could get over the specialty aspect of movies," he says. "It wasn't what was done on the stage but what could be done later that hooked me."

When the owner of Pacific Title offered to let him whet his appetite for the after-the-shoot manipulations at the burgeoning post house, Rundell quit school and never looked back. "It was the days of early motion control, shooting inserts and doing opticals through compositing techniques," he explains. "The shooting had to be very rigid. And, blue screen was the given source. We would then pull YCM separations off the negative for quality."

Rundell quickly learned that the success or failure of a shot was often in the matting process. "I learned how to pull mattes. We would use Kodak's 5362, 5366 stock, or the 60 (reversal) – depending on the kind of blue screen we had.

"Other elements, like smoke, water, and dust were shot in front of a black screen because black drops out. At this point in the process,

you couldn't manipulate the image or skew the perspective; the only thing you could do is reposition it left to right or top to bottom."

An admirer of Albert Whitlock, Rundell became fascinated by the world of matte painting. He soon left Pacific Title and began working as a freelance optical printer for hire. "Shooting matte plates required a massive amount of detail at the camera level," he explains.

When Disney Studios was doing *Captain EO* 3-D, 65mm, Rundell was hired to shoot the motion control logo. He then stayed on to work on the Shelley Long-Bette Midler project, ***Outrageous Fortune.*** He was to do 17 different matte paintings. The biggest part of the project was a major chase sequence. The script direction said that the two female lead actresses were to be chased across a canyon by Peter Coyote's character. "Shelley Long's character must jump four pinnacle peaks," Rundell explains.

"Mike Lloyd created several pinnacle matte paintings," he continues. He had used a version of Albert Whitlock's photography called "O-Negative" to shoot. "Whitlock would shoot a lot of footage for the photo backgrounds and put the film in the refrigerator," Rundell explains. "He would then snip a piece of unexposed film and put that in the camera-magazine in the darkroom. He would test the stock, then double expose the footage with the matte." This allowed Whitlock to create the elements without a generation loss.

Instead, Rundell felt more comfortable developing his plate and pulling YCM separations off from it. He then photographed the matte painting and put it together with the plate. "That meant doing at least three passes with YCM process, plus frontlight and backlight passes," he explains. "It also meant we could do as many tests as we wanted, without running out of film."

By doing the process this way, Rundell could project another element in the process either through or behind the glass, reduce the elements (people, cars, etc.). "We could also animate elements across the screen or make a foreground miniature that would work with the background," he explains. "Of course today, you would do all this in computer motion control. Back then, you couldn't do it.

"In the process we used on the 1987 film ***Outrageous Fortune***, we literally had to trace the background plate out on a piece of glass, by putting the rear-screen material behind it, and projected it out so we could see it. We then put in any additional elements shot for real as an insert, based on the lineup. There was not a lot of flexibility to position things or move them around.

"For the background plate, we had a stuntperson jump from one trailer to another on the lot. This was the up shot," he explains. "It was specifically for the canyon's point of view. We then put a matte painting over the truck."

The team did a few passes at high speed, so it would appear Long's character was jumping in slow motion. "Then, director Arthur Hiller added a little wrinkle," he laughs. "He wanted the grand finale jump to be really long. Okay, today we could do that very easily on the computer. However, at that point, we were locked into a certain amount of time. To pull this off, we had to take the separations of the jumping shot and create a precomposite on the motion control optical printer extending her leap. The last clear single frame with her in mid-air was used to fly the rest of the way. Once that element was created and split up into the black-and-white separations, we then could composite it with the matte painting."

At this point in effects, matte paintings were limited. They were stuck between a single dimension and a three-dimensional look. "The good matte painters would sample areas and make them come to life by reducing rear elements in perspective, putting in depth through various means. Playing with light and dark areas against each other creates depth, along with just 'noodling detail.'

"Today, there is no limit to what we can do, providing we have the tools to work with once we get to the computer. When I am on location, if I have a camera available, I will shoot elements – just to have something to pull out, once we get to the post-effects."

Rundell's next interesting project was the quirky 1987 Chris Columbus project *Adventures in Babysitting*. "Chris wanted to use a new process called Introvision™ for the whole show," Rundell explains. "Now, Introvision™ was a great tool for specific situations such as a staged stunt, preventing actors from being harmed. With that there is considerable amount of construction, which narrows the ability of the director to change his or her mind. However, people often try to force tools into other areas because of the intimidation factor. When the tools are available, they have to justify the cost.

"In this case, a matte painting was a better way to go. Here, the flexibility of establishing the 'Associates Building' within the storyline in other background plates was more cost-effective and could give us greater production value.

"Of course now, we would sit the actors in front of a blue screen and put the elements behind them, creating a virtual environment, " he adds quickly.

At this time, Rundell was developing a reputation for producing stunning matte painting effects in the optical process. He thought it would be a plus for Disney to have its own department. Thus, Buena Vista Visual Effects Group was created. And, the first big feature job they tackled was Warren Beatty's 1990 version of *Dick Tracy*.

"When BVVEG was established, we supported the department doing a lot of trailers," he says. "Michael Eisner cared about the film distribution end of the product. He wanted his trailers to have the same quality as the first-generation negative, for both foreign and domestic. So, we would do Ips (inter-positives) and generate individual new negatives for each trailer and each country, creating first-generation elements and maintaining feature quality, as a first print run.

"Then, things changed, and the department's focus shifted. The *Dick Tracy* project was something very different and very stylized. The whole concept of the movie was primary colors.

"When we created the matte paintings, we had to keep in mind how Vittorio Storaro was painting the first unit action with light and what production designer Richard Sylbert had created with his sets. Vittorio might be lighting the streets with fuschia and the back alley sets with pure yellow or green or blue. We would have to match the colors he used.

"Plus," Rundell adds, "we had to compensate for the ENR process Vittorio used to desaturate the colors, and retain the blacks.

"When we wanted brown, we might have painted with purple. We always had to take into consideration what the lab would do and where Vittorio had the first unit color temperature."

Because 90 percent of the project's exterior was shot at night, it was always dark. Rundell had many calculations to figure while maintaining color palate and black density. "We often had 10, up to 15 passes for one shot," he explains. "Some of them started on the matte painting motion control system and were finished on the optical printer. Interchangeable camera magazines were a big deal then.

"Often, the shot was straightforward," he continues. "A car driving up to a location, for example, shot on Universal's backlot and finished with a matte painting of the wharf in New York City.

"We would have to do separate passes for steamboats, water reflections, smokestacks, bi-plane flybys, twinkling stars, all making the shot come to life and magical.

"In addition, we might have an X-Y camera move and a pull-back, which often happened on the miniatures, especially at the end of the picture," he adds. "We had a steamboat with people moving about the deck, fireworks in the air, an establishing shot of New York Harbor, all from a camera crane's point of view. It was a very daring thing to do, at that point, in effects.

"Of course," Rundell says with a smile, "if it was today, Warren would have gotten his way, which would have been to matte-paint the whole movie. Back then, the computers were in their infancy and not sophisticated enough. So, we had to have real sets!"

With the uncertainty of the success of this picture, Disney and Rundell weren't sure an in-house matte shop was the way to go. Rundell went freelance once again, putting packages together for various films. "The 1991 Jean-Claude van Damme buddy picture *Double Impact* was the next step in matte effects for me," Rundell says.

"By now we were doing real-time motion control on the set," he explains. "However, it was still left-side, right-side split screen, which you had to put together. Everything still had to be repeated perfectly because we were working with a traveling matte.

"You would make a matte and throw it slightly out of focus for the blend line. We would use architectural elements for the split – wall lines, lampposts, and so forth. That was why registration was so critical; you couldn't have the left side and the right side vibrate against each other."

In *Double Impact,* the effect became a little more difficult. Rundell and crew would have to plot where the brothers would be, in an 80-degree turn, as they stalked each other. "The split line was constantly moving, so it wasn't easy to lock off the left side and right side down the middle," he says. "When the two characters came face-to-face, it was the closest to the split line I have ever gotten."

Fortunately, video playback was in use at this time. Jean-Claude van Damme could shoot the left side with the camera move. Once that was recorded, he could go off and do a wardrobe change and come back as his brother. Using the playback as a reference, he could then match the moves for the second character.

"Not as easy as it seems," says Rundell. "Timing was the key. Fortunately, Jean-Claude knew cadence and was good at rehearsing fights. He could be consistent. However, the energy had to be consistent, and so did the takes."

Rundell and crew were using Image G's motion control camera, which was the best at the time for accuracy. He was shooting Kodak's 5295 color stock, which was reasonable for the lighting. However, even with the great camera and stock, the crew was locked into several important elements.

"We had to make director Sheldon Lettich do what no director wants to do – commit to a shot," Rundell smiles. "Whatever take was the hero take on the A-side was the key take. He could change his mind on the A-side and reshoot a different camera move. However, when we got to shooting the B-side, Lettich could not say 'Take five is better' because the camera was in a different position on take five than it was on take three from the last A-side take."

On top of the elements of commitment, Rundell and crew pushed the envelope of effects a step further on this split. At one point in the story, one brother has to slap the other's face. "That meant crossing the split line," Rundell explains. "The match had to be perfect. All we could do was hope that, at a given point in the slap, it was fast enough so that all you have to worry about is about eight frames in the cross-split. To make it match, we had to heavily rotoscope those frames."

It was on this picture that Rundell was introduced to the concept of digital work. "We had a fight sequence where Jean-Claude was hanging some 35 feet in the air. He looks down and sees a ship, a dock, and a truck pulling up underneath.

"The traditional method for shooting this would be to suspend him hanging down with a wire and dropping him onto a blue screen air bag," Rundell explains. "Now, the challenge was to get rid of the wire."

The Paint Box™ program was just appearing on the effects scene. Rundell could take the elements and put them on the Paint Box™, taking the wire out. "The question was of how the Paint Box™ elements would cut into the picture," he explains. "Fortunately, the shot was a night scene. It had different lighting than the sequences around it. Therefore, there was nothing to judge against if we had inferior resolution. Using the box on this sequence proved it could work for other elements."

Rundell took the shot to CIS (Composite Image Systems), and they telecined it in on a proprietary pin register system. "This meant taking a shot that was done in 625 (PAL) lines of resolution and putting it into a proprietary system that was 1,250 lines," he explains. "Once the element was finished, we then had to take it back to film resolution.

"What I found out was that the resolution was only as good as the film was shot, or exposed from the director of photography," he explains. Rundell also learned a few other valuable lessons that helped him with elements on the Paint Box™ for the 1992 movie *Patriot Games* and the 1993 movie *Coneheads*.

"On *Coneheads*, we were able to do things with more confidence on the Paint Box™," he explains. "We completed 65 shots in six weeks at the early stages of 2K resolution. "There is a scene where the characters are hanging on a conveyor belt. We quickly realized that when we took the video image (525 resolution) and it it seemed slightly soft, due to a lower resolution, when we reduced it down to about 1/16 of an inch on the screen, it would look sharp. That allowed us to do really neat things on matte paintings and compositing."

Utilizing the CIS proprietary system, these new effects techniques became an integral part of Michael Apted's 1994 film, *Blink*. "Since this was a story told from a blind woman's point of view, you didn't have to have the highest resolution," he explains. "In fact, what she saw should be out of focus, which could be in a lower resolution.

"We didn't want to do the traditional Vaseline on the lens, so we played with what we could do on the Paint Box™. The idea was to create images with enough resolution to maintain density, but create her point of view so that it related only to what she saw. The fine line we walked was creating the images without letting the blacks milk out."

From *Blink*, Rundell moved into commercial work. This was the era when directors, like Richard Donner, were creating commercials not as much for television but to play in the major theaters between films. "This is when equipment really began to appear on the scene," says Rundell, allowing the film community to tap into the video techniques via software, usually associated with Henry and System G. "New scanners and film recorders became available that allowed us to get more detail into the computers."

On the 1995 film *Bad Boys*, Rundell realized the strengths and weaknesses of the Domino™ process. "Sure, we could change dimensions, augment shots, add other elements like smoke and fire," he says. "But there were limitations in resolution. There was also the controversy over 8-bit color vs. 10-bit color.

"Digital purists will argue a 10-bit color full scan is superior even when the color has been matrixed down to 8-bit for film recording versus scan RGB color records in 8-bit. The latter is comparable to the optical printer process, where color timing each record when scanning is critical, limitations being hot white skys or blown, out white areas in the original negative."

Rundell was hooked on the digital world. Soon, he began thinking of building up his company, called D-Rez, by adding Domino™, Flame™, and other equipment. "The idea was not to hang my hat on specific software but to have enough to fulfill a variety of needs, both as an effects house and effects supervisor," he explains.

That ability really came into play with the 1996 film *Mulholland Falls*. "This was really where we got to use all the capabilities of the computers," he explains enthusiastically. "Not only were we involved in creating shots after Haskell Wexler finished the first unit, we were integral in designing the shots – even scanned location photos and did cut-and-pastes to learn how to make the most cost-effective sets and locations for this period piece."

Rundell worked with production designer Richard Sylbert (who also previously worked on *Dick Tracy*) and art director Greg Bolton to create "color proxy images" from photos taken by the location scout. "This allowed us to identify what photographic elements would be necessary to make the best out of each shot," he explains.

Using a Mac Power PC, Rundell created color photos from shots he took on location along with Bolton's schematic drawings, creating the new style in storyboards. "One of the important story points in *Mulholland Falls* involved the four main characters – and a huge crater that had been created after an atomic test," he continues. "In the wide money shot, we had to see the crater from the view of a camera booming up to 35 to 40 feet. We then needed to see the four characters against a blue sky as they walk up to the edge of the crater in the reverse shot, from the crater point of view.

"Any existing craters within reach of our camera crews were in restricted areas," he continues. "So, all we had were the reference photos." Rundell combined reference photos with desert location scout

material and created a 3-D model. This allowed director Lee Tamahori to see the location and choose his angles. It also allowed cinematographer Haskell Wexler ASC to choose his lighting package.

"Sounds easy, right?" he laughs. "In a way, it is. Now, all we had to do is go to the location, create the environment for the crater, bring the shots back to D-Rez, and combine them in the computer with our version of the crater.

"Of course, by the time we got the equipment to the location, the sun was setting and the wind was blowing. A storm was coming up and we were getting shadows that were four miles long! Just as we were ready to shoot, Lee came up with another wrinkle. 'By the way, did I tell you there is a car driving up in the shot?' he said to me.

"Short of chopping off a director's head, when he comes up with a creative idea at the last moment, an effects supervisor has to go with the flow," Rundell says dryly. "I took a deep breath. I could fix the sky with a matte painting. I could paint the shadows out and do light exposures in the computer.

"What I realized was that we would have a tracking problem," he continues. "We needed to know where the car would stop.

"Fortunately, we had a phenomenal art director. When he looked at the 3-D model, he agreed we might need references. Somehow, he had these huge 10-foot, 4-by-4 barbershop poles. With the help of three grips, we quickly placed them in strategic points in the location and covered them with Manzaneta branches. Now I had a place for the car to stop, when I put it in!"

By the time Rundell was ready to shoot, the camera was wide open. "If it wasn't for Haskell's ability to do what he does, we wouldn't have had a shot," Rundell says. "The creativity and cooperation of the first unit cinematographer is more important than ever in effects today. We are only as good as what they can give us."

When Rundell got to the computer, he had everything he needed. "In a way, we were going back to the old discipline of using architecture," he says. "We could use the tracking poles to line up the composites in the computer. We could also use things like a house on the hill or the mountains in the background, which didn't move. This allowed us to move with the camera as it rises, even change perspective.

"Tracking points are key to any shot," he continues. "Recently, I used hundreds of Avery circle tabs outside the window of a shot to track it. I even added cross hairs. When we got to the computer, I realized we didn't even need the cross hairs. The white would be good enough, with

the sophistication of equipment. Since white is contrast density to any background, it is completely different, and visible."

Effects were now becoming integral to making movies that were traditionally "non-effects" products. In *Mulholland Falls* as well as in the 1995 project *Devil in a Blue Dress*, Rundell was able to turn modern buildings into period architecture. "In *Devil in a Blue Dress*, we did simple things like fix non-period windows," he says.

"Of course, we were now able to do other 'little things' for the film," he adds with a slight smile. "You know what you do is vital and working when you have one of the camera crew come up to you and say, 'You know, I wasn't really happy with my camera move on this or that shot – fix it in post for me, will you?' Now we know we are a valuable asset to a project, when we are asked to help make a better camera move."

In 1996, Steve Rundell and team brought all of the latest elements in effects into play, working with director/actor Tom Hanks on his breakout film *That Thing You Do*. "The money shot on this picture was a concert sequence, where the boys are at the pinnacle of their budding career," he explains. "Tom wanted to have the camera behind the boys as they play to tens of thousands of fans at night – and have flashbulbs going off.

"In the old days, we would place cardboard people in the rafters for matte paintings," he says. "We didn't want to do that. What we did is hire 500 extras, bring them to the Pomona fairgrounds, and stage them in 21 different positions, doing a 190-degree motion control shot, in sync with the music track."

Rundell's team shot the stage from the infield. He then moves behind the position where the band would play. His first 30-second camera move from point A to point B and back set the stage for the other 20 moves. By mixing the people around, changing their positions even some costumes, he created 21 different crowd elements. "On the workstation, we could cut and paste them together," he explains. "We could go in and precomposite each section, using the architectural positions designed in the shot."

To give himself extra coverage, Rundell decided to have a B-camera set up onstage to do lock-off long lens shots, in case Hanks wanted over-the-shoulders of the bass player in the group. "The night before, we thought we were ready to shoot," he says, slowly. "That was, until Tom came up to me and said, 'By the way, there are going to be mounted horse patrols in front of the stage.' Another element!

"Fortunately, I was ready for the unexpected. My first question – When can the patrol get there? Fortunately, it wasn't until the end of the day. So, I was able to shoot the 21 passes in six hours. When the patrol arrived, we placed them in the foreground, making sure they would be below the matte line over their heads. It's just another element."

Rundell wasn't finished. He moved to Stage 22 at Fox and shot the band in front of a blue screen, re-creating the music synchronicity from the location in playback.

"That wasn't the finish," he adds. "I wanted one other element. We needed stadium spotlight passes, flashes of light off the cymbols and drum. With the gaffer Randy Woodside, I put four 10ks at specific heights near the blue screen, a height that would simulate the placement on the arena's posts. We shut the rest of the lights off and did a pass. Now, we had about 30 elements to composite in post."

In the computer, Rundell was able to make the shots look like night footage. He could go back in and animate flashbulb effects from kids taking pictures. He could also finesse the gradating of density of light, so the people in the front row looked brighter than the people in the back of the arena.

"Once directors like Tom Hanks get on the page of effects, there is almost nothing that cannot be done today," says Rundell. "In fact, the sophistication of effects now makes virtually impossible projects possible."

This was true of the 1996 art-type film *The Winter Guest*, directed by actor Alan Richman. "There were two givens to getting this project off the ground," says Rundell. "One was that Alan would direct (and that Emma Thompson would star). The other was that he would be able to shoot on a location similar to the one in the story, that could later be frozen."

The second was easy for Rundell to prove. He showed Richman tests he had done, creating the desert in *Mulholland Falls*. "The film was to be shot on a seaside location in Scotland," he explains. "I was brought in, not only to do the effects but also to supervise and shoot the second unit, along with attending to B-camera.

"When Alan and I scouted locations, our first desire was to find a way not to shoot the actors in front of blue or green screen. Alan wanted to give the actors a reality to play to. I wanted as much interaction between actor and location as possible to work with."

Rundell's first requirement was to find a way to get the actors in backlight at all times. "This way, we had well-defined sections we could pick out and freeze in the computer," he explains.

"The next requirement was to make sure the foreground elements in the plates were separated enough from the sea," he says. "That meant making sure costume design did not blend with a sea that would go green or gray."

Rundell's next requirement was to maintain the sun at a 45-degree angle off the horizon. This gave him the brightness he needed for melding elements.

"It was the simplest element of the picture," he admits. "For other shots, we created plates on the exterior of an airfield, built in fake snow, and created a barrier about 100 yards out (with hay bales covered with white muslin) for infinite background. By adding these shots to a model, and putting in the two young actors, we had a shot that explained why this village had become prisoner of the weather. Once the ocean was frozen to infinity, villagers could not leave the island. That is, until two young lovers show them they can venture beyond their boundaries."

When the picture was finished, Rundell accompanied it to the Venice Film Festival. In one interview after another, writers could not believe the massive ocean surrounding the small village was not a location. "It would have been impossible to do this picture that way," he kept explaining. "We couldn't get the equipment to such a place. No insurance company would cover our actors for that kind of weather. It would also be a logistical nightmare, lighting and moving the equipment, if we got it there.

"Alan Richman saw what the computer tools, created in the last few years, can do to advance a director's vision. He knew effects are a lot more than moving flying saucers around a galaxy."

So did director Jonathan Demme, when he took on Oprah Winfrey's version of Toni Morrison's story *Beloved*. "At first, effects were to have a minimal involvement in the project," Rundell explains. "However, once Jonathan Demme saw how sophisticated the equipment had become, his creative mind just took off. Many of the shots we did will never be noticed as effects – they will just be enhancements of what 'should have been there but wasn't.'

"We did a series of sophisticated opticals," he continues. "There is a dream sequence. There is also a huge matte painting (next page) of a slaughterhouse where 500 pigs run down the street and take a turn

(Figure 1 location shot. Figure 2 matte. Figure 3 composite)

into the house that isn't there. We also did a huge reveal of the city of Cincinnati with a bridge, riverboats, and even the correct signage that weren't there."

Even though matte paintings have become much more sophisticated, they are still paintings. It is what Rundell created that made all the elements fit together that hides the technique. "For the cityscape, we added a few computer touches – like birds flying through the shot and even smoke and haze depicting a lazy afternoon."

Rundell was able to finesse everything Demme wanted, even in the tricky sequences where cinematographer Tak Fujimoto used a very old technique, shooting with reversal stock. "This raw stock has a short life span before fading, so we had to act quickly relative to scanning the information into the computer. Also difficult was the continued balance of the stock under different color temperatures and lighting schemes. The reversal film gave a flashback look in color rather than utilizing traditional techniques that our audiences have seen over and over."

The stock did away with the need for many time-consuming and costly opticals or digital enhancements. By blowing out the whites when shooting, Fujimoto left Rundell vibrant colors of green, yellow, and red, depending on the filtration. "This way, we could enhance the colors we wanted, leaving the negative the way we wanted," Rundell explains.

Rundell's next challenge was to find a way to project the flashback images against the walls of Winfrey's bedroom wall. "The stock was great, but we knew 'straight-on' camera angles wouldn't be interesting," he says. "So, Tak went for dutch angles and forced perspective. Couple that with Tak's 'less-is-more' approach to lighting the shots (he used a pan of water and shards of mirror to reflect the light), we had unusual images that were manipulated to director Jonathan Demme's satisfaction."

Viewers of *Beloved*'s noneffects techniques were mesmerized by what Rundell's company could do. "I'll repeat myself, again," he says. "What we can do is only as good as what we get to work with. In the case of *Beloved*, we had an incredible cinematographer who was willing to learn how the computer can further his creativity. Once he understood we weren't there to subvert his work but to help him, he gave us so much."

Also in 1998, Steve Rundell took on another effects film – "that shouldn't look like effects, but the audience will know much is computer-generated," he says. "Nevertheless, for *Elmo in*

Grouchland, the trick was to create the illusion that Elmo, with his running legs is real to his audience.

"Typically, muppets were always shot from the waist up. Directors would purposely stay away from massive 3-D CG (budget constraints). We created a rig that allowed the puppeteers to perform standing in place in front of a green/blue screen and allow them to perform to video playback of the plate, all the while moving them relative to the camera at the same time. By visual effects standards, this was a very undisciplined technique but proved to be very effective when composited together with the background plate.

"We were able to take these green-screen elements shot 'wild' and finesse them in the computer. The trick is selling to the audience that fact that these muppets are actually skating or running down the street. Creating shadow mattes from the actual muppet in motion, skewing perspective, and compositing the shadow on the ground in sync with the muppet motion allow the believability of actual interacting on a given surface. Of course, there were four shots that called for CG Elmo interacting with a Giant Chicken.

"With a very tight shooting (30 days) and post schedule (15 weeks), the trick was to shoot what was needed but also to shoot as much additional footage that would benefit the storytelling as we edited in postproduction.

"One technique was to utilize both blue and green screens at the same time," he explains.

"In one shot for camera we are looking over the shoulder of Elmo up at the chicken. Elmo (red/green screen) hanging on a tree branch, is being held by a giant 40-foot chicken (white/blue screen) with his chicken wing. It was shot with two cameras and two different lens sizes, at the same time.

"The chicken being 40 feet tall (actual size was a 3 1/2 foot puppet, same size as Elmo) a size perspective problem.

"Using two cameras was a way to assure the director that the sizes would be believable, using two different lens setups. And, a great way for me to have the director commit to the exact take for post-production purposes.

"Each camera's video signal was fed into a video switcher, allowing us to preview a precomposite as the performances were delivered. Each puppet could also react to the other's character properly, while viewing a video monitor during shooting of the scene.

"Allowing the puppeteers to have the freedom of movement, whether walking, skating, or flying their characters, while viewing the background plate through video monitors, proves to be the answer to great performances and shot sequences," Rundell feels.

Elmo singing, dancing, and walking on his journey to the castle proved to be another great performance sequence for the team. "Again, Elmo's choreographed movements (shot against blue screen) had to be in sync, not only with the plates of other singing puppets shot days before but also with the music and song dialog."

Thankfully, Steve Rundell and team did their homework. "With that complete and our task at hand, we finished principal photography one day early with twice as much footage. This proved to be valuable when edited and screened, for the studio (Sony Pictures), aware of our strategy, loved the additions and allowed for the coverages. An example of how visual effects, when managed properly, can be the pivotal point of helping the filmmaker tell the story."

"In visual effects, we succeed when we live by the same axiom as in successful film production – 'put the money on the screen.' When I am working on a toplevel production, I want to make sure the audience sees as much of our effort up there as possible."

Mark Stetson

Before the idea of a film career had entered his imagination, Mark Stetson began studying industrial design at the University of Bridgeport in Connecticut (1973). He then trained for a year as an industrial model maker at General Electric Company's Housewares Product Design division, also in Bridgeport.

In 1975, he moved to Los Angeles to study at Art Center College of Design. But, by his fifth term, he was restless. Although he enjoyed the work assignments and the problem-solving processes of industrial design, the subject matter and the environment he encountered in design offices were "too quiet, too conservative," he says.

"Then, I went to see *Star Wars* on opening night at the Chinese Theater in Hollywood, and my whole view of the world changed," he explains. "As soon as I saw the spaceships fly over my head in the opening shot, I realized I was seeing something I could be a part of. Something that was a more creative outlet."

Since he was already doing product design and industrial modeling when he wasn't in school, Stetson had the professional skills. "Building spaceships looked like a lot more fun than building smoke alarms and clocks!"

Fortunately, Stetson found himself in the right place at the right time, in the middle of the emerging renaissance of visual effects. The leading visionaries, like Douglas Trumbull, John Dykstra, and Richard Edlund, who were busy reinventing the industry drew many of their recruits from schools of industrial design in Southern California.

"Two of my classmates, Chris Ross and Tom Pahk, answered a call to the school for model makers, from Jim Dow at Magicam (founded by Joe Matza, current president of Composite Image Systems, Rob King, and Doug Trumbull). They had developed a process of real-

time video compositing suitable for broadcast television, based on four innovative components," Stetson explains.

"First, Paramount (the umbrella studio) dedicated a stage on their lot to a permanent blue screen cove with a specially poured epoxy floor for optimum smoothness.

"Second, a video production camera mounted on a studio camera dolly was equipped with electronic motion sensors, or encoders, for recording motions of the camera as it dollied in and out, panned, tilted, and rolled. The smoothness of the stage floor helped eliminate vibrations and glitches in the encoded camera motions.

"Third, a miniaturized pitching mirror snorkel lens system, mounted on a small overhead gantry system, was installed in a small stage built right inside the blue screen cove stage at Paramount. The slave camera and motion-controlled gantry were driven, real time, by inputs from the encoded production dolly.

"Fourth, images were composited in real time, using an early version of the Ultimatte™ compositing system. This system all worked together to create real-time shots of actors on the blue screen cove, shot with dolly moves, composited together with scaled, motion-controlled match-moves of miniature background environments shot with the slave gantry system.

"Keep in mind that this was 1978! This kind of ambitious technology was as much research and development as it was applied engineering. Using this system, Magicam later won an Emmy for Visual Effects in Carl Sagan's *Cosmos*."

Magicam had been assigned by Paramount to create the visual effects for a ***Star Trek*** reunion television movie. Dow had called the *Art Center* looking for recruits for a team of model makers to build the miniatures. After the success of *Star Wars*, however, Paramount decided they wanted to make ***Star Trek*** into a theatrical feature film, instead of a television reunion.

Ultimately, Magicam was kept on to complete the task of making the models, while Robert Abel and Associates was assigned the rest of the effects work.

"Jim Dow finally succumbed to my almost daily pestering, and with the additional prodding of my friends, in 1978, he gave me a job as a model maker on ***Star Trek***," Stetson says.

"There I was, a competent model maker with no clue about the special needs of miniatures for film," he admits. "After the exact tolerances required of industrial model making, in fact, it was an

incredible release to not be concerned with exterior model dimensions accurate to .005 inch!

"When I learned the axiom, 'You can't hold a ruler to the screen,' I took it to heart. It was easy to learn the idea that it was much more important how a model looked – that it should be proportionally accurate rather than dimensionally accurate."

With a trained designer's eye for proportion and a good sense of automotive-type paint finishes, Stetson had a good start. He now needed to learn everything he could about detail indication and scale, aging and patinas, and how miniatures are designed for the camera. A lot of the training came from visual effects director Richard Taylor, who had been with Abel for years.

"The look of the models in *Star Wars* had become an overnight standard for the look of spacecraft, with their intricate surface detail, battle damage, and heavy aging. Fortunately for me, the **Star Trek** designs were a lot more sculptural, and their smooth skins and shiny finishes left me with something to contribute.

"Almost like a fraternity hazing, on my first day on the job, I experienced my first all-nighter (the 'red badge of courage' of visual effects artists) helping to finish the Klingon model for delivery. We had the original Klingon model from the television series on loan from the Smithsonian Institute as a design reference.

"It was about three feet long and had one armature mount point in the bottom. It had a smooth skin, and it was finished with a fairly shiny satin paint job, with very few panel details.

"The model that Magicam built was, by contrast, about five feet long, with mount points in the bottom, top, rear, and both sides. The finish was nicely broken up with panel areas of very flat paint in a beautiful bird-like graphic pattern. There was a modest effort at breaking up the surfaces with little clusters of fine, low-relief surface details, to help contrast the design with that of the smooth-skinned *Enterprise*.

"With **Star Trek**, we were building the models to suit all shooting possibilities since, with the tumult of production, the ships were being built before shots were designed. The models had multiple armature points and were finished on all sides. The approach was valid. We spent more to prepare for the unknown, and to prevent slowdowns on stage, but the problem-solving steps of construction created their own set of predetermined compromises in the use of the models.

"The construction assumptions became shooting constraints. For example, the size of the model, at 8 feet, made it difficult to handle onstage, yet it wasn't really big enough to get really close to it with a camera. (By comparison, the original TV *Enterprise* was about 14 feet long.)

"Cameras and lenses were large enough that it wasn't possible to get a point of view in close to the hull. The light output of the miniature bulbs and interior lights was established for the size of the bulb, rather than the brightness, and these decisions were made before the visual effects director of photography came on board. So, considerations for exposure times were not complete. The shots were later compromised around those constraints.

"Jim Dow was a good teacher for me in all the basic skills of model making for films, being a veteran of Douglas Trumbull's *Silent Running*. He had assembled a very talented and eager crew, but he was constrained by the business relationship between Paramount and Abel and Associates. We all wanted to work endlessly on the detail and finish on these important shooting models; he was also pressured to just get them delivered and let Abel and Associates sweat the details.

"So with Jim Dow trying to get the models delivered, and Richard Taylor trying to develop a finished look, I found myself caught up for the first time in the classic struggle in moviemaking – the struggle between art and commerce.

"In my naiveté, I was dumbfounded by instructions to leave the models essentially unfinished and unshootable. I thought it was our job to complete the work, but in fact both Magicam and Abel wanted the models turned over as soon as possible, so that the Abel team could finalize the look to their specification."

Frustrated, Stetson gave notice. He was going to get out of the business and began negotiations with an industrial design firm for a permanent job.

"In retrospect, I still struggle with this basic conflict today. Moviemaking requires a collaboration of many, many people. They are thrown together to work under extreme pressures of both time and money. As long as there is more than one business entity involved in a film project, there is the inherent potential for conflict of interests. The result is often distrust.

"Well, the Abel team was building up a model unit of their own to prepare the models and handle them during photography, and they found out that I was leaving Magicam. So, I happily learned my next

major lesson in filmmaking – what to say to the 'offer you can't refuse!'

In January 1979, Stetson moved to Robert Abel and Associates to continue work on the same models he had built at Magicam. "However, my lessons in the struggles of art and commerce in movie-making were to continue.

"As I was getting comfortable working with this new team of model makers, however, Paramount was becoming very concerned with their contracted effects provider's ability to finish the job in time. With just nine months left to complete the huge project, Robert Abel and Associates was asked to leave the project and Douglas Trumbull was hired to take over.

"This was a truly major decision for the studio to make. They were very afraid that they would fail to meet their obligations to their distributors to deliver the picture for Christmas. With 365 shots to complete (optically!) in nine months, the studio pulled out all the stops to get it done.

"Doug helped map out the plan with his partner, Richard Yuricich, and the Paramount production staff, led by Lindsley Parsons, Jr., which involved splitting up the work between Doug's Future General Corporation facility and the recently formed Apogee, Inc., led by John Dykstra and his partners. It also involved a major expansion, the Future General facility in Marina Del Rey.

"Some of the model crew moved up to the Apogee stages in Van Nuys, and some, including me, were assigned to Trumbull's unit in Marina Del Rey. A few days later, we packed all the models destined for Trumbull's stages into studio trucks and rode on down from Hollywood to the new stages on Maxella Avenue.

"When finished, the *Enterprise* became more than an icon of the film – it was the icon of the 1970s era in visual effects model making, and was used repeatedly through at least the next four installments of the franchise. A young Jeffrey Katzenberg had recently arrived at Paramount from the New York parent company, then Gulf and Western. He had been assigned his trial by fire as a studio executive – he was given the responsibility to get **Star Trek** done for Christmas.

"He performed in a way that is now recognized as the Katzenberg genius – he was thoroughly involved from the top to the bottom, working fast, cutting red tape, wrangling production deals, and being in touch with the details to the extent of even checking in to

encourage us model makers as we painstakingly detailed the models shot by shot.

"In the midst of all this adventure, my appreciation of Doug Trumbull really stands out. Doug was an incredible mentor for me," Stetson acknowledges. "I often think about him walking around the *Enterprise* model on the stage, with his hands up to his eye to create an impromptu director's finder to view the model through.

"It struck me then that despite all the storyboards and planning, you could still do better by continuing to evaluate what you have. I saw that as a fundamental part of what makes Doug a great artist. Never stop looking for the better shot. Question your assumptions. Always look further down the road to completion of a shot, to fulfillment of a project.

"Perhaps this struck a chord with me, because that is part of my own nature. Even as a teenager, my employers commented that I had a gift for looking ahead to see the consequences of an action. 'Fast learner – quick study' – I was learning this artist's approach to visual effects problem-solving. Brainstorm loosely, try out ideas quickly, try to look at things with fresh ideas. Solicit new ideas. Delegate authority.

"A last noteworthy event in the **Star Trek** story was my chance to meet and work with Greg Jein, who had been Doug Trumbull's chief model maker on *Close Encounters of the Third Kind*.

"Doug had big plans for miniature work for the climax of the film – the revelation of the 'V'ger,' but he wanted to work with Greg (who was finishing work on *1941*) to achieve it. Doug trusted Greg's ability to organize and deliver the massive 'V'ger' interior sets within the extremely short schedule.

"That was an extremely lucky break for me, for it gave me a chance to work for Greg and demonstrate my capabilities. What was important about my experiences on **Star Trek** was, first, that I was thrown into a high-end visual effects environment so that I learned from the outset of my visual effects career how things were done at the top of the form ('visual effects 101'). Second, the project lasted long enough for me to learn the skills that I needed for a foundation in my newly chosen career."

Stetson had found a home at this facility. He worked on a series of projects there, but **Blade Runner** was, to him, the next important milestone in his career.

As the chief model maker on **Blade Runner**, he was able to implement the skills (technical and people) he had learned from his

mentors. "I had learned about perspective, drafting, illustration, light and shadow, and other techniques that were important on *Star Trek*, but on *Blade Runner*, I was quickly immersed in the design development of the film," he explains. "That was a great, new, exciting area of involvement for me. I started my first project in my garage, making a foam study model of the Spinner interior.

"I met production designer Larry Paull, art director David Snyder, many of the designers and illustrators in Larry's art department, and, perhaps most significantly the great visual futurist Syd Mead.

"We visited the sets frequently to absorb the pioneering retrofitted style of architectural decay. We worked closely with custom car builder Gene Winfield as he executed Syd's designs for the Spinner and other vehicles. We followed all that work very closely and used it all as a departure point to expand Ridley's vision of the future through our visual effects work.

"To help us achieve the richness of design in the visual effects, we made big strides in the materials used to form the models," he explains. "On this project, I decided to use etched brass for detail on a number of the key miniatures in the film, including the Tyrell pyramid and the Hades landscape.

"With our success, that technique became a standard for the industry. Model makers were able to get more reality into their details because of our ability to create extremely fine detail in a medium that was sturdy enough to hold up to rough handling onstage. The fine detail capabilities of the brass also allowed us to work at a finer scale than we might otherwise have considered.

"We started out with a rather devastating review of work in progress. We had invested a lot of time in the design and preparation of the Hades landscape miniature for the sequence of shots approaching the Twin Tyrell Corporation pyramids that open the film.

"I had gone out with still photographer Virgil Mirano to shoot stills of refineries in the local area. Chris Ross had worked tirelessly to strip up futuristic skylines, inked by hand over high-contrast photostats of the refinery reference stills. He had set them up in ground-row-style skylines in diminishing scale, for a semi-forced perspective view of the refineries to the horizon.

"We had spent thousands of dollars getting these skylines photo-etched so that we could mass-produce them to cover our tabletop

landscape of the relatively diminutive size of 18 feet wide by 13 feet deep.

"The tabletop was made of clear Plexiglas so that it could be lit from beneath, making a nice city glow in the smoky atmospheres used to photograph the models, as Trumbull had pioneered on *Close Encounters*. All the brass had been laid out and hot-glued onto the Plexiglas tabletop, but no paint work had been done.

"My original idea was that the skyline rows would be silhouette-lit by the bottom light in layers in the smoke," Stetson says. However, that wasn't working as Trumbull and Scott had expected. Especially since they viewed the model in a bright fluorescent-lit shop space, not the darkened smoke stage environment it was being built for. "Without much thought, Doug blurted out, 'This looks like Sh. . . !!!' " Stetson recalls.

Although the crew was devastated, Stetson stood his ground. "Since the bottom-lighting gag wasn't working well enough to carry off the effect, it got me thinking about the look of city lights," he explains. "Fortunately, I happened to be flying out of town that weekend, so when I flew back in on a clear Sunday night, I was studying the LA Basin intently. What I saw we were missing was the uncountable point sources of light in the city. We had been adding little grain-of-wheat lights to the towers, but it was clear to me that we needed a massive amount of additional light sources. That Monday, I started ordering fiber-optic spools.

"Eventually, we threaded seven miles of fiber optics into that little tabletop, and the landscape was transformed into a real city.

"The design of the Tyrell pyramid was likewise focused on using lights to convey its massive scale. In this case, since the pyramid was composed of big monolithic solid shapes, I approached it as if it was a set of giant light boxes. After Tom Field and Bill George made up a set of highly detailed patterns for the main structural sides, mold maker Sean Casey cast up transparent polyester replicas backed with clear Plexiglas.

"Bill had designed thousands of windows into the pyramid sides, glued in as higher relief squares on each floor of the structure. So after we opaqued and painted the outer surface of the pyramid, we scraped off the high points, allowing light to shine through from the inside of the model. Onstage, we lit it up with a bare 10,000 watt studio bulb. That worked great! It made the pyramid look gigantic! The model was only 30 inches high."

With those successes, Stetson and crew really took off in using light to enrich the shots. They resurrected the old fiber-optic swivelling scanner lights made for the flying saucers on *Close Encounters* and fitted them to the advertising blimp, as well as to building rooftops in some of the city flybys.

"We set up background buildings with ceiling grids partially taped off and backlit them so that fantastical rays of light were cast through the smoky atmosphere of the shots. We rigged lightbulbs on wires and pulled them through shots with motion control to look like background traffic. Visual effects supervisor David Dryer's basic motto was, 'If there's a problem, fix it with light.'

"After the lessons I learned on this project about the integration of production design in visual effects the uses of light in photography, the next important lesson was the application of scale to camera moves.

"Again, it was a master of the craft who introduced me to the basics. The late Dave Stewart had been Doug Trumbull's visual effects director of photography for *Close Encounters* and *Star Trek,* among others. Dave is the one who gave me a basic understanding of motion in scale. His approach to designing camera moves was founded in restraint.

"When you are dealing with fine-scale miniature environments, it is a great temptation to fly the camera all around the environment to show off all the work that went into it. Long since learning to resist that urge, Dave's first thought was always to help sell the scale of the environment by creating camera moves that were familiar to the viewer.

"In other words, if the camera was flying over a landscape, fly as fast as a camera helicopter could fly in the scale of the landscape. Likewise with a dolly or a camera crane or a jet. A great example is in the opening shots of ***Blade Runner***, when the camera is flying over the Hades landscape. On the stage, the camera barely moved more than three feet in those shots!"

As work wound down on ***Blade Runner***, visual effects supervisor David Dryer had stepped in to take over the completion of the effects work as Doug Trumbull and his partner, Richard Yuricich moved on to Doug's second directing effort, ***Brainstorm***. "Doug has a gift for leading people, for getting the most out of his teams," says Stetson. "Part of the gift is that he recognizes talent, and part of it is that he gives people a chance to express themselves; he delegates responsibility and makes his expectations for excellence be known.

"He gave me an opportunity, beyond the scope of my work in *Blade Runner*, to supervise all the action props for the film as well as the miniatures for the visual effects for him on *Brainstorm*. So, we started out on development of the laboratory action props and set pieces before we had finished up all the work on *Blade Runner*.

"Well, *Brainstorm* was the film that I consider to have really opened my eyes about the complexities of work in the film industry. We had action props, mechanisms, and special effects. Here, I did my first really intensive work on set, work closely with production designer John Vallone to make all the elements fit together."

Stetson's crew created all the brain-wave recording machines used in the film, as well as the action props and much of the set dressing. "I remember vividly the design process for the early prototype brain-wave recorder props," he says. "Tom Cranham and Chris Ross would make sketches under John Vallone's guidance, and I would run up to Apex Electronics with the sketches, look around for cool-looking aerospace junked parts that could become the basis for the machines in the sketches, then bring the parts back to Chris and Tom to redraw based on what I found.

"If I took my car, it would always cost $1,000 to fill it with parts! If I went in a studio truck, it cost $3,000! I think we picked Apex clean by the end of that film. I found some parts that looked so cool I couldn't throw them away for years!

"Through David Dryer, we met his brother Ivan, who ran Laser Images, Inc., the Laserium Company. We started working with them to outfit the props with practical lasers and scanners that would be photographable. We quickly got right down into the guts of their equipment and stripped it apart so we could fit it into the portable brain-wave recorder props. It could get exciting playing with high-powered lasers that could burn through a telephone case after running through a 100 foot fiber optic!

"We also built a whole flight simulator set onto a backhoe arm of a front-end loader, working with hydraulic motors to spin the set with an actor in it as if he was rolling a jet fighter.

"We even made the flight helmets. But, perhaps the most exciting work was designing a robotic production line around industrial robots that we acquired and installed onto stages at the MGM (now Sony) lot in Culver City," Stetson recalls. "We designed the work flow, made all the robots' end-effectors, all the parts and subassemblies under construction, even false cutters to explode, a conveyor line that

could go crazy, and robotic material handlers. Then, Bob Spurlock and Leslie Ekker learned how to program the robots so we could operate them during photography. We were seriously into steel and hydraulics during this period."

After his experiences directing *Brainstorm*, Douglas Trumbull wanted to put his energy into developing his Showscan special venue film company.

"Doug had been trying to get studio interest in shooting feature films using his Showscan process, and, in fact, *Brainstorm* had been designed with that idea in mind – jumping in and out of Showscan as the brain-wave recorder playback engaged," Stetson says. The studios couldn't envision wide distribution of films that required specially equipped theaters, so Trumbull began his pursuit of other venues, focusing on ride films.

"He made a deal with Richard Edlund to take over the feature film visual effects operations of Entertainment Effects Group," Stetson explains. "I was enthralled with feature film work then, as I am now, so I decided to stick to that area. This gave me a chance to work with Richard Edlund, another mentor.

"Each man (Trumbull and Edlund) had a totally different way of approaching the work," Stetson says. "Doug is a great creator and visualizer. He entered the film business as an illustrator, and he always seemed to be playing with ideas about light. His focus, during that period at least, always seemed to be on the project, the film, rather than the business. Or rather, he was concerned about the business structure only to the extent that it directly served the project.

"When he started up on a film like *Blade Runner*, he structured a deal with the studio so that he and his crew were all direct employees of the studio. This was a very elegant answer to the problem of conflicts of interest between his company's needs and the needs of the studio.

"It didn't allow, however, for much continuity of the business between projects. When a film was completed, the staff was disbanded, leaving just the production accountants and the receptionist to button things up. That left his crew looking for work elsewhere.

"I always felt that Doug used these downtimes between shows to clean house. When he got another show going, it was a new opportunity to build a new and different team. I thought that was pretty smart. It gave him a chance to try out new talent and refresh his

thinking, and it gave me a good foundation in the self-reliance and self-confidence that the effects industry requires.

"So, when Richard came down from ILM to start up the facility for *Ghostbusters* and **2010**, he was a bit dismayed with the disarrayed state of the facility that had just created such landmark visual effects for **Blade Runner** and **Brainstorm** – everything in storage or stacked on the stages, crew mostly disbanded, and optical equipment about a generation behind that which he was using at ILM.

"Richard's focus seemed different from Doug's right from the start. He is a real hard driver, and he's very good at seeing what he needs to complete a project. He was determined to build a company with more continuums, and with a more solid technological foundation. This meant a pretty comprehensive reorganization of the facility, in terms of the physical plant and equipment, as well as the staff.

"In fact, only still photographer Virgil Mirano and I carried over as department heads. Richard started redesigning the layout of the rooms, finding bigger spaces for the machine shop, the matte department and optical labs, and started a major design effort to create new advanced optical printers.

"I always imagined this effort as a giant Richard Edlund picking up the entire studio and shaking it in his hands to see it settle into a new configuration more to his liking. But this was a very necessary step for Richard to take, to set up the studio in such a way that he was able to push those two huge projects through there in his first year.

"I think he looked at the studio as a long-term home for his career objectives rather than as a place to execute a single project, as Doug seemed to. He was investing for the long run, and he was more interested in keeping his teams together between the big projects.

"There were risks to that approach – it meant that Richard had to consider working on projects just to meet the overhead between times when there were major films available for him. This would mean the risk that his creative teams would dilute over time. There is a tendency for the best people to move on to other creative challenges when things are slow while the rank-and-file matured into vacated positions. This meant there was the risk that mediocrity could migrate upwards in the company. Richard fought that by bringing top talent back into the company when he had a new project that would attract them.

"But both these trends put pressure on Richard's reputation for the highest level of quality. In fact, this seemed to be a threat to the

life cycle of many visual effects houses, and my observation of that phenomenon became a strong factor in the short-life business plan we made when I started Stetson Visual Services, Inc., with Bob Spurlock some years later."

The five-month interim between wrapping up *Brainstorm* and starting up with Richard Edlund on *Ghostbusters* and *2010* also had created another opportunity for Stetson. "After *Brainstorm* wrapped, I saw an opportunity to start a business of my own. I had already set up five different model shops to serve Doug's needs during the Entertainment Effects Group years. One of them was in my own garage!"

The first incarnation of Stetson Visual Services was born, and helped him to establish a symbiotic venue that came and went as needed to keep a crew of craftsmen together when things were slow at Boss Films.

Mention *2010*, and you can see Mark Stetson still has a soft spot for the film and the work he did with Edlund. Working on *2010* began with a lot of research into the original *Discovery* design. "First, I bought all the books I could find about the making of *2001*. So, we worked from photos, analyzing the perspective convergence and building little mock-ups to make sure our interpretations of the proportions were right. We assembled a library of the best shots to match detail and followed them scrupulously. Meanwhile, Syd Mead was completing his work on the new designs for Peter Hyams, and we began mocking up those designs in scale with our discovery mock ups.

"I was quite surprised by the size of the original *Discovery* model. Our biggest composite *Discovery* model was about 12 feet long," he admits. "The original was 54 feet. The reason we could use a smaller model was partially that we had the cumulative skill to fine-detail the models at that size, but it was primarily because of the types of shots that Peter Hyams had in mind – more action-oriented than the stately flybys of Kubrick's masterpiece.

"My favorite shot in *2010* is the wide shot when *Discovery* is out there tumbling," he says. "To me, that shot is a classic scene setter, with the motion of the *Discovery* making a wonderful accent. It was great shot designed by visual effects art director George Jensen. Working with the 12-foot *Discovery* model, the stage effects crew built a big rotator on a stand high enough off the ground to allow the ship to spin. It was all driven by motion control.

"We ended up building several scales of the *Discovery* and the *Leonov* models, and various additional models of probes, pods, astronauts, and other rigs. We also built some very nice tabletop miniature landscapes for the surface of Europa as it was first encountered by the probe, and later as it evolved into the habitable planet of the newly formed star that was Jupiter.

"The monolith itself was interesting," Stetson continues. "We tried a number of different finishes to make it the mysterious black object with the inexplicable sheen that you see in the film. It proved difficult to light and shoot. Most of the monoliths in the film were represented by matte paintings. I think the model monolith only survived in one shot – the end of the movie where we see it on the placid, watery surface of Europa, at the dawn of life. The monolith would have been an ideal subject for CG, of course."

The film was a success, due to the painstaking efforts of the entire visual effects staff. In 1985, Stetson, Richard Edlund, Neil Krepela, and George Jensen received an Academy Award nomination for the project.

"Probably, the most important thing that Richard taught me was that art is not the only world a model maker or effects artist needs to understand. The technology of effects constantly changes.

"It is fascinating, to me how many different disciplines we all have to study to make things work," Stetson says. "There are so many things we need to know to get the shot. And Richard's emphasis on pushing technology kept my skills in visual effects vital through the digital revolution to come."

Take one of the most challenging jobs Stetson did, when he was working with Richard Edlund at Boss Films on **Die Hard**. "For this project, we had to build a forced perspective miniature elevator shaft and erect it on the stage," he says. "An elevator shaft is a particularly easy-to-understand example of forced perspective. The camera is looking down this rectangular tunnel, so the view is confined to a one-point perspective – all the lines that recede from the camera converge to a single vanishing point.

"Using the storyboard, we identified the point in space at the top of the shaft where the camera would be placed (the viewpoint) and designed the model to converge in scale to a vanishing point straight down the shaft along the pointing angle of the camera.

"The forced perspective of the model was necessary to convey the tremendous height of the elevator shaft in the high-rise office building

of the movie's story and still contain it in the stage as well as keep it within a size range that made the pyrotechnic work safe and manageable.

"People often think that forced perspective is a way to save money," he says. "Sometimes, that is not the case. For example, the *Die Hard* elevator shaft was built to forced perspective because of the needs of the shot – the pyro explosion performed better rising straight up.

"The shaft had to be large enough in the foreground to allow the camera to fit inside, as well as for the flames to scale convincingly, but we could only fit the proper size shaft vertically onstage if we forced the perspective."

As simple as the forced perspective was, Stetson knew that the miniature would still be more expensive than a straight scale miniature because, with a straight scale miniature many pieces can be replicated in mass production. With a forced perspective model of the shaft, every floor is cut to a different size, every beam is cut to a different angle however, this expense was a trade off for the reality of the shot.

"Of course, working with people who know what they are doing is always rewarding, especially when it comes to pyro. On *Ghostbusters*, for instance, Thaine asked me to provide him with a blast cage on top of Dana's apartment building made of ¼-inch welded steel plate for the explosion of the Gozer Temple.

"This seemed insanely overbuilt to me at the time, but not after I saw what he intended to do in there! Thaine had been given the tasked of creating an explosion that was cross-shaped, for a very graphic, stylized blast. It required a lot of power to drive the blast out horizontally as far as the shot required.

"Also, because the Gozer Temple scale was relatively small (1/18-scale), even though it stood 25 feet high in the Boss Film's parking lot, a very high camera frame rate was dictated (about 300 frames per second).

"That, in turn, dictated that the effect must be shot completely in-camera, since the camera speeds he and visual effects cameraman Bill Neil were contemplating would result in a shot that would be too unsteady for compositing, in those days.

"I learned a lesson about economical preparedness there because, in fact, it was just a few dollars more in material for the heavy cage than anything thinner might have cost – cheap insurance for reliable turnaround of the gag. So, I was quite surprised when Thaine told me

that I could build the **Die Hard** elevator shaft out of masonite and one-by-four pine. He was confident he would barely singe the paint, and he was right again.

"So the miniature stood about 20 feet tall on the 26-foot stage. Visual effects director of photography Bill Neil put a camera on top of it. Thaine Morris set the pyrotechnics inside. The explosion rushed – convected – up to camera, with only five feet of airspace between the top of the shaft and the ceiling of the stage.

"The funnel shape of the forced perspective shaft, however, caused the flames to lose energy and dissipate too quickly. Solving that problem was a challenge, and Bill Neil had the courage to find the solution.

"The problem was that the flames were slowing down too quickly before they reached the camera. Bill figured that if he ran his camera at the high speed (120 frames per second), required to convey the scale and power of the explosion at the beginning of the shot, then shut the motor off during the shot, the camera shutter speed would slow down as the flames were slowing down. And so the flames would appear to continue rushing up.

"Sounds simple – but this was a real challenge," he adds. "The timing of the camera was entirely in Bill's hands. That takes experience, skill, and luck. It was a bold move, and it worked."

Die Hard was destined to be Stetson's last film project at Boss Films Corp. At the end of 1988, he left to start another new company with Robert Spurlock. Thus Stetson Visual Services, Inc. was born. He had already established a name for Stetson Visual Services, primarily working for commercial production houses. He had continued using that name as he brought freelance work into the Boss Films shops between film projects. This was at a time when Boss was not doing commercials, so the work was noncompetitive.

But after nine years, Stetson was feeling like he wanted more influence over choosing the projects he worked on, so the establishment of their own company facilitated that for both him and Spurlock. They specialized in miniature effects and special effects for theatrical films, ride films, and commercials.

One of the first jobs the company took on was for **Total Recall**, directed by Paul Verhoeven. They produced a series of elements, including a miniature of the alien reactor room.

"The room was supposed to appear infinitely tall," Stetson explains. "We built a segment that was repeated photographically, as a

rear projection plate behind a fight sequence involving Arnold Schwarzenegger and the villain.

"The model (32 feet long, 18 feet wide, and 12 feet deep) was constructed to be shot on its side, so the length would represent height.

"We also built a miniature of the elevator, used in the fight sequence."

One of the other models built by Stetson and crew stood 18 feet tall, even though the area shot was only 12 feet by 8 feet deep. "This was a down shot on seven of the rods penetrating the ice surface," Stetson explains. "Each rod had 7,000 watts of light inside a 1/8-inch thick acrylic tube that is 12 inches in diameter."

Not long after, Stetson's team began working on Warren Beatty's *Dick Tracy*. "We divided the work into three parts," Stetson explains. "The first 'model' was a train, but hardly a miniature.

"Luckily, a neighbor of mine, John Ellett, owned a beautiful 1/8-scale steam-operated model train. John provided us with the engines and tender, and the passenger cars were provided by Bart Sissons, one of the officers of the Los Angeles Live Steamers Club."

Finding the train was easier for Stetson than creating the shot. Because of the size of the model, the track and accompanying miniatures were built on a 180-foot platform. About 60 feet of the set would be seen in the shot, but the rest was needed for acceleration and breaking.

"The miniature effects were only one element of the shots, which also included live action plates and matte paintings," Stetson explains. "One additional challenge was to make everything take place at night.

"The only way to do that was to motion-control the train."

To do this meant adding a servo that could pull the train at 15 miles per hour. The high speed (for motion control) was necessary to shoot the smoke element. "And, of course, everything had to be repeatable," Stetson added.

The second component of Stetson's assignment was shooting a high-angle shot of a miniature drawbridge and an appropriately sized steamship. The drawbridge was designed by the art department (Dick Sylbert) about 12 feet long and a 1/4-inch scale model.

The final component of their assignment was one of a visual effects artist's nightmares – moving miniature water!

"This was about five years before Micheal McAlister pioneered the use of Arete software's digital water effects for *Waterworld*. There were fewer possible techniques to create water then," Stetson recalls.

"However, effects cameraman Bill Neil suggested a type of ripple acrylic sheet that he had used on a commercial.

"Tom Valentine, the effects crew chief, engineered a 12-foot-wide steel frame to support the water table and move it about 3 feet during the motion control shot, causing it to slide at a different rate than both the bridge and the ship. This gave us moving highlights and reflections. As it was a night shot, Bill was able to light it in a sketchy way, using pools of light, that completed the illusion."

In their first year of operation, Stetson Visual Services, Inc. contributed miniature effects to five of the seven films considered that year for an Academy Award nomination, including all the miniature effects work for Dream Quest Images for the winner that year, *Total Recall*. In 1990, Stetson Visual Services, Inc., was also nominated for a Saturn Award for their work on **Total Recall**.

At the end of 1994, SVSU closed, and in 1995, Mark Stetson joined Digital Domain to supervise the visual effects for Luc Besson's **The Fifth Element,** a science fiction fantasy that presents a view of the future that is probably the most original and complex since **Blade Runner**.

Stetson supervised 225 visual effects shots for this far-reaching spectacle, nearly all of which were produced in-house at Digital Domain. This achievement was especially notable considering that the project was delivered under extreme pressure, sandwiched between the grueling productions of *Dante's Peak* and *Titanic*! Most of the work included blends of miniature and digital elements and was highlighted by important advances in previsualization methodologies at digital domain, as well as the fantastical art direction.

One of the most complicated and fascinating challenges in **The Fifth Element** was the opening cab chase, which featured a full-size cab, miniature cab, and digital cab as well as a full-size cop car, miniature cop car, and digital cop car. "There was more free exchange between elements in this project than ever been done before," he says. "It is all about communication," he says. "It is really important that everyone participate in carrying the idea from concept through design and implementation and understand what is needed.

"When we were in England working on **The Fifth Element**, for example, even the gofers were being trained to project a true perspective view on an object that we were working on.

"Computers have made the creativity and the process more accessible," he continues. "However, a lot of people who operate the

tools don't have the foundation of experience. I went to art school, but I have a small background in art history. It is really scary to talk to artists who work on projects who know less than I do. And, they are doing modern art."

In 1998, Stetson won the British Academy Award for Best Visual Effects for his work on **The Fifth Element**.

Recently, Stetson was able to revisit the problems of visual effects design for a spaceship movie with a much more sophisticated set of tools, with a major project called **Supernova**. "Every time I get involved with a new spaceship project, I wonder if it's the last time I'll get to see a model spaceship built" he says, with a twinkle in his eye. "As long ago as *The Last Starfighter*, and as recently as *Wing Commander*, films have been completed using exclusively digital representations of spaceships.

"I find, however, that I am still able to execute a more photo-realistic result mixing digital images with photographed images – the miniature photography provides a visual standard that improves the digital ships, and the digital ships solve problems of camera and model motion and depth of focus that are difficult with miniatures. As time goes by, digital model shots are also becoming more economical than photographed miniatures."

In 1998, Stetson and the Digital Domain visual effects team took the art of spaceship design further than Stetson had ever gone before. "The *Enterprise* was the icon of the **Star Trek** era, and the *Leonov* for **2010** was a masterpiece that represented the pinnacle of Syd Mead's work in films." Stetson says. "But I'm as proud of the *Nightingale* ship we designed for **Supernova** as anything I've done before. It's truly integrated with the design of the interior spaces created by production designer Marek Dobrowolski's team, and it has a fresh look and balance that all the visual effects team continues to love even after working with it for a year. Usually, at this point in a show, we hate everything we've done," he laughs.

"We start with the formal problem-solving process I first learned at Art Center, 22 years ago. First, we establish the criteria for success. That means the final visual design must meet the needs of everything from integration with the design style of the film to the designed interior spaces to the photographic presence to the story boarded shot requirements to the production schedule, to the means of imaging to the budget. We would design it to satisfy exactly what it is going to be used for and, hopefully, nothing more.

"In visual effects, we succeed when we live by the same axiom as in successful film production – 'put the money on the screen.' When I am working on a top-level production, I want to make sure the audience sees as much of our effort up there as possible.

"As it turned out, I was handed a significant hurdle in my first meeting with the director, Walter Hill. We discussed his recent work – *Last Man Standing, Wild Bill* – and I complimented him and his director of photography, Lloyd Ahern, on the beautiful look of *Geronimo*. I liked the classic western panoramas, which seemed to hold my attention forever, and the way they were contrasted by the tight, in-your-face action sequences. He said, 'Well thanks, but you should be thinking more about what we did in *Wild Bill*.' Well, I don't remember one really wide shot in that whole picture. It was quite claustrophobic, and the camera always kept you in close to the actors.

"Walter wanted this picture to be a long-lens movie, with long, inquisitive shots that hover around the subject and never quite come to rest," Stetson explains. "He called it the 'nervous camera.' By conventional wisdom, that style is an anathema for visual effects work, where we think in terms of five-second shots, with wide-angle lenses.

"And, at first, I was troubled by the idea of shooting long-lens space exterior shots, until I realized that we were certainly not constrained by distance in shot design (there's a lot of room to pull back in space!), but only in the design and use of miniatures for the film.

"I was really glad that this was the first thing Walter said because it gave me a chance to start thinking right away about the problem that would define our approach to the project.

"The common use of wide-angle lenses in miniature photography came primarily from the need to work on stages that are typically quite confined ('economical') relative to the vast scope of the shot we often are asked to convey.

"A space shot where an 8-foot model spaceship might need to look 500 feet or 1,000 feet long, traveling through the vastness of space, somehow is not satisfying when you are limited to maybe a 60-foot motion control track.

"Beyond that, the main problem is depth of focus. Wide-angle lenses, with their properties of fast recession of image size and broader field of view and depth of focus in close, are a very practical solution to the problem."

To facilitate the process, Stetson and team involved the company's CG department in the early design development stages of

the spaceship. "By creating a study model in the computer, we were able to quickly check out how our design would look, when featured through long lenses," he explains.

The computer allowed Stetson and team to view the image in an accurate perspective, in a selected focal length, that could not be accomplished nearly as quickly or accurately in the traditional method of hand-drawn perspective projection. "We discovered right away that our first model was rather clunky," he admits. "We stretched the length of the ship by probably 50 percent to accommodate the 'stacked-up' look of foreshortening which is characteristic of long lens photography. That gave us a ship that photographed much more elegantly."

Instead of taking months for design and development, like the 1984 Academy Award nominated project *2010*, design for the *Supernova* ship took George Trimmer's team just four weeks, and construction of the shooting model took miniature effects supervisor Scott Schneider's crew only eight weeks.

"This was remarkable, due in large part to the enhanced capabilities we have with computer graphics," he says. "New programs and the intuition, experience, and creativity of our designers made this possible.

"As we commenced work on *Supernova*, we found ourselves once again thrown into a huge rush. The studio had just hired Walter and green-lit the picture prematurely in hopes of completing principal photography before a threatened actors' strike.

"By the time Digital Domain came on board, we had just two weeks to prepare before shooting began. I rushed to set up a visual effects plate photography unit, headed by my longtime collaborator Bill Neil, and a visual effects art department, headed by even longer-time collaborators Ron Gress and George Trimmer.

"Ron rounded up a team of storyboard artists and illustrators and addressed the look of the space environments in the film, while George wrangled the spaceship designs.

"We moved onto the studio lot to be close to Walter, Lloyd, and the art department. After Bill was prepped, our main goal was to story-board the effects sequences fast enough to stay ahead of the shooting schedule – to know we were covering Walter's needs for effects plates. So I absorbed the shooting style that Lloyd was developing for this film, and we started to get ahead on the sequence boards.

"I continued to update the effects breakdown, and the designs for the ships and locales took shape; I started to get a handle on how we would be portraying the ship in the film."

Meanwhile, digital effects supervisor Jonathan Egstad had worked with tracking supervisor Mike O'Neal to solve some of the tracking data-acquisition problems associated with the long-lens look of the show. "Walter was intent on keeping his rhythmic, fluid camera motion going through his production photography and into our effects shots.

"With an incredibly tight 56-day schedule, motion control equipment would take too long to set up, so it was always considered as a last resort during production. Thus, we were counting on advanced digital motion tracking to create the data we would need to complete the shot backgrounds in our visual effects work.

"Lloyd Ahern's photography, however, often held such a narrow depth of focus that traditional surveys and tracking markers didn't work -- many of the backgrounds were out-of-focus blurs.

"One solution Jonathan used was to strap a wide-angle digital video camera to the production camera and record the takes in sync. Then Mike's team could track the video shots and apply an offset to derive the track for the picked take. We called it 'monkey-cam'!

"To accommodate the long-lens shots, we chose to build a 20-foot-long *Nightingale* miniature as our primary shooting model. This would help us maintain depth of focus but made it harder to get long shots of the ship, keeping it small in frame. In the days of **Star Trek** or **2010,** this problem was solved by building a smaller shooting model.

"We had built an 18-inch *Enterprise*, for instance, and a 24-inch *Discovery* model.

"Well, nowadays, with better options available, we discarded plans for a smaller scale *Nightingale* miniature quite early on, in favor of a digital model. As the show progressed, CG supervisor Eric Barba led his team in the development of the digital *Nightingale* model well beyond our original goal of using it for long shots.

"As the polygon count exceeded 2 million in his Lightwave™ model, and the texture maps derived from the shooting model were wrestled into shape, we shifted more and more shots from the miniature stages to the digital render farm.

"Once the effort had gone into the digital model, it was generally cheaper to create a shot of the *Nightingale* digitally than to photograph it onstage. We were also able to beat the depth-of-focus limitations we

faced with the miniature, as big as it was. So Bill Neil's photography became a 'handbook' for the digital artists to follow as they lit, rendered, and composited the digital ships. It was a great combination of talent and capability. Ultimately, we pushed in closer to the CG *Nightingale* than we did to the miniature.

"As the show developed, we were even able to replace a complete liveaction set with a digital version. The observation dome set was probably the most difficult set for Lloyd to handle because of the zero-gravity environment and the amount of interaction between the players.

"Marek Dobrowolski's initial design for the set had been established before Walter Hill came on board, and it was not very satisfactory to any of us, as it tended to block views outside from certain viewing angles.

"Also, Walter and Lloyd were very reluctant to accept any constraints to shooting the actors within the set, even though they would be flying on wires inside the relatively small set. The turn around time to reconfigure the set to gain clearance for the wires for different camera setups was too great for the short shooting schedule.

"So, with Marek's construction department working hard to get the unsatisfactory design built in time to give us at least something to shoot (and as we were unable to get Walter to sign off on a set of continuity boards for the sequences), I finally recommended that we just scrap the set. We would shoot the actors only against green screen, leaving the set design and execution to visual effects.

"To my surprise, everybody just jumped at the idea. Even though quite a bit of money had been spent on the half-completed set, even the producers recognized that it would be much faster to shoot the actors against green and deal with the set later.

"Lloyd could concentrate on lighting, Tommy Fischer could do a much better job flying the actors, and Walter could get the angles he wanted without bumping into something at every turn. And to the producers' relief, we were able to stick much closer to the tight shooting schedule."

Stetson spent just over a year on **Supernova**, delivering more than 200 shots that totaled more than half an hour of running footage.

In his job now, Stetson has a much broader responsibility for the overall look of the visual effects than he ever expected as he entered the industry. "My job now is a continuum of analysis, judgment, creativity, questioning, searching for excellence, and taking chances!" he says.

"The problem-solving steps I learned in school, and learned to apply to ever-larger sets of problems during my career, now encompass nearly every aspect of putting images on film.

"Now, I work with a creative team of visual effects art directors, designers, illustrators, and artists to design the effects subjects and concepts for the overall project. I work with a previsualization team to follow the compositions and camera style of our film. I work with the film editor and our visual effects editor to make sure our shots play in continuity, matching action, screen direction, and rhythm to integrate the shooting style that the director and director of photography develop for the film into all the visual effects shots.

"As our work progresses, I work with our photographic and technical teams to make sure we have all the images and data we need from the live-action production photography. I work with my team of supervisors as we go down the path to completion – develop the shots for the sequences with the director and editors; track our live action plates; get feedback; make changes; develop a camera style for the show; teach that style to a wide team of pre-vis artists; make more changes; make compromises to do things we can afford; start locking moves; port the moves from pre-vis to motion-control software to drive the effects stage camera rigs; shoot the miniatures, effects elements, and pyro as needed onstage, port the moves to Lightwave™; so we could light and render the CG elements; create the ancillary effects elements in CG, then turn the elements over to the compositing team.

"In a nutshell, that's how the work progresses . . . Well, then there's continuing visual effects art direction, graphic design, rotoscope work to fix things we couldn't do better onstage or during plate photography, more tracking, 2-D animation by the compositors, matte painting development . . . Then there's scanning, grading, and recording issues; there are color, lighting, contrast, and density issues on every shot...

"Then there's letting go of a project when you are not quite ready to admit it's finished, and the next one on the horizon. Is this a great job, or what?"

*"What I learned on **Armageddon** is that there is always a solution to any given problem – no matter how impossible it seems. Sometimes, this might involve 40 motion control passes or 26 different cameras – or it can be as simple as fishing wire and smoke. The truth is, there is always a way to do it – you just have to know how...."*

Philipp Timme

Philipp Timme began shooting Super 8mm movies when he was 10, moving on to 16mm before he had finished school. Looking for a way to earn money and with no great hope of getting into one of the few film school slots available, he took an internship at a local television station. After six months, the station wanted him to stay as an assistant cameraman. "They were still shooting documentaries on 16mm, and I thought it would be a great way to learn my trade," he comments.

Timme stayed with the station for three years. Finally, a new film school opened in Stuttgart, Germany. He applied and, to his surprise, got accepted. "Because there were few people with camera experience, I got to shoot a lot of the early student films," he explains.

Somewhat experienced as a first assistant at the time, Timme was also constantly getting work outside of the school. By the second of the four years required, he was called in to see the headmaster. "He told me I was working too much," Timme laughs.

"It was only a matter of time before I would have to leave the school and go to work full-time. But, the time I spent there was important. I made some connections. I had heard Volker Engel lecture on *The Abyss* and *Terminator 2*. He had already worked with Roland

Emmerich on some of his early low-budget projects. That area of the industry fascinated me," he says.

"Although visual effects in Germany went back to films like *The Cabinet of Doctor Caligary*, as well as *Metropolis* and *Faust*, they really disappeared for some time," he continues. "They came back with *Das Boot, The Never Ending Story*, and *Enemy Mine* (with a lot of help from Hollywood). And, since there was not a lot of effects work being done in Germany then, there were few experts. Volker was on track to be one of them, and I was excited to be able to work with him."

One of the first things Timme and Engel collaborated on was a glass shot for a German television movie with limited theatrical runs called ***Drei Tage im April (Three Days in April)***. "The film was directed by Oliver Storz, shot by Hans Grimmelmann, and produced by SDR," Timme says. "The story was about the last days of WW II, but told with a lot of flashbacks. An integral part of the movie was to take place at the small town train station, both now and then.

"The dilemma we faced was, of course, how to use the same village (and train station) that the location scout had found for both the contemporary (1980s) and historic sequences.

"We could see the place was perfect as a backdrop for the 1945 part. It was located in former East Germany, and few things had changed since then. But, how could we establish the same town and train station with a contemporary look?"

The natural assumption would be to do this as a digital matte painting. However, the project was being done in-house at a television station, using their post facilities. "For obvious reasons, the resolution of their machines did not exceed 'video-rez' at the time," Timme explains. "So, a theatrical release of the movie would have required a low-resolution film out onto 35mm, producing a noticeable jump in image quality between the effects shots and the rest of the movie.

"Since the budget did not allow for subcontracting, a digital matte painting in full resolution, we suggested doing a glass shot, using photo cutouts specifically shot for this purpose," Timme says. "This had some obvious advantages. First, as an in-camera technique, it rendered a 35mm negative, without the necessity of going through any sort of postproduction. Second, the results of the shot could be viewed through the eyepiece of the camera before shooting, giving the director an accurate idea of the finished shot. Third, while somewhat time-consuming and cumbersome to set up, it was a low-budget solution that could be done with a skeleton crew.

"Since I had been Hans's (director of photography Hans Grimmelmann) assistant for some time, and started to shoot 2nd unit, he asked me to help Volker set up and shoot the glass shot," Timme explains. "I knew Volker, and we immediately set out to do a test, pretty much convincing everybody that our low-tech approach was right.

"After the location scout, Volker took various photographs of high-rise apartment buildings, power lines, etc., from a variety of angles," Timme explains. "We enlarged each one of them to different sizes and color tints.

"Armed with these photographs, we traveled to the location to set up our glass shot. After positioning the camera for the desired framing, the tripod was bolted down and the camera head was thoroughly wedged into place. (I had originally suggested using a nodal head in order to help panning or tilting but was assured that a lock-off shot would be sufficient.)

"A big sheet of glass (approximately six feet by eight feet) in a heavy wood frame had been set up to our specifications and was now positioned in front of the camera, about six feet away. With both the camera and the glass in place, Volker began to attach the photographic cut-outs to the glass, while his assistant double-checked positioning and size of the elements.

"After adding some high-rise buildings, a string of power lines, and some other details, Volker then had a second piece of glass, somewhat smaller than the first one placed between the camera and the big windowpane. Using dulling spray and masking tape, he then added atmospheric haze to areas of the cutouts.

"By using a second sheet of glass, we were able to position this 'haze' closer to the camera than the artwork (i.e., the photographic cut-outs) and therefore out of the range of deep focus that is necessary to make a glass shot work. With this much glass in front of the lens, it was absolutely crucial to reduce the chance of reflections from objects behind and next to the camera.

"For this purpose, a large tent of black duvetyn had been erected around the camera, extending from the foremost plate of glass above and behind the camera and closed on all sides except the front. After eliminating all reflections, we were finally ready to shoot.

"We used the Arriflex 35 BL IVs – the first unit A-camera – since the effects were to be intercut with other live action footage shot with this camera, thereby keeping image steadiness and look

consistent. The resulting effect was extremely convincing, and I doubt anybody ever realized that it was, in fact, a visual effects shot – although if you look closely, you'll be able to see some smoke from an old chimney in the foreground mysteriously disappear behind a modern apartment building in the distance . . . "

With this first major project, the relationship between Philipp Timme and Volker Engel was solidified. The two went on to do several other visual effects projects together, including *Der Letzte Kosmonaut (The Last Cosmonaut)* (directed by Nico Hofmann, cinematography by Tom Fährmann, produced by Flamingo Film), which was shot in the early 1990s in Germany.

The effects for *The Last Cosmonaut* consisted of various establishing shots in outer space involving the MIR space station and the smaller *Soyus* capsule as well as a fairly large forced-perspective setup of the Russian launch site at Baikonur.

"When I first learned about *The Last Cosmonaut* from Volker, the technical details he gave me were these – first unit would shoot on Super 16mm, since it was a TV movie of the week not intended for theatrical release. They were going to shoot in the 1:1.78 format at 25 frames per second (as is common in Germany), and the effects were to be delivered on Betacam SP.

"Based on these specifications, the first question was what format to shoot the visual effects on. Super 16mm would have been an easy solution at first glance – matching the grain and resolution of the first unit footage, reducing costs, obtaining more depth of field, etc. – but the problems with shooting effects in this format soon became obvious.

"To start with, the image stability is not very good, due to the fact that you are limited to single-perf film with the Super 16mm format. Another problem was the reduced resolution compared to 35mm film and the subsequent difficulties in extracting a matte from blue or green screen elements.

"We therefore decided to shoot the effects in 35mm on the Arriflex 35-III cameras, with a full aperture gate and re-centered lens, using the 1:1.78 ground glass for framing in order to match first unit. This gave us the most negative area above and below the 1:1.78 frame line, while keeping the image centered.

"Although we did not have any motion control rig, almost all of the shots called for a moving camera or moving (rotating) miniatures. We solved this problem by using an antiquated Elemack™ dolly on

regular track, eliminating as many bumps as possible and pushing as smoothly as we could.

"For obvious reasons, we could not do any double exposures or repeat passes with this setup, so all the moving elements had to be shot on a single pass.

"The rotation of the MIR space station in its orbit was achieved through a hand crank attached to the main axis of the miniature and operated by Volker himself, trying to spin the miniature as slowly as he could.

"I remember fighting the shadow of this rod that turned the model as I was lighting the space station, trying to find a balance between the harsh single-source lighting on the MIR and the even and shadowless light required by the green screen cards hiding the rod.

"Since flicker-free HMI's would have been too expensive and the film speed could not be limited to flicker-free windows in order to use magnetic ballasts, I chose tungsten lights for both the miniatures and the green screen. (The choice of green over blue was dictated by the fact that most of my fill light would be blue, simulating the earth's bounce light - and since I could not separate the beauty pass and the matte pass for green screen remained our only option.)

"By trading in HMI's for tungsten, of course, I was sacrificing some of my depth of field, a disadvantage I tried to make up for by using Eastman Kodak 5293 200T film stock. The difference between the first unit footage and our effects in terms of grain and resolution would be more than compensated for the larger 35mm negative.

"Nevertheless, I recall many instances in which we had to pull focus as the space station or other elements were pulling away from us – especially in a shot where we were looking at 'trash' jettisoned by the MIR crew slowly float away from us toward earth.

"For this specific shot, the camera was placed just underneath the rafters of the stage, looking straight down with a 32mm lens. We then covered the stage floor with a large piece of green screen fabric and placed our lights around it, keeping them as close to the floor as possible in order to avoid shadows from the falling objects on the green screen, while still trying to get an even exposure.

"I usually try to light a green screen to within a third of a stop difference, but I distinctly remember that on this project I tried to have no exposure variations *at all*.

"The key light for the falling 'trash' (which was actually ¼-scale papier mâché in order to increase the impression of distance) was a 10K

Fresnel as a strong sidelight, with another 10K bouncing into dark blue seamless paper to simulate the soft blue 'earth fill.'

"All the background plates of starfields and the earth's blue surface were shot on a motorized Crass rostrum stand using Mark-Roberts™ software – one of only two such stands in existence. Since I was one of the few students sufficiently familiar with this 'monster' (resetting the track axis could easily result in smashing through huge multiplane glass sheets!), I had the honor of shooting those backgrounds in between setups onstage.

"The earth plates were actually matte paintings by Volker himself, while the starfield was done the old-fashioned way using back-lit black seamless paper with pinholes.

"For a shot in which the sun appears behind the dark silhouette of earth, bathing the MIR space station in very heavy backlight (à la *2001. . .*), I attached a Dedo light with projection snoot to the east-west axis of the rostrum stand, slowly revealing it behind a cardboard cutout to get the desired flare effect.

"Another setup that I distinctly recall was the establishing shot for the Baikonur space center. Although the production designer had found a large array of old warehouses that would be used to shoot some first unit footage, they could not do the establishing shot the director had asked for. He wanted to start with a shot of the moon, with the image suddenly starting to ripple. Realizing that we are looking at a reflection of the moon in a puddle, the camera tilts up to reveal a wide shot of the Baikonur space center complete with searchlights, rain, and lightning.

"Furthermore, there had to be two moving cars, tying into the following first unit shots. Volker decided to set this shot up as a forced perspective miniature, using a halfscale foreground element including the puddle, and slowly reducing scale toward the background of the shot, ending with fairly small model rockets on launchpads in the very distance.

"The moon was a black-and-white Xerox™ on cell that we backed with tracing paper and slightly warm gels, adding cotton clouds for realism. The background miniature had been built on a parallel, enabling us to light some of the buildings from below.

"The searchlights were old slide projectors manually operated by two electricians, while I used flashbulbs mounted vertically on a piece of wood and set off in sequence with a nail board for the lightning.

Volker's idea of using Hudson sprayers for the rain worked beautifully, and I used crossed backlights to enhance the effect.

"The truck was again manually pulled, and since there were about 10 cues triggering everything from the initial raindrops to the lightning, shooting this scene reminded me of a military drill – with the stage echoing the sharp commands given from the director's chair.

"Early on in the project, Volker had assembled a very talented crew of model makers and set them to work on building a faithful miniature replica of the MIR space station. The resulting miniature was beautiful and highly detailed – it did have, however, some features I came to dislike during the course of shooting.

"One of the main problems was that the solar sails as well as some parts of the space station's body were somewhat reflective. Since our low-budget approach demanded that we shoot all moving elements of a shot in one green screen pass, we did not have the chance to eliminate green reflections on the MIR by shooting separate matte passes.

"The next best option was therefore to reduce the size of the green screen to the minimum size needed to cover the foreground element – making it necessary to use more garbage mattes in post-production but drastically cutting down on green spill and reflections.

"We therefore used black duvetyne curtains that could be lowered or raised as needed on all sides of the green screen. For almost all the shots featuring the MIR, the key light again was a 10K Fresnel without the lens.

"The fill light was always a four-by-eight-foot sheet of seamless dark blue paper with a second 10K bounce. By slightly cheating the key and fill into half- to backlight positions, I was able to eliminate almost all of the remaining spill from the green screen.

"Years later, while working on the visual effects for **Armageddon**, I would shoot another replica of the MIR space station – this time in Hollywood. And while the circumstances were decidedly different, I could not help remembering this first project and the lessons it had taught me . . ."

Timme went on to do other projects in Germany, several of which garnered awards. When Engel and Roland Emmerich made the plans for their first major American production, **Independence Day**, it was only natural to add Philipp Timme to their crew. Timme and Anna Foerster were brought over to join the massive team.

Although both Timme and Foerster were set to do most of the major effects shots in this picture together, the job grew to the point that work had to be divided. At a certain point in production, Foerster and Timme headed their own units.

Ask Philipp Timme what effect shot in *Independence Day* stands out in his mind, and it would have to be the White House explosion. "It is probably the most famous (and most perfect) shot I have ever done," he says. "Of course, it could not have been done without Anna (who was responsible for camera placement and setup), Victor Abbene, my gaffer, and Dave (the Wave) Novak, my key grip, and their crews."

According to Timme, the lighting plot for the shot itself was pretty straightforward. "For the façade of the building, I used a technique that I had developed earlier for and successfully employed during the filming of other destruction sequences in *Independence Day*. It was based on the requirement (stated by Volker and Roland) that, for ease of postproduction compositing, the street level itself should never be visible." This made it possible to simply composite different layers of people running, cars flying, and dogs jumping on top of the miniature explosion background plates without having to worry about shadows or other interactions of foreground elements with the street surface.

"Knowing I would never see the street surface, I had the model shop cut out most of that area, leaving just enough to hold the miniature together. Using clear Lexan and heavy diffusion gel, I was now able to light the streets from below. This gave me the typical wash of light you can find on any city block.

"Of course, in reality this is caused by the accumulation of light from different sources – such as headlights, bounce light from overhead street lights, shop window illumination, etc. However, the light looks as if it emanates from below. That means I didn't have to light from the top, thereby enhancing the scale and making it easier to hide the lights," he explains.

"In the case of the White House (which, as we all know, is situated on a little hill), I used this technique to simulate the architectural lights placed around the building. This gave the illusion of glowing white walls in the dark of night. At my request, Mike Joyce cut a small trench into the wood around the base of the miniature, about three inches wide.

"Using color gels, heavy diffusion, and lots of Altman Parcans with 1,200W VNSP globes, I duplicated these architectural lights.

"Having accomplished this, I started to think about the interior lights. Looking at photographs the art department had found, I determined a color scheme for these.

"If you study different buildings at night (and this is especially true with office buildings like the White House), you find that every section of the building (for example, a floor or 'half a floor,' that is an apartment) has a certain color scheme regarding the interior lights.

"In some cases, a certain color can be attributed to a whole building – which is the case with corporate office buildings that have a certain type of fluorescent fixture installed, while in other cases, the color varies from floor to floor or apartment to apartment.

"But even in those last cases, you will rarely find complementary colors within one building, just because it is somewhat uncommon to have completely complementary lighting fixtures, such as fluorescent, tungsten, and mercury vapor lamps, mixed in the same structure.

"I developed the habit of giving each building on a miniature street setup a name implying its function – such as 'Insurance Headquarters,' 'The Dakota,' or 'Department Store' – from which I could then derive a color scheme, which I would subsequently translate into gels and print on a piece of paper affixed to the back of the miniature. Using this guideline, the electricians could use the specified color and ND gels and combine them within the boundaries of the notes.

"For the White House, this technique needed some fine-tuning. So far, I had been able to use gels to create the colored interior lights, since the buildings throughout the early part of the destruction sequence had not been blown up but merely functioned as a 'funnel' for the so-called 'wall of destruction.'

"To avoid the danger of seeing little pieces of lighting gel flying through the air and destroying the illusion of scale, we had to use very thin tempered glass sprayed with different layers of Rosco's 'liquid gel.' The model shop came up with this, based on gel samples we had asked them to match. We also used K-Line™ neutral-density spray to achieve a variety of different light levels.

"In order to actually light the 'rooms,' Victor used 500W Photoflood bulbs that Joe wrapped with primacord. They were triggered together with the second stage of the blast that was to blow

out the walls of the White House. This would destroy every trace (including the ceramic sockets) of our 'interior' lighting and add to the reality of the shot.

"After taking care of all the 'available' light in and around the White House, the next logical step was to think about how one would light the White House if you were to actually shoot there. Simulating a scaled-down Musco light in size and distance as my key light, I placed a 36K Dino light at a three-quarter back angle, giving the miniature some depth and backlighting some of the smoke and pulverized debris.

"For the foreground trees, I used a 20K Fresnel as a key, supplementing it with up lights from below the frame line. Some soft fill completed the lighting from the ground. The last thing left to do was to simulate the greenish 'destruction beam' emanating from the 'destroyer' spaceship hovering over the White House.

"I had found Lee 'Peacock Blue' to match the gels Karl Walter Lindenlaub was using on first unit. In order to get the intensity I was exposing for, I had to take the brightness of the explosion into consideration. I found that my T-stop, for all of the destruction sequence using the Photosonics A-camera running at 360 frames per second with Eastman Kodak 5298 rated at a true 500 ASA, was a 5.6. I therefore asked Dave to hang six Maxi-Brutes with 1,200W VNSP globes and color and diffusion gel in two rows above the White House, shining straight down as a very steep rim light, outlining the building against the black sky.

"After the lighting plot had been drawn up, I was curious to see the result on film. As is typical for Roland, we used the White House miniature not only for this one pyro shot but also for some four or five other setups, which he thought he could use for coverage. As it turned out, not only did he use all of those shots – they also gave us a chance to preview our lighting for the 'big night' and make minor adjustments.

"The most important of these corrections was to keep the green 'destruction beam' interactive light slightly farther back than anticipated (although the spaceship was supposedly hovering directly above the White House). Since the green glow was fighting the architectural up lights on the façade, we had a very dirty mixture of green and straw tints. We also ended up using most of the 5K keys on the foreground trees at full spot, since they had a tendency to blend in with the night sky.

"As powerful as the shot turned out to be, I have to admit that, in hindsight, I do not think I was fully aware of the significance of it.

Obviously, this was an expensive miniature to blow up. It was hard to ignore the tension that started spreading throughout the production office just days before the explosion. After all, it had been postponed twice, and it was going to be a big, costly shot, (I think we had seven cameras going anywhere from 120 to 360 frames per second and a total lighting setup east of 200K.)

"On the other hand, though, there actually was a second-take backup miniature. When, on the day of the blast, a truck with a small grandstand showed up and we were handed red ID badges that read 'CREW' – as opposed to the ones showing up later that night, reading 'PRESS' – I couldn't help but take notice of the implications of blowing up the White House.

"Due to the location on the former landing strip of the Hughes Airport, we had a deadline of 10:00 PM to push the button. At 9:45 PM, I took a look around I remember counting four video news cameras, a 16mm Bolex™ somebody had brought in, a 16mm Äaton™ camera, and three IMAX™ cameras in addition to our little setup.

"I started to realize that this was more than just another shot for the 'destruction sequence' that we had been working on for so long now. When Joe finally pushed the button, everything was over in less than three seconds – and even before the echo from the blast had faded away, the assembled crowd burst into spontaneous applause."

Obviously, this is Philipp Timme's favorite shot in **Independence Day**. However, the so-called destruction sequence was one of the more complicated effects sequences. In the movie, New York, Los Angeles, and large parts of Washington D.C., are being blown to smithereens by a green destruction beam emanating from alien *Destroyer* spaceships hovering above those cities.

"When we first met Roland in Germany in February 1995, we had talked about possible looks for this sequence," he says. "Since I was at that point familiar with the script, I had already done a simple but detailed effects breakdown and some research on what mass destruction at this level could look like.

"Apart from black-and-white photographs of the WW II firestorm over London and some shots of atomic bomb test blasts, I remembered a picture I had seen in an old *National Geographic* magazine on volcanic eruptions. It was a three-page foldout, taken with a long lens looking down a dirt road in what looked like the tropics.

"In the center of the frame, you could see a Land Rover speeding toward camera," he explains. "Seemingly directly behind it, covering all

of the upper two-thirds of the photograph, spreads the ghostly gray boiling mass of a pyroclastic cloud, a deadly mixture of superhot gases and ash, racing down the slopes of the volcano at speeds up to 100 miles an hour.

"This picture had made a lasting impression on me when I first saw it, and I decided to give Roland a copy. Together with another photograph – a very simple Photoshop™ composite of a New York street scene with a still from cloud-tank tests Anna and I had done – the shot from the *National Geographic* magazine became the real-life model for the look of the wall of flames in the destruction sequence. The one question that remained, however, was how to actually create that look.

"Very early on, Doug Smith had a brilliant idea. He tested a set-up in which he used a $^1/_{24}$-scale miniature of a New York street tilted back 90 degrees, so the cameras were looking straight down at the source of the explosion. The fireball rose toward the lens – which, when viewed on the big screen, looked as if a wall of flames was racing down the street.

"He then shot some miniature cars in the same scale, albeit horizontally this time, in front of a green screen, launching them with air movers.

"For the larger-scale cars in the foreground ($^1/_{12}$-and $^1/_8$-cale) he used die-cast models with metal wires attached to them. Wrapping the wire around the cars twice or three times and then pulling on the loose end, these cars would flip end over end through the air as if being blasted down the street by the unimaginable force of the destruction bam.

"Combining these elements with green screen shots of screaming extras fleeing in panic, Doug was able to create the kind of destruction wave Roland and Volker were looking for. The test shot was so good in fact, it was eventually used not only in the trailer for **Independence Day** but also in the final cut.

"After establishing the technique of shooting the destruction sequence, we now had to come up with a practical way of setting up a stage especially for these shots. We were assigned Building 35 of the former Hughes Airport, dubbed the 'Pyro Stage,' and started to modify it to our needs.

"The building had a layout of approximately 150 feet by 80 feet, with a ceiling height of about 30 feet, and featured some powerful ceiling fans that proved to be extremely helpful in getting rid of nasty postexplosive fumes. After painting the ceiling black and covering the

walls with black Refacil wherever possible, Dave Novak, my key grip, had two I-beams installed over the whole length of the building.

"He then built a 20-by-20-foot platform with a four-by-four-foot hole in the middle, equally covered in black Refacil on the bottom. The platform was suspended from four chain motors on motorized track wheels moving on the I-beams above.

"Using a remote control box, Dave was now able to put one, two, or as many cameras as needed on this rig, lifting it to the desired height (even being able to tip and tilt the platform if need be). The 'flying carpet' device facilitated the simultaneous shoot and setup of two pyro miniatures at opposite ends of the stage without any danger of seeing rigging down below, while at the same time eliminating the need for scissors lifts or towers. To get a feeling for the different types and sizes of explosions, and in order to create a library of 'generic fireballs,' as they came to be known, we started out by shooting a variety of different combustible mixtures that Joe Viscocil came up with.

"These fireballs were shot against black to facilitate a luminance key," Timme explains. "Apart from putting us on the steep end of the learning curve of all things flammable, I do believe that quite a lot of these 'generic' explosions ended up being composited over, under, above and below a lot of destruction shots.

"The first miniature to be delivered to the pyro stage was a $\frac{1}{24}$-scale model of a section of the Second Street tunnel in downtown Los Angeles. Since it was completely enclosed with the exception of the entrance and exit, the first question was how to get light into this 'tube' at all.

"Using the scaled-down practicals on the ceiling was out of the question, seeing that we needed a T-stop of around a 5.6 in order to achieve at least some illusion of depth of field, while at the same time holding the highlights of the explosion. Exposing for these explosions was, in fact, a situation in which I did not have a lot of choices. The stop was pretty much dictated by the brightness of the explosion, and I needed the 5298's film speed for the depth of field, leaving frame rate (and shutter angle) as the only way of changing the stop at all.

"As one would expect, shooting below 300 frames per second was almost never an option, and in the case of Second Street tunnel, both cameras on the 'flying carpet' were going at 360 frames per second. The first thing we did was pull the pellicule for the video assist out of the two Photosonics™ high-speed cameras and mounting a little

CCD 'lipstick' video camera as an external video surveillance as close to the matte box as we could.

"This gave us about one-third of a stop more and helped in terms of depth of field, but the initial problem as to where to place our lights still remained. In addition, Roland had not yet shot the first unit sequence, so we had no footage at all to match to. Thanks to Karl-Walter Lindenlaub, however, we were able to visit the location in downtown Los Angeles together. Here, he explained his lighting plot for this specific sequence, making it possible for me to duplicate his setup.

"Since Roland and Volker had decided that it would not be necessary to see the floor on the destruction sequence shots, I thought that our best option would be to cut out the floor of the miniature tunnel, replacing it with clear Lexan.

"My gaffer, Victor Abbene, and his crew were now able to use the notorious Altman Parcans with 1,200W globes to light up the tunnel from below, centering each light on the miniature practical on the tunnel ceiling. The only thing passing through those lights, and thereby giving away the direction of the key, was a ball of flames. Hopefully it would supply enough ambient light itself to correct for the shadows it would create.

"We also added some overall fill light from below and used two crossed back keys as our rim light for the tunnel entrance, which we gelled with a full CTB to simulate Karl-Walter's uncorrected HMIs.

"All other sources, including the key lights, were gelled with a 1/4 Plus green, bringing it closer to the real color of the mercury vapor practicals in the tunnel.

"During the location scout to the Second Street bridge, I had also noticed that the highly reflective tiles on the tunnel walls and ceiling were easily lit up by the head lights and brake lights of passing cars. To add a touch of realism to our effects shot, Victor mounted some 100W projection bulbs, several of them dipped in red, to the street level of the miniature, giving us some kicks and reflections in the model's tiles.

"After some initial problems with getting the fireball into the tunnel, everything finally worked, and we could now move on to shoot the elements of the cars sitting inside the tunnel, being swept away by the force of the explosion. We had decided to use a blue screen key, since the orange and yellow interactive light on the cars came too close to the chrominance values of the green screen.

"Victor suggested using flicker-free 4K HMI Pars on the blue screen, and although I had originally had some problems with this notion, it turned out to be a brilliant idea. The blue screen was about 20 feet by 30 feet, and after some calculating, we decided to use 12-4K Pars with additional blue gel in order to enhance the chrominance of our blue screen.

"The interactive light from the wall of flames was created by four MaxiBrutes with 1,200W VNSP globes and a checkerboard pattern of double full CTO and CTS gels; the "streetlights" in the tunnel were simulated again by Parcans with the same gel configuration as on the pyro stage, although this time correctly suspended above the cars.

"The next challenge was to make the cars actually 'bounce' off the tunnel ceiling – without using the tunnel! I suggested building a Lexan 'tube' with the approximate diameter and height of the $\frac{1}{24}$-scale miniature, thus creating an 'invisible' ceiling.

"Naturally, the problem with this kind of setup was that the tunnel would be everything but invisible, since we were looking down the length of the Lexan tube, thereby dramatically reducing the exposure of the blue screen behind the translucent walls and the ceiling of the 'tunnel.'

"At this point, Victor's Pars proved to be a lifesaver. Although we had anticipated using them with the widest lenses available and adding some diffusion on top, we were now able to focus them in using narrower lenses, bringing the blue screen a good stop and a half up in those spots where it had been obscured by the Lexan.

"When viewed from a distance, it must have looked like the world's worst lit blue screen ever – but through the eyepiece, the effect was, in fact, very acceptable. As it turned out, seeing the cars in the final composite hit the tunnel ceiling helped to tie all the elements together, making it a quite believable shot."

From **Independence Day**, which won Volker Engel and his team an Academy Award, Philipp Timme went on to do the effects for the film *Dante's Peak*. Being responsible for the motion control unit, he feels that his contribution to the project was minor.

"There were five effects units working on 400 plus shots, blowing up ¼-scale dams and washing away bridges, while we were locked away in the perpetual night of the motion control stage. . . Out of everything I did, there are two shots that I really liked, and they totally pale in comparison to Chris Duddy's bridge sequence.

"Another very interesting sequence, in terms of the different techniques used, was the dogfight taking place in the Grand Canyon – or, to be exact, a lot of different sets, locations, and miniatures that were altogether made to look like that most famous of all canyons," says Timme, not ready to let go of *Independence Day*.

"Doug Smith started out by shooting some 'simple' background plates of a Grand Canyon stand-in, using an old converted army plane with a payload of stripped-down cameras instead of bombs.

"Shooting at a variety of different camera speeds, some of the radically undercranked footage actually looked like the POV from an F-18 fighter plane blasting through the canyon, narrowly missing the walls. Doug's footage became the background for a lot of the shots as they appear in the movie, with space ships and F-18s added as motion-control or CG elements. However, there were some angles and shots that had to be done in a more controlled environment.

"The next setup for this sequence, therefore, featured the end of the dogfight, in which Will Smith, running low on fuel, heads for a dead-end canyon while deploying his chute, momentarily blinding the alien Attacker, chasing him.

"Will ejects from his plane a second before he hits the wall, while the alien ship collides with the rim of the canyon, crashing on top of the surrounding plateau.

(An F-18 propelled through a fireball using bungee cord for acceleration and three guide wires for flight path.)

"For the impact, we used a set of wild 'Grand Canyon wall pieces,' scaled down to a height of approximately 12 feet.

"The F-18 was guided along two very thin steel cables and rigged to explode as it hits the rocks. This, like all the other miniature sets for the sequence, was set up outside in the parking lot in front of Hangar 45 at Hughes Airport.

"It soon became clear that, at this point in production, we could not completely rely on the sun to be our sole light source. By adding a bank of Maxi-Brutes with tungsten globes to simulate the harsh desert light visible in the original background plates, I no longer had the high contrast of strong, even illumination and razor-sharp shadows only the sun can produce or the realistic touch it would add to a miniature. I was, however, now able to shoot in overcast conditions.

"This saved money that was needed on other shots – which is just part of the thin line between artistry and craftsmanship that defines our job."

After some initial timing problems, the shot finally worked out, and Timme and team moved to what became known as the 'pizza slice' set. This was a huge platform of about 30 feet in length, built at an angle in order to keep the horizon line clear of surrounding buildings and trees, and shaped like – a giant pizza slice. This had a forced-perspective desert landscape as a topping.

The set was built to represent the plateau on which the attacker ship crashes after making contact with the canyon rim.

"The initial challenge we faced was how to actually launch the miniature ship so it would impact at the right spot," Timme explains. "After some brainstorming, we came up with a combination of parallel speed rail tracks (as a launch ramp), a set of powerful bungee cords, and a safety net on the far side of the set. This proved to be quite important, since we discovered on the first trial run that the spaceship was actually capable of really flying.

"On some of the shots, the bungee was therefore eventually replaced by a car-pull, using the continuous force of a pickup truck rather than the momentous impulse of the bungee.

"While these shots make up the better part of the Grand Canyon sequence, there were still some elements left – most notably a POV from Will Smith's F-18 as it is headed for the canyon wall, just before impact.

"In order to achieve this shot, Dave Novak came up with a device that looked like a wheelchair from hell. Using PVC tubing

screwed down on large sheets of plywood, he was able to create a narrow-gauge custom track system winding its way through a maze of six-foot-tall miniature canyon pieces. By suspending the camera on bungee cords, mounted to an overhead rig, that was itself attached to the 'wheelchair' device, I was now able to simulate what I thought looked like the view from a fighter plane racing through the Grand Canyon at Mach 1. Unfortunately, the speed at which Dave had to push our dolly down the plastic track also seemed to rapidly approach supersonic speeds!"

(The infamous wheelchair dolly.)

Fascinating and technically challenging, ***Independence Day*** will go down in Philipp Timme's memory book. However, what became his most challenging and fascinating project was the blockbuster Michael Bay thriller, ***Armageddon***. "It is somewhat difficult to describe the single most complicated element shot in ***Armageddon***, simply because almost all of the effects shots were unusually challenging," he says.

"One of the main reasons for this would be the fact that throughout the movie (and the effects sequences) the camera is always moving. In order to enhance this feeling of motion, we would constantly end up inches away from the miniatures, sometimes pushing the physical limitations of our lenses to gain precious millimeters.

"Very few of the moves in the effects sequences were actually achieved in post (usually by using the larger VistaVision™ negative in order to 'push in' and move the image up and down in digital post-production), but rather through a combination of encoded or 'free' background plates and high-speed moves, motion-control elements (sometimes using motion tracking data), and a variety of different elements shot on everything from Super 35mm, Anamorphic 35mm and VistaVision™ to 35mm and 2 ¼-inch stills.

"Naturally, having to move the camera during a high-speed explosion shot at 360 frames per second, while precisely following the pyro hits tearing apart thousands and thousands of dollars spent on a single miniature, requires some refined techniques," he comments.

"Richard Stutsman, our VFX special effects supervisor, for example, came up with a way of tying his pyro trigger board into the high-speed motion control setup so that it was possible for us to time the single explosions to the camera move, literally down to split seconds.

"And, we are not only talking about one or two events – the close-up shot of the space shuttle wing being hit by a 'meteor shower' in the opening sequence of the movie consisted of over 200 hits alone, every single one of them triggered by the camera move. Chris Dawson, motion control operator on *Armageddon*, and A. J. Raitano, first AC, had to overcome the countless challenges associated with extracting motion control data from a hand-operated background plate shot at 24 frames per second. They then had to try running a motion control rig about four times as fast, in order to compensate for the miniature high-speed shooting speed of 100 frames per second or more.

"They once had to weld a motion control pan-tilt head on a HiHat to a metal plate bolted into the concrete in order to eliminate the camera shake that occurred while spinning a VistaVision™ camera at 200 frames per second through a 90-degree move in less than a second.

"Brian Mussetter, also first AC, had spacer rings built out of copper in order to extend our lenses on the motion control VistaVision™ camera between one and two millimeters. This gained us an inch or so of close focus for the countless shots in which we had to use a snorkel lens just to get to the miniature.

"Of course, finding that snorkel and periscope lens was a whole different story," he laughs.

"The visual effects for *Armageddon* started on A-camera in the middle of 1997 and ended up on ZZ-camera in March 1998, having shot

footage on everything from Eyemos, Fries-Mitchells™, Arri™ cameras, Panavision™ cameras as well as Beaucams™, Photosonics™, Wilcams™, Paramount/Mitchell VistaVision™, and so on.

"A vast variety of cameras like this is usually something you try to avoid, given the different tolerances of each one regarding image steadiness, ground-glass alignment, and gate specifications – not to talk of the different lenses required for mounts ranging from PL to Nikon. In this case, however, it was impossible to avoid, since literally every format that we used had been chosen for a specific task. Even so, we pushed every camera to its physical limit, sacrificing camera continuity in favor of best possible execution."

The most complicated element shot in **Armageddon** was achieved using 3 different film formats and about 15 elements. "This was by no means a record," Timme says. "On *Dante's Peak*, we did more than 40 elements for a single shot.

"However, I've rarely had to go to such extremes in obtaining the elements as in **Armageddon**," he adds. "In this shot, we start on a medium close-up of the Russian cosmonaut inside the MIR-like space station. We then pull back through a window in a hatch and end in a wide shot of the station spinning in space.

"Since the actor had to be shot by the plate unit, it was decided to do this live-action, green screen element of him on a teeter-totter device, to emulate zero gravity.

"This element was shot as a lock-off on 35mm full aperture and was later motion-tracked.

"The other main component for this shot was a motion control pullback from the miniature space station, in 1/24-scale, starting within two inches of the surface of the hatch and dropping down to reveal a wide shot of the spinning space station, while continuously rolling around the optical axis.

"This shot was done with the Paramount Butterfly VistaVision™ camera plus snorkel on a modified Gazelle rig.

"The element presented some challenges. First, the close focus of the VistaVision™ snorkel was completely insufficient, even stopped down to an F32, and generously making some adjustments for depth of field. So, we resorted to the two-millimeter lens extension ring, much to the dismay of motioncontrol operator Chris Dawson and first AC A.J. Raitano. They had to eye-focus the entire 10-second shot!

"At the same time, this cheat, while eliminating the close-focus problem, caused some trouble on the wide end of the move. Now the

focus was shifted toward the camera. That meant we ran out of depth of field to hold the entire space station in focus.

"That was something that became quite obvious when we passed within an eighth of an inch of a truss work antenna.

"Chris solved this by speeding up the rotation of the miniature and thereby blurring the antenna sufficiently for the softness not to be noticeable. I helped him by keeping the far end of the station dark and back ighting it during the last part of the shot, in which I also selectively enhanced the 'subjective focus' of the distant part of the model.

"Another difficulty was the fact that the beautifully and very detailed miniature was not completely self-supported. That meant we could use only one axis of rotation on the model mover," he comments. "We had to rely on Chris to simulate all the other axes of the roll, on the camera head.

"This, of course, complicated the move immensely. Especially since we started to lose the correct nesting order."

Once Timme and crew solved this problem, they shot seven or more passes, including a beauty pass with key and fill, a practical pass, a high-con matte pass (which could also be used for reference), three UV-matte passes (because the move was so complex, doing a single matte pass would have resulted in green spill and a huge screen), and lastly, a "grid" pass, with which the exact camera move could be tracked in postproduction.

"The next element was a third scale hatch, through which we had to pull back in order to be able to start the shot 'within' the space station," he continues. "Naturally, we had to scale the motion-control camera move in order to fit this element in with the background of the smaller miniature. In other words, we were looking for a perfect match-move in a completely different scale, on a different model mover (since the rotational offset of the surface had to be scaled up as well).

"We anticipated that we would run out of vertical boom movement," he adds. "So, on the large-scale set, we had to cheat the hatch out of frame one-third, into the original camera move. This was a decision that allowed us to stop the boom down inches above the stage floor, without having to dig a hole for the camera, as we had to do on *Dante's Peak*.

"This element, by the way, required only four passes – VistaVision™, of course. We had a beauty, a practical, a high-con, and a UV matte pass."

Touchstone Pictures
"ARMAGEDDON"

VFX Data

Internal Count 1

Slate	HB-01 [Takes 4 through 9]
Date	07/09/1997
Element Name	Beauty Pass for Hubble Telescope
Use	To be combined with all other passes. There are several different Versions (takes 4 through 9) regarding the exposure (see notes below).
Takes	4 (with earth fill), 5 (with earth fill), 6 (with earth fill), 7 (no earth fill), 8 (no earth fill), 9 (no earth fill)
Camera T-Stop	16
Camera Filters	No Filter
Camera Speed	.315 FPS
Camera Roll	FX VV A 5
Film Stock	5248
Notes	This is the beauty pass to be combined with all the remaining passes. Take 4 and take 7 show the first 73 frames of this shot (0 - 72) with the camera locked off and the Hubble moving; take 5 and take 8 show the first 73 frames of the move (0 - 72) with both the camera head (no track move) and the Hubble moving; take 6 and take 9 consist of the move from frame 48 to the end. This was done to extend the move in post by adding two seconds (frames 0 to 47) to the head of the shot. This can either be accomplished by using the version with camera lock-off (to create the roll in post) or with the camera head moving (use the programmed roll). Corresponding takes are: Takes 4, 7, 10, 13, 16 and 20; takes 5, 8, 11, 14, 17 and 21 respectively; and takes 6, 9, 12, 15, 18 and 19 respectively.

Scan Status

(Typical *Armageddon* effects log. Above, from space station shot.)

Now that the team knew the moves, shooting the interior of the space station for the composite behind the live action was easy. "The background plate was shot again in another scale," Timme explains. "We ended up doing two passes – a clean and a smoke pass."

After completing all these elements and looking at a rough composite, Timme notices the absence of the window glass "feeling." None of the elements contained an actual pane of glass, "for obvious reasons," he adds. "We therefore decided to take some still pictures of various backlit glass 'scratches' on 2¼-by-2¼-inch still film. These 'scratches' were essentially two-dimensional, and therefore could be animated digitally, matching the movement of the miniatures."

As if that wasn't difficult, Timme and his group found the destruction of large parts of New York another challenge. "Immediately after we see a dog bark ferociously at some inflatable *Godzilla* puppets, the Big Apple gets plummeted by a series of meteorites, destroying, among other things, the Chrysler Building and Grand Central Station," he says.

"The background plates for these shots were filmed in three locations. Some, like the one following the impact of a meteorite from the skyscraper to Grand Central, in New York City proper; like the shot showing the top of the Chrysler Building impacting on a New York street, were done in downtown Los Angeles. The third location was the miniature sets behind a warehouse in Culver City."

Obviously, this presented several problems. Matching seamlessly would be the key to the power of the effects sequence. It had to work. "Some of the plates had been shot with encoding heads," Timme remembers. "That enabled us to use the recorded move data. Others had to be painstakingly tracked by hand, in order to re-create the original move.

"The biggest challenge for these shots was to match the already very fast camera moves in the background plates with high-speed VistaVision™ cameras, weighing around 40 pounds and going between 100 and 200 frames per second, about four to eight times the original speed.

"In addition to this, most of the shots required elements that followed the path of destruction, such as the meteorite striking Grand Central Station, or things hurtling through the air, like the top of the Chrysler Building dropping into the street below.

"This, of course, meant timing explosions, air mortars, wire cutters, and other highly destructive devices to one-hundredth of a second!

"Thankfully, Richard Stutsman and Chris Dawson came up with a way of tying the timer box into the motion control system! This enabled one computer to move the camera and trigger the pyro at the same time – down to the exact frame desired!

"This system made it possible for us to follow a 1/12˝ scale, 16-foot part of the Chrysler Building on its way down to the moment of impact, as well as show the destruction of three major New York buildings, in one continuous pan, ending on the frieze of Grand Central Station – and witnessing its demise."

No wonder **Armageddon** got nominated for a Visual Effects Oscar!

"What I learned on **Armageddon**," Timme concludes, "is that there is always a solution to any given problem – no matter how impossible it seems. Sometimes, this might involve 40 motion control passes or 26 different cameras – or it can be as simple as fishing wire and smoke. The truth is, there is always a way to do it – you just have to know how."

"One of the most important things I began to understand is that film is just a sensitive surface upon which you can put light in any way you can think of."

Douglas Trumbull

"I think it was a childhood thing, in retrospect," he says. "I was always fascinated with the Disney feature-length cartoons and Disneyland. But, I never thought consciously about being in the movie business."

It wasn't until his last year in high school that multi-Academy Award nominee for Best Visual Effects, Doug Trumbull, found something other than Disneyland to his interest. He got into architectural drawing and decided to go to junior college at El Camino in Los Angeles. He took drawing, painting, architectural, and mechanical drawing.

"I had a gifted instructor by the name of Charles Bluske, and he just blew my mind," Trumbull recalls. "I had no idea of the world of commercial art but started painting like crazy. I did a lot of airbrush work and semi-photo realistic illustrations. They were science fiction-type book covers."

Since he wasn't "into school," Trumbull left after a year. He wanted to work and make money. A job in a small advertising agency introduced him to the world of animation. A job at Graphic Films, a company doing space and technical films for NASA and the Air Force, introduced him to outer space films. "I painted stars, moon, trajectories, lunar landings' and so forth for films about the Apollo program," he recalls.

One of the projects he worked on was **To the Moon and Beyond**, for the New York World's Fair. Filmed in a dome projection process called Cinerama™ 360, it was a precursor to OmniMax™ 70mm.

When Stanley Kubrick saw the film, he realized the people from Graphic Films could work on his project called **Journey Beyond the**

Stars AKA 2001, A Space Odyssey. Trumbull started doing the original moon and spacecraft drawings at the Los Angeles Graphic Films facility. Then Kubrick decided to move the operation to England. "I was out of a job," says Trumbull, "but, not for long. I called him in England and told him I would like to work on the movie."

Trumbull joined the English production, thinking of himself as an animator. His first job was doing all the HAL readouts. Soon, that blossomed into miniature photography. "The year was 1967, and 'effects' were in their infancy. The project was being done on Super Panavision 65mm," Trumbull says. "The negative was large and we had to fill the space."

Ask Doug Trumbull what the most fascinating shot was in *2001*, and he will pick the stargate sequence. "It was a two-layer shot, both done in camera, so it was a one-pass job," he explains. "It was based on some of the work that I heard John Whitney was doing in Los Angeles – figuring out how to keep the camera shutter open while moving things in front of animation stands."

"It occurred to me that this could be done dimensionally, if you built a really big rig," he adds. Trumbull pitched the idea to Kubrick. He even made small Polaroid photographs, showing how it would work on the animation stands, exposing through a narrow slit.

Trumbull was authorized to build what he called the "slit-scan machine." The tool allowed Kubrick, Trumbull, and team to create some startling visuals that still hold up today – and it contributed to Kubrick's Academy Award win.

"We learned a great deal on this picture," says Trumbull. "One of the most important things I began to understand is that film is just a sensitive surface upon which you can put light in any way you can think of. This slit-scan process started making me think about images and light in a completely different way."

Trumbull began separating camera and film. "I started looking at film. You can put light on it any way you can get it on. You can scan a laser beam on it, a CRT. You can take the lens off and let sunlight hit it with shadows.

"The whole idea of a camera with a lens stuck on the front went away from me."

This is what Trumbull was doing. The slit-scan material was based on frames of film with two minutes' exposure on each frame – of a camera tracking in and out on a piece of abstract artwork. "The 65mm camera was on a track facing a narrow slit, behind which was

backlit transparent artwork. As the camera approached the slit, the shutter was opened so that a time exposure was put in the film frame with focus from 15 feet to 2 inches," he explains. "The light was accumulated on the film over a minute's time – not in a continuous still frame."

After the success of *2001*, Trumbull began to witness some growth in the world of video production. "It fascinated me," he says honestly. "Petro Vlahos had invented the Ultimatte™ system, which could actually carry shadows in a composite. I had this idea that you could superimpose people into miniatures in real time. It could be done right then and there, if you could solve the motion control problem."

The idea was to do a fully dynamically moving composite in real time, matching the camera, pans, and filters. It would be a breakthrough for episodic television production.

Trumbull pitched the idea to Paramount, which was producing the *Star Trek* series. They decided to back his idea, developing Magicam™. It was used on many television commercials, as well as the *Cosmos* television series with Carl Sagan.

"I realized that it was not a user-friendly tool," Trumbull says. "It was somewhat confusing to directors to work in an abstract space. They lose their orientation of what was north, south, east, and west, and where the actors relate to the set.

"It was also making the process more difficult rather than easier because the foreground had to be perfect, the lighting of the actors and props, and the background also had to be perfect. And, the composite had to be perfect. This exponentially increased the number of difficulties to get a perfect shot."

Trumbull shifted his thinking. The next step would be to use the background as a reference. "I tried to think, 'Don't worry about it; if it's not right, shoot anyway.' If we could deal with the foreground, get it in focus, and light it right, we could frame and shoot. We could then put the background in, during post."

Although interesting, the studio closed down the process. It wasn't profitable enough. However, it was a tremendous learning experience for Trumbull. The idea never went away. It eventually led to his 1998 concept of virtual sets.

In 1970, with partner Jamie Shourt, Doug Trumbull began working on the futuristic feature *The Andromeda Strain*. "I underbid the job, would you believe $135,000!," he recalls. "But, we really wanted to push our effects into computer-controlled motion control. We

had one of the first Digital Equipment Corp. PDP11 computers. It was small, but it was the first microcomputer.

"Jamie was writing code because there were no programs to control the two kinds of photography we wanted to use."

To do the microphotography the film required, Trumbull rigged a microscope on the motion control stage that could pan, zoom, and tilt. He also built a motion control rig to create the strange effects for replication of the disease known as the *Andromeda Strain*.

"We designed the organism as a replicating, truncated, tetrahedron crystal structure, which is a whole series of nested hexagons," says Trumbull. "We created a bizarre device mounted on stepper motors, which could flip this thing to any position, rotate it, pan it, move it in XYZ coordinated space. The whole idea was to make this replicate kind of like quick 'click-clack blocks,' these little wooden toys with straps around them."

Shourt and Trumbull created the program to do this with a strobe flash for each facet. "It started exponentially increasing in exposure time," he explains. "The first exposure was one strobe flash, the next was two, the next was four, the next was eight. This went on until we couldn't stand it anymore!"

This was Trumbull's first experience with true computer motion control moves.

At the same time, Trumbull and Shourt built the first electronic optical printer. They contracted with a company called Lear-Siegler to build a black-and-white, high-resolution television camera. This camera ran 2,000 line video, had 8 fields per frame, and a video processor box. "We then added a digital-image processor box that could take the image and posterize it, edge-generate it, and do all sorts of manipulations to the image. We could then put it back onto a flat-faced Miratel™ high resolution monitor," he explains.

"We had a film chain of a 35mm single-frame optical printer projector head, and the video camera to look at the film we shot as it went through the digital processor and back to the monitor. It then went back to a 35mm camera, allowing us to do three passes through, to create color."

The tools were highly effective on *The Andromeda Strain* and were responsible for the startling ending, where the audience sees the strain replicating itself. It was the first real high-definition video digital composite printer. Trumbull was the first person to ever do digital motion control – to record square wave pulses.

"We used a standard off-the-shelf stereo tape recorder," he explains. "We could play these pulse trains into the electronic drivers for the motors to create acceleration or deceleration. In actuality, the first time we used the tool was for commercials – 1968-9 for True Cigarette and Eastern Airlines."

In 1970, Trumbull wrote and directed another landmark, somewhat cult, picture called *Silent Running*. This was a simple picture, featuring few major effects. However, it was the next generation of motion control and front projection. Trumbull used miniatures for projection plates and live action photography – a tool that Kubrick first used on *2001*.

"You had to get the perspective and color to match exactly, and to make sure there is no fringing around the edges or reflected light," he explains. "It had to be a really seamless perfect composite.

"I remember watching Tommy Howard on *2001*. He had built this 8 by 10 front projection machine that was as big as a trailer. Kubrick had decided to make the stage rotate, so he could go for different camera angles without moving the camera. The front projection screen was fixed to the wall.

"My idea was to miniaturize the whole thing and make it mobile," he adds. Trumbull found engineer Howard Pearson, who built a small front projection machine with him. They designed the optics and projected four-by-five plates. "I thought they would be good enough for 35mm photography," Trumbull says.

"We made this tiny front projection machine with multiple focal length lenses that would sit on a Worral™ head. We had an Arriflex camera that was light and easy to use. This allowed us to shoot 15 process setups a day, while we were doing other live action stuff.

"It was unbelievably fast," he adds. "When I submitted *Silent Running* for an Academy Award at that time, I told them one of the big things was this front projection. They simply didn't believe it. They didn't want to hear that you could shoot 15 process setups a day. It was annoying to me, but I was very proud of what we had done.

"We had also used the front projection on miniatures for the spacecraft," he recalls. "This was what John Dykstra was doing with me. We used a small front projection screen and a model of the spaceship. We stopped everything down to F-22 and shot it in one pass. It was a 32-day live action shoot – and cost about $1.3 million to finish."

Trumbull was deeply affected by the picture *2001*. For him, it was a forerunner to possibilities. It was done in Cinerama™, on the

giant curved screens, and was powerful in first-person experience. He couldn't shake a concept created on the picture. "In the stargate sequence, Kubrick realized if we took out the shots of the pod and Kier Dullea, we could take the audience on a personal trip," he says. "This was 17 minutes of uninterrupted visual effects with no dialog, no plot, and people were riveted by this 'ride.' If the huge cinemas and 70mm pictures hadn't been phased out, there is no end to what could have been done."

For years after *Silent Running*, Trumbull was in development hell. Almost every major studio had opened negotiations with Trumbull for features, which fell out for all the wrong reasons. "I never took it personally, but it was frustrating," he says. "I realized I couldn't make a living on development deals, so I went to my lawyer with technical ideas. The idea was to help the industry with equipment."

Trumbull hooked up with Paramount, and they helped him form Future General Corporation, an R and D subsidiary. The idea that began to cook came out of the *2001* memory. It was ride simulations. Since Trumbull had been in flight simulators in his earlier years, he realized this would be a great entertainment experience. "We built the first simulator ride in Marina del Rey in 1975," he says.

Trumbull and crew also looked at thousands of feet of old films, realizing what was missing. "We did our first test shot at 72 frames per second," he says. "It was mind-boggling. We did lab tests, hooking people up to EKGs and ECGs as well as galvanic skin response sensors, showing them films at different rates – finally settling on 60 frames per second."

This process, called Showscan™, became a revolutionary method of photographing and projecting film. Although developed in 1974, it was not really recognized by the movie industry until 1993, when Trumbull was honored with an Academy Award for the Showscan™ camera system. In 1995, he also achieved the International Monitor Awards Lifetime Achievement Award as well as the American Society of Cinematographers President's Award – for creating another venue for moviemaking.

The first Showscan™ project was done entirely live action, for a screen that Trumbull designed floor to ceiling and wall to wall. "It had an opening sequence that a lot of people remember," he says. "I was fascinated with the whole idea of the difference between 35mm/24 frames and 70mm/60 frames.

"I came up with the idea of filming a scene as though everything had gone wrong and the projectionist had left the booth, had gone through some corridor, and had come out through a door in the wall behind the screen. He comes out with a flashlight and talks to the audience through the screen.

"I purposely filmed the world's worst documentary by making it handheld, badly lit and cut. I even abused and scratched the film, making the sound track wobble, and projecting it small inside a large screen."

This film goes on for a minute, then the film jams and burns in the gate. It was projected in real time, at 24 frames, and photographed at 60 frames, from exactly the point of view of the audience members.

"Then I built a scrim, partly translucent where the projectionist came out," he adds. "I had the houselights raking the scrim from the top. They come on so,when the guy pushes on the screen, it is an uninterrupted shot."

This goes on for about five minutes, without a cut. "Bear with me; we're going to run this film for you, but it is partly messed up and we've got a new projectionist" is what Trumbull would say to the major players in the industry who would come to his studio to watch his new invention. "They would fall for it," he laughs. "As soon as the film breaks and the projectionist comes out, they would get up out of their seats, shake my hand, and say thank you.

"Only when they got to the door, and they are looking at the screen obliquely, they realize it is a movie I'm projecting!

"They have bought the reality," he says. "That's what 60 frames does for you. It is so fluid and so liquid that it's almost 3-D and lifelike. The grain is gone. So, they really appreciated it."

The process Trumbull created got a lot of attention. However, over the next 10 years Trumbull kept hitting blank walls. The general excuse – would the theaters fit their projection screens for the process? "I got close," says Trumbull. "Henry Plitt wanted to make a real statement. At 70, he'd been around for a while and seen everything. He wanted to do something really great. So, I sold him 80 percent of the process and he was going to set up his Century City Theaters. Three months later, he sold the chain – and I had no way to get out of my contract!"

This was the breaking point for Trumbull. He decided to go back to his roots and create rides. "You don't need Los Angeles to do that," he says.

In 1991, one of Trumbull's first rides was the **Back to the Future** ride, for Universal Studios in Florida and Hollywood. It set the standard for immersive entertainment and remains the most popular theme park attraction in the world. "It is the special giant screen film process and simulation that intrigued me," he says. "The whole idea of the audience actually being able to penetrate the old proscenium arch, the flat screen, and enter into the movie is a challenge.

"There were a whole lot of hairy difficulties in that dome process," he says. "You get a lot of cross-reflectance on the dome. If you put something really bright on the left side, it will flood out the right side. The bright sky washes everything out, so you have to shoot at night.

"We shot this with the fish-eye lens. All the cameras were as big as a house," he recalls. "The cameras had to go through and into the miniatures we created, so I had Ron Schmidt build the first microscopically small IMAX™ camera. We had special little hundred foot loads, which could film just 25 seconds per roll. And, Mike Sorensen built the most sophisticated motion control booms ever made, so that we could reach the camera out and over into the miniatures.

"Of course, we then had to deal with fish-eye lenses," he adds. "Where do you put the lights? So, the miniatures had to be self-lit. There was lava, porch lights, and streetlights. We used smoke to make it look like a foggy night.

"Then, we had the glacier sequence where we had glowing light inside the glacier, making it light itself.

"It was a big challenge," he says. "There were no optical printers at the time, printers that we could rely on. So, we tried to do as much in-camera as we could. So, we built a special nine-wire gimbal rig to support the DeLorean car that we were chasing instead of compositing it on a printer.

"One problem with IMAX™ is that it is 24 frames per second. It is not enough frame rate for us. If you are filling that field of view, each frame is moving a few feet. You get a lot of blurring and strobing.

"The eye has to follow the DeLorean – an object that doesn't blur. We had to do a reverse-engineering thing, where the lights and perspective and frame rate as well as camera motion were all optimized. It was a major undertaking for just four minutes of film."

While Trumbull was developing his ride process, he participated in several major film projects. In 1976, he lent his creative and engineering talents to **Close Encounters of the Third Kind**. "It was

when Paramount was feeling like there was no future in Showscan™," he recalls. "George Lucas asked me to do the effects for *Star Wars*. Then Spielberg came along and asked me about ***Close Encounters***.

"This was an opportunity to really break through with motion control," he explains. "We hired an engineer named Jerry Jeffress to do the actual integration engineering of a truly robust motion control system. My father, Don Trumbull, worked on it as well. We built a camera head and dolly system that we could record live-action camera moves, put on tape, take it back to the studio, and replay it through motion control, single frame. This way we could add dynamically moving effects shots.

"It is the first time this was done," he says. "We had to work out what the UFO would look like, and how we were going to create something that was going to be new and different."

Trumbull admits that the first experiment didn't work. He tried a weird saucer shape with film projected onto the surface. "We actually ended up using it for the mother ship," he says. "Steven didn't want to see a saucer shape, just the lights, bright lights, like an airplane landing at LAX."

Trumbull and crew built a motion-controlled smoke room for the shots. "It had a black velvet wall, with smoke that was evenly distributed by fans," he explains. "We used laser beams to measure it and keep the smoke at an absolutely constant density for a long period of time, while we were shooting the motion control.

"You could create the neon glow in the dark and in smoke," he says. "So, we developed an optical package of devices to assemble on any shape that would create glaring light."

This was when Trumbull began experimenting with computer graphics. He was using several different composite techniques to try to carry the glows off the UFO. "That took a lot of delicate handling in the optical printer," he says. "We did a lot of front projection. We built a 70mm front projection machine – something that had never been done before.

"This machine was a real advantage, if you have a way of doing shots in real time," he explains. "You can see the results right then and there and verify that you got what you wanted.

"The mother ship ended up having a projected moiré effect," he continues. "We used an 8-by-10 projector, projecting a shimmering pattern on the underbelly. The rim of light was actually a single light, oscillating around and going on and off. It was a magical effect."

Trumbull's work on *Close Encounters* earned him a 1977 Academy Award nomination (along with Roy Arbogast, Richard Yuricich, and Matthew Yuricich). So did his work on the 1979 feature *Star Trek: The Motion Picture* (along with John Dykstra, Richard Yuricich, Robert Swarthe, David K. Stewart,v and Grant McCune) and the 1982 feature *Blade Runner* (with Richard Yuricich and David Dryer). "My heart really is in the rides and other filmmaking projects – outside the Hollywood system," he says, shying away from talking about the been-there-done-that work on these features.

"I was really pleased that *Back to the Future*, the ride, was such a success," he says. "When we were making the ride in the Berkshires, we built a 30-foot-diameter dome and a single DeLorean car. We used an IMAX projector, and we had our own film processing lab right there.

"We could do black-and-white tests to work out the relationship between the motion of the camera and the vehicle.

"It was a very complicated process to figure out," he admits. "After the ride opened in Florida, we realized our little 30-foot dome with one vehicle in the middle of the dome was much better than the big dome in Florida.

"This is when I realized that we could miniaturize the whole thing and could place it in thousands of locations."

The concept was built into *Secrets of the Luxor Pyramid*, for Luxor Las Vegas. It broke further ground with its innovative use of immersive technologies and received the annual Digital Hollywood Award for best virtual reality experience in the world.

"It has a dome screen and a 48-frame projection because we couldn't license the Showscan™ process," he explains. "So, we were two frames per second under the Showscan™ patent.

"But, it has its advantage you can show each frame of film only once instead of twice. That smoothed out the motion control. It is brighter, sharper, and clearer than the *Back to the Future* ride."

Now that Trumbull's rides are moving into computer graphics, it is less expensive to do and can be done faster. "Forget the miniatures," he says.

"The Luxor project was also a very interesting experiment in what I thought was important to figure out – how to seamlessly combine live action, miniatures, and computer graphics so that you can mix them in any quantity but exactly match the spatial relationships.

"It's a complicated matching issue. But, that's what a ride is all about."

Trumbull says there is no difference in designing elements for the 3-D perspective. "You have to correlate the 3-D space that the lens sees to the 3-D space that the computer sees exactly," he says. "We developed several techniques to do this.

"One was to build a cubicle box with grids on it, on all sides. This way, you could stick the camera in the box at a certain location, look into the box, and photograph it.

"We also used the computer to generate the box.

"The grids were drawn by the computer," he explains. "We photograph the grid, then look at the film and analyze how much had been distorted. We then put an algorithm into the computer that can exactly match the distortion characteristics of that particular lens. That way, once you have it worked out, the computer space and camera space are aligned.

"To use this, we have built a huge Gantry camera, the best ever built, and another more miniature camera. Again, Mike Sorensen engineered the gantry and Ron Schmidt built the cameras.

"We took the same design that was built for the *Back to the Future* ride and made it smaller for VistaVision™ cameras. We also have a 3CCD color video tap that we can put on the camera; take a live feed off the gantry, up into the computer graphics department, and fit everything together while we are shooting miniatures.

"We also did some live action photography, but not as much as we had planned," he adds. "The gantry wouldn't run as fast as we wanted at first, but we finally got it up to 8 feet per second, which is monstrously fast for a motion control rig over a 45-by-90-foot area.

"With this, we can actually track a running actor! It is incredible, and I'm proud of the rig and that we solved all the problems. It was used by Mass Illusion on *What Dreams May Come* and *Eraser* and is still in use today."

Doug Trumbull's heart has definitely left mainstream Hollywood. He is making his mark on alternative entertainment – and making it big. He holds 15 patents, including the Showscan™ process. Recently, he has created yet another approach to ride entertainment.

"Microvision™ is redefining the visual interface in a way that will truly deliver on the promise of virtual reality," he says. "It is a lightweight head-mounted display with high-resolution, 3-D color imagery."

Trumbull's idea is to create experiences that engage people as participants with highly realistic full-motion 3-D imagery.

By 1999, Trumbull will also reveal a yet-to-be-named simulator that utilizes a revolutionary, electromechanically actuated motion base, coupled with an extremely lightweight capsule. "The idea is to have an interactive, six-passenger 'all-electric simulation system,' with digital projection," he explains.

"The screen (13 feet wide and hemispherical) will employ multi-projection to create a seamlessly merged, five-panel panorama," he explains. "It will also feature digital sound."

He is also involved in what he truly believes is the future of moviemaking. "I feel like I have given enough of my life to the technical infrastructure of the industry," he says. "When I see movies like *Titanic*, I see brilliant filmmaking.

"On one hand, Jim Cameron has built a 900-foot ship and has a cast of thousands, and it looks great. And, in the next shot, the digital characters on the digital ship are intercut.

"It is seamless. It proves that you don't need the 900-foot ship anymore. In fact, you don't need sets at all. You can, in fact, use virtual sets, and they can be bigger, better, and more incredible than any place you can actually shoot.

"My direction, now, is toward virtual sets and electronic cinematography," he says. "We will have film-quality digital cameras in a few years, and these are going to combine together in a technique that is like MagiCam™, but, with a very specific approach to where you are.

"You do see a very compelling composite in the camera viewfinder. And, the whole thing is so robustly automated that you can never lose track of your orientation. You can shoot everything very quickly.

"We are entering the world of the digital backlot," he says. "Studios won't have to have a western street, a New York street, European streets. It is all digital. With the flick of a switch, you can automate the lighting set up the sets and locations immediately. And, you can digitally archive everything, turning it on again whenever you want."

At Trumbull's New England-based company, Entertainment Design Workshop, he and his staff are developing an advanced virtual set system for television, digital HDTV, and film production – including

provision for all film formats, including 35mm, 65mm, VistaVision™, IMAX™, and IMAX™ 3-D.

"We have built a stage dedicated to this development process and are integrating ultra-high-resolution camera-position trackers, which can work on a dolly, boom, Steadicam™, and handheld – all utilizing real-time CGI composites via a Silicon Graphics Onyx™ Reality Engine, Ultimatte™, and a variety of CG software packages, such as Alias/Wavefront™'s Maya and others," Trumbull explains.

"We are committed to implementing a truly robust and user-friendly system, which will make possible full camera freedom, real-time compositing, photo-realism, lighting automation, dramatically increased setups per day, and significantly lower costs of production," he adds.

"In addition, we are developing comprehensive process management tools, for the design, creation, implementation, and archiving of 'digital assets' such as objects, props, buildings, terrain, skies, etc., for what will become an ever-expanding and easily accessible 'digital backlot.' "

Trumbull's purpose is to create tools for his company and other companies, which benefit from the rapidly improving power of digital technologies. "This is the only aspect of film and television production that grows more powerful and less expensive each year," he explains. "Given the film and television industry's desperate need to control production costs of spectacular 'event' material, we feel confident that our experience in the production of feature films, television, special-format productions, and theme park attractions will be vital to the efforts to make a major breakthrough in the way media is produced.

"At EDW, we are now in preproduction on an important pilot and series for one of the major studios – using virtual set technology. We are proud that we are being recognized as the leader in creating the first truly comprehensive virtual set solution."

The future of moviemaking is computers and digital work, for Doug Trumbull. He's forged many inroads in visual effects over the past 30 years, and his future direction is just as innovative as his past.

"Again, it's not just the animation that makes the scene work; it's applying design principles to the scene to make it live there and tell a story. We look at what flavor the director is painting his scenes with – is it over-the-top, in-your-face slapstick? Or a subtle serious twist of imagery? What palette of lighting is the D.P. using? We have to match and enhance the director's vision."

John
Van Vliet

When John Van Vliet was in the U.S. Air Force in the early 1970s, he served his time as a graphics illustrator and draftsman. While creating storyboards and related art for combat-crew training ads, he also prepared audiovisual art for command-level briefings. It was his first experience in turning text into images, and he found he had a flair for this kind of creativity.

"It was basically eyewash," he says. "However, the really cool part of the work was that I got to take dry text from training manuals and make it into visuals. It was the time of the energy crisis, so the Air Force was trying to get pilots out of the planes and train them as much as they could on the ground. It was my job to build visual elements to instruct bomber pilots – and keep them interested."

By the time he rejoined the civilian workforce, Van Vliet was solidly committed to the visual arts. He went to California Art Institute and enrolled in the Disney Animation Program. "I could draw and I knew photography," he explains. Although he had an affinity for drawing characters, he wanted more.

"Animation is essentially drawing one character over and over with some variations," he says. "Effects, now that was really interesting. After the school shut down for Christmas break, I decided to stay there and get some quality time with my animation. Someone I knew from New Jersey (Peter Kuran) happened to stop by, saw my name on the dorm list, and saw what I was working on. At that time, he was heading up north to run the new animation department at ILM, so

a couple of weeks later, he invited me to join the group. That was it for school, I wanted to be in the effects world."

So, Van Vliet began his work in flat-art animation at LucasFilm's Industrial Light and Magic. Here, he served as effects animator and rotoscope artist on several legendary ILM projects, including *The Empire Strikes Back, Raiders of the Lost Ark,* and *Dragonslayer.*

"Flat-art animation in the early days of ILM was not a well-understood technique," he says. "Its main application to the effects factory was to be used when a repair job was necessary. We were the cleanup crew when mattes needed to be made for optical and fixes had to be found to avoid costly reshoots.

"The great part was when we were occasionally handed the fun stuff like animating electricity, lightning, shadows, and that sort of thing. That's when we got a chance to stretch. In the snow battle scene in *Empire*, for example, every time a laser goes by one of the AT-AT's, or walkers, there is a traveling reflection from the laser. When there is a flash and the vehicle is hit, there is a source and a receiver of light showing. This was all animated on cells and hand-painted and airbrushed. We weren't even thinking of computers yet.

"Peter Kuran, who was then head of the animation department," knew the potential of our techniques," he continues. "Peter was 10 steps ahead of everyone else and was always trying to push the envelope on what we could do, plus struggling with ILM's perceptions of what we should do. After *Empire*, Peter finally decided to head back to Los Angeles to do it his way at his own company. He really was 10 steps ahead of us all."

By the time Van Vliet became involved in *Raiders*, he had a working familiarity with the techniques used in the ILM facility, although he was still in the animation department. "While the initial concept of what we were supposed to do was pretty simple, we all wanted to improve the process," he says. "The crew was always looking for a better way to approach a problem.

"Being able to interact with optical and stage and editorial made innovation possible through the awareness of other processes. This saw the beginning of such innovations as pin-blocking film elements under an animation stand and better techniques to create soft-edge mattes and blends as well as ways to integrate what we could do with elements generated onstage."

These were the early days of ILM in Marin, and there was a lot of encouragement from the supervisors to find new and better solutions.

There was still a huge mountain of work that required the old-fashioned thankless task of roto-animating fixes for shots that had gone bad. So, when things got too tedious, Van Vliet would sneak into the dark stage and watch the new effects wizards and techniques.

"*Dragonslayer* was the show I had the least involvement in," he admits. "However, I was more impressed with what was going on with that show than a lot of the other projects.

"It was the creativity, I guess. When creative juices are flowing, it generates an aura of excitement, and that aura is an intoxicant to certain people. The invention of go-motion was happening right in front of us. There had been some development during *Empire*, but this was the next big step. This was the effort to introduce blur to stop-motion to create a more lifelike appearance to the animation.

"Successful blur to this type of work would be as important a breakthrough to puppet animation as motion control was to model photography. While not included in that particular development team, it was a treat to be able to watch the evolution of an art form happen right in front of us. I would come in early and sit on the stage and watch what was going on. This was better than any film school."

One of the men Van Vliet watched was Ken Ralston. When he had a question, Ralston would stop what he was doing and explain. "I understood the technique of stop-motion photography," he says. "I'd already played with that. However, what I wanted to understand was the blue screen process and motion control. From the time of *Empire*, I'd watch Ken and Phil Tippett as well as John Berg working on the various miniature sets, lighting and animating their work.

"They were intense," he says. "There was a focus on the work that demanded total dedication. The general attitude was that good enough wasn't. I admired that." Van Vliet was learning.

In 1981, Van Vliet landed at Walt Disney Studios, doing effects animation and design on the landmark picture *Tron*. "This was an odd show in many respects, as this was supposed to be a big computer-animated feature, and we were needed to generate a ton of the animation by conventional hand techniques.

"The computers at the time were able to deliver about 15 minutes of film time, and their applications were limited by today's

standards. So, that left a lot of film that had to be fabricated by a more traditional method.

"Richard Taylor and his group came up with a process of filming the live action that was supposed to be people in the computer world and turning each frame into a huge 20-inch photo-roto transparency, which was essentially a backlit animation cell. From this raw footage, we in animation were tasked with creating suitable effects that gave the impression of a high-tech world where everything was painted in light and energy. The work was hard and long and we had a ball."

This was essentially Disney's first experience with the new generation of outside effects people. Since the Disney in-house effects people were unavailable, "The *Tron* team decided they would install their own effects department to run the show through, which is how I got recruited to come down and work at Disney," he explains.

"So, on top of doing the work, we were forced to build the effects department from the ground up. Fortunately, I'd been paired with a man by the name of Lee Dyer, who happily took on the lion's share of management, and I pursued the design and animation, which was my goal."

In designing shots for *Tron*, Van Vliet began by looking at what he felt people expected computers to do. "To me, it was mostly a design issue," he explains. "The techniques were pretty much the tried-and-true backlight animation methods. They were the Robert Abel-type glowy manifestations. My job, which I really enjoyed, was to come up with the first cell, so to speak. I would set the tone for the character of the effect, and the rest of the cell animation department would take off from there.

"One of the things that still kills me today, whenever I see any documentaries on the history of computer animation, is that they always show this one shot from *Tron*. It's from the sequence where this motorcycle rises up from a series of grid frames, turns into a fully materialized bike, and goes zooming off down the game grid. The effect might have run 24 or 30 frames, but it is so reproduced – it is even part of some of the posters. It was everywhere.

"Well, that was all done by hand," Van Vliet explains. "Richard Taylor, the effects supervisor, came in with a transparency of the motorcycle and put it on my desk. 'This is the bike and this is the guy.' My job was to get the guy onto the bike."

Essentially, Van Vliet's job was the first attempt at morphing. He had to take the elements – actor Jeff Bridges, shot in various crouching positions, and the bike – and bend them together.

"I began by drawing grid cage patterns and a grid engine-suspension system," he explains. "Then I went back and airbrushed almost every frame of the effect. These multiple layers of art were wiped on with various overlapping matte layers to give it the impression of complex parts being formed and modeled in front of your eyes.

"We did passes – wiping on the engines, wiping on the suspension. Then there are the cross dissolves and so on. It got weird," he admits. "All these figures – and you have to toy with the percentages of light. The effect might last only 30 frames, but it involved multiple layers or passes on the animation stand. That's, say, 10 layers of 30 frames each. That was 300 pieces of art, for 30 frames of film.

"All of this was actually very strange. We were trying to simulate what people expected a computer image to do, and the Magi Animation System™, which was what the motorcycle sequence was animated on, didn't involve grid lines or wire cages at all. It was a system that used a menu of shapes that were blended and sculpted to create objects.

"When I look back on it, I think we must have been nuts, to do this much work in a frame-by-frame, hand-animation method! Today, this effect is almost a by-product in 3-D animation. But at the time, we thought it was just the coolest thing on the planet."

After *Tron*'s release and fade, Disney retained Van Vliet to work on *Something Wicked This Way Comes*. "I did a lot of design work, then the show went into a holding pattern," he explains. "Rather than stay on and do nothing, I moved over to Magi, which had decided to open a West Coast office to make a serious bid in the feature film market. (The group worked on *Tron*'s motorcycles.) Magi wasn't going where I thought it should be going, so I left and decided to open my own company."

In 1983, Van Vliet and partner Katherine Kean opened Available Light Ltd., a company dedicated to being a versatile, all-service animation effects production facility. "At first, we were dealing with cell animation," he says. "On our first feature (uncredited), **Deal of the Century**, we animated gunfire and shadows for jets flying around, did some matte work, and so forth. We were what I laughingly called 'hired pencils and migrant film workers.' "

From then on, Van Vliet's company got more than their share of cell animation jobs. "I've animated so much electricity that I could really get sick of it," he laughs. "On **Buckaroo Banzai,** for example, we did a lot of flying around in the eighth dimension. The effects group I was subcontracting to had made all of this motion control photography of bugs and dirt from an electron microscope. The images were in black and white, so we animated traveling mattes to introduce color in the scene as well as generating all manner of weird electrical events flitting about in the eighth-dimension."

For Van Vliet, and many other purists in the industry, one of the few effects that still works better "by hand" is electricity. "There is something about the computer that makes electricity look like it is computer-generated," he says. "The computer programs that are available today still don't understand the chaos that mimics electrical events well. Plus, if you have to have the electricity interact with a human, you would need to build and animate a human figure to mimic the real character in order to have it wrap around it.

"Even when we brought computer animation into the company (1994), I've still opted for cell animation on electricity. On **My Favorite Martian,** for example, there are about 14 shots we did in animation rather than computer."

Pieces of film projects came in from all over Hollywood. Van Vliet and company worked on films like *Flight of the Navigator, The Golden Child, Spaceballs,* and even *Who Framed Roger Rabbit?*

But it was **Willow** where he had the heaviest cell work. "This was one of the last attempts in the movies where mouths were animated to lip-sync without aid of digital – animal mouths of possums, crows, and goats. We have around 40 shots of talking animals plus another 30 or so shots of other effects.

"We broke up production into little units around the shop. The camera would track and photo-roto; the line animators would actually animate the lips to the dialog track. Then, Katherine would lock herself into a room and match all the fur textures, teeth, and lips with colored pencils on frosted cells, blending each one so that we got what was essentially a mini-matte painting for each frame.

"A lot of the animation was simplified by match-moving the mouth positions under a computerized animation/rotoscope stand. What this means is that the camera operator stabilizes the image in a central area the best he or she can. Essentially, this is animating the north-south/east-west and zoom moves of the animal so that the flat-art

animator is able to focus more time on dealing with the animation issues of lipsync, perspective, and pitch and roll." This type of production planning and task separation enabled the company to produce work in record time.

Van Vliet and company had by now become known as "fixers." When a studio or visual effects house went into overload, Van Vliet was called in to take some of the pressure. "We love 911 calls," he laughs. "They not only bring money into the company, but they gave us a wide exposure to different production styles and a chance to be involved in a number of shows in a short time frame. This was great, since I strongly believe that development as an artist is enhanced by variety and experience. You have to keep fresh thoughts flowing.

"*Spaceballs*, for example, was all about meeting a deadline. There was a shot where Mel Brooks makes his appearance as Yogurt (a takeoff on Yoda). They needed sparkle and twinkle and dust as he comes out of the magic fortune cookie. Our challenge was to fit the animation into the shot.

"Again, it's not just the animation that makes the scene work; it's applying design principles to the scene to make it live there and tell a story. We look at what flavor the director is painting his scenes with – is it over-the-top, in-your-face slapstick? Or a subtle serious twist of imagery? What palette of lighting is the DP using? We have to match and enhance the director's vision."

One of Van Vliet's biggest jobs, at this time, was on the landmark animation/live action feature *Who Framed Roger Rabbit?* "The director, Bob Zemekis, had shot a lot of footage of Bob Hoskins against a blue screen, with the cameras moving all over the place as he supposedly traveled through ToonTown," he says. "What we had to do was take backgrounds from Disney and match-move them into the blue screen set to create a multi-planned ToonTown.

"Unlike most jobs where we were required to animate as our primary job, *Roger Rabbit*'s main need was for a camera service," he recalls. But unlike most camera service jobs, they were asked to animate levels of background art and make creative decisions on how to make the art fit and track. This was unusual in that Disney was not only going outside their own camera service but also that the work was assigned as an open-ended question looking for an answer.

Normally in the Disney animation work chain, the camera operators are left with explicit instructions on how to shoot every frame. Creative input was rarely asked for in that system. "But the

Disney system was struggling with an overloaded schedule and an unusual position of being a collaborator in an animation film," he says. "Animation was being generated in both London and Los Angeles and being composited at ILM to make use of their finely tuned optical department, which had become an expert at high-volume, technically sophisticated VistaVision™ composite work. Because of the volume of work and the fact that so much had to be tracked, ILM recommended Disney send the work to Available Light.

"Fortunately, we had already established a comfortable relationship with ILM as a subcontractor and had previously rebuilt our animation stand to meet the needs and demands of shooting animation for ILM, so our technology was in place and ready to go.

"One of the biggest challenges was the collaboration that we had to achieve between different departments – ours, Disney's, and ILM's," he admits. "Film work is a collaborative effort, and we had to insert ourselves between these behemoth companies and perform our part as another member of the 'Bucket Brigade' to keep the animation and film rolling smoothly.

"Doing this sort of work is often a thankless task; if you do your job well, nobody notices since the work flows smoothly. You become sort of invisible. People involved in this end of the business have to be truly dedicated to work in that kind of environment and be part of a team. Joseph Thomas was our head camera operator at that time and he demonstrated all of those traits.

"Joseph and I figured out that the best way to create the illusion of depth with all of the flat art background pieces was to track the witness points that the live action crew had thoughtfully placed on the blue screen. (Thank you Ken Ralston!)

"After the motion had been tracked, we determined at what point those witness points were in the scene. Then we either added or subtracted percentages of the moves for the different layers to simulate the amount of movement you would observe on sets as they got farther and farther from the camera. All elements were shot in VistaVision™ for ILM to composite up north. Although we had installed an electronic auto-focus on the system for shots such as these, focus was kept crisp so that the option of a focus rack would be with the optical operators," he explains.

"Once the formulas were arrived at, Joseph did the lion's share of scene planning for this work and spent months in the camera room cranking the shots out and keeping the camera and the crew intact.

The camera was often running three shifts so that it was in operation for 24 hours a day to make the deadlines.

"Working an animation camera is a special kind of job," he explains. "You spend all day in a small black room under hot light. It is tedious, at best, and requires an attention focus that many people just don't have. Joseph merits special mention as he continued shooting up until he sort of sagged to the floor after the last shot was delivered. As it turned out, he had hepatitis! That's dedication."

Not all of Van Vliet's work was or will ever be something that screams "effects in an effects picture." Oftentimes, he has been called in to do subtle elements of dramas or even romantic comedies like the 1989 movie **Chances Are**. "It was a short job, but a lot of fun," he says. "We animated two elements – when the main guy dies, he has to plead his case to a harried bureaucrat tapping imaginary buttons on a Plexiglas clipboard/tablet.

"We had to make this big block of Plexiglas appear as if each fingertap produced a ping of energy that would in turn generate brief flashes of a texture that suggested a beautiful stained glass window. This was one of those subtle effects that took a tremendous amount of work for what amounted to a pinch of flavoring in the entire picture. But it's these little pinches, properly applied, that can add up to a fine visual feast."

In 1990, Van Vliet and Kean got one of the plum assignments of the year – **Ghost**. "It was really bizarre," he says. "This started out to be a modestly budgeted picture. I got the impression that Paramount thought of Jerry Zucker as this crazy comedy director, and that they sort of figured this wasn't exactly the thing he should be trying to do. I don't think anyone knew what they had, until the test screenings."

Working with Zucker was an experience for Van Vliet. He had found a soul mate of sorts. Unlike many directors who have a specific element in mind, Zucker didn't have a clear image of what he wanted for a lot of effects, but he was very clear that he was looking for a feeling and a reaction within himself when presented with a test.

"Take the dark spirits, as an example," says Van Vliet. "We spent a lot of time talking with Jerry about what he wanted to see - to feel. It was, at times, a frustrating experience as we approached a lot of the problems with animation techniques, which are inherently slow to produce and put to film. Time and budget were an issue.

"It became a process of experimentation. Whenever we showed Jerry a test, we tried to get him to identify what he liked and didn't like

and then apply those results to the next set of tests. The original description of the dark spirits in the script was something called 'clickers.' These were described as being part of the shadows. When the time arrived to escort a soul to hell, they would separate from the existing shadows and sort of take a more active form in our world just long enough to grab their victim and drag him off. We liked to think of them as chauffeurs to hell.

"What we gleaned from Jerry was that we needed something that had a nervous quality to it that looked different from our basic time-based reality. I rationalized that these creatures would live in a time frame that was essentially on a different frame rate than our own.

"Since Jerry seemed to be favoring the classic dark-hooded figure, we applied that costume treatment to a stop-motion model with 'Mr. Death,' a skull for a head and little bone arms and hands. We dressed the figure in white and shot it against a black background. This film image was then reversed on the printer to produce a dark figure with a clear background. This was then bi-packed on the printer to create a holdout matte on the live action background. Jerry saw this and got very enthusiastic, and we were able to proceed.

"The next step was to introduce some kind of nervous quality to the creatures that gave the impression that they weren't from around here, so to speak. I had observed the effect on time-exposure photography of waterfalls where the water appears to be a soft creamy mass.

"This, of course, is a result of the water blurring together over an exposure that lasts longer than what our 'framerate' of the human eye is. We get used to thinking that what we see with our 'frame-rate' is normal, but in reality, there are many different visions of our world when we dislodge our thinking from the constraints of that 'frame rate.'

"Water is my favorite example. Look at the action of a stream of water when lit with a high-speed strobe, or better yet, look at that same water when shot with a high-speed camera. A completely different image! This is what I refer to as 'time bending.'

"Using this 'time bending' concept, we shot tests with the little ghost puppet with flowing robes being blown by a fan with single-frame exposures up to 30 seconds each. We noticed that after 4 seconds, the robes started to blend into a creamy blur; it optimized at around 8 seconds, with longer exposures not really giving much improvement for the time spent.

"But the really cool thing was that the sequential frames of the robe did not always animate smoothly, although the armature did. The robes often acted like a fire element in the way they flickered and then would follow through in their action. It was a really nice juxtaposition of smooth and nervous motion. We had found our 'look.'

"The next big hurdle was trying to get the dark spirits to articulate in a manner that would allow them to interact with the live action characters. The stop-motion puppets had the degree of articulation that we needed, but the scale on the robes blowing looked wrong.

"We experimented with different sizes of puppets to find out which would give us the best scale against a full sized human. As it turned out, we needed to go with a full-size human figure to make that scale work.

"The prospect of animating, let alone building and maintaining full-size stop-motion puppets was immediately rejected as insane. We figured that the best way to do this was to put an animator in a suit and let him or her stop-motion against a black background.

"The original dark spirit was Mike Jittlov, who had done a number of memorable short films in which he animated himself. He carried the first month or so of self-puppeteering until the tremendous physical strain of doing this for 10 hours a day put him out of action.

"Bill Arance stepped in to finish the bulk of the remaining work with myself occasionally jumping in to relieve Bill when he had to take a break."

All of this filming of the dark spirits took place in a blacked out warehouse, with each frame being exposed for eight seconds each. Every shot was carefully choreographed and timed on exposure sheets to put the dark spirit exactly where he needed to be on a particular frame with his arms or hands in a certain position to interact with the previously shot live action plates. All of the dark spirit elements were filmed over a three-month period.

During this time, another unit under Katherine Kean was designing and animating the scenes where Sam (Patrick Swayze) is confronted with his own death, and the lights from heaven appear in NYC to entice him to make the journey to heaven. Most of this was accomplished with backlit animation techniques and motion-controlled artwork under the animation camera stand. "We didn't know it at the time, but this was to be one of the last big shows before digital blasted through and changed everything we knew," says Van Vliet.

After *Ghost*, he did a series of what he calls "quick jobs." "We had a lot of fun with *Hot Shots*! and the *Honey I Blew Up the Kids* project," he says. "*Honey* had the usual laser cannons, animation of more electricity, and shrinking shots. We used a few techniques that are obsolete skills now – like pin-blocking film elements."

In 1992, Van Vliet signed on to create elements for Coppola's version of *Dracula*. "It was six months of going nuts," he laughs. "We did cell animation for just one shot. Nothing special, just time-consuming.

"There is a sequence where Dracula finishes eating Winona Rider's girlfriend and looks up to see Winona's character. He sees her not as a full-bodied human but sees through her to all the muscles and veins.

"They had tried to make the shot work with a dummy and blinking lights, but it wasn't successful. So on the last day of shooting, we had access to Winona Ryder and filmed her wild as the camera pushed in on her.

"We had wanted to do this with motion control and make various rigs to get the multiple passes that we felt were needed to make this successful but were told that in the spirit of the old *Dracula* pictures, Francis wanted to shoot this with a minimum of modern equipment.

"That decision ultimately contributed to our working for months on that shot, trying to track in multiple levels of animated muscle tissue, bones, arteries, and an articulated beating heart. Besides the generation of the artwork and animation, it was just a grueling trial to keep trying to match-move this perfectly under camera."

From *Dracula*, Van Vliet and company went on to a series of 911 calls and a "lot more animation of electricity," he laughs. "We had about 40 shots in *Demolition Man*, working for Mike McAlistar, most of it being animation of lasers and yet more electricity that was composited with opticals, but this was also when we first started pushing to do some of our first digital work.

"Mike was kind enough to trust us in one of our first computer forays when we did a small number of shots using a Macintosh Quadra™ 950." This started the transition to digital.

In 1994, Available Light Ltd. joined the world, creating a digital effects division. "Many design skills from traditional cell animation are transferable to the digital world," Van Vliet says. "The first Macintosh Quadra™ that was installed did not have animation programs or

compositing programs that were compatible with the type of work that was needed. So traditional animation artwork was scanned into the computer and digitally enhanced to achieve our new look."

This process actually used the computer more for an effects ink and paint machine. Compositing was accomplished by batch-processing image files in Photoshop™. But the process also allowed a relatively cost-effective alternative to the hugely expensive SGI systems. While there were limitations, it allowed a lot of "budget-challenged" films to start incorporating digital shots – and it kept Available Light alive and in the effects market.

The company's first big job involving digital consisted of about 110 shots for Roland Emmerich's *Stargate*. "I had never met Roland but had seen *Universal Soldier*," he says. "I thought the art direction was terrific and the continuity surprising. I was looking forward to working with him on this new project."

The bulk of the assignment was weapons work, energy beams from the stick guns of the Egyptian guards, impact flashes, and enhancements of the air mortars that were used to blow sand into the air for simulating weapons impacts.

Even though Van Vliet had a digital system on board, there were many shots in this picture that were, in his estimation, still better done in cell animation. "I am always beating this drum," he says firmly. "There are time's when traditional animation works better. It isn't that machine that makes it work; it is the art that goes into the shot. So for the bulk of the shots, we animated by hand, composited on the printer ,and kept the shots coming."

The digital work for *Stargate* was the design and animation of the rippling air whenever the evil leader projected his energy field onto his hapless subjects. This work was all accomplished on the Macintosh with the now tried-and-true process of generating the art originally on paper and then scanning it into the computer.

The fledgling digital department came of age when Van Vliet began work on the *Tales From the Crypt* feature films. "It was at this point that compositing software began to appear, and we were now doing more than 50 percent of our work on the computer," says Van Vliet. "It was the beginning of the end for the effects optical printer. An interesting note to the first *Crypt* feature, *Demon Knight*, was a chance to work with the DP turned director, Ernest Dickerson.

"This was the first time I had a chance to work directly with a director who had spent years behind the camera," says Van Vliet.

"What a difference it made with a boss who actually thought in terms of visuals instead of script!

"Coupled with Ernest at the helm was Rick Bota, who had the daunting task of being an ex-director of photography's DP. Rick and Ernest seemed to be in sync, and I found the whole production team to be one of the best groups I have had the pleasure of working with.

"Most of the *Crypt* crew had worked together for years on the television series, so there was this understanding of each other's capabilities that was already in place when I joined the show. A lot of the people whom I met on that show, such as the physical effects people (B&B effects) and the prosthetics (masters effects), I continue to try to work with today."

In spite of a meager budget, little time, and less than opulent shooting conditions, it turned into a bit of a milestone for Van Vliet. "I had this great opportunity to actually get in and contribute directly to the look of the film as it was being planned out. Ernest immediately grasped what I was trying to do and what I needed from him on the set. He was gracious with his time and gave us great support on difficult setups. After this, I remember thinking that all directors should be required to actually spend some time behind a camera before being given a show.

"A lot of people don't understand that successful effects are not just accomplished by throwing vast amounts of time and money at a problem," he says strongly. "A large part of the solution is management of your resources.

"It doesn't do the show any good if you squander all of your assets on a couple of shots and let the rest of the work wither. When you have a director who understands the process, and can think in terms of component filmmaking, your speed on set increases, the setups go faster, and then you can spend the time you need to truly focus on the inevitable special shots. When you have a crew that knows its job and each other, you're in heaven."

Over the next few years, animation and digital were blended well at Available Light Ltd. – on *The Prophecy, First Night, Destiny Turns On the Radio*, and a few other projects. "We then got to work on a really fun project," he says. "Allison Savitch called us in on some additional shooting for the first *Mortal Kombat*. At that time, all I knew was that this film was taken from a video game.

"The first thing that I saw when I looked at the film and went on the set was the incredible lighting job cinematographer John

Leonetti had done. He certainly gave us something special to work with," Van Vliet comments.

At first, Van Vliet was asked to CG exploding warriors with a lot of oozing lava instead of blood. "Now, I am not one to talk myself out of making a lot of money on a job," he says. "However, this was a small budget, and I was seeing this headlong rush of the producers to incorporate what they perceived as the latest buzz in film.

"I was in the unusual spot of trying to talk them out of spending this vast sum of money. They were suspicious of this, and it was difficult to get them to understand the limitations of the new technology and what their dollars could and could not buy. If they wanted CG lava, we would certainly get it for them, but it wouldn't go very far and chances are, it wouldn't look as good as what could be done practically and then enhanced in post.

"However, I've always been a proponent of applying what works for the shot. And, in this case, CG wasn't going to work as well." His confidence in what he needed to make the shot work eventually transferred to the producers. Rather than CG all the elements, Van Vliet worked closely with pyro specialists from Bellissimo & Belardinelli and prosthetics expert Todd Masters to set up fire burns and the splaying of bodies for this soon-to-be monster hit film.

"When we did do CG or cell animation, it was for the right reasons," he says. "The components shot on set dovetailed pretty much as planned, and CG was incorporated as part of the process instead of being the process. The nice part of the film was that once we got rolling, Allison managed to get everyone on her end of the show on board, and we were able to proceed smoothly through the shooting. The effects photography was supervised by John Leonetti, who was a great asset to making what was potentially a dangerous work environment, both safe and creative."

From *Mortal Kombat*, Van Vliet moved on to another series of bits and pieces on films such as *Vampire in Brooklyn, Bordello of Blood, Executive Decision, The Arrival, Escape From L.A.*, and finally, into another comedy – with a few effects – John Landis's *Blues Brothers 2000*.

"Right in the middle of this story, they suddenly introduce these ghost cowboys and cattle soaring above a concert stage as the Blues Brothers perform, of course, 'Ghost Riders in the Sky,' " he says enthusiastically.

"Again, there was talk of trying to generate these characters completely with CG work, and once again, we had to talk the producers out of CG and into more traditional techniques.

"Walter Hart was the effects producer on the show, and we had worked with him before on a Landis project. From previous experience, we learned that Landis enjoyed having options on his work, and that translated to multiple takes with performance variations. That ruled out going the full CG route as budget considerations once again reared their ugly heads.

"The other thought was that the animation of the ghost creatures should be the driving factor in these shots, so it was our recommendation to the production company to have puppets built and animated by puppeteers. Steve Johnson's X-EFX group provided the puppets and actual animation on our set.

"They spent a week dressed in green screen bodysuits doing some really terrific work. Les Bernstein ran both the camera and the motion control unit. Steve Moore stepped in to supervise the shots, working with Walter, who was always on the set to lend a hand. Walter Hart is a different sort of producer, as he has worked in the effects trenches for years and understands all the aspects of getting the work done. When you are shooting, he's there at every level to make things happen and is able to step in to make things work right. Oh, if they could all be of his caliber."

The biggest project Van Vliet and company worked on, to date, is the 1999 feature of the television hit *My Favorite Martian*. "This was a big job," he says. "We had a chance to get in on a moderately budgeted picture to do some really fun work. This was the sort of thing we could die for. Also, *Martian* was a favorite of mine as a kid, so it was kind of great that we could bring to life the feature that I enjoyed so much in my youth.

"The director was Donald Petrie and his director of photography was Thomas Ackerman, who had much experience on effects pictures. Donald was not from a heavy effects background and that was a concern, considering the amount of effects work that had to be accomplished. Directors are often horrified to find out how much time and prep it takes to get the job done. If they are actor performance-oriented, which Donald seemed to be, they can quickly become adversarial to the needs of the effects people whom they perceive as stealing away their quality time with the talent.

"Tom turned out to be a huge asset to us as he understood what we needed to do and often jumped in to suggest an improvement to the process. His experience made the set time efficient and allowed creative input from us as well as the director. Without him aboard, a show like this could have been a slow-motion train wreck. I cannot stress enough how important it is to have cooperative and supportive crew people.

"Donald adapted quickly to what part he had to play in this process and lent us his trust and time in large doses. Ultimately we completed around 90 shots on this picture as well as supervising much of the design work that ended up at the various other vendors around town.

"Phil Tippett's group, headed up by Trey Stokes, worked parallel to us in shooting the plates for what will probably be the show stealer, a fully CG-animated spacesuit that jumps on and off the Martian. This gave us an opportunity to compare notes, drink bad coffee, and tell worse jokes. So Donald had his hands full dealing with both camps vying for his time and attention. The fact that he was able to get what he needed from both of our groups, give us what we needed, plus keep his focus on directing his picture, speaks volumes about his level of energy, endurance and patience.

"The *Martian* script was not a big-budgeted epic looking to break new ground," Van Vliet explains. But to the Available Light crew, this was an opportunity to make something special when nobody really was expecting it.

"When I look back at this film, I realize we could do a whole book on how we did it," he says. "However, one of the background characters in the show was the Martian spaceship itself.

"The story used it as the pivot point for all the rest of the action. The ship got the Martian to our planet, provided comic surprises by its ability to shrink and expand for purposes of concealment, and added a drama. The ship revealed that it had a self-destruct and bomb on board to prevent it from falling into human hands. It also revealed that the bomb countdown could only be halted by getting the ship back into space. So, repairs and launch in a timely fashion became the backbone of the story."

The running gag in this picture was the ability of the ship to be shrunk and then expand through the Martian's "molecular compressor," a handy device that looked and sounded very much like some futuristic car alarm activator. The Martian uses this size

transformation throughout the picture and even applies it to a 1962 Valient that the two main characters are trying to make a getaway in.

"The first order of business for planning an effects sequence is to establish what the rules are for this event concerning alien technology," says Van Vliet. "Through meetings with the film's director and numerous tests on the computer, we determined that the ship expansion/contraction would have the following characteristics.

"The beginning event that signified a change was about to happen was to animate an electrical charge over the craft. As part of the 'alien technology analysis,' this action rearranged the hull mass from its rigid construction and enabled it to be more pliable. It also said to the audience, 'Hey watch this! Bring your eyes here!'

"The spaceship then started its first change, which was when the surface would go soft and a ripple would pulse through it. This rippling surface action diminished, and then the shape would settle back to normal proportions as the actual shrink started," he continues.

"From a visual design standpoint, it was very important to get everyone's attention before the actual shrink started. This is because the actual shrink is not that dramatic in itself to be instantly noticed. And, in an action sequence, the time it takes to become aware of what is going on would have slowed down the cutting, (which is a good reason to make sure that the editor is part of the discussion when planning these things)."

Van Vliet feels that the actual shrink/expansion was simple. For the most part, it was a basic scaling of the CG model in the computer and getting the appropriate timing of the shrink/expansion to fit events in the practical room. "As the ship size changes, director Donald Petrie specified that he wanted to have a warping of the image around the ship, sort of an aura of distortion as if whatever was affecting the ship was spilling into the air around it, almost like a heat ripple," Van Vliet explains.

"This was the only aspect of this event that I was concerned about. With today's effects-savvy audiences, I was concerned that it would appear more like a poor matting job. The effect stayed – nobody complained I worried for naught," he adds.

"The electricity stays on as the ship completes its sizing change and diminishes as it comes to rest, outlasting all other effects. This also gave us a cheat to use the full-size prop or the small-size unit in cuts that bookended the sequence with just the electrical effect on them. This was partially for budget reasons. Electricity is a relatively cheap

effect, while the full-blown CG ship addition was expensive. We got more shots in the sequence by stretching our dollar and managing our resources.

"The actual implementation of this set of rules was best shown by the SETI (Search for Extra Terrestrial Intelligence Group) lab sequence. It was a standard practice in all effects shots to have a complete set of storyboards on hand to show *all* the plates that were needed to complete a shot. These boards were reviewed with special effects, camera and assistant director before we started the shot.

"This preparation and review of boards made for a quick and thorough explanation of what was to transpire and what was to be expected. Boards were made available to any of our crew members who desired to see what was going on. Pictures and diagrams instantly transfer the image you have in your head to all those around you. A crew can then better do the job to make the picture in your head arrive on the film. A picture is truly worth a thousand words, or at least avoids several bad takes until everyone 'gets it.' "

In the lab sequence, the ship is to grow quickly atop the pedestal. It also increases its weight. The effects crew did extensive rigging under the floor. They installed hydraulics to pull a cable down inside the pedestal that the ship rested on.

"This crushed the pedestal and gave us a real-world connection to hang the CG ship on," Van Vliet explains. "We added squibs popping as if there was electrical shorting occurring during the crush of the pedestal. This livened things up from an action standpoint. It also gave us the added bonus of getting the actors to really react, as if they were frightened. (That verifies the old adage about their being very few problems that the proper application of explosives won't fix.)

"All plates were shot with pin-registered cameras locked off and sandbagged for stability. Since it was a raised wooden floor, foot traffic was diverted. The first plate had the small model of the ship in place on the pedestal to give the CG artists a reference for lighting and position. Next, we removed the small prop ship and shot the crushing pedestal with the talent reacting.

"A plate was then shot of the wrecked set without actors for a 'safe plate' in the event we needed to patch something back in. After that, we would install a white card in the pedestal position and turn off the main set lights, using only the lights that were designated to be casting the effects glow from the ship. This gave us a color sample and speed rhythm of the pulsating lights in case we had difficulty in matching them in the CG world.

"All plates were then shipped back to Available Light Ltd. where animation of the ship was to take place. Careful consideration was given to small events that occurred in the actual crushing of the pedestal. These small moments were used to create action extremes of the ship.

"This gave us the motivation to have the ship grow, slide as the pedestal tilts, and ultimately have the landing feet contact the lab floor and slide. The squibs were integrated by creating corresponding flash frames in the CG world. Some extra debris was computer-generated on the floor to mix in with the real carnage and was then kicked about by the legs of the CG ship.

"The shots following the CG ship expansion were with the real full-size ship in place. Since we needed to extend the sequence a bit longer, Tom Ackerman did subtle push-ins with a wide lens on his camera to simulate the final growths of the ship. This enabled the director to have actors touching it and sliding off the ship and reacting to its presence in general. It also saved a bundle on the effects and let us focus on a few really good shots instead of spreading our budget too thin. Again, resource management."

Some effects shots go right from the start. John Van Vliet knows "Murphy's Law" can and will kick in. Such was the case with the now "infamous" (at least to the crew) sewer sequence in **Martian**. "It is always interesting to look at what went wrong," he says. "And, what was done to make it go right. A good case study in this would be the chase sequence that takes place in the sewer.

"The scenario – the heroes (Jeff Daniels and Christopher Lloyd) have been pursued by the bad guys and have the distinct disadvantage of trying to evade their antagonists by fleeing in a 1962 Chrysler Valient. When confronted by a roadblock ahead and the prospect of the pursuers about to overtake them, Uncle Martian produces his 'Molecular Compressor.' He used this to shrink and compress his ship earlier in the film. He applies it to the Valient in which they are riding.

"The story line is that the Valient ducks into a nearby storm sewer opening and makes its way back up to the surface by way of coming out of some citizen's toilet. Never mind the fact that the sewers for storm drains and human waste are two different systems!"

The original plan to execute the sequence – a late addition to the original story – floundered, due to the distraction of production shooting that had already started. "There were variations of the concept, and the storyboard crew was kept extremely busy, fleshing out the many versions into picture form," Van Vliet admits.

"Effects rule #1. Have a plan in place before you start shooting!

"Shooting production is a difficult job on it's own and should not be clouded with distractions. The reality of production will rarely allow you to split your focus to other areas and still do your job well. In a perfect world, this should have all happened in preproduction. But, the reality is, this sort of thing will happen."

At a certain point, a general theme was established for the sewer sequence. The purpose of the chase, established as a story vehicle to get the audience to the main gag, at the finale. This was to place the two principals in their miniature Valient, stuck in a toilet bowl. The peril of the situation being – the toilet is about to be used for its primary purpose.

"The storyboarding was left in a loose fashion and had not been transformed into the exhaustive detailed effects boards that would be necessary to completely understand what the action needed to be," Van Vliet explains. "From this loose collection of drawings and concepts, we were expected to derive an accurate budget and production that we would be held to.

"From our viewpoint, it was a poor investment of time to continue pursuing this direction of research during production. It was suggested that to find out what was really needed, we assemble a pre-visualization animation group, or as it's now called, the pre-viz.

"This would enable a director to hand off his concept work to be developed by animators working with the editor and then presented back to the director for comments and changes. This minimizes the time lost to the production from the director being distracted and gives him or her the most choices in 'sculpting' the action of his sequence.

"I have found pre-vis to be a great help in coaxing details out of a director when planning a shot or sequence," he adds. "If he or she is distracted with shooting production or similar ongoing train wrecks, it is an absolute necessity. Tired people are often not at their best in planning for details.

"At this stage, we suggested to the producers that further time spent on this sequence without pre-vis would be a waste of everyone's time, and that we would rather decline further bidding/budgeting until the pre-vis was accomplished.

"Effects rule #2. Use previsualization whenever possible to establish a plan!

"Movies are pictures, and words may not be to able capture the flavor and pacing that the director has in mind. Putting images in front of the director to tinker with will solve a lot of translation problems quickly. It is better to invest the time in low-resolution tests than when you are trying to do full production."

Because this was not a cash-rich show, the producers declined the pre-vis option because of the expense. They used the existing story-boards to secure bids from other vendors. At Available Light, John Van Vliet and crew held to their position. This should not be bid on until an actual plan was in place. So, they declined further action on the sequence. Ultimately, the sequence was awarded to a well-known miniature specialty group.

"Effects rule #3. Assume that the producers will always take the path of least expense when planning!

"Making a plan takes time and money, and when it is happening shows no results – that comes later," Van Vliet says. Since they rarely see an immediate return on their money, they will be hesitant to spend it."

As the production shooting neared completion, the director was able to once again focus on the sewer sequence. Before principal

photography was wrapped, they managed to build and shoot oversized sets with the car and the heroes in it. Cinematographer Tom Ackerman and second unit DP Doug Ryan shot numerous plates of the actors in front of a "Poor Man's Process" screen, which was essentially a moving blurred background to look like tunnel walls streaking by outside the car windows. Green screens were shot with witness marks on the screens to act as a reference when placing in a new background. With that, the shooting crew wrapped, and the long march into post-production began.

The sewer sequence was now being approached as a full miniature production. A ¼-scale car was being built, pipes were being constructed for the cars to travel through, and huge oversized p-traps were being set up with a pool of water for the car to crash into. The preliminary efforts looked very promising.

As shooting commenced on the miniature car, the crew had to establish a "look" for the sewer environment, such as style and levels of light, wetness, and debris.

"This was no small task as, in the real world, there simply is no light deep in the bowels of a sewer, and it generally has a lot more water in it; after all, that is what it is there for," says Van Vliet, logically. "These tasks were completed, and then the realities of car performance became an issue.

"Since this sequence was being designed and budgeted on the fly, it had been impossible to plan for every contingency. Specific requirements for the performance of the car were now being clarified, and the limitations of real-world physics as well as the existing background sets did not always allow this type of action." The miniature crew was now faced with changes that would be costly and time-consuming since all new sets would have to be built. This contributed to the great that frustration was felt on all sides.

"Effects rule #4. When there is no detailed plan in place, assume the requirements will evolve beyond the assumptions!

"Even with a careful plan in place, I expect some changes and development; that is part of the learning and growing process. But, having a plan in place would have at least enabled everyone to have a better idea of which direction it would have evolved. Previsualization work could have saved a lot of time, money, and frustration.

"At this time, we took a risk and went back to our shop and pulled an all-nighter to cobble together an unsolicited, very quick, and dirty test with our digital Valient in a CG tunnel.

"This was essentially making a pre-vis after the fact; our approach was that by offering this service, we could assist in getting a plan assembled that would get all involved back on track. We hoped that if this test was accepted, some of the more difficult shots would then be assigned to the CG realm and allow the miniature crew to continue to work on the shots that their process was most appropriate for.

"Politically, this was difficult, as we had no wish to undermine the efforts of a very talented miniature crew, but the sequence had reached an impasse and we felt obligated to the director to offer assistance.

"After viewing the test we ran, the production company decided that they wanted **all** of the tunnel in CG. They were frustrated and looking for quick answers, and they wanted what they felt was the flexibility of a CG project. This was further complicated by the fact that the entire sequence had to be done in 12 weeks – for a release date.

"We knew that to create a plan, build a complete CG environment, light it, and they animate it was a difficult task at best. The time factor was more than a minor concern. We finally convinced the director and producer that it was absolutely necessary to retain the miniature crew to keep going on their efforts to have the water interaction shots and to have them provide us with their preapproved set dressing for texture mapping the CG sewer walls.

"Effects rule #5. Frustration leads to demanding more options; this can be destructive in the end.

"Unless the director is very familiar with the effects process, you may have inadvertently diverted his focus and resources from the problem at hand. Unless the project has very deep pockets, it is important to be able to keep things moving and on track," Van Vliet says.

The first part to making this sequence work was to finally get the previsualization step accomplished so that everyone involved had a clear picture in front of them of what was expected. "Our approach to this was to take the existing boards, couple them with the director's comments on what he felt was needed, and go off and push pixels with wild abandon," Van Vliet explains.

"In the CG world, we created several generic sections of pipe with various degrees of bends and turns. These were coupled together in a long section that gave us straightaways, right turns, left turns, traveling up, and descending.

"We then animated the car traveling through this long section and had it experience as many turns and twists as possible. Once the animation was established, we treated the CG car as if it was a real-world camera car. We assigned cameras to its front hood and back deck; we then had it chase and follow a duplicate Valient. When these camera points were established, we hit the low-resolution setting and rendered out what was essentially the same journey with about six different camera viewpoints.

"The end results were then brought over to the director and editor, who cut the sequence to establish the pacing and directions. Additional scenes were added as 'events,' like going through mini-chambers and vaults, hitting debris shrinking further to accommodate smaller pipes. All of this with a giant rotor rooter blade in hot pursuit!

"This pre-vis stage lasted about two weeks, and we got a fairly detailed blueprint on what was needed to make this work. From this point on, the main task was understood, and the individual animators could focus more on enhancing the framework of the story instead of being concerned with translating it.

"Details were added, such as establishing color cues we used cool blue lights from the headlight illumination to always show hope and the possibility of escape, and the red taillights from the rear view of the car showed evil and destruction in pursuit (especially when you saw that big nasty rotor blade glinting in the red light).

"An added lighting trick was to have the rotor blades occasionally spark against the walls, providing momentary bright flashes of blinding illumination. This enhanced the overall danger and gave the sound guys some wonderful opportunities to play. Also, if you look carefully in the flash frames, we tried to position the CG light to cast shadows from the blades that gave the impression of terrible crab-like shadow creatures on the walls of the tunnel. Why pass up such a great chance to throw in some subliminal images?

"A big part of creating effects shots is knowing where to commit your resources; this is especially true in CG environments," Van Vliet comments. "We knew that, with the time and budget restrictions, splashing water, mud, and most events that I class as "chaos events" should best be left to the real world. (I define chaos events as those natural events that don't easily lend themselves to mathematical analysis. This would cover things like fire, smoke, explosions, and fracturing. These events can be done on a computer and can be manipulated and polished to a degree that will make you question your sanity, but it wasn't time or cost-effective in this case.)

"So the miniature guys shot mud, water splashes, and cables that we used to model animation action from; in one case, we actually gave them a printout of our CG plans for sewer grating details so that the extreme close-ups could be shot as a real-world item, and we then matted our CG world behind it. It was a fairly successful collaboration of mixing the two disciplines.

"Effects rule #6. Successful effects production is equal parts of art, technology, and management of resources.

"When all was said and done, the miniature car and set were utilized to make the transition into and out of the sewer world and the bulk of the time underground was CG, with live-action window dressing mixed in. The CG load was 20 plus shots, and all of this was designed, animated, and rendered in the specified 12 weeks. My only regret was that we couldn't make the sequence longer. Maybe next time."

"It was opted not to have a dedicated effects shooting team as a separate unit on this show, since so much of the effects had to be shot with the lead talent and main unit," Van Vliet explains carefully.

"From time to time, a second splinter unit formed from the main unit to go off and cover specific shots. That means the roles of the director of photography and the camera operator now include being part of the effects team. Switching your thinking and pacing from main

unit shooting to a specialized form of shooting like effects is a difficult transition in the middle of a production, and it puts extra strain on the crew. As an effects supervisor, you need to understand this and be able to incorporate that understanding into your planning. Working together and sharing the particular talents and special visions of the camera crew create a powerful filmmaking tool. *Martian* was the sort of collaboration that you could write textbooks about."

Glossary

AATON. Camera in 16/35mm. Made in France. Can be considered lightweight and portable.

ACCENT LIGHT (key light, kicker, or backlight). Light fixture placed in such a way as to emphasize a particular subject.

ACE. 1,000-watt incandescent light stop.

ACETATE. Clear sheet of plastic composed of cellulose triacetate, used as a base for filter gels.

AKELA CRANE. One of the largest camera cranes, which extends to 80 feet and enables the camera to arc over a location or bring equipment from floor to 80 feet above.

ALIAS POWER ANIMATOR™. Software used for animating 2-D/3-D developed by Alias/Wavefront.

ALIAS WAVEFRONT™. Software developer owned by Silicon Graphics Company.

AMBIENT LIGHT. (1) Soft, overall light of undefined origin. (2) Natural light or available light.

ANALOG. Form of electronic signal that depends on varying voltage levels.

ANAMORPHIC. Wide-screen photography for an aspect ratio of 2.35:1. Shows more width on the screen through the use of an **ANAMORPHIC LENS.** Compresses the picture horizontally. To correct compression, it is projected onto screen, through a similar lens achieving lateral expansion. (Also known as wide-screen photography.)

ANIMATION CAMERA (rostrum camera). Built exclusively for single-frame photography with high-precision registration mechanism and film movement. Single-frame capacity, automatic faders, dissolvers, and follow-focus, as well as forward and reverse run. Mounted vertically on a rigid animation stand (rostrum stand).

ANIMATION STAND. Multiple effects – use stand originally designed for cell animation. Parts include single-frame animation camera and easel (or bed) that can hold registered art work. Camera moves in relation to artwork, which

can also move in relation to camera. Two formats; the vertical stand has a camera mounted on a column shooting down at an easel on a table; the horizontal stand tracks along artwork mounted on a vertical easel. Today's stands are computer-controlled – setting focus, exposure, and motion.

ANSWER PRINT. First color and density-timed composite print of a motion picture or filmed television program, made from an edited picture negative and dubbed.

APERTURE (Lens aperture.) Opening on a camera or projector lens or printer through which light passes. The amount can be controlled by adjustment of the diaphragm (iris) or by a masked opening. (Also called T-stop).

ARC. High-intensity lamp that creates an intense light when electrical current sparks continuously between negative and positive rods or electrodes. Open arc, carbon arc – Xenon or HMI.

ARRI (Arriflex™ camera.) Brand name of a high-quality film camera that brought 16mm into professional acceptance. The Arriflex company also manufactures high-quality 35mm cameras. They built the first reflex viewfinder motion picture camera in 1937, creating a small and lightweight instrument for handheld shooting.

ARTICULATED ARM. Adjustable appendage containing ball and socket joints at regular intervals, used to hold a gobo from a C-stand or camera in different angles.

ARTIFICIAL LIGHT. Light produced by an electrical or other power source, as opposed to natural light (sun, etc.).

ASA. ASA number on a film designates the film's relative sensitivity to light. It is an arithmetic scale. A film with an ASA of 100 is half as sensitive as a film with an ASA rating of 200. The former, therefore, needs twice the amount of light to obtain the identical T-stop at a given frame rate.

ASC. American Society of Cinematographers. Founded in 1919, as a non-profit organization.

ASPECT RATIO. Screen size as expressed by the ratio of the width to the height. Standard aspect ratio is 1.33:1. Most commonly used are 1.66:1, 1.78:1, and 1.85:1. VistaVision is 2.21:1 Television is 4:3 (same as Academy, 1.33:1). HDTV ratio is 1.78:1.

AVAILABLE LIGHT. Light existing naturally within a given area.

BABY. Focusing Fresnel fixture with a 1,000-watt lamp.

BABY JUNIOR. A focusing Fresnel fixture incorporating a 2,000-watt lamp in a standard baby body.

BACKGROUND PLATE. Shot produced especially for use as a background in process photography (i.e., rear/front projection).

BACKLIGHT. Light used to separate subject from background.

BEADBOARD. Polystyrene bead foam sheeting. Highly porous surface makes it an excellent, very soft reflector.

BEAM SPLITTER. Optical device, such as a prism, that splits the light beam from the lens into two separate images. In visual effects, forms image on negative and the same image on other film stock to be made into traveling matte. With optical printers, with two projectors on each axis, it allows separate images to come together to form a composite.

BEAUCAM. Lightweight VistaVision™ camera system built by Greg Beaumont.

BETACAM™. Trade name for professional half-inch video format created by Sony.

BIPACK CAMERA. Camera that can hold two magazines and run two film strips at the same time, usually in contact. Together with BiPack printing, one of the most important tools in optical effects.

BIPACK PRINTING. Ability to generate composite images on the optical printer, i.e. matte painting/live action plate, etc.. Prints through two strips of film running at the same time.

BLEEDING. Light or color dispersed around the edges of a matte (or a front projection subject) due to misalignment or poor film registration.

BLUE SCREEN PHOTOGRAPHY. Also are done green screen, orange screen, and less frequently black limbo. Photography of actors or objects in front of blue/green/orange/black background to generate elements for compositing. Choice of background depends on color elements in shot. A cost-effective method of putting actors into locations too expensive or too far away.

BOLEX. Precision built, lightweight, handheld 16mm camera with a wind-up motor made in Switzerland. Has been widely used for documentaries and travelogues before the advent of ENG/EFP.

BOUNCE BOARD/CARD. Large white card used as a reflector. Because of limited reflectance, it must be placed close to subject to be effective.

BRUTE. Large carbon arc fixture of 225 amps.

CAD/CAM. Computer-aided design/computer aided manufacture. Used with computer graphics or motion control.

CARBON ARC. Arc lamp using carbon arc electrodes for high power location/studio illumination.

CEL. Thin, transparent, plastic sheet used to record some elements of artwork (usually animation) before photographing.

CEL ANIMATION. Animation process that employs a number of cels (at different levels of the easel of the rostrum stand), on which are drawn various parts of a scene both to create a sense of depth and to avoid drawing again and again the stationary parts of a scene or character.

CGI (CG). Computer generated imagery.

CHINESE LANTERN. Large paper globe used as a diffusion shade. The lantern is often used to soften bare lamps ranging in power up to 2,000 watts.

CHROMINANCE. Color portion of a video signal. Refers to the saturation and hue of a color, not its value.

CINEMASCOPE. Wide-screen process, used extensively, involving anamorphic lens and an image on 35mm film laterally compressed in a 2.35:1 ratio.

CINEORAMA™. Wide-screen system of 360 degrees that uses 10 separate film strips and projectors running in sync. The viewer sits in circular building and is surrounded by screens.

COLOR CORRECTION. Lab process where scenes of a film are selectively printed or reproduced electronically to yield the most pleasing color balance or to match the color hues of different shots in order to produce a homogeneous print.

COLOR-REVERSAL INTERMEDIATE (CRI). Negative from which the laboratory strikes release prints.

COMPED (or composited). Combining fine-grain positive print(s) together with sound.

COMPOSITE. Combination of two or more images shot on different locations (noun). Process of combining several images in one shot (verb).

COMPUTER GRAPHICS. Art designed and executed on a computer.

CRANE. Large camera trolley with a long projected arm or boom at the end of which is a platform holding the camera.

CRANE SHOT. Shot taken from a crane, generally when the camera moves as a result of the crane's mobility.

C-STAND (or century stand). Three-legged mobile stand that holds flags or other apparatus to control light or reduce intensity. Also holds objects for shadow effects.

CTB (color temperature blue). Blue filter for increasing the color temperature of a source in varying amounts. A full CTB, for example, increased the color temperature of transmitted tungsten light from 3,200 degrees K (kelvin) to approximately 5,500 degrees K.

CTO (color temperature orange). Orange or amber filter for decreasing the color temperature of a source in varying amounts. A full CTO lowers the color temperature of transmited daylight from approximately 5,500 degrees K to 3,200 degrees K.

CUCALORUS (also known as Cookaloris, Coualoris, Cuke, Kukaloris or Cookie). Irregular shadow pattern (cutout) placed in front of a spot light and projected to break up the monotony of a dull, flat surface.

CUTTER. Long, narrow flag, used for blocking light from the camera or an area of the set.

CYBERWARE. 3-D software package for scanning.

CYC (cyclorama). Large, continuous piece of cloth curved around the scenery to form a backdrop or to indicate sky.

DAY FOR NIGHT. Shooting in daylight, but giving the effect of night through underexposure, filters, or printing, or a combination thereof.

DEDO LIGHT. Very small, low-voltage focusing fixture with external plane convex lens of 100 or 150 watts, invented by Dedo Weigert.

DEPTH OF FIELD. Area of acceptable focus on either side of the primary plane of focus. The field in front of the camera in which the objects placed in different distances register in sharp focus. The depth of field depends on focusing distance and focal length as well as aperture of lens in a given lighting condition.

DESATURATE. Decrease of color saturation. Oftentimes colors are intentionally desaturated to get a required effect. Can be achieved through various methods, including flashing and skip-bleach processing as well as other lab processes.

DEUCE. A 2,000-watt incandescent spotlight. (Also called a Junior.)

DIFFUSION. Translucent materials that soften highlights and shadows, reduce contrast, and increase the size of a light source.

DIGITAL. Manipulation or storage of information using the electronic equivalent of ones and zeros.

DIGITAL CORNER PINNING. Altering the perspective on a 2-D plate by offsetting the corner positions. Similar to holding a postcard in front of a camera and tilting it.

DINO (Dino Light). Module light fixture consisting of 24 or 32 single, 1,000 - watt par lamps that can be focused in groups of 6.

DIRECTOR OF PHOTOGRAPHY (DP). Person responsible for capturing the image on film or video. Lights the set, composes the scene and chooses colors of the image, cameras, lenses, filters, film stock. Maintains overall style of picture.

DOLLY. Wheeled platform, sometimes mounted on tracks, that offers untroubled, smooth movement of the camera.

DOMINO™. Compositing software/hardware (SGI Onyx-based), developed by Quantel.

DOUBLE EXPOSURE. Exposing of a single piece of film to two different images.

DOUBLE PRINTING. (1) Optically slowing down film action, accomplished by printing each frame a multiple number of times. (2) Combining two negatives in a single printing (composite).

DULLING SPRAY. Pressurized spray in a can used to eliminate or reduce glare and reflection of light on shiny surfaces.

DUPE. Duplicate negative made from a positive original.

DUTCH ANGLE. Camera angle that seriously deviates from the normal vertical and horizontal axis of the image. (Also known as canting.)

DUVETYN. Heavy, fire-retardant black fabric used for making teasers, flags, solids, and cutters. Also used to block out windows, conceal objects from view, and control spill light.

DYKSTRAFLEX. One of the first and most sophisticated (for the time) electronically controlled camera rigs, developed by John Dykstra while working at ILM during the time of *Star Wars*. (Also called motion control.)

EFFECTS ANIMATION. Introducing lightning, rain, laser blasts, etc., into live action or miniature footage through animation techniques.

ENR PROCESS. Proprietary silver-retaining, color-positive developing technique of Technicolor, named for it's inventor, Ernesto Novelli Rimo. Adds density in the areas of most exposure, among other things.

EXABYTE. Hardware to store digital information on a metal hybrid tape. The system uses the same tape format as Hi8 video.

EXPOSURE. Process of exposing the motion picture film to light in the camera or printer in order to produce a latent image on the emulsion coating. Determined by time and degree of illumination.

EYEMO. Very small 35mm camera, widely used in crash boxes to capture action from precarious angles.

FISH-EYE LENS. Extremely wide-angle lens, used for special effects, either during production or in film postproduction.

FLAME™. Real-time compositing software/hardware (SGI Onyx-based) developed by Descreet Logic.

FLASHING. Process of exposing the film before or after shooting to a controlled light in order to reduce and distinguish contrasts. Also allows over-saturation by muting colors.

FLICKER-FREE. (1) Absence of the unsteady appearance of illumination on screen caused by alternating periods of light and dark at too slow a frequency to allow viewer's persistence of vision. (2) Term used to describe discharge lamps that do not have to be synchronized with the frame rate of the camera to avoid flickering images.

FOCAL LENGTH. Distance from the center of the lens to the light's convergence point (focal point) behind the lens.

FOOTCANDLE. Measurement of the intensity of light equivalent to that produced by one standard candle on the surface of a sphere with a radius of one foot surrounding the light source. Equivalent to one lumen per square foot.

FORCED PERSPECTIVE. Background objects in miniatures made on smaller scale to make them appear farther from the camera.

FPS. Frames per second.

FRAME RATE. Number of frames per second that are being exposed or displayed. Usually kept at sound speed (24 fps).

FRAZIER LENS. Special-designed lens by Jim Frazier that allows the cinematographer to set shots that keep deep focus (i.e. a golf ball in foreground and golfer in far background). Originally used for photographing tiny bugs or elements of that size.

FRESNEL. Lens with stepped-down concentric circles on the convex side, which is placed in front of a bulb as a condensor. Light is flooded when the bulb is close to the lens, but when it is moved back, the lens acts as a spotter, controlling area and intensity of illumination.

FRONT PROJECTION. Method of photographing actors in a studio with a moving or still background shot elsewhere and projected on a screen behind them. Projector is placed in front and to the side of the camera at a 90-degree angle, and the optical axis of both are precisely lined up with the help of a semi-reflecting mirror positioned at a 45-degree angle in front of the camera.

F-STOP. Ratio of the focal length to the widest effective diameter of the lens opening, determining the "relative aperture" of a lens (Also see T-stop).

GAFFER. Head lighting technician for a film or television program. Responsible for consulting with and carrying out the plans of the director of photography.

GAMMA. Contrast gradient of a film, representing the particular relationship of the light and dark areas of images developed upon it.

GANTRY (or catwalk). Elevated platform to hold lights, usually suspended from the stage ceiling.

GARBAGE MATTE. Animated matte that are generally made of black paper and shot on an animation stand. Used to roughly block out unwanted areas or objects in picture element that will go to composite image.

GATE. Opening in a camera or projector, behind the lens and shutter, in which the film is held while being projected or exposed.

GAZELLE RIG. Motion control rig built by Sorensen design.

GEL. Filter placed in front of a light to change the color or intensity of that light. Usually made of a translucent material. Gel colors can be obtained as liquid paint to create custom gels or to tint windows in a practical location.

GENERATION. Number of duplications away from the camera original.

GIMBAL. Mechanical rig that allows a camera or set (such as plane body) to be suspended and move independently of surrounding setups.

GLASS SHOT. Image painted on or otherwise affixed to glass in front of a set. Can be photographed to make it appear as if set and image are one, thereby adding elements to the shot in camera.

GOBO. Lighting accessory that is used in front of or inside of a luminaire to shape or alter the quality of a beam.

GO-MOTION. Next step from stop motion (ILM development in 1970s, first used in 1981). Electronically controlled moving miniatures. While in motion and shutter is open, creating a realism by adding motion blur to the effect of stop motion.

GYROSPHERE (gyro head/zoom). Gyroscopic head on a camera tripod that incorporates a gear train and heavy flywheel to ensure smooth movement. Stabilizes lens.

HALATION. Undesired illumination around the subject of an image, normally in the form of a halo. Caused by light passing through the emulsion and reflecting off the film base.

HALOGEN. Nonmetallic elements (chlorine, fluorine, bromine, and iodine) that are combined with silver particles to form the halides in film emulsion.

HANDHELD. Shot taken with an unmounted, portable camera held by a cameraperson.

HDTV high-definition television. Wide-screen, high-resolution television system that is the next generation of television broadcasting.

HI-CON. Black-and-white image that is made on high-contrast film and used in effects creation.

HMI. (hydragyrum or mercury, medium arc length, and iodide). Together, the generic designation of an enclosed-arc ac-discharge photographic lamp. Extremely rich in ultraviolet energy. Produces about three to four times the light of incandescent fixtures of equal wattage.

HUDSON SPRAYER. Manually operated low-pressure device for spraying coater, pesticides, etc.

IMAGE ENHANCEMENT. Process that sharpens the edges within a video picture and raises the apparent resolution of the image.

IMAX. Camera and projector system that employs the largest film frame of motion picture history, 65mm film, moving through the camera horizontally, allowing individual frames that are 15 perforations wide (10 times larger than 35mm).

IN-CAMERA. Effects done entirely on the original camera negative, either on a single pass or involving multiple exposures on one strip of film (i.e., same strip of film run through the camera as many times as needed to produce effect).

INCANDESCENT LIGHT. Light emitted from a filament inside a bulb that glows as a result of being heated.

INKIE. Small fresnel light, usually 100 watts.

INSERT. Shot relevant to a certain scene, but filmed at a different time and later cut into footage.

INTER-NEGATIVE (IN). Negative created from the original negative or an interpositive, in order to strike release prints. In most cases, the internegative is duped from a timed IP.

INTER-POSITIVE (IP). Master positive created from the original negative. In order to make dupe negative, used as a protection for the cut negative or as an intermediate step in the process of making a release print.

INTROVISION™. Proprietary front-projection technique that employs elements of the Shufftan process, in order to integrate a foreground subject into a background plate.

IRIS. Variable lens opening that controls the amount of light reaching the film. (Also called a diaphragm.)

JIB ARM. Projected arm of a dolly or crane, with either the camera or light attached. Can be placed in a number of positions and rotated a full 360 degrees.

JUNIOR. Focusing Fresnel fixture with a 2,000-watt lamp. (Also called a deuce.)

KELVIN SCALE. Measure of color temperature by means of comparing the visible aspects of a light source to a heated body. Often abbreviated as degrees K.

KEY LIGHT. Major source of illumination for a subject or scene.

KINESCOPE. Film image made by photographing a television monitor or recorded directly onto the film emulsion by an electron beam.

KINETOSCOPE. Peep-show viewer developed around 1893 by Edison.

LATITUDE. (1) Range of exposure for a film that allows a satisfactory image. (2) Range of contrast a film emulsion can record.

LEKO. Another term for ellipsoidal fixture.

LEXAN™. Tough, resilient, optically clear acrylic sheet material often used as a protective shield for the camera to shoot through when photographing gunshots or explosions.

LIGHTWAVE™. Modeling/animating software primarily used by NT/PC machines.

LIMBO. Area or set with no defined characteristics. Background seems to extend to infinity or is completely black.

LOCK OFF. Production term referring to a shot in which the camera is not moved and is secured in a particular spot.

LUMINANCE. Amount of pure white in a picture signal. The brightness information to the picture signal.

MACINTOSH QUANDRA™. MAC hardware used for 2-D graphics.

MAG (magazine.) Lightproof container that feeds the film into the camera and takes it up after exposure.

MAGIC HOUR. Time when the sun goes down (i.e. dusk). Usually a 20-minute window during which contrast is low and hues are most saturated, often with a rose cast.

MATTE BOX. Front attached device for camera lens. Holds filters and masks as well as a sunshade to avoid lens flares.

MATTE PAINTING. Painting that is added to a scene to form a composite image. Can be part of a glass shot, a separate element altogether, or a background for front or rear projection and other process photography.

MAXI BRUTE. Nine-light cluster of 1K Pars. Useful for lighting large night exteriors as well as spacious interiors.

MERCURY VAPOR. Tubular discharge-type lamp in which the light is produced by the radiation from mercury vapor. Predominantly blue-green light for industrial applications.

METAL HALIDE LAMP. Industrial, high-intensity discharge-type lamp, in which the light is produced by the radiation from mercury, together with halides of metals such as sodium and scandium.

MICRO-PHOTOGRAPHY. Photography of subject that is microscopic in size and done with a film camera mounted on a microscope-type camera.

MINIATURE. Small-scale model of buildings, cars, animals, people, locations.

MIRROR SHOT. Shot that employs a mirror in order to achieve a visual effect or render a mirror image of the subject.

MITCHELL CAMERA. Nowadays, most likely used in visual effects applications because of high-precision registration in the movement. Somewhat big and cumbersome.

MODELING. Detailed three-dimensional look of a subject achieved through the interplay of light and shadow.

MORPHING. Blending of two images in a seamless manner. Changing one image into another.

MOTION CAPTURE. Using computer "probes" attached to a person or moving object to "capture" movement and translate it into data that will generate the movement of the object into a computer for reproduction digitally.

MOTION CONTROL. Computer-controlled camera capable of precisely repeating elaborate camera moves in exact replication of original shot. Multiple elements are photographed separately and then composited together.

MOVIOLA. Trade name for a portable editing machine run by a motor and equipped to handle a single reel of film and single sound track.

MUSCO LIGHT. Self-contained articulating lighting system of very high output, mounted on a truck that carries a generator, thus eliminating the necessity of a large amount of cabling and crew.

MUSLIN. Coarsely woven cotton fabric used as a reflective material for bounce lighting.

MYLAR™. Highly reflective, very thin polyester film used as a base for magnetic tape, made by DuPont.

NEUTRAL DENSITY. Filter on a camera or light fixture that reduces the light levels reaching the lens or subject without altering the color values of the light.

NODAL HEAD. Support used in special-effects cinematography that permits camera to pan or tilt without perspective shift by turning on the nodal point of lens. Prevents separation of hanging models or glass mattes from background or the subject in front projection.

NIGHT FOR DAY. Shooting a scene at night with sufficient light so that scene appears in the film as if it were shot during the day.

OMNIMAX™. 65mm large-screen system based on the IMAX™ technology, but using a fish-eye lens on camera and projector.

ONYX™. Silicom Graphics Unix-based workstation computer multiprocessor based.

OPTICAL PRINTER. Optical bench setup modified for film printing. Projector and camera mounted with lenses facing each other. The projector throws image at camera, allowing for simple to elaborate compositing.

OVERCRANKING, UNDERCRANKING. Slowing or accelerating the rate at which film passes through the gate to create either a slow-motion effect (overcrank) or sped-up effect (undercranking).

PAINT BOX™. Brand name of Quantel Corporation's electronic paint system, a type of flexible graphics device.

PANAVISION™. Major manufacturer of high-quality 35mm and 16mm film cameras, and equipment.

PAR. Sealed-beam parabolic aluminized reflector lamp, comparable in design to an automobile headlight.

PARALLAX. Apparent displacement of an object that results from the change of perspective with which it is viewed.

PEPPER. Small Fresnel fixture in one of several sizes accommodating a 100, 200-420-650-1,000-watt tungsten-halogen lamp.

PERISCOPE CAMERA. Camera with attachment that allows shooting at extremely low angles or odd angles. Sometimes used in miniature photography.

PHOTO FLOOD. Incandescent lamp similar to (but more powerful than) a standard household tungsten bulb.

PHOTOSHOP™. 2-D paint software used for multiple platforms.

PHOTOSONICS. High-speed camera system that allows frame rates as high as 360 frames per second for 35mm film, while utilizing an intermittent movement.

PIN BLOCKING. Alignment of two or more single frames of film on a "pin block" in order to check for matte lines or framing differences by overlaying one element of a composite with another.

PIN REGISTERED. Method of providing image stability during photography or projection that inserts a pin into a film sprocket hole as each frame is exposed or projected.

PIXEL. Photo element. Specks of phosphorescent color in the photo image. In CGI, the number of pixels makes up the degree of resolution.

PLATE. Glass-mounted still photograph. (Also see background plates.)

POLYGON. A piece of surface in three dimensional space. A simple polygon can be dissected into triangles with the verticals at the verticals of the polygon.

PRACTICAL. Either a place (i.e., street or structure) or piece of equipment (usually a light) that is found where it stands or is used normally.

PRE-RIGGING. Practice of setting lights before the shooting day.

PRIMACORD. Explosive of string-like appearance. Produces a very fast and powerful detonation.

PROCESS CAMERA. Specially designed camera with the highest quality of registration and precision possible. Used on special effects matte shots.

PROSTAR. Computer monitor.

PYROTECHNICS. Controlled use of fire and explosions.

RCI (restored color image.) Brings back the original color image. A patent-pending process developed by Peter Kuran.

REAR PROJECTION. Projection of a still or moving picture onto a screen behind the action that is being photographed. Projector is placed behind the translucent screen, while synchronized with the camera.

REFACIL. Brand name for fire-retardant cloth.

REGISTRATION. Placement of each frame in the exact same position with perfect steadiness.

RESOLUTION (HIGH/LOW). Degree of screen reproduction of an image in fine detail, expressed in number of lines per millimeter defined in the image.

REVERSAL STOCK. Film stock that, after processing, yields an image of the same type as that to which it was originally exposed.

RITTER FAN. Large wind machine using propeller-like blades.

ROTOSCOPING. Projecting of images (one frame at a time) on surface. Outline of character or set piece is then traced by hand. The emerging silhouette then used as reference for hand-drawn elements.

SCRIM. **(1)** Small wire-mesh gobo used to reduce light output without altering color temperature of a light fixture, held in the front brackets of the lamp housing. (2) Large piece of stretched gauze placed in front of a light fixture to diffuse the beam.

SHOWSCAN™. 65mm, five-perf-large screen format photographed and projected at 60 frames per second to reduce flicker, grain and image "strobing."

SHUFFTAN PROCESS. Invented by Eugene Shufftan in 1920s. Through the use of a front-surface mirror, placed at 45-degree angle in front of the camera and the subsequent removal of parts of the silver mirror coating, two elements of different scale or origin can be composited in-camera.

16 MILLIMETER. Small-format, negative-positive motion picture film stock in width of 16mm, containing 40 frames per foot, with single or double perforations on the edges.

65 MILLIMETER Wide-screen cinematography camera original (negative) film stock, using 70mm duplication and release prints. 12.8 frames per foot.

SLAVE CAMERA. Reference camera generating a "slave" or computer/video code.

SLIT-SCAN. First used in *2001: A Space Odyssey*. Shooting of art through a controlled slit, where two of the key elements are in motion during a long single-frame exposure.

SNOOT. Flanged tube or funnel-shaped accessory that fits over the front of a fixture and focuses the light into a small circle.

SNORKEL CAMERA. Similar to periscope camera, but yielding greater depth of field. Camera has an attachment that allows it to get low and close or with special housing under water.

SPLIT SCREEN. Multiple images on one screen, as picture is repositioned for the split. Allows two or more scenes (or images of same character) to be displayed at same time.

STEADICAM™. Trademarked camera-stabilizing device that attaches to the human body, allowing the camera to float alongside the operator, smoothing the movement.

STOP MOTION. Technique of repeatedly stopping and starting the camera while changing the subject inbetween intervals. Can be used to make inanimate object appear to be moving of its own accord. In stop-motion animation, the camera exposes a frame, the object is moved, another frame is exposed, etc.

STORYBOARD. Graphic representation of the general continuity of a film or video production via graphics, sketches or art work.

SUPER 16mm. Motion picture original, with about 24 percent larger frames than the regular 16mm film. Aspect ratio of 1.66:1.

TEASER. Large black cloth screen for controlling soft light.

TECHNIRAMA. Wide-screen film process, developed by Technicolor that used 35mm film moving horizontally through the camera while exposing a frame of eight perforations behind an optical system, which compressed the image.

35-MILLIMETER. Accepted standard film of the professional film industry. 35mm wide and has sprocket holes running along both edges. 16 frames per foot of film, and 4 perforations on each side per frame.

3-D PHOTOGRAPHY. Stereoscopic cinematography, creating the illusion of three-dimensional images on flat screen so foreground seems to stand out and other planes are separated spatially.

TRANSPARENCY. Still image printed on a transparent medium, such as glass or celluloid, and projected.

TRAVELING MATTE. Mask on portions of elements of a composite shot that moves and changes from frame to frame.

T-STOP. Calibrating system for determining how much light a lens transmits to a film. Uses aperture dimensions and factors of lens absorption and reflection to determine the actual amount of light that will fall on the film. (Also F-stop).

TUNGSTEN. White metallic element that withstands extremely high temperatures without melting. Commonly used for filaments in incandescent lamps.

ULTIMATE™. Trademarked name of the Ultimatte Corporation for an advanced form of chroma key. The device is used for creating high-contrast images in telecine and edit bays. Analogous to sophisticated optical printer.

VIDEO REZ. A video image consisting of horizontal pixels and vertical lines. The pixel resolution of one regular video frame in NTSC format is 640 pixels by 486 lines.

VISTAVISION™. Wide-screen film production system using 35mm film running horizontally through the camera, exposing an image eight performations wide with an aspect ratio of 1.5:1. Used in visual effects because of negative area twice as large as regular 35mm. Also the trade name for film cameras running 35mm film stock horizontally.

VISUAL EFFECT. (photographic effect or optical effect). Image manipulated with the aid of computers or optical systems, as opposed to mechanical (special) effect.

WEDGE (exposure wedge). Strip of negative film that progressively gets darker from frame to frame and is used by the laboratory for testing (Also called sensitometric strip.)

WILCAM™. High-speed VistaVision™ and 35mm camera system.

WIPE. Optical effect in variety of shapes that serves as transition between two successive shots.

XENON. High-intensity lamp or light containing xenon gas.

YCM SEPARATION. Technique of extracting from a single stirp of color film: three separate black-and-white negatives, each one of them representing one of the three colors: yellow, Cyan, or magenta.

References

Bognar, Desi K. *International Dictionary of Broadcasting and Film.* Focal Press. Newton, MA. 1995.

Browne, Steven E. *Film/Video Terms and Concepts.* Focal Press. Newton, MA. 1992.

Carlson, Sylvia and Vern Carlson. *Professional Cameraman's Handbook.* Fourth Edition. Focal Press, Newton, Ma. 1994.

Ferncase, Richard K. *Film And Video Lighting Terms And Concepts.* Focal Press. Newton, Ma. 1995.

Fielding, Raymond. *Special Effects Cinematography.* Fourth Edition. Focal Press. Newton, Ma. 1985.

Finch, Christopher. *Special Effects: Creating Movie Magic.* Abbeville Press, N.Y. /Cross River Press Ltd. 1984.

Konigsberg, Ira. *The Complete Film Dictionary.* Meridian Books. New York. 1989.

Samuelson, David. *Hands-On Manual For Cinematographers.* Focal Press, Newton, Ma. 1994.

Schneider, Arthur. *Electronic Post-Production Terms And Concepts.* Focal Press. Newton, Ma. 1990.

Smith, Thomas G. *Industrial Light & Magic, The Art Of Special Effects.* Del Rey/Ballantine. New York. 1986.

Vaz, Mark Cotta And Shinji Hata – *From Star Wars To Indiana Jones. The Best Of The Lucasfilm Archives.* Chronicle Books. San Francisco, Ca 1994.

Photo Credits

Scott E. Anderson photo courtesy of ImageWorks

Mat Beck photo courtesy of Mat Beck

Eric Brevig photo courtesy of Industrial Light and Magic

John Dykstra photo courtesy of ImageWorks

Richard Edlund photo courtesy of Richard Edlund Productions

Volker Engel photo by Isabella Vasmikova
 Inclusions in chapter by Volker Engel

Anna Foerster photo by Volker Engel
 Inclusions in chapter by Volker Engel

John Knoll photo courtesy of Industrial Light and Magic

Peter Kuran photo courtesy of VCE

Rob Legato photo courtesy of Digital Domain

Ken Ralston photo courtesy of ImageWorks

Steve Rundell photos courtesy of Ground Zero Studios

Mark Stetson by Anthony Friedkin

Philipp Timme by Scott Fuller

Doug Trumbull by Douglas Kirkland

John van Vliet photos courtesy of Available Light